ARTISTS
IN EXILE

ALSO BY JOSEPH HOROWITZ

Classical Music in America: A History

Dvořák in America: In Search of the New World
(for young readers)

The Post-Classical Predicament:
Essays on Music and Society

Wagner Nights: An American History

The Ivory Trade: Piano Competitions and
the Business of Music at the Van Cliburn
International Piano Competition

Understanding Toscanini: How He Became an
American Culture-God and Helped Create
a New Audience for Old Music

Conversations with Arrau

ARTISTS IN EXILE

HOW REFUGEES FROM TWENTIETH-CENTURY WAR AND REVOLUTION TRANSFORMED THE AMERICAN PERFORMING ARTS

JOSEPH HOROWITZ

HARPER

An Imprint of HarperCollins*Publishers*
www.harpercollins.com

HarperCollins books may be purchased for educational, business, or sales promotional use. For information, please write: Special Markets Department, HarperCollins Publishers, 10 East 53rd Street, New York, NY 10022.

FIRST EDITION

Designed by Emily Cavett Taff

Library of Congress Cataloging-in-Publication Data

Horowitz, Joseph.
 Artists in exile : how refugees from twentieth-century war and revolution transformed the American performing arts / Joseph Horowitz—1st ed.
 p. cm.
 ISBN 978-0-06-074846-3
 1. Performing arts—United States—History—20th century. 2. Europeans—United States. 3. Refugees—United States. I. Title.
 PN2266.3H67 2007
 791.086'9140973—dc22 2007025690

08 09 10 11 12 ❖/RRD 10 9 8 7 6 5 4 3 2 1

What today is the meaning of foreign, the meaning of homeland? . . . When the homeland becomes foreign, the foreign becomes the homeland.

—Thomas Mann, 1941
Santa Monica, California

CONTENTS

ILLUSTRATIONS

PREFACE

THE COMPOSER ROGER SESSIONS, whose grandmother's great-grandfather was a Civil War general, did not believe in consciously seeking an "American" musical identity. "I never worried about it," he once told an interviewer. "Now, Aaron Copland said that I didn't worry about it because I came from an old family, and that is undoubtedly part of my life, because I realized that with that background I always had a basic sense of social security—security in American society."[1]

Copland's parents came from Russia. So did George Gershwin's. So did Leonard Bernstein's. Copland, Gershwin, and Bernstein all thought and wrote about what makes music sound "American." Other American composers left this topic alone; like Sessions, they preferred to let it take care of itself. John Knowles Paine, who could trace his ancestry directly to the *Mayflower*, counseled against imitating folk songs, Negro melodies, or Indian tunes in conscious pursuit of national style. Virgil Thomson, who traced his ancestry to the American Revolution, defined "American" music as music composed by Americans, period.

As newcomers, the performing arts immigrants of my book were all confronted by the puzzle of American culture. It seemed

elusive in comparison with the cultural identities of nations older and less polyglot. "What is America?" is a question they necessarily addressed, publicly or privately, crucially or tangentially. It was in this spirit that Kurt Weill sought out iconic American writers as collaborators; that George Balanchine chose to cross the United States by car a dozen times, camping in New Mexico and Wyoming; that Fritz Lang visited Indian reservations and clipped American newspapers; that Boris Aronson inspected five-and-ten-cent stores, and also the shacks and hotel rooms of poor blacks.

As Hugh van Dusen of HarperCollins recognized when he proposed that I write about the twentieth-century "intellectual migration" to the United States, the topic of my books has ever been the fate of Old World art and artists transplanted to the New World. Like Copland, Gershwin, and Bernstein, I have felt a need to figure out what it is to be American. *Understanding Toscanini: How He Became an American Culture-God and Helped Create a New Audience for Old Music* (1987) studies a flawed democratization of European high culture. *The Ivory Trade: Music and the Business of Music at the Van Cliburn International Piano Competition* (1980), a kind of sequel, scrutinizes the culture of the piano as transformed—as buoyed or disfigured—in and by Fort Worth, Texas. *Wagner Nights: An American History* (1994) shows how Wagnerism was reinterpreted by Americans as a meliorist crusade in the late Gilded Age. *Classical Music in America: A History of Its Rise and Fall* (2005) pays special attention to practitioners—beleaguered, outnumbered—who "charted paths remote from Old World models." *Dvořák in America: In Search of the New World* (2003) uses Europe to help young readers define what makes America different. *The Post-Classical Predicament: Essays on Music and Society* (1995) includes, as "The Composer as Emigrant," the kernel of *Artists in Exile*. Even *Conversations with Arrau*

(1982), a piano book, happens to deal with an artist who relocated to the United States—and with how relocation impacted on his life and career.

My fascination with cultural displacement and accommodation must say something about my own cultural condition. I am neither an immigrant nor the son of immigrants. But all my grandparents were born abroad, within the "Jewish pale" of Russia and Eastern Europe. My father grew up in a Yiddish home on Manhattan's Lower East Side. As a New Yorker, I inhabit what remains a city of immigrants. My Upper West Side neighborhood resists homogenization. My daughter, who was born in China, attends school with Mexicans, Puerto Ricans, Koreans, African-Americans. My wife was born in Budapest. Many of my close friends are European, Russian, or Asian. My son was, like myself, born in New York. I do and do not feel "American."

That classical music has been a lifelong personal passion compounds my situation. Born in Europe, imported to the United States, it has since World War I occupied an increasingly odd and insular corner of the American experience. To be an American classical musician is a challenged vocation. Even Bernstein, whose vocation in music triumphed internationally, pursued the puzzle of American identity so tenaciously as to embody it: his TV lectures and Young People's Concerts chronicle a never-ending quest for validation. They mount argument after argument to buttress the case for a distinct American music worthy of comparison to the parent culture—that *Of Thee I Sing* exhibits a technical mastery equivalent to that of *The Mikado*; that Rodgers and Hammerstein is akin to *Carmen* in its original opéra comique form; that "orchestration" is as typically exemplified by a Gershwin clarinet riff as by a Debussy flute solo. My own pertinent experience was to discover myself, in young adulthood, brainwashed into equating great music with dead European masters, and subsequently to

discover the intellectual decline of classical music generally. My remedial activities have included writing books and producing concerts that seek to expand the parameters of the concert experience, and to celebrate a "post-classical" American musical landscape with excursions into film, dance, and literature, and into the popular and indigenous arts.

The condition of cultural exile explored in the present book is, in part, a heightened instance of the condition of the American artist, for whom transaction with foreign models is a nearly inescapable exercise. The American experience is itself an experience of cultural exchange. The arts of the United States have not undergone many centuries of rooted organic growth. That they are instead recent transplants, subject to sudden shock and jarring contradiction, creates both obstacles and opportunities for native and immigrant practitioners alike.

IN ANY CULTURAL HISTORY, the breadth of subject matter requires a writer to tackle many topics others know more about than he does. My chapter on theater was read in manuscript by Rob Marx and Bill Coco. The film chapter was read by Kenny Turan and Richard Schickel. Joan Acocella and Bernard Taper read the chapter on George Balanchine and Igor Stravinsky. Hans Vaget read what I had to say about Thomas Mann. Olivia Mattis and Sabine Feisst read the sections on Edgard Varèse and Arnold Schoenberg, respectively. I am indebted to all of them for their shrewd and informative feedback. I enjoyed the opportunity to interview people with unique personal knowledge of six of my principal subjects: Joan Roberts, who was an original member of the *Oklahoma!* cast directed by Rouben Mamoulian; Chou Wen-Chung, who studied with and later assisted Varèse; Nancy Shear, who was Leopold Stokowski's personal librarian; Lukas Foss, who with Leonard Bernstein was one of Serge Koussevitzky's surro-

gate American sons; and Lisa Aronson, who is the widow of Boris Aronson. In 1979, I was able to interview Lotte Lenya at length (for the *New York Times*) about Kurt Weill and *Street Scene*.

A fellowship from the National Endowment for the Humanities supported my research. In addition to Hugh van Dusen, Rob Crawford at HarperCollins was ever helpful, as was my agent, Elizabeth Kaplan. My wife and two children are by now fully inured to certain exigencies imposed on a writer's family; I thank them anyway.

ARTISTS
IN EXILE

INTRODUCTION: CULTURAL EXCHANGE

Dvořák and the New World—The intellectual migration—The American performing arts in 1900

WHEN WILLIAM J. HENDERSON reviewed the premiere of Antonín Dvořák's symphony *From the New World* for the *New York Times,* he closed by posing the question all were asking: Is this music "American"? Henderson's answer was clarion:

> In spite of all assertions to the contrary, the plantation songs of the American negro possess a striking individuality. No matter whence their germs came, they have in their growth been subjected to local influences which have made of them a new species. That species is the direct result of causes climatic and political, but never anything else than American. Our South is ours. Its twin does not exist. Our system of slavery, with all its domestic and racial conditions, was ours, and its twin never existed. Out of the heart of this slavery, environed by this sweet

and languorous South, from the canebrake and the cotton field, arose the spontaneous musical utterance of a people. That folk-music struck an answering note in the American heart. . . . If those songs are not national, then there is no such thing as national music.

Henderson's December 17, 1893, review, still one of the most incisive descriptions of Dvořák's symphony ever penned, gauged the magnitude of the achievement. An American of some fifteen months' residence, an eminent outsider entrusted by Mrs. Jeannette Thurber with the directorship of her visionary National Conservatory of Music, Dvořák had validated plantation song—the music we now call "spirituals"—as no American ever did or could. He had lent the weight of his authority as a master European musician to "Swing Low, Sweet Chariot," "Deep River," and countless other "Negro melodies" wholly new to him; very possibly, he had never actually met a black man before arriving in Manhattan in September 1892. Not eight months later, he told a *New York Herald* reporter that

> the future music of this country must be founded upon what are called the negro melodies. This must be the real foundation of any serious and original school of composition to be developed in the United States. When I first came here last year I was impressed with this idea and it has developed into a settled conviction. . . .
> In the negro melodies of America I discover all that is needed for a great and noble school of music. They are pathetic, tender, passionate, melancholy, solemn, religious, bold, merry, gay or what you will. It is music that suits itself to any mood or any purpose. There is nothing in the whole range of composition that cannot be supplied with themes from this source.[1]

Like Henderson's, Dvořák's convictions contradicted widely held notions of musical authorship. Philip Hale, the impressive

ARTISTS IN EXILE

Boston critic who called Dvořák a "negrophile," was not alone in believing the Negro melodies were essentially white melodies appropriated by ignorant slaves. In fact, Dvořák was a controversial central participant in an ongoing national discussion about American identity. To this day, the *New World* Symphony excites debate over the defining characteristics of American musical speech.

Henderson likened the polyvalent slow movement of Dvořák's symphony to "an idealized slave song made to fit the impressive quiet of night on the prairie."

> When the star of empire took its way over those mighty Western plains blood and sweat and agony and bleaching human bones marked its course. Something of this awful buried sorrow of the prairie must have forced itself upon Dr. Dvořák's mind when he saw the plains after reading "The Famine."★ It is a picture of the peace and beauty of to-day colored by a memory of sorrows gone that the composer has given us at the beginning and end of his second movement.

After Dvořák died, his onetime American student William Arms Fisher turned this Largo into a popular ersatz spiritual: "Goin' Home." In movement one, Dvořák's symphony practically quotes "Swing Low." The *Hiawatha* connection is equally valid: both middle movements are indebted to Longfellow's poem (in 1893, still the most-read and best-loved work of American literature). We know from the composer's stray comments that the opening of the Scherzo (movement three), with its vigorous tom-tom beat, was inspired by the dance of Pau-Puk Keewis at Hiawatha's wed-

★"The Famine" is chapter 20 of Longfellow's *Song of Hiawatha*. Actually, Dvořák had not yet seen the western plains when he composed the *New World* Symphony in New York.

ding. The death of Minnehaha informs the poignance of the Largo. Scanning the entire four-movement composition, Henderson discovered "the melancholy of our Western wastes" and "the strangeness and vastness of the new world"—subjective impressions as tangible as their objective sources: a greater simplicity of texture and construction, compared to the more Brahmsian cast of Dvořák's earlier style; a penchant for tall chords widely spaced, top to bottom; a tendency to digress from the directional harmonic thrust of dominant to tonic. Nowhere in American music can the "American sublime" of Frederic Church's spacious landscapes be more stirringly discerned than in the apotheosis of Dvořák's Largo, where the symphony's motto theme soars aloft in the brass over fortissimo string tremolos. Elsewhere in the *New World*, Henderson found a different American signature: "the tremendous activity of the most energetic of all peoples." Withal, Dvořák fashioned an enduring portrait, still the most potent, most popular symphony composed on American soil.*

*Frederick Delius, born in England in 1862 to German parents, was a second major European composer so smitten by plantation song that his music was instantly stamped by "Negro melodies." Delius was sent by his father to Florida to manage an orange grove at the age of twenty-two. The songs of the plantation workers were an epiphany in which he discovered "a truly wonderful sense of musicianship and harmonic resource." Hearing this singing "in such romantic surroundings," he later told his disciple Eric Fenby, "I first felt the urge to express myself in music" (Fenby, *Delius as I Knew Him* [1936], p. 25). A few years later, his father finally agreed to allow him to study composition formally—in Leipzig. For Delius, unlike Dvořák, the encounter with plantation song was early and formative. At least four Delius compositions explicitly evoke the sounds of the American South: the *Florida* Suite (1887, revised 1889); the operas *The Magic Fountain* (1895) and *Koanga* (1897); and—a veritable New World symphony—*Appalachia*: "Variations on an old slave song with finale chorus" (1898–1903). The last title does not denote the Carolina region, but appropriates a Native American word for the whole of North America. *Appalachia* begins with an unforgettable preamble: an epic sunrise on virgin terrain. For Dvořák, the vast unpopulated American prairie inspired feelings melancholy and existential; for Delius, the American landscape here revealed by the dawning light is both physical and metaphysical: untrammeled, life-affirming. Next come the first stirrings of nature, then the bustle of human life rising to a high pitch of elation; the orchestra fairly shouts, "America!"

ARTISTS IN EXILE

Dvořák's portraiture relies on twin creative tacks. Probing beyond and beneath America's singular ethnic diversity, its bewildering range of sights and sounds, he seeks binding native attributes. At the same time, he retains his roots in European symphony and opera. It was his genius to discover ways in which these points of orientation, new and old, could—a Henderson neologism—"symphonize."

No sooner did Dvořák finish his symphony in May 1893 than he left for Spillville, Iowa: a Bohemian hamlet some decades old. There he spoke Czech, played the organ in church, and enjoyed early-morning walks along the Turkey River. He also encountered the itinerant Kickapoo Medicine Show, whose Native American entertainers nightly excited his musical imagination. This was the summer of the *American* String Quartet, with its Turkey River birdcalls, and of the *American* String Quintet, whose slow movement uses a tune to which Dvořák (on another occasion) set the words

> My country 'tis of thee
> Sweet land of liberty
> Of thee I sing

as a possible future anthem for the United States.

Back in New York, Dvořák's subsequent output included a Violin Sonatina whose Larghetto is a moody Minnehaha vignette, and a set of Humoresques for piano, the bluesy fourth of which anticipates Gershwin's *Porgy and Bess*. There is also a little-known *American* Suite—the purest example of Dvořák's "American style"—in which an Indian dance mutates into a minstrel song for banjo. The interpenetration of New World motifs and Old World techniques here attains its apex; Dvořák's characteristic voice is transformed.

The "Indianist" movement Dvořák helped to launch proved a

false hope for American music. But Negro melodies, though they took a jazz turn he could not have envisioned, struck and sustained a fundamental American chord. It bears mentioning in this regard that Dvořák's African-American New York assistant, Harry Burleigh, became a prominent singer and composer; the first recitalist to arrange and sing Negro melodies as art songs, he set the stage for Paul Robeson and Marian Anderson. Dvořák's American students included, however briefly, Will Marion Cook, later a mentor to Duke Ellington.

A composer "must prick his ear," Dvořák told American reporters. "Nothing must be [considered] too low or too insignificant"; he should "listen to every whistling boy, every street singer or blind organ grinder."[2] In America, Dvořák listened to the screech of Manhattan's elevated trains, the Babel of its languages, the whoop and cry of Buffalo Bill's Wild West at Madison Square Garden, the silence of the Iowa prairie, the ripple of Minnehaha Falls and the roar of Niagara. His sensitivity to such stimulants destined him to digress from his "Bohemian" style and attempt a protean New World symphony as surely as Gustav Mahler—though he lived in Manhattan longer than Dvořák did—was destined ever to explore the embattled spiritual landscapes of his own mind and soul. The same sensitivity ensured that upon returning to Prague in 1895, Dvořák would forget his American accent. His departure was occasioned by the Panic of 1893; it decimated the fortunes of Mrs. Thurber's husband, who had bankrolled Dvořák's considerable salary. We cannot guess how long his American sojourn might otherwise have lasted.

Dvořák loved Spillville, and was heard to ponder retiring there. New York, by comparison, was bracingly and confoundingly unfamiliar, bigger and busier than Vienna, let alone Prague. Its towering walls of cement, its teeming harbor, its turreted mansions and abject tenements astonished and disarmed. Dvořák was known to require companionship even crossing the street. With

his young assistant, Josef Kovařík, he escaped uptown to watch from a hilltop as the Chicago or Boston express sped by, or to the harbor to inspect the big transatlantic passenger ships. He frequented the aviary at the Central Park Zoo to remind himself of the sounds of nature. He could not endure the world of fashion on ostentatious display at the Metropolitan Opera. He could not understand the government's reluctance to fund institutions of culture and cultural education, as in Europe. And yet the energy of the already great city, with its already great orchestra and opera company, with its eager and impressionable musical public, with a signature optimism and brio feeding on its very contradictions—all this unquestionably inspired the otherwise caged and intimidated composer. Incredibly, his best-known music in three genres—the *New World* Symphony, the Cello Concerto in B minor, and the *American* String Quartet—was composed during his United States sojourn of less than three years.

The story of Dvořák in America encapsulates the core topic of the present study: "cultural exchange." I use this term as a shorthand for the synergies of Old World and New, outsider and insider, memory and discovery, that distinguish the films and dances, symphonies and shows, made by Europeans who relocated to the United States in the decades after Dvořák's visit. As these were decades of European war and revolution, the newcomers did not have the option of packing and returning home, as Dvořák did. And yet Dvořák stayed long enough to embody an immigrant world of paradox they would inhabit. For any number of Europe's supreme performing artists, and makers of film, theater, and ballet, the United States would be a land both strange and opportune. A foreign homeland, it would confuse and yet—as when Dvořák heard Burleigh sing his grandfather's slave songs—afford a clarity of understanding unencumbered by native habit and bias. However fortuitously or inadvertently, the condition of cultural exile would promote acute inquiries into the elusive nature of the

American experience. My topic, in short, is how during the first half of the twentieth century immigrants in the performing arts impacted American culture—and how, as part of the same process of transference and exchange, the United States impacted upon them.

THE UNITED STATES IS a nation of immigrants. Insofar as it survives, the indigenous population is marginal to national identity. Such Indianists as Longfellow and Dvořák, James Fenimore Cooper and George Catlin, produced exotic entertainments that do not endure as fully defining American statements. Rather, early American masters in the arts trace a lineage that is variously British, German, or French. The nineteenth-century writers, painters, and composers we today honor as iconic include Ralph Waldo Emerson and Henry David Thoreau; Nathaniel Hawthorne, Herman Melville, and Henry James; Frederic Church, Winslow Homer, James McNeill Whistler, John Singer Sargent, and Thomas Eakins; Louis Moreau Gottschalk, Stephen Foster, and Charles Ives. Of this group, Gottschalk, Sargent, Whistler, and James were expatriates—as earlier were John Singleton Copley and Benjamin West. But all these men were native-born.

Later, after victoriously intervening in World War I, the United States became an acknowledged world power. Culturally, it had come of age swiftly if incompletely. American arts were not just a hodgepodge of imported ethnic strands; the transatlantic cord had thinned or shredded. In the natural order of things, it might have vaporized as generations of American artists and intellectuals went their own way. In the wake of the Great War, conscious American stylists sought a New World idiom scrubbed clean of encrustation, freed from aged cultural parents. The new nationalists included the composer Aaron Copland, the novelist Ernest Hemingway, and—unself-consciously—

the painter Edward Hopper. But—an accident of fate—European instability at this very moment chased hundreds of preeminent artists and intellectuals to American shores: a hemorrhaging of talent and expertise without historical precedent. The Russian Revolution, then fascism, then World War II, propelled this "intellectual migration." Some famous newcomers had already relocated to the United States and could not go back; others—the majority—arrived in flight. All, in effect, were exiles. Before, the United States had its immigrant cultural pioneers: Anton Seidl, the missionary New York conductor who took over the Metropolitan Opera in 1885; the painter Thomas Cole, a catalytic influence on the "American sublime," who was seventeen when his family emigrated from England. But these figures and others like them, born in England, France, or Central Europe, were not themselves iconic creators. By comparison, the twentieth-century exiles, with their great reputations, were sudden central occupants of the American house of culture. Would they impose or assist? Would this second home become an outpost or new frontier?

The scientists and mathematicians adapted readily. Professionally, they spoke a universal language whose American speakers regarded them as masters and mentors. They comprise a veritable who's who: Hans Bethe, Albert Einstein, Enrico Fermi, Kurt Gödel, Leo Szilard, Edward Teller, John von Neumann, Victor Weisskopf.

Immigrants in the humanities and social sciences also pursued disciplines significantly more evolved in the Old World. Some specialties, such as musicology and art history, were nascent in the United States. Others—nuclear physics, experimental psychology, psychoanalysis—were rapidly developing and hungry for support. In these fields, grateful Americans commonly helped refugees find suitable employment. In sociology, social theory, and psychology, the notable émigrés included Theodor Adorno, Hannah

Arendt, Rudolf Arnheim, Bruno Bettelheim, Erik Erikson, Otto Fenichel, Erich Fromm, Karen Horney, Fritz Perls, Otto Reich, Theodor Reik. The historians and political scientists included Hajo Holborn, Hans Kohn, Hans Morgenthau, Leo Strauss. The music, art, and film historians included Willi Apel, Alfred Einstein, Siegfried Kracauer, Irwin Panofsky, Curt Sachs. The philosophers and theologians included Rudolf Carnap and Paul Tillich. In his landmark 1983 study *Exiled in Paradise: German Refugee Artists and Intellectuals in America from the 1930s to the Present*, Anthony Heilbut observes a "conquest of American academia" not unaccompanied by "unceasing disappointment and anxiety."[3] With his emphasis on writers and social scientists (he is less attuned to musicians), Heilbut narrates how the travails of German disintegration conditioned newcomers to become shrewd and often cynical observers of American capitalism and mass culture.

Immigrants in the visual arts also proved notably adaptable. As Germany's Bauhaus stressed functionalism over ornament (and hence rejected local color), it generated an "international style" successfully pursued by such immigrant architects and designers as Josef Albers, Marcel Breuer, Walter Gropius, László Moholy-Nagy, and Ludwig Mies van der Rohe. The painters Max Beckmann and Hans Hofmann,* the sculptor Jacques Lipschitz, the cartoonist Saul Steinberg, the photographer Alfred Eisenstaedt, and the avant-gardist Hans Richter also sustained important American careers. Piet Mondrian's enthusiasm for the visual rhythms of Manhattan and Max Ernst's affinity for lunar Arizona landscapes interestingly promoted cultural exchange.

Writers naturally faced the toughest adaptation. Not only

*Abstract Expressionism, of which Hofmann was part, may be considered American-born; though its prime movers included the immigrants Arshile Gorky and Willem de Kooning, both arrived in the United States as young adults.

ARTISTS IN EXILE

were they masters of the wrong languages, but their novels and poems in many cases embraced what Americans could only experience as vagaries of style and political/philosophical argument. As a group, they were the intellectual immigrants most prone to sudden obscurity, typically in Hollywood, where some found sinecures as ostensible screenwriters. They also proved exceptionally prone to return to Europe once World War II ended. Their numbers were such that Salka Viertel observed at her Santa Monica salon "the Parnassus of German literature" come to California. Bertolt Brecht, Hermann Broch, Alfred Döblin, Lion Feuchtwanger, Heinrich Mann, Erich Maria Remarque, and Franz Werfel were a few of the once-great names now chiefly known to one another. Werfel managed (in translation) an American best seller—*The Song of Bernadette*—and a Broadway hit— *Jacobowsky and the Colonel*. Remarque produced, in *Arch of Triumph*, a novel only remarkable as a memento of his American infatuation with Marlene Dietrich. Brecht's one memorable English-language script was that of his inquisition by the House Un-American Activities Committee—as recounted later in these pages. The only undiminished literary careers belonged to Thomas Mann and Vladimir Nabokov. In Mann's *Joseph the Provider,* Joseph's administrative feats in service to the pharaoh echoed FDR's New Deal reforms; Joseph in exile embodied the immigrant as national contributor: Mann's public role as New World speechmaker against fascism and, later, McCarthyism. Mann acknowledged the California sky as a smiling accessory to his Egyptian locales. Nabokov's masterful English-language fictions also incidentally explored newfound American landscapes. His *Pnin,* not so incidentally, is a portrait of refugee loneliness endured. (I will have more to say about Mann and Nabokov when summarizing German and Russian immigrant templates in my Conclusion.)

In terms of adaptation, my performing arts subjects fall in between the scientists and the writers. Immigrant actors, whether

in film or on stage, were challenged to speak new words; directors, predictably, enjoyed more success. Dance as a high art form beckoned or perplexed as an open opportunity: as with musicology or art history, there was no American tradition to speak of. Classical music was already crowded: for better or worse, Americans knew what they liked and did not. Successful hybrids emerged in each of these fields. As an expression of cultural exchange, F. W. Murnau's *Sunrise* intermingles Bauhaus and Expressionism with Hollywood mores. Directing *Porgy and Bess*, Rouben Mamoulian introduced Broadway to something like Russian "total theater." George Balanchine's version of Stravinsky's Violin Concerto extrapolates Greenwich Village. Erich Korngold's score for *Kings Row* applies Viennese opera to American melodrama.

My survey is by no means comprehensive.* Rather, I offer case studies. The immigrants that matter to my account both stayed foreign and became American. In every case, they arrived in the United States with formative adult years behind them; I therefore do not deal with Erich von Stroheim, or Lee Strasberg, or Frank Capra. Though not every one of my subjects became an American citizen, all stayed a long time (a criterion disqualifying many of the French). They arrived from continental Europe or Russia: with the exception of Leopold Stokowski, who claimed to be Polish, I have excluded Britons such as Lynn Fontanne, Eva Le Gallienne, or Alfred Hitchcock because as native English

*Of the migrating artists and intellectuals featured in my book, all substantially settled in the United States and almost all became American citizens. In my title, I use the terms *exile* and *refugee* loosely. Stokowski, for instance, moved to America before World War I. But he abandoned his Munich villa once the war began; as with Balanchine, Stravinsky, and others who did not flee Europe, it was conflict abroad that eventually ensured that his career would be so preponderantly based in the United States. Another such instance is Alla Nazimova, who began her American career in 1905. I could not tell my story of Russian influence on the American theater without her.

speakers they less exemplify the dialectics of exchange. Focusing on exiles, cut off from homelands despoiled or entrapped, I also exclude the twentieth-century Cuban musicians who Latinized American jazz and pop.[4]

Distinguished creators who floundered utterly in America—the important composer Alexander von Zemlinsky, who died in obscurity in Larchmont, New York, is an extreme example—do not figure in my account. Nor are the personal travails of immigration my focus.* And I do not necessarily most attend to the greatest names. That as agents of cultural exchange a Mamoulian or Kurt Weill, with their Broadway and Hollywood successes, more engage my attention than a Béla Bartók or Arnold Schoenberg is a choice of topic, not a value judgment.

BEFORE BEGINNING: WHERE DID the individual performing arts stand in America before war and revolution triggered the intellectual migration? And what, therefore, were the conditions for cultural exchange in the decades to follow?

As of 1900, there was little ballet in the United States. Two landmark points of initiation were Pavlova's tours, beginning in 1910, and a pair of visits by Diaghilev's Ballets Russes in 1916 and 1917. Of the Diaghilev dancers who stayed on, Adolph Bolm became an important influence in Chicago and California. Michel Fokine was a frequent American resident from 1919 until his death in 1942: a dim pendant to his luminous Diaghilev years. Colonel W. de Basil's Ballets Russes de Monte Carlo and Sergei Denham's

*In his massive study *Weimar in Exile: The Anti-Fascist Emigration in Europe and America* (2006), Jean-Michel Palmier finds "the disproportion of lifestyles of the émigrés in the United States" to be "more marked than in any other country of exile. If some of them managed to integrate into American life with relative ease, others . . . almost died of hunger or were forced to work as elevator boys or dishwashers in restaurants" (p. 495).

Ballet Russe de Monte Carlo—rival claimants to Diaghilev's un-rivaled legacy and for more than a decade the most famous ballet companies in the world—regularly toured the United States under Sol Hurok's zealous management, beginning with de Basil in 1933. The artistic mainspring of both enterprises, at one time or another, was Leonide Massine. De Basil, Denham, Hurok, Bolm, Fokine, and Massine were Russians; Ballets Russes and Ballet Russe dancers who were not changed their names to pretend that they were.

Though Massine attempted Americana, and though Agnes de Mille ultimately choreographed *Rodeo* for the Ballet Russe in 1942, all this activity remained rooted in a foreign sensibility: bal-let was popularized as an exotic visitation. A striking exception was Germany's Hanya Holm, who became a founding practitioner of American modern dance; I consider this transatlantic cultural transaction in the context of transplanted German musicians in chapter 2. But the great dialectician of European-American dance—the creator of an American ballet tradition utterly distinct from Petipa and Diaghilev—was of course George Balanchine, the dominant figure of chapter 1 alongside Igor Stravinsky, whose indispensable champion and interpreter he became during Stravin-sky's long California exile.

In the case of cinema, there was again little notable American activity a century ago: the moving picture only came of age around the time of the first world war. D. W. Griffith's pioneer-ing efforts coincided with European pioneers. Hollywood and Berlin soon emerged as twin film capitals. What happened next—the subject matter of chapter 4—was a startling migration of Ger-man filmmakers, actors, and technicians. Among those luminaries who wound up becoming consequential American directors were F. W. Murnau, Ernst Lubitsch, and Fritz Lang. Billy Wilder, Greta Garbo, and Marlene Dietrich owed their world fame to Hollywood. And yet all six remained discernibly European in

outlook and personality—a circumstance that variously enhanced or hindered their New World prospects.

The United States did not produce important nineteenth-century playwrights. At the turn of the twentieth century, American theater was still dominated by the commercial melodrama. Not the play but the star performers mattered most. A vital counter-tradition was foreign-language theater, promoting world classics in repertoire. New York's Yiddish theater was one variety, colorful and demotic. The elite American playhouse, circa 1900, was arguably Manhattan's Irving Place Theatre, where a world-class ensemble played Shakespeare, Goethe, Schiller, and Ibsen in German under the distinguished management of the immigrant actor Heinrich Conried (later less distinguished as manager of the Metropolitan Opera). The dissipation of Yiddishkeit and *Deutschtum* in the early twentieth century effectively terminated these efforts; Conried's dream of an American "national theater" stocked with native actors and writers would be dreamed by others with equal futility. Meanwhile, the sporadic introduction of Ibsen and Shaw sent shock waves through Broadway. "Little theater" and "art theater" ideals, betokening ferment, led by the 1920s to the emergence of Eugene O'Neill as America's first playwright of enduring consequence.

All this furnished a scant or belated foundation for the illustrious German and Russian stage actors and directors of the intellectual migration, bearing fresh ideas they sought to transplant. One such idea was Konstantin Stanislavsky's emphasis on natural speech and psychologically self-motivated gesture and inflection. Another was "total theater," as espoused by Vsevolod Meyerhold and Alexander Tairov, Max Reinhardt, Erwin Piscator, and Leopold Jessner. The American careers of Reinhardt, Jessner, Piscator, and Bertolt Brecht were casualties of the transatlantic hiatus. A greater New World influence was exerted by the Russians, beginning with the 1906 Hedda Gabler of Alla

Nazimova—one of three immigrants who predominate in chapter 5, the others being Mamoulian and the scenic designer Boris Aronson.

In striking contrast to the sluggish development of theater in America, and to the twentieth-century starts of cinema and of American ballet, is the astonishing early history of classical music in the United States. Decades before Pavlova's first tours, decades before O'Neill and D. W. Griffith, New York and Boston were already world music capitals, with orchestras and opera companies to rival those of Berlin, Vienna, and Milan. Other American cities, with Cincinnati and Chicago in the lead, were not far behind. This late-nineteenth-century efflorescence was chiefly the work of Germans for whom orchestras and *Singvereine* seemed as necessary as wurst and beer. Unlike German theaters, German orchestras spoke to all Americans. As early as midcentury Louis Moreau Gottschalk, whose musical culture was based in New Orleans and Paris, encountered in St. Louis "a type found everywhere": an "old German musician with uncombed hair, bushy beard, a constitution like a bear, a disposition the amenity of a boar at bay to a pack of hounds."[5] A landmark incursion was that of the Germania Orchestra, a self-governing ensemble of young instrumentalists who, fleeing the revolutions of 1848 as self-proclaimed "Communists," greeted America as the wellspring of freedom and democracy.* The Germanians toured widely, and everywhere set new symphonic standards. Theodore Thomas, who arrived from Esens in 1845 as a ten-year-old prodigy violinist, became the founding father of the American symphony orchestra. His itinerant Thomas Orchestra, a marvel of polish and precision, was to the 1870s and

*The "spirit of '48" was also detectable, if less explicitly, at the Irving Place and other German-language theaters. To a degree, American's midcentury German immigrants were notably self-selected for political liberalism and intellectual aspiration.

1880s what the Germania had been decades before. His prophetic credo was, "A symphony orchestra shows the culture of a community, not opera." Budapest-born Anton Seidl, who succeeded Thomas as New York's leading performing musician (driving Thomas to Chicago, where he founded the Chicago Orchestra), was the central catalyst for American Wagnerism, a national addiction of the 1880s and 1890s. It was Seidl who led the 1893 Carnegie Hall premiere of Dvořák's *New World* Symphony. No musician of such established European eminence had previously taken American citizenship; with his enthusiasm for democracy and democratized culture (he conducted fourteen times a week in July and August on Coney Island), he was known to friends as an "Americamaniac." And there were many others: Leopold Damrosch, who founded the New York Symphony in 1878; Frank Van der Stucken,★ who became the first music director of the Cincinnati Symphony in 1895; Victor Herbert (an Irishman trained and seasoned in Germany), who led the fledgling Pittsburgh Symphony beginning in 1898; and Emil Oberhoffer, who created the Minneapolis Symphony in 1903, all inspired fervent local loyalties. If American orchestras were led (and stocked) by Germans, opera in America was German, French, and Italian. In this department, an Italian tenor, Enrico Caruso, seemed the very embodiment of American fellowship and enthusiasm; his World War I recording of George M. Cohan's "Over There!" was a patriotic sensation.

Immigrant composers, however, were significantly rare. There was the Bohemian Anthony Philip Heinrich, a grand eccentric who settled in Philadelphia, then Pittsburgh (to which he walked, a distance of three hundred miles), then Kentucky, where he lived in a log cabin; his idiosyncratic recyclings of seeming

★Born in Texas, Van der Stucken was raised and trained in Belgium and Germany. He returned to the United States in 1884 at the age of twenty-six.

scraps of Haydn and Beethoven place him first in a lineage of American musical mavericks who variously rejected or revised European practices. Charles Martin Loeffler, a German who claimed to be Alsatian, was a pungent addition to the Francophile aestheticist Boston subculture also including Isabella Stewart Gardner and (when he was not abroad) John Singer Sargent. Dvořák and Mahler merely visited. Prior to 1900, the only composer to resituate in the United States and make a lasting difference was Victor Herbert, who in addition to conducting or playing the cello wrote an engaging Second Cello Concerto (1894), in which the rigors of a European genre are progressively softened by a breezy informality of tone and gesture; he subsequently became the leading confectioner of American operettas. For the most part, American-born composers—as Jeannette Thurber observed when she hired Dvořák—were European clones. The most eminent, as of 1900, was Edward MacDowell, whose higher education and early career were wholly German. In retrospect, only three important native concert composers from the nineteenth century may be said to sound a distinctly "American" note: Gottschalk, whose many keyboard showpieces include such flavorful vignettes as *The Banjo* and *Souvenir of Porto Rico*; George Whitefield Chadwick, who unlike his Boston colleagues specialized in a kind of Americana paralleling the homespun features of certain Mark Twain stories and Winslow Homer canvases; and Charles Ives, the homemade Connecticut genius who by century's end had already composed a Second Symphony that, when it finally became known in the 1950s, proved a peak achievement in marrying Germanic models to New England hymn, band, and parlor tunes.[6]

In fact, in the course of the twentieth century it became obvious that American classical music was peculiarly dedicated to a culture of performance that welcomed illustrious immigrant

conductors, pianists, and violinists, and ignored illustrious immigrant composers. My two chapters on music, then, observe the frustrations of Arnold Schoenberg, Paul Hindemith, and Béla Bartók alongside—my greater focus—the successes of lesser talents: Erich Korngold in Hollywood, Kurt Weill on Broadway, and Edgard Varèse as Manhattan's musical enfant terrible. Of the many immigrant celebrity performers, Arturo Toscanini was the very symbol of classical music in the United States and yet remained a marginal participant in cultural exchange: he stayed Italian. My attentions are more directed toward Serge Koussevitzky, whose Boston orchestra quested tirelessly for the Great American Symphony; Leopold Stokowski, a sui generis immigrant for whom America licensed marvels of self-invention; and Rudolf Serkin, who rerooted German music in the virgin soil of Vermont.

THEODOR ADORNO, THAT NOISIEST and most contentious of immigrant intellectuals, preached the importance of alienation; without maintaining a critical distance, he insisted, the American immigrant could not engage New World surroundings with proper European aplomb. Like so much of Adorno, this prescription proves both pertinent and complacent. Applied to Kurt Weill, whose Broadway shows Adorno savaged, it credibly surmises that too great an eagerness to fit in can vitiate creative possibilities. Certainly, the examples of cultural exchange to be found in the pages that follow document a twofold posture of openness and retention, a percolating mixture of new ways and old.

But the deepest cultural exchange pervading the American experience is one to which Adorno was not attuned: the complex transaction of the African-American. Because they mainly arrived

as slaves, because their skin color rendered them separate and suspect, black Americans necessarily maintained a cultural distance even as they infused American culture. Adorno's presumptuous rejection of jazz registers a debilitating alienation: an outsider's deafness. The black makers of jazz were outsiders and insiders both—ironically, they precisely embodied Adorno's Frankfurt School model of dialectical knowledge and expression.

It is one of the fascinations of the intellectual migration that, Adorno notwithstanding, immigrants in the performing arts gravitated to gifted African-American colleagues and necessary African-American causes. Like Dvořák, they comprehended what American prejudice obscured. Like Dvořák—an instinctive democrat, a butcher's son—they identified with the outsider.

A symbiotic relationship to black culture is an ongoing motif emerging from my survey. A second, larger extrapolation bears mentioning before we begin. Most of the immigrants I deal with were Russian or Germanic. The "Russians," typically, were not wholly Russian; they spoke French or German or Yiddish; they knew Berlin and Paris; their own St. Petersburg or Tiflis were culturally remote from Moscow. The "Germans"—whether from Berlin or Vienna or outlying Hapsburg lands—were by comparison truly German; their high-cultural pedigree, centuries old, was united and fixed. This axis of interpretation, permeating my account, intersects with another: compared to the Germans, the Russians assimilated to a greater degree. Germanic musicians were in many cases a belated colonizing presence. The polar extremes were Balanchine, who shed Petipa to invent a New World template for ballet, and the conductor George Szell, who treated his American players as New World Calibans to be taught Mozart and Beethoven. This, too, may be accounted cultural exchange: Szell appreciated that the Cleveland Orchestra, as he famously re-created it, could only have existed in the United States.

To understand how twentieth-century immigrant contributors to American music, dance, film, and theater fit in or did not, to explore what they could and could not realize, marrying the Old World with the New, is ultimately an exercise in American self-understanding.

CHAPTER ONE

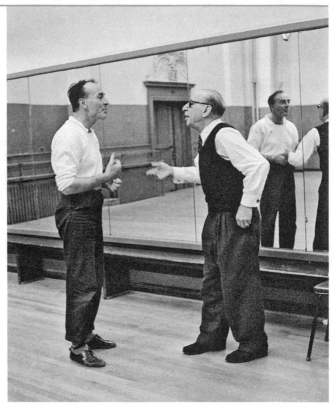

George Balanchine and Igor Stravinsky in rehearsal for the premiere of Agon (1957).

HOW TO BECOME AN AMERICAN: A FORTUITOUS PARTNERSHIP OF DANCE AND MUSIC

St. Petersburg and Sergey Diaghilev educate Georgi Balan-chivadze—Balanchine invents an American ballet—Igor Stravinsky eyes America—The Balanchine/Stravinsky synthesis—Returning to Russia

GEORGI BALANCHIVADZE—A GEORGIAN NAME, because his father was Georgian—was born in St. Petersburg in 1904. His early childhood was spent in a country house in what is now Finland. From the age of nine he was a ballet student back in St. Petersburg, at the Imperial Theatre School. That is: his formative years were spent on his own in a city neither European nor Slavic, where pastel Italian palaces and Venetian canals were darkened by arctic winters or magically lit through the white nights of summer.

As Balanchivadze would prove absorbent and adaptive, St. Petersburg at the turn of the twentieth century was itself as porous and mutable as Leningrad would be monolithic and inbred. And St. Petersburg was youthful, fabricated from swampland as recently

as the early 1700s as Peter the Great's window on the west. The St. Petersburg court of Catherine the Great, later in the century, chiefly spoke French. Court composers included the important Italians Giovanni Paisiello and Domenico Cimarosa, and the Spaniard Vicente Martín y Soler—who also, however, composed Italian operas for Russian consumption. The Irish pianist/composer John Field, a significant precursor to Chopin, settled in St. Petersburg in 1803. The German Adolf von Henselt tutored a generation of Russian pianists beginning in 1838. At the St. Petersburg Conservatory, the presiding violin pedagogue was the Hungarian Leopold Auer. Meanwhile, beginning in the late 1860s, France's Marius Petipa guided the fortunes of Russian ballet. With its cosmopolitan court and intelligentsia, its surreal but potent juxtaposition of Russian weather and European architecture, St. Petersburg was a city bristling with artistic achievement. Compared to Moscow—or Berlin, or Paris, or London—it was also to a peculiar degree deracinated. Not unlike New York, it transcended the colonizing influences that had textured and diversified its brief but momentous history.

And St. Petersburg was of course a cauldron of social and political unrest, famously erupting into violence in 1905–1907 and 1917. In the wake of the Russian Revolution, it was—as Petrograd (1914–1924)—the site of civil war and martial law, of barricades and stray bullets. Even after the Imperial Theatre School reopened as the State Academy, unabated hardship and upheaval furnished another kind of schooling, equally valuable in its way for life and art. Students of classical dance scrounged for food and for wood to heat the Russian winter. They sewed their own clothes and costumes. They took odd jobs—in Balanchivadze's case, as a pianist for a shabby movie theater by night, and by day as a saddler's assistant, stitching canvas to horses' bellybands. Pursuing their aristocratic calling amid Marxist slogans and proletarian masses, they were susceptible both to privation and to a radical idealism. Were

Tchaikovsky and Petipa antiquated? Did high art best serve society? What constituted art? In fact, the early Soviet period was a crucible for acute experimentation: Mayakovski's Futurist poems, Malevich's *White on White,* Eisenstein's *Potemkin.* In dance, Kasyan Goleizovsky—a name little known in the West—scandalized and inspired Russian balletomanes of the twenties. Like Fokine, he believed that classical ballet had degenerated into a superficial entertainment. He espoused a pure dance art eschewing stereotyped steps; his troupe danced barefoot and scantily clad.

Balanchivadze was galvanized by Goleizovsky's heresies. Two years after graduating in 1921, he created Evenings of the Young Ballet, of which the first was titled "The Evolution of Ballet: From Petipa through Fokine to Balanchivadze." Balanchivadze's contributions, set to Ravel and Chopin, and to his own *Extase,* created a sensation. Subsequent Evenings ranged from classical adagios to fox-trots. Balanchivadze's vocabulary included elements of acrobatics, popular dance, and cabaret. This intermingling of tradition and innovation fed the American dance artist to come. The turbulent Petrograd years equally shaped Balanchivadze the man: his resourcefulness, adaptability, self-sufficiency. And he acquired—unless it was always there—a fatalistic equanimity under pressure that would become one of his most pronounced and unfathomable personal attributes.

Many years later, George Balanchine was asked why he emigrated to the West. He replied:

> It was impossible to live in Russia, it was terrible—there was nothing to eat. People here can't understand what that means. We were hungry all the time. We dreamed of moving anywhere at all, just to get away. To go or not to go—I never had the slightest doubts about it. None! I never doubted, I always knew: if there were ever an opportunity—I'd leave![1]

The opportunity came in 1924: he was permitted to go abroad as part of a tiny troupe called the Soviet State Dancers. The dancers, hastily packed, took a German steamer to East Prussia. A telegram from the Soviet Union ordered them back. Balanchivadze and five others chose to defect. Some work was found in German resorts, then in a London music hall. They took cheap rooms in Paris with money enough to last two weeks. Another telegram arrived: from Sergey Diaghilev. He urgently needed a choreographer for his Ballets Russes. He had scouted Balanchivadze. He wanted to know if Balanchivadze could work quickly. Balanchivadze said he could. And so, at the age of twenty-one, George Balanchine—as he would now be known—became ballet master for the premier ballet company in the world.

Like Balanchine, Diaghilev was a Russian exile of notably fluid identity. He had last visited his homeland in 1914. His Ballets Russes, created in 1911, had never appeared in Russia. Rather, he and it were peripatetic, with special ties to Paris, Monte Carlo, and London. Whether Balanchine was at first aware of it, Diaghilev had already revolutionized ballet. Though his dancers retained the benefits of rigorous classical training, such training was put to new uses. The full-length Petipa-style narrative ballets, with their exogenous star turns and complicated plots, their mixture of mime, character dance, and formulaic finales, were overthrown. Diaghilev espoused an integrated performance art in which music and design figured significantly. To this end, he engaged (at one time or another) Debussy, Ravel, Stravinsky, Falla, and Prokofiev; Picasso, Matisse, Rouault, Miró, and Braque. His choreographers Fokine, Massine, Nijinsky, and Nijinska variously dispensed with plot and with classical steps. Pursuing the modernist imperative to innovate, Diaghilev had even—in *Parade*—embraced a Satie score punctuated by typewriter sounds; the occupants of its three-dimensional cubist costumes eschewed balletic movement. He set taste and redefined art. He was a genius, one of a kind.

Diaghilev tutored and advised his new ballet master. He introduced Balanchine to music he did not know. He shared with him the mysteries and treasures of Italian churches and museums. Meanwhile, Balanchine sharpened the Ballets Russes corps, revised ballets in repertoire, and created new works. He also did a certain amount of dancing. In blackface as Snowball, in *The Triumph of Neptune*, he created an American minstrel type whose cakewalk antics—a "paradoxical blend of pretended nervous apprehension and blustering confidence," wrote the British dance critic Cyril Beaumont[2]—capitalized on the blurring of art and entertainment that Diaghilev the worldly eclectic and provocateur more than sanctioned.

Then, in 1928, Balanchine choreographed Stravinsky's *Apollon musagète* for the Ballets Russes. He later called *Apollo* (the title Stravinsky subsequently preferred) "the turning point in my life." The score "was a revelation. It seemed to tell me that I could dare not to use all my ideas, that I, too, could eliminate. I began to see how I could clarify, by limiting, by reducing what seemed to be myriad possibilities to the one possibility that is inevitable."

Diaghilev found the music "part Glinka and part sixteenth century Italian, though without any intentional Russianizing"; in fact, Stravinsky had arguably never before composed anything so relatively free of overt national markers. Restricting himself to an orchestra of strings, he conceived a "ballet blanc" eschewing "many-colored effects and . . . all superfluities."[3] Eschewed, as well, were chromatic and textural density. A vigorous classical lucidity was Stravinsky's goal. Balanchine, accordingly, restricted himself to seven dancers (a later version, dropping the Prologue, used only four) to convey the simple scenario of Apollo empowering the muses Calliope, Polyhymnia, and Terpsichore. Like Stravinsky's, Balanchine's return to classical ideals was at the same time contemporary; the composer's modernist sharpness of rhythm and contour—his frequent biting accents and angularity

of movement—correlated with the dancers' frequent turned-in legs, torso distortions, jutting hips and shoulders. In both cases, the effect was not agitating but wonderfully bracing, an energized scrubbing action renewing traditions gone soft and limp. The essential serenity of *Apollo* was sealed by the first of Stravinsky's iconic frozen codas, supported by a physical tableau also iconic: the three muses, legs splayed, radiating from the backside of the god.★ With *Apollo,* Stravinsky stabilized the post-Romantic search for order. Balanchine, too, limned a virgin new world. These achievements, individually historic, also comprised (as time would tell) an historic conjunction of music and dance.

A year later, Diaghilev was dead at the age of fifty-seven. No less than would Balanchine, he had managed to turn the experience of exile into an opportunity for renewal. Balanchine's debt to Diaghilev was immense: the advanced music of Stravinsky, the instances of abstract choreography by Fokine, the marriage of ballet with revue, of classicism with modernism, were all Diaghilev lessons; so too was the new phenomenon of an independent ballet troupe, dispensing with state support. But Balanchine, whose relations with his employer were sometimes tense, was not a submissive or passive recipient of instruction. His own predilections had long pointed toward many of Diaghilev's, and with Diaghilev's passing he continued in transit. He worked in Paris, in Monte Carlo, in Denmark. In London, his employers were the showmen Sir Charles B. Cochran of the *Cochran Revue* and Sir Oswald Stoll of the Coliseum. He even began to fancy himself an Englishman, nattily attired at Anderson and Sheppard.

Alexandra Danilova, who accompanied Balanchine from revolutionary Russia to the Ballets Russes (and later lived with him), once reminisced: "In a way we were like little wild animals. We

★In Balanchine's original *Apollo,* this now-famous ending was followed by Apollo and the muses ascending to Parnassus.

ARTISTS IN EXILE

were forced to bring ourselves up, to improvise our lives—and that left its mark."[4] Balanchine's experimental bowler hat and umbrella conveyed a cheerful rootlessness in London at the age of twenty-six—and an infinitude of possibilities.

LINCOLN KIRSTEIN WAS BORN in 1907 to a wealthy Jewish family in Rochester, New York. He was raised in Boston. At ten, he bought his first work of art. At fourteen, he wrote a play and got it published. At fifteen, he spent the summer in London, where he mingled with the Bloomsbury set. At Harvard, he won a prize for drawing, wrote a novel, helped to establish the literary quarterly *Hound and Horn*, and cofounded a society for contemporary art that led to the creation of New York's Museum of Modern Art.

But ballet was Kirstein's reigning passion. He saw Pavlova in Boston and, beginning at the age of seventeen, Diaghilev's Ballets Russes in Europe. After college, he wrote a history of dance, helped Romola Nijinsky write her biography of her husband, and took ballet lessons from Fokine. Having already claimed his inheritance, he was fired with an ambition to bring ballet to the United States—not as some worn but gaudy import, afflicted with what (following Cocteau) he called "red and gold disease," but as an experience that would draw fresh breath from a fresh environment. As ballet had been imported from France to Russia by Petipa and others, Kirstein sought a great ballet master to affect a comprehensive transplantation. He fixed on George Balanchine.

Forty years before Jeannette Thurber had picked Antonín Dvořák to help Americans cultivate their own classical music. Thurber reasoned that as a cultural nationalist, Dvořák could help Americans acquire a national concert music. Perhaps, too, she intuited from his origins that he would prove an instinctive democrat. Kirstein, appraising Balanchine, perceived a young choreographer with something new to offer. What is more, as

Kirstein must have appreciated, Balanchine was a young man—barely older than himself—in flux.

They met in London in July 1933. Kirstein expressed his admiration for Balanchine and his dreams for ballet in America. Balanchine expressed his admiration for Ginger Rogers. Three months later, Balanchine arrived in New York. "I liked New York immediately," he later recalled.

> I liked America better than Europe. First of all, compared to America, Europe is small. Secondly, everything was over for me in Paris, there was no work. And I didn't like the people there; it was all the same thing, over and over. And it was impossible to get work in England. I wanted to go to America, I thought it would be more interesting there, something would happen, something different. . . . Life in America, I thought, would be fun.

To which Balanchine's biographer Bernard Taper has added:

> One of the things he found congenial about America was that, like Russia, it was unfinished. Most of all, he liked the way the people moved—their athleticism and unselfconscious freedom of gesture, which showed in their games and daily activities, if not yet in their dance. The long-limbed girls he found a pleasure to behold. . . . "The land of lovely bodies," he called America.[5]

As ever, Balanchine lived in the present. He chose an apartment, then moved to another, and another. He bought a car on impulse and enjoyed driving with friends to Connecticut or Long Island. Then in 1935 he took a false step that unexpectedly reconfirmed that for him Europe was over. The American Ballet, which he had created with Kirstein, accepted an invitation to furnish ballets for the Metropolitan Opera, as Balanchine and Diaghilev

had once done for the opera in Monte Carlo. The Met had a new manager, the former tenor Edward Johnson. In retrospect, neither partner in this misalliance knew much about the other. Johnson upheld Eurocentric past practice. For American works he had even less use than his predecessor, Giulio Gatti-Casazza—and Gatti did not even speak English. This was because with his background at La Scala, Gatti understood opera as a living art; he assumed a commitment, however modest, to native and contemporary repertoire. Johnson, as an American, understood opera as something hallowed, exotic, and old. The twentieth-century composers represented in his 1935–36 repertoire were Humperdinck, Leoncavallo, Mascagni, Massenet, and Puccini. And this was the Depression: new productions, new costumes, new toe shoes, were at a premium. Nevertheless, in addition to contributing to *Aida, Die Meistersinger,* and the like, Balanchine was asked to stage and choreograph an entire work: *Orpheus and Eurydice.* He turned Gluck's opera into a dance drama, with singers and chorus relegated to the pit. Pavel Tchelitchev, in Kirstein's opinion "the most gifted scenic designer of his epoch," created what Kirstein considered "the most beautiful visual spectacle I have seen on any stage." The scenery "was made out of chicken wire, cheesecloth, and dead birch branches. . . . The entire production was conceived without an element of paint. Rather, pigment was actually light. All hand-props and scenery were three-dimensional. Backgrounds were impalpable, chosen for their capacity to transmit, reflect, or change light. Everything occurred in air."[6] The premiere, on May 19, 1936, was received with titters, yawns, and weak applause. There was one subsequent performance.

When the American Ballet quit the company in 1938, Balanchine permitted himself a rare expression of anger. "The Met is a heap of ruins," he told the press. For the moment, he had found happier employment uptown. Choreographing Rodgers and Hart's *On Your Toes* (1936), he had created a landmark Broadway ballet,

Slaughter on Tenth Avenue, for Tamara Geva (whom he had both partnered and married in Petrograd) and Ray Bolger. For the first time, a Broadway show listed a "choreographer." Bolger, who danced in two more shows choreographed by Balanchine, said that it was like spinning from Juilliard to the Louvre to the Royal Academy of Dramatic Arts to Stillman's Gymnasium. Bolger also said that Balanchine taught Broadway "that in the American musical you don't have to do kick, stomp, thump, turn, jump, turn, kick. You can *dance*." The sophistication and range of Balanchine's Broadway work—eighteen shows in all, including the all-black *Cabin in the Sky* (1940), which he both choreographed and (after a fashion) directed★—derived equally from his European training and his admiration for Ginger Rogers and Fred Astaire (whom he once called the dancer he most liked to watch).[7]

Sam Goldwyn invited Balanchine to Hollywood, to choreograph *The Goldwyn Follies* (1938). Balanchine's contributions included a Romeo and Juliet sequence in which Montague tap dancers in shorts battled Capulet ballet dancers in tutus; at the close, the parents shook hands and the dancers cheerfully joined forces. Balanchine subsequently choreographed a Hollywood version of *On Your Toes* in which the *Slaughter on Tenth Avenue* partners were Eddie Albert and the German-born Vera Zorina. He married Zorina, then a top Hollywood/Broadway star, in 1938. He became an American citizen in 1939. Judging from such ephemera as the song "Love Is a Simple Thing" and the waltz "Ashfield's Nights" (to be found in manuscript in the Harvard Theatre Collection), his own compositions—a hobby—were airily sophisticated in the Gershwin manner. But this was not his true métier. "I'm like a potato," he once told Taper. "A potato is pretty tough. It can grow anywhere. But even a potato has a soil in which it grows best. My soil is ballet."[8]

★See page 390.

And soil implies permanence. To Kirstein, in their initial conversation, Balanchine had said, "But first a school." Kirstein, too, was committed to permanence: a school, a company, a repertoire, an audience, all of it comprising an indigenous American ballet, native to the United States in ways the venerable Metropolitan Opera, in half a century, had never attempted. The Kirstein/Balanchine School of American Ballet opened on January 1, 1934. Of thirty applicants, twenty-five (of whom twenty-two were female) were accepted—not because of the excellence of their preparation, but because a beginning must begin somewhere. And yet this blank slate—"There was no one here who could dance," Balanchine would later say[9]—was the right beginning. It was Balanchine's good fortune that few Americans had ever seen ballet. Pavlova, Fokine, Nijinsky had toured. Colonel W. de Basil's Ballets Russes de Monte Carlo, which with Sergei Denham's Ballet Russe de Monte Carlo would use itinerant Russians to inculcate a ballet consciousness in the United States, had first arrived in New York as recently as December 1933. Rather than ballet dancers or troupes, North America had singularly produced maverick "modern" dancers. The two phenomena were of course related: Loie Fuller, Isadora Duncan, Ruth St. Denis, Ted Shawn, and Maud Allan (born in Canada) materialized in the New World less in opposition to ballet (as is sometimes supposed) than in ignorance of Petipa and Diaghilev. And their liberating influence was felt first and foremost in Europe, beginning in the 1890s.

By the time Kirstein met Balanchine in 1933, American modern dance was exemplified by Martha Graham, Doris Humphrey, Charles Weidman, and Hanya Holm—of whom Holm, like Balanchine, was an inquisitive, acquisitive immigrant, a direct disciple of Mary Wigman and German *Ausdruckstanz*, with its emphasis on intensified feeling and subconscious emotion. Other defining products of Weimar culture—*The Threepenny Opera, The Cabinet of Dr. Caligari*—were too much for American theater, film,

and classical music. *Ausdruckstanz,* however, proved influential among consciously progressive American dancers. And so was Holm, who arrived in 1931 to direct a Wigman school initiated by Sol Hurok. Holm eagerly proceeded to tour the United States with her troupe by train, performing in gymnasiums and other makeshift spaces. She evolved a more lyrical, more playful style than her German mentor while at the same time stressing the discipline and technique she felt American modern dancers lacked.

To Lincoln Kirstein, American modern dance nonetheless remained deficient in lineage and tradition. He considered it self-indulgent and ephemeral. He found the work of Martha Graham an "arrogant . . . brand of hysteria."[10] He sought a new American dance tradition of another kind: a fusion of classical ballet with American openness that only a grounded but adventurous European could instill. And so George Balanchine, with his School of American Ballet dancers, did not start with *Swan Lake* or any other canonized Old World masterwork. Rather, he improvised a new ballet using the untried materials at hand. When seventeen young women—and no men—showed up at the first School of American Ballet rehearsal, he began by distributing all of them in crossing diagonals. When, subsequently, he had nine or six dancers to work with, he used nine or six dancers. When a dancer tripped and fell, he used that, too. The result was *Serenade,* set to Tchaikovsky's Serenade for Strings. His first ballet created in the United States, it remains in the repertoire as a signature Balanchine achievement. Its polyvalence is characteristic: though soloists are deployed, the corps is a full partner, never generic or merely pictorial; though eventful interactions are depicted, there is no plot. The attire—scenery, lighting, costuming—is simplicity itself.

The thirty minutes of *Serenade* suggest a trajectory of maturation starting in semidarkness with the dancers assuming the first position: a chrysalis. The stage brightens and the dancing begins. The second movement is a gentle waltz. The third (not part of

the original ballet) is a vigorous Russian dance that high-kicking Moiseyev Cossacks might have appropriated, here deracinated as an exhilarating catalyst for freed bodies and spirits. The Elegy, which Tchaikovsky places third, thus becomes the finale: a fruition of adult feeling, intimating pain and loss. Appraising this encapsulation of release and self-discovery, the peerless American dance critic Edwin Denby wrote that Balanchine

> had to find a way for Americans to look grand and noble, yet not be embarrassed about it. The Russian way is for each dancer to *feel* what he is expressing. The Americans weren't ready to do that. By concentrating on form and the whole ensemble, Balanchine was able to bypass the uncertainties of the individual dancer. The thrill of *Serenade* depends on the sweetness of the bond between all the young dancers. The dancing and the behavior are as exact as in a strict ballet class. The bond is made by the music, by the hereditary classic steps, and by a collective look the dancers in action have unconsciously—their American young look. That local look had never before been used as a dramatic effect in classic ballet.[11]

Observing the plain attire and clean lines of Dvořák's *American String Quartet*, and the persuasive effects of innocence and spontaneity so skillfully achieved, Henry Krehbiel—an American critic to set beside Denby—conjectured (in 1894) that Dvořák had purposely adopted a style that would furnish American composers "the clearest model before them." *Serenade*, too, bespeaks pedagogical intent—a model for American ballet dancers.

A few months after the first private performance of *Serenade*, in June 1934, Balanchine and Kirstein decided their students were ready to perform publicly as the American Ballet. This, then, was the company engaged by the Metropolitan Opera from 1935 to 1938. Its demise coincided with Balanchine's redirection toward

Broadway and Hollywood. Its successor, again linked to the on-going School of American Ballet, was Ballet Society, unveiled by Kirstein and Balanchine in 1946. The debut program introduced a new Balanchine ballet: *The Four Temperaments*, set to a score Balanchine had commissioned from Paul Hindemith for $500. This was another seminal American work, combining the austerity and angularity of *Apollo* with the plotless organic trajectory of *Serenade*. Its cumulative vocabulary of step and gesture, scoured and pared, invites abstract cerebral engagement. At the same time, its imagery evokes the personal intensities of American modern dance. The male soloist in "Melancholy" falls and gropes. He imprisons his torso in the wrapping action of his arms. He is accosted by a grid of strutting women, whose thrusting pelvises and interlocking arms menace and deflect his tortuous course; his rebuffed body curls backward. Balanchine's further embellishment of these and other cheerless motifs is aesthetically and intellectually enthralling. No less than nascent bodies, his early American ballets train a nascent audience in new ways of watching and understanding. And listening: with its rigorous structure and proportion, and uncompromising precision of rhythm, Hindemith's astringent score, for piano and strings, is more than fully served. Its welter of variations—on a theme, on the variations themselves—translates into choreography equally self-referential in its evolutionary growth. Its forlorn patches of mechanical note-spinning, filling out the design, are rescued by the continuity of the dance. If Balanchine's *Four Temperaments* is a greater accomplishment than Hindemith's, it also whets the appetite for this forbidding composer. It is a rare lesson in music appreciation.

TWO YEARS LATER, BALLET Society premiered *Orpheus,* with music by Stravinsky and choreography by Balanchine. The performances took place at the City Center, which presented popularly

priced drama and opera at a building New York City had taken over for back taxes: the 2,750-seat former Mecca Temple on West Fifty-fifth Street. In the audience, taking in a program also including Balanchine's *Symphony in C* and *Symphonie Concertante*, was Morton Baum, the chairman of the City Center's finance committee. Baum proceeded to offer Ballet Society a home at the City Center—and so the New York City Ballet was born. In place of its sporadic schedule at the auditorium of the Central High School of Needle Trades, the Balanchine/Kirstein troupe now performed every Monday and Tuesday with (a miracle) Baum's committee pledged to cover the inevitable deficits.

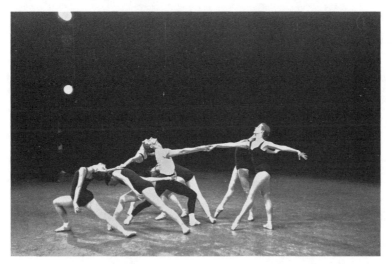

Marrying ballet with the personal intensities of American modern dance: The Four Temperaments, *as performed by the New York City Ballet in the 1980s.*

The City Center was a makeshift "people's theater." The lobbies were mainly stark and the stage was small. But glamour and social status were for Kirstein beside the point except insofar as they might magnetize money. In fact, he discovered that "the idea of combining populist service and aristocratic quality" appealed to certain benefactors, and that Baum had succeeded in attracting "a new audience of second generation New Yorkers

with a long tradition of musical appreciation in Middle Europe—an audience which was scarcely made comfortable by the heirs of Dutch patroons and the Hamiltonian succession of Murray Hill's rich, well-born, and able."[12]

The pedigree the company most required, as it turned out, was not conferrable by snobbish Americans. When a 1950 nine-week British season was negotiated, David Webster, director of the Royal Opera House, told Kirstein's business manager: "We shall be very glad to have New York City Ballet at the Royal Opera House. But I also want you to know that London will make the company."[13] Not all London approved of what Balanchine had wrought. But the magnitude of his achievement was obvious to foreign eyes. The City Ballet returned home with a fame and prestige it had previously deserved but not yet acquired. In 1964 it moved to Lincoln Center's New York State Theater, designed according to Kirstein's wishes by Philip Johnson: a clean American architectural statement beside the wannabe glamour of the neighboring Metropolitan Opera House.

John Martin of the *New York Times*, for decades the most influential American dance critic, had embraced Martha Graham but resisted Balanchine as an unwanted Franco-Russian import of "Riviera aesthetics" and "*Le Ballet Americain*." After the London season, Martin was converted. But Balanchine's national affinities remained elusive. His enthusiasm for the United States survived first impressions. He liked Jack Benny, fast cars, the rhythm and speed of Manhattan. He did not share the nostalgia for Mother Russia of many Russian émigrés. At the same time, he annually regaled his Russian friends with a traditional Easter feast following midnight Orthodox services. And the autocratic discipline of his pedagogy was supported and enforced by many a Russian administrator and ballet instructor.

Kurt Weill, who (as we shall see) would not speak German upon arriving in Manhattan in 1935, had to stop being a German

to become an American. Balanchine arrived with a layered identity that easily absorbed additional layers. In his choreography, he chose from these various affinities, or ironically combined them. He was, for instance, partial to television Westerns. He wore pearl-buttoned shirts, black string ties, and plaid vests. His apartment, according to Taper, featured "the kind of furniture one sees in the salons of prosperous mustached Westerners in cowboy films."[14] His City Ballet repertoire included *Western Symphony* (1954) and *Square Dance* (1957). The ingredients of the latter included concerto movements by Corelli and Vivaldi as performed on a bandstand with a square dance caller; but the high-spirited dancing is classical, not folk. For the former ballet Balanchine commissioned from Hershy Kay a frothy symphony (similar in spirit to the Bizet and Gounod symphonies he also set) using tunes like "Red River Valley" and "Good Night, Ladies." Again, the western flavor is conveyed by classical steps, as when four ballerinas en pointe simulate a team of stagecoach horses; their male driver inaudibly giddyaps and invisibly tosses the reins. Annotating this plotless frontier dance party, Balanchine wrote (in the spirit of Dvořák in Iowa):

> I have crossed the United States by car some dozen times, have camped in the open air in New Mexico and Wyoming, in Montana and South Dakota. The vast sweep of the land, the impression of the Rockies and the plains, and the vision of the men who crossed the mountains and worked the plains, on foot and on horseback, cannot fail to move any newcomer, particularly one who has fresh memories of Europe, most of which is closely settled and where there have been few empty natural spaces for thousands of years.[15]

The open space and wholesome energy of *Western Symphony* help to evoke the lore and landscape of a virgin American West. Edwin Denby likened the ballet's second movement to "a cowboy's

vision of a pure ballerina" and added: "At a rehearsal I saw Balanchine miming this cowboy; it was so real, one would have thought he had never been anything else."[16] But only superficially does *Western Symphony* resemble Eugene Loring's *Billy the Kid* (1938) or Agnes de Mille's *Rodeo* (1942) and *Oklahoma!* dances (1943). These are narrative pantomimes full of "cowboy" and "cowgirl" steps. Nor is Balanchine here topping a Russian confection with exotic local colors after the fashion of Glinka's Spain or Rimsky-Korsakov's Italy. Rather, *Western Symphony* knowingly combines Americana and ballet, New World and Old; an ironic wink seals its sophistication and charm. In *Who Cares?* (1970), it is the absence of irony that tells us that, for Balanchine, George Gershwin is the real thing.

Another component of the City Ballet repertoire—a repertoire blithely dispensing with the European canon—experimentally explored iconic twentieth-century intensities of alienation and depersonalization. "New York City Ballet" was here precisely suggestive of the Balanchine synthesis. Succeeding *The Four Temperaments*, these ballets included *Opus 34* (1954), *Ivesiana* (1954), *Agon* (1957), *Episodes* (1959), and *Movements for Piano and Orchestra* (1963). All of the music—by Schoenberg, Ives, Stravinsky, and Webern—was virtually unknown except to a handful of initiates. As with the Hindemith, Balanchine rendered these esoteric scores suddenly communicative. "Twelve-tone nights" became a City Ballet specialty. Meanwhile, there were important Balanchine ballets to Bach and Mozart. Of the Romantics, he memorably set Mendelssohn, Schumann, Brahms, Gounod, Bizet, Johann Strauss Jr., and of course Tchaikovsky, whom he adored. Ravel was another specialty. Finally, there were no fewer than thirty-three Stravinsky ballets, spanning the sixty-one years from *Sonata* (setting the Scherzo of the Sonata in F-sharp minor of 1905) to *Requiem Canticles*.

Of his *New World* Symphony, Dvořák wrote, "the influence of America must be felt by everyone who has any 'nose' at all." Of

 ARTISTS IN EXILE

his *American* Quartet and Quintet, both composed in Iowa, he said, "I should never have written these works 'just so' if I hadn't seen America." How "American" is the American Balanchine? Most obviously, his New York City Ballet dancers were American. "America has its own spirit—cold, luminous, hard as light," Balanchine said. "Good American dancers can express clean emotion in a manner that might almost be termed angelic."[17] Though Balanchine's ballets are not about ego, their most compelling practitioners register identity and personality without the "I." Dancers like Merrill Ashley were Balanchine's racehorses, his sleek athletes. The men, too, established a new breed. As the peasant lad in *Tarantella,* Edward Villella planted his kiss with the teasing self-confidence of a practiced lover. Even if we did not know that Villella was a truck driver's son, a brawler and boxer from the streets of Queens, his blue-collar origins would remain apparent because Balanchine's explosive choreography did not invite their concealment. Or consider Bart Cook, a veritable Gene Kelly in *Stravinsky Violin Concerto;* the aristocratic Dane Peter Martins, in the same ballet, was not remotely jazzy or "beat."

Balanchine's usual eschewal of glamour is also American. Lacking international stars, lacking stories, eliminating mime and pageantry, many a Balanchine ballet equalizes the dancers to a rare degree. On tour in Barcelona in 1952, Balanchine learned that his dancers would not be permitted to sit in box seats; he exploded: "My dancers will sit where they want. They are good enough to sit anywhere." For Kirstein, the American style of the City Ballet was a point of pride. He pertinently observed a "cool frankness," "a candor that seemed at once lyric and natively athletic," "a straightforward yet passionate clarity and freshness suitable to the foundation of a non-European academy," a "selfless efficiency that Balanchine would use to forge a new style which, though based on Petersburg, found sharp definition and athletic accent in Manhattan." Referring to American girls, Kirstein wrote:

They were basketball champions and queens of the tennis court, whose proper domain was athletics. They were long-legged, long-necked, slim-hipped, and capable of endless acrobatic virtuosity. The drum majorettes, the cheerleader of the high-school football team of the thirties filled [Balanchine's] eye. . . . The pathos and suavity of the dying swan, the purity and regal behavior of the elder ballerina, were to be replaced by a raciness, an alert celerity which claimed as its own the gaiety of sport and the skill of the champion athlete.

For Denby, the American speed and athleticism of Balanchine's dancers were core attributes of the company's defining classicism, its rejection of mannerism, extravagance, and subjectivity in favor of "perspicacity and action."

American ballet is like a straight and narrow path compared to the pretty primrose fields the French tumble in so happily. . . . Limpid, easy, large, open, bounding; calm in temper and steady in pulse; virtuoso in precision, in stamina, in rapidity. So honest, so fresh and modest the company looks in action. The company's stance, the bearing of the dancer's whole body in action is the most straightforward, the clearest I ever saw. . . . So the dancers dance unhurried, assured and ample. They achieve a continuity of line and a steadiness of impetus that is unique, and can brilliantly increase the power of it and the exhilarating speed to the point where it glitters like cut glass.[18]

The dance historian Brenda Dixon Gottschild has additionally proposed that, on a deeper level, the Americanisms of the Balanchine style—whether offshoots of Broadway, Hollywood, or jazz—align with African-American dance as experienced in Paris (where Balanchine danced Snowball in blackface for Diaghilev and later worked with Josephine Baker), on Broadway (where he

ARTISTS IN EXILE

admired the "rhythm and precision" of Katherine Dunham's dancers in *Cabin in the Sky**), or at the City Ballet (where his African-American soloist Arthur Mitchell, once a tap dancer, was regularly invited to "show these kids old-fashioned jazz"). From this perspective, the Balanchine body type—small head, short torso, long legs and arms—is itself Africanist. Of *The Four Temperaments*, with its backward body curls and thrusting angularities of arm and pelvis, Gottschild writes that it is

> of a different ilk than the cool of a classic like *Swan Lake*. Balanchinian cool, like its mother, the Africanist cool . . . , is tongue-in-cheek, sassy, and somewhat ironic. It leads to open-endedness and double entendre, not to the resolution of traditional European ballet. It is not the aristocratic, haughty coolness of that tradition but the cool arrogance of people with an attitude—Americans, black, brown, and white.

It is instructive to group Balanchine with those Americans in post–World War I Paris who returned to the United States in the twenties and thirties eager to define an American voice. Of the musicians, Aaron Copland was the most influential. Like Balanchine, he was schooled in an anti-Romantic aesthetic of objectivity. Like Balanchine, he potently absorbed popular culture alongside high art. For Ravel, Milhaud, Stravinsky, Bartók, and countless other Europeans, America's important new music was that of Gershwin, Duke Ellington, and Louis Armstrong. Though in the twenties Copland invoked jazz in his *Music for the Theatre* and Piano Concerto—pieces in which he felt the need to dress it up with shifting meters and other signatures of modernism—he

*As director of William Grant Still's *Troubled Island* at the New York City Opera in 1949, Balanchine also collaborated with Jean Léon Destiné's African-American dance company.

did not rush to Harlem as the visiting Parisians did. In his copious writings, he ignored jazz or put it in its place as a kind of stunted art music of limited interest to "serious" Americans in search of an indigenous high-cultural identity. The whole of American classical music, for that matter, revered itself as the Old World parent culture did not have to.

Compared to Balanchine, Copland in Hollywood in the populist thirties was a marginal player who never fit; for Broadway, he was an unthinkable candidate. Unthinkable, as well, would have been American musical parodies of Bach or Beethoven, Debussy or Stravinsky. But Balanchine could not resist spoofing ballet. He did it in *On Your Toes* with a burlesque *Scheherazade*. He did it for the Barnum and Bailey Circus with a polka for elephants in tutus (to music by Stravinsky). He did it in *The Goldwyn Follies* with his *Romeo and Juliet* send-up. The same film's over-the-top water ballet, in which Vera Zorina emerges drenched from a circular pool of water, was the apparent inspiration for the Dance of the Hours in Disney's *Fantasia*, where the emerging aqua-ballerina is a hippopotamus. Americans (other than cartoonists) were notably solemn about imported high art because they were not fully comfortable with it. That Balanchine was European supported his stock-in-trade mediation of Old World and New, high culture and pop. It took Dvořák to pedigree plantation song. It took London to pedigree the New York City Ballet. Supremely unencumbered by the anxiety of cultural status, Balanchine with his City Ballet pursued a prophetic high-low eclecticism unique among American cultural institutions of the mid-twentieth century, when "postmodernism" was not even a word. No American could have achieved such an "American" renewal of classical ballet.

That the City Ballet has deteriorated since Balanchine's death in 1983 thins his legacy, but not his achievement. At the turn of the twenty-first century, the United States is no longer virgin terrain for dance. Balanchine's progeny have established or directed

important ballet companies of their own in Chicago, Harlem, Kansas City, Los Angeles, Miami, Pittsburgh, San Francisco, and Seattle, as well as abroad. Balanchine's example has contributed crucially to validating dance as a contemporary American art form nourished by tradition and frequently vitalized—as symphony and opera are not—by important new work. Balanchine and the United States proved an inspired partnership. What is more, Balanchine in America was the beneficiary, and indispensable benefactor, of another immigrant artist—one who happened to be the greatest living composer for the ballet.

Vera and Igor Stravinsky at home in Los Angeles.

LIKE BALANCHINE, IGOR STRAVINSKY was born in St. Petersburg. As with Balanchine, the Russian Revolution had the eventual effect of expelling him to Paris. Like Balanchine's, his association with Diaghilev was crucial both for opportunity and

instruction. Diaghilev's death condemned him, no less than Balanchine, to a period of wandering—until, like Balanchine, he washed up on American shores.

But the circumstances of this last development were much different from Lincoln Kirstein's invitation to found an American classical ballet. In the 1930s, Stravinsky was living a double life. He was married with four children; as was well known, his truer love was Vera de Bosset. Then, in 1938 and 1939, his elder daughter, wife, and mother died in succession. His recent music had failed to achieve popularity even in France. Stalinist Russia ignored him. The Nazis dispatched him as *entartete*, "degenerate." And there was the war. Stravinsky was "perplexed and jittery," according to his publisher Gabriel Paichadze. "He could neither eat nor sleep, he could not work . . . he got angry, nervous and irritable. All he wanted was to get out as quickly as possible, out of Paris, out of Europe, into America where life was still orderly."[19] Stravinsky fled with Vera to begin anew. Months after Vera arrived in the United States, they married in Massachusetts in 1940. They settled in Los Angeles and applied for naturalization. America, for Stravinsky, was a refuge from the past. But in itself it held no obvious attractions. His elitist politics and personality remained those of a finicky Parisian or of a Russian dispossessed by Lenin.

His musical odyssey, too, was migratory. As a youngster, under Rimsky-Korsakov's wing, he was a conservative traditionalist. With *Le Sacre du Printemps* he became an enfant terrible. After World War I, he was an Apollonian classicist, in music and public utterance a Francophile and Germanophobe. Along the way, he refashioned music by "Pergolesi"* (*Pulcinella*) and Tchaikovsky (*The Fairy's Kiss*). In the United States, as in Europe, conventional wisdom condemned his post-*Sacre* output as hollow. As in Europe,

*It has since come to light that music once attributed to Pergolesi, and used in *Pulcinella,* was composed by other eighteenth-century Italians.

ARTISTS IN EXILE

a modernist coterie condemned conventional wisdom as philistine. Stravinsky himself was eventually victimized by self-doubt. According to a famous anecdote, he broke down upon encountering some Schoenberg and Webern in 1952; he expressed fear he could no longer compose.[20] He now capitulated to the twelve-tone method of Schoenberg—a name once never mentioned in his presence. His favorite music, in his last years, was the late Beethoven string quartets. Though Stravinsky was often regarded as the leading composer of the twentieth century, his twenty-first-century reputation is for the moment unsettled. His catalogue of six decades is more uneven than his champions ever supposed. In retrospect, his more questionable works—the episodic Symphony in C of 1940, for example, with its stretches of ostinato chugging—are arguably inferior to the ripest, most incisive music of contemporaries his adherents held in contempt: the incurable Romantics Sibelius and Rachmaninoff. Aaron Copland, in private correspondence in 1943, surmised in Stravinsky a "psychology of exile" characterized (as in Henry James) by "exquisite perfection" and a "lack of immediacy of contact with the world around him." Copland added, "I don't think he's in a very good period. He copies himself unashamedly, and therefore one rarely comes upon a really fresh page—for him, I mean."[21] However protean, Stravinsky was not just a happy magpie. Undeniable, as well, is the New World debacle of an Old World artist exceptionally reliant, at every stage of his journey, on inspired collaborators and attentive advocates. Does Stravinsky's long American career reduce to a saga of sustained creative decline?

And the Stravinsky story is shadowed by concomitant issues of personal identity. Balanchine, who took four wives and permitted no offspring, was a transatlantic explorer whose psychological rudder was at all times improbably steady. There are few stories of Balanchine aroused to anger. Alexandra Danilova, who knew him from their student days, once reflected that his early

separation from his family, and the further ordeal of self-reliance imposed by the Russian Revolution, left its mark on Balanchine's way of "burying his feelings."[22] But Stravinsky's lesions showed. In France, the strain of his two households—with Vera; with his wife and children—contributed to his decision to leave; according to his son Soulina, "he couldn't cope." In later life, his estrangement from his children became embarrassingly public. His elusive nationality signified both adaptability and ambiguity. He became a French citizen in 1934 and two years later called France his "second motherland." Through 1933, he regularly visited Germany, where his appeal was great and his champions included Otto Klemperer; "Stravinsky in Permanenz?" asked a 1928 Berlin headline. A Chicago paper reported in 1937: "Stravinsky, in German, Says He's French." As a World War II American patriot, he registered for defense work, participated in gas rationing, joined in a broadcast for the U.S. War Department, and made an arrangement of "The Star-Spangled Banner" (which proved illegal). He took United States citizenship in 1945. Nicolas Nabokov, who knew him forever, found Stravinsky a self-contradictory personality, half hedonist—"he loved to eat, loved good wine and women"—and half "a rigorously religious and ritualistic person, like ancient people are."[23]

Like Balanchine, Stravinsky was considered famously hard really to know; unlike Balanchine, he labored to explain himself. His notorious aversion to "interpretations" of his music, any and all of which distorted its meaning, paralleled larger areas of purported misunderstanding. To better explain himself, he would write lengthy letters to established scholars or obscure students. His private papers abound in marginalia disclosing self-doubt. His published correspondence is editorially scrubbed. He is credited with an *Autobiography* (1935) and an essay collection (*Poetics of Music*, 1942). The authorship (in French) of both these volumes is clandestine. The autobiography was ghostwritten by Walter Nou-

vel. Pierre Souvtchinsky helped to formulate the *Poetics* in Russian; the French musicologist Roland-Manuel regularly sent drafts of the French version to Stravinsky, who (as archival copies show) made relatively minor revisions. The autobiography is frequently defensive. The foreword reads in part: "In numerous interviews I have given, my thoughts, my words, and even facts have often been disfigured to the extent of becoming absolutely unrecognizable. I therefore undertake this task today in order to present to the reader a true picture of myself." The book ends with a challenge to Stravinsky's critics: "Their attitude certainly cannot make me deviate from my path. I shall assuredly not sacrifice my predilections and my aspirations to the demands of those who, in their blindness, do not realize that they are simply asking me to go backwards."[24]

The *Poetics* is a veritable apologia, painstakingly arguing for the stylistic unity of an output seemingly eclectic. Staking a claim to Apollonian lucidity, the author vilifies Wagner as the doomed prophet of "a cult of disorder," and (tellingly) rejects Russia as a condition confused and anarchic, neither Eastern nor Western, unknowable and unknown to itself. Stravinsky was also the ostensible coauthor of a series of published conversations with Robert Craft, who himself called the earlier books ghostwritten in their entirety. But the extent to which Stravinsky's words as quoted by Craft are in fact his own is also disputable. In all of these works, moreover, Stravinsky emerges as conspicuously, even fulsomely erudite. In a much-cited study, the music historian Richard Taruskin has presented Stravinsky as an inveterate liar who in his various misrepresentations revealed "an astonishing, chronic sense of cultural inferiority"; one does not have to fully agree with this combative assessment to recognize an ongoing search for personal bearings complicated by the effects of exile and immigration.[25]

And how complicating was the composer's eventual American

residency? Stravinsky and Vera settled in Los Angeles in spring 1941, about two years after Stravinsky arrived in Cambridge, where he delivered (in French) his *Poetics of Music* at Harvard University. Southern California was chosen for its climate. The Stravinskys were happy at 1260 North Wetherly Drive. Stravinsky "did not permit criticism of America in his presence," Nicolas Nabokov recorded; of Europe, he would say, "As far as I am concerned, they can have their generalissimos and Führers. Leave me Mr. Truman and I'm quite satisfied." And Stravinsky was not immune to the frisson of Hollywood glamour; his aquaintances included Harpo Marx and Orson Welles. There were scores of distinguished expatriates with whom to socialize. The Stravinskys' circle included the English writers Aldous Huxley, Gerald Heard, and Christopher Isherwood, the Russian actor Vladimir Sokoloff, the Russian painter Eugene Berman, the Polish composer Alexandre Tansman, the Czech Franz Werfel, the Germans Thomas Mann and Max Reinhardt. As Stravinsky was fluent in German from childhood, German—as well as French and Russian—was a frequent common language. According to Mann, "Hollywood during the war was a more intellectually stimulating and cosmopolitan city than Paris or Munich had ever been." Stravinsky's study, according to Nicolas Nabokov, was "perhaps the best planned and organized workroom I have ever seen in my life." Nabokov also wrote, "For Stravinsky social disorder of any kind is primarily something which prevents him from doing his work—that is, fulfilling his duty. He hates disorder with all the strength of his egocentric nature. He dislikes even the terms *revolution* and *revolutionary*, particularly when they are applied to music." Shortly after Pearl Harbor, Nabokov observed Stravinsky growing anxious that there might be a revolution in America. "'But where will I go?' said Stravinsky in an appalled and indignant tone." First and foremost, Los Angeles was for him a haven, refuge from the storm.[26]

Stravinsky was at the same time a frustrated outsider. His ambivalent, abortive relationship to the film industry was a microcosm of the whole. He denounced as "execrable" Disney's appropriation, truncated and rearranged to fit a scenario of dinosaurs and drought, of The Rite of Spring in Fantasia—and yet agreed to option to Disney The Firebird and Renard. He rejected outright a $100,000 offer to "pad a film with music."27 A series of collapsed collaborations fed Four Norwegian Moods, Scherzo à la Russe, Ode, and Symphony in Three Movements, all containing music originally conceived for sound tracks. The failure of the Los Angeles Philharmonic to acknowledge Stravinsky's eighty-fifth birthday, in 1967, was a watershed in his alienation from the city in which he had established residence nearly three decades before. His singular association with the Boston Symphony, which he guest-conducted nineteen times, ended with the death of Serge Koussevitzky in 1951. Only in 1967 did an American orchestra— the New York Philharmonic—mount anything like a Stravinsky festival sympathetic to the range and scope of his achievement. He came to view Europe as more receptive. Meanwhile, the Hollywood expatriates died or dispersed. Never at home speaking English, he grew isolated in California. As early as 1957, he and Vera thought of resettling in England. Paris was also considered.28 The novelist Paul Horgan, who knew the Stravinskys via the Santa Fe Opera (and its Stravinsky productions) beginning in the 1950s, remarked that aside from Huxley, Isherwood, and Heard

> they had, so far as I know, no close friends with whom to
> have even the idlest conversation. . . . I remember how I
> burst into laughter at Stravinsky's reply when I once asked
> him whether he found any amusement in Hollywood par-
> ties given by acquaintances in the film world. He replied
> that they were intolerably boring to him, and he referred
> to the most recent he had unwillingly attended, which

was, he said, populated by "forty-five pederasts and seventy-six miscellaneous idiots."

Horgan also offered this memorable glimpse of how it felt to be in the great man's company:

> To be with him was to be conscious that one was within the field of energy of genius, even during its lapses into restful triviality. I think at times he may have found my company somewhat trying, for the tone of my response to him; for in his presence I often found it difficult to release to its fullest, for whatever that was worth, my own intrinsic personality—and it would be just that sort of release which would have engaged him most in anyone. Even with the growing familiarity of years, I never lost something of awed restraint; but it was one of his powers that he never needed explanations—he could feel what one felt, and if there was something genuine behind it, he was aware of that, too, and accepted what could not easily find expression when he knew it to be compact of both respect and love, with a pinch of intelligence thrown in.[29]

All of this was to the side of Stravinsky's intense professional life as composer and conductor. To speak of his American career in either capacity is to speak of Robert Craft. They met in 1948, when Craft was only twenty-four; Craft gradually became a part of the Stravinsky household, taking nearby rooms (where Vera had a studio), and sharing meals and the attentions of Mrs. Gate, the Russian housekeeper. His first assignments included compiling a catalogue of Stravinsky's works and helping with issues of English pronunciation and accentuation in *The Rake's Progress*. His eventual responsibilities included reading Stravinsy's mail and overseeing the schedule of conducting engagements mutually

undertaken by Stravinsky and himself. (After 1956 Stravinsky no longer wished to conduct full-length symphonic programs.) Craft also chose the recorded music to which the two of them would listen after dinner, some of it by composers Stravinsky did not know.[30]

It was Craft who witnessed and reported Stravinsky's tearful outburst of self-doubt in 1952 and who introduced Stravinsky to twelve-tone serial composition, as practiced by Schoenberg and his followers, as a creative life-support system. There are famous instances of composers who stopped in midstream: Rossini, Elgar, Sibelius. Something comparable might have happened to Stravinsky. Though from 1936 Schoenberg lived in Brentwood Park, ten miles distant, they did not once meet in Los Angeles. It is often speculated that Schoenberg's death in 1951 psychologically facilitated Stravinsky's late conversion to Schoenbergian techniques both esoteric and, by the 1960s, de rigueur. But this conversion required mentorship as well (twelve-tone methods of pitch manipulation cannot be extrapolated by the untutored eye or ear). In fact, according to Craft, "every Stravinsky opus, after and including *Three Songs from William Shakespeare* (1953), was undertaken as a result of discussions between us." Craft has also written:

> It was my ignorance of his other languages that forced on Stravinsky the Anglo-American dimension, which eventually became more important to him than any except the Russian. When I entered the home, the library contained only a handful of books in English, whereas in a few years there were thousands, on every subject. . . . Stravinsky was a rapid learner, and English soon became the language of his professional and literary life, though he continued to count money and baggage, and to converse with his wife, in Russian.[31]

As Stravinsky's personal manager and press representative, and later his "nurse," Lillian Libman was a shrewd eyewitness to the final twelve years of the twenty-three-year Stravinsky/Craft relationship. Her *And Music at the Close: Stravinsky's Last Years* (1972) records scenes of intense and complex symbiosis. In Libman's account, Craft pushed Stravinsky to conduct concerts and recordings—activities that sustained Craft's own performance and recording career—beyond the natural limits of old age, even to the point that some of the "Stravinsky Conducts Stravinsky" recordings issued by Columbia would more truthfully have been titled "Craft Conducts Stravinsky." On one occasion, recording *Pulcinella,* Craft was observed attempting to correct Stravinsky's slower tempo, and also admonishing Stravinsky not to insult an error-prone instrumentalist. Libman continues:

> Stravinsky whirled on Robert and retorted, in an enraged and imperial tone, "How dare you address me in this manner!" White-faced, Robert snatched his jacket, towel, and scores, and left the studio. Stravinsky resumed his work. But he was visibly shaken. . . .
>
> Robert had really become a *fils adoptif* by this time, and between "father" and "son" it would be extremely unlikely for peace to prevail at all times. Still, a public argument of the nature of the present one had never before taken place, to my knowledge. Stravinsky's open reprimand to Robert in the studio deprived his colleague of the privileged position that others believed him to hold. Robert had been humiliated, and before almost a hundred people.
>
> . . . Mrs. Stravinsky tried to reason with Robert, and so did I, but it was very apparent after the first day and a half that Robert had no intention of giving in. "He will go away, unless my husband apologizes," she told me, and with such a desolate note in her voice that had I not already begun to see how important Robert was in the

household, Mrs. Stravinsky's total dependence on him, if not her husband's, would have been revealed by this simple remark.

. . . Finally, on the fourth morning, he hinted to me that he would not take it amiss if someone let Robert know that he hoped he would come down to lunch. Robert did; and the meeting had all the old camaraderie. . . .

The significance of the entire episode (for me) lay in the fact that it was Stravinsky who had yielded. It was a simple admission that he could not—or at least certainly did not wish to—manage without Robert. No one acquainted with Stravinsky in the years before Robert's arrival would not agree that this concession represented a complete change in the composer's nature: in former days he would never have tolerated an association on any terms save his own, and such an episode as had occurred at the recording studio would have brought an instant end to a relationship.

But Craft, too, made concessions: he lived for Stravinsky. Libman: "Even if Robert had wanted to marry while Stravinsky was alive (and there was at least one occasion when I am sure he did), no compromise on a division of time for his private life could ever have been reached, unless it were 95 percent versus 5."[32]

Craft's editorial role in the conversation books and other Stravinsky writings has been greatly aired and debated. According to Craft, in *Stravinsky: Glimpses of a Life* (1992):

Was [Stravinsky's] English sufficiently fluent to write books of "conversations" without me? The answer is "no," for which reason I helped him, as must always have been obvious to those familiar with the idiosyncratic wording in his correspondence. . . .

Apart from programme notes and "open" letters, the "conversations" books are the only published writings

attributed to Stravinsky that are very largely by him. . . . Most of the "conversations"—for which many of the manuscript and typescript drafts survive—were in fact written or dictated by the composer. . . . Much of the language of the books is mine.

Ten years later, Craft toned down this claim as follows: "The *Conversations* books . . . are the only published writings attributed to Stravinsky that are actually 'by him,' *in the sense of fidelity to the substance of his thoughts*. The language, unavoidably, is *very largely mine*" (italics added). In Libman's view,

> Stravinsky's English was certainly pregnant enough to be quoted directly, and in the first two volumes [of the *Conversations*] much of its flavor is preserved, but his exact phrasing of an answer or his lengthy expositions on a topic always sounded better and more literary in languages over whose idiom he had a more complete command than over English. Robert, therefore, created a style that he felt conveyed the quality of Stravinsky's exact expressions. But, being a writer himself, it was bound after a while to become much more his own style.

So much did this abnormal situation become normalized that even Libman, when Craft was "too busy," found herself authoring an article on Gilbert and Sullivan for the *New York Times* under the byline "Igor Stravinsky." The Stravinsky writings also notably included, as a "unique cultural document," a 1965 article for *Hi Fi/ Stereo Review* comparing three recordings of *The Rite of Spring*—by Herbert von Karajan, Pierre Boulez, and Robert Craft—in which Craft's version is extolled as superior.[33]

Of the many Columbia recordings conducted (in full) by Craft, the vast majority surveyed the output of Schoenberg, Berg, and Webern. As much of this "Second Viennese School" reper-

toire had not previously been recorded, the Craft performances were influential. But emigré musicians who had known these composers—most especially Felix Galimir, whose Galimir String Quartet was coached by Berg and Webern—regarded Craft's renditions as brisk and clinical: an American mutation of Viennese post-Romanticism.[34] The musicians most discontented by Craft's role and influence, however, were American composers. Though Stravinsky did not teach, the example emanating from California was a beacon light reaching to the Northeast's seats of higher learning. At first, a group of neoclassicists—centrally, the Brandeis University contingent of Arthur Berger, Irving Fine, and Harold Shapero—comprised Stravinsky's chief American disciples. Once Stravinsky abandoned tonal music, he was fervently adopted by the American serialists associated with Milton Babbitt of Princeton University. From their high perch, the neglect and indifference shown Stravinsky's latest music—by critics, by orchestras, by the musical public at large—registered unfortunate American conditions. At the same time, they viewed Craft as a rogue interloper, almost an agent of house arrest. When Stravinsky died in 1971, a eulogy by Babbitt's composer colleague Claudio Spies, whose own personal proximity to Stravinsky had been diminished by Craft's accession, laid bare a catalogue of resentments:

> Books appeared under his name, yet none of these were written by him; recordings were issued, ostensibly to provide evidence of his specific wishes as to the performance of practically his entire oeuvre, yet he edited no tapes and was frequently prevented by local or momentary circumstances—as well as by the carelessness, the tension, and incompetence which usually pervade recording enterprises—from enabling a given recorded performance to represent his preferences. . . .
>
> It is in his final two years that the limelight reaped its bitterest, crassest harvest of publicity, by focusing with

consummate cruelty on the old gentleman's physical failings and the pitiful, sharp decline of his faculties. His infirmity was subjected to outrageous public display, and his ensnarement was rendered the more appallingly evident through those reiterated projections of his "image," cast into such preposterous roles as: columnist on the performing arts, reviewer of books on Beethoven's music, and endlessly chattering granter of interviews for the popular press. The cynical cultivation of his public inextinguishability had reached beyond itself, in effect, by obliterating any reminders of his unique, most distinctive trait: his identity, after all, as the composer of his music![35]

Libman reflected of Stravinsky in America: "To think about composing required an atmosphere of peace, and every moment of all the years I knew him, that was *all* he wanted."[36] What he ultimately found, in his singular Los Angeles abode, was a kind of disembodied calm, adrift from the world he once knew. As a further function of his displacement, he found himself, as well, an object of exaggerated celebrity and exaggerated neglect. Given his penchant for self-scrutiny and self-justification, what "Igor Stravinsky" could be glimpsed in this complex and self-contradictory American mirror? Even the community he temporarily discovered—of neighbors like-minded and comparably venerable—was itself uprooted. And these, moreover, were social relations, not to be compared with the working relationships he had earlier enjoyed with Diaghilev, Picasso, Cocteau, Roerich, Bakst, and Nijinsky, or with intimate access to such august composer colleagues as Debussy, Ravel, and Falla. The one exception was a man twenty-one years his junior, neither acolyte nor amanuensis.

GEORGE BALANCHINE'S FIRST STRAVINSKY ballet was *The Song of the Nightingale,* for Diaghilev in 1925; there is no record of Balanchine conferring with the composer on this occasion.[37] But *Apollo,* three years later, was a collaboration: Stravinsky again conducted *The Fairy's Kiss* and *Jeu de cartes,* presented in tandem by Balanchine at the Metropolitan Opera in 1937. Subsequent to Stravinsky's move to California, Balanchine choreographed or staged fifteen more Stravinsky works, often with the composer's participation, then another fourteen after Stravinsky's death.[38]

The relationship was anchoring for both men. For Balanchine, it furnished the music most suited to his choreographic style. For Stravinsky, with his tenuous American ties, it furnished a collaborator not only aesthetically kindred but psychologically impregnable, institutionally grounded, and bonded with his environs. Above all, it was a consuming practical partnership. Balanchine appreciated Stravinsky the artist for what he was, not as an icon worshipped from afar. A well-known anecdote has Balanchine asking Stravinsky to add "about two and a half minutes" of music to *Orpheus.* "Don't say 'about,'" Stravinsky replied. "Is it two minutes, two minutes and fifteen seconds, two minutes and thirty seconds, or something in between?" After observing Balanchine and Stravinsky at work on *Jeu de cartes,* Kirstein wrote:

> Stravinsky was as impersonal as a surgeon, carpenter, or plumber. . . . We had only a limited time allotted for rehearsals. Clocks ruled everything, starting with the duration of sections of a score. Stravinsky would sit for six hours at a stretch in our studio, then haul the rehearsal pianist off to his hotel for more work. He was a precision instrument, a corporeal metronome, but neither captious nor inelastic. When he saw that Balanchine needed additional music to permit a desired development, he would promptly decide whether to repeat measures or add new

notes. If the latter, the necessary piano part would appear next morning, accompanied by its immaculate orchestration ready for the copyist.[39]

Balanchine would say: "Only God creates. I am only a chef cooking up another dish for the audience, that's all." Stravinsky would say: "I do not work with subjective elements. . . . My artistic goal is to make an object. . . . I create the object because God makes me create, just as he created me." Work and aesthetic habits were one and the same: methodically, professionally, they mutually undertook to discover the inherent order of things—a task also inherently economical, and valuing economy of means. They mutually shunned self-expression. Their objectivity predisposed them to humor, to irony, and to a quality Denby (writing only of Balanchine) termed "virtuoso calm." "If I were feeling suicidal," Balanchine told Bernard Taper, "I would never try to express this in a ballet. I would make as beautiful a variation as I could for a ballerina, and then—well, then I'd go and kill myself." Of Stravinsky, Balanchine said: "He is like a child, so light-hearted, so funny, so playful." Balanchine's mistrust of "sincerity," which was also Stravinsky's, found embodiment in his dancers' faces, which never said "I feel." (Denby, watching Balanchine in rehearsal, observed that he never gave instructions for facial expression.) The best-known sentence of Stravinsky's autobiography—that music is "essentially powerless to *express* anything at all"—is echoed by Balanchine's "Dancing isn't about anything except dancing." This tight creative fit also fit American mores. Denby wrote of Balanchine's dancers: "They seem, as is natural to Americans, unemphatic." As in their response to performing musicians (as we will see), American audiences gravitated toward ideals of practicality and efficiency, not soul-searching "genius," interpolated emphasis, and foreign "tradition." Though Balanchine and Stravinsky were nothing if not elitist, in denying their own privileged "inspiration"

and self-expressive "depth," they equally denied notions of privileged access favoring connoisseurs themselves endowed with special divinatory skills.[40]★

The practical skills Balanchine shared with Stravinsky were also specifically musical. Said Stravinsky: "I don't see how anyone can be a choreographer unless, like Balanchine, he is a musician first."[41] In addition to his dance studies, Balanchine had been a piano student at the St. Petersburg Conservatory. He also studied French horn, trumpet, and violin. He composed. He resumed studying music theory in the 1930s with Nicolas Nabokov. All his life he was in the habit of preparing piano reductions of the orchestra scores he choreographed. The evidence of his musical sophistication marks his ballets in ways obvious and hidden, general and specific. His *Scotch Symphony* solves the problem of Mendelssohn's *Scotch* Symphony—a work undone by a long coda whose cheerful note of triumph is (at least for post-Victorian ears) impossibly thin. Balanchine's ballet omits all but a few introductory measures of the symphony's long A minor first movement. As a result, the entire work begins and ends in the major. With its most turbulent music left out, with the finale the only sonata form, the center of gravity is shifted toward the fortified close. This recomposition is clinched by the choreography, which (in addition to turning the repetitive Adagio into a pas de deux both central and sublime) achieves closure by pairing the dancers as "wedded" couples—a Shakespearean ending. No other choreographer could stage and "correct" a Mendelssohn symphony this persuasively, but there is a cost: the Scherzo must be slowed down for dancing. Comparably: in *Brahms/Schoenberg Piano Quartet,* Balanchine finds a delicious irony in the Hungarian finale un-

★The harmoniousness of the Balanchine-Stravinsky relationship has been conspicuously challenged by Robert Garis in his *Following Balanchine* (1995)—a querulous and unpersuasive account, but much discussed.

known to Brahms or Schoenberg: the coda, with the gypsy lover flying across the floor on his knees and the gypsy beloved collapsing in his arms, is Looney Tunes, pure Hollywood. But the big first movement (notwithstanding Balanchine's masterly handling of the sonata form) calls for a play of tempo and rubato his double ensemble of dancer and musicians cannot attempt. For that matter, any number of Balanchine ballets suffer in musical performance. Schumann's *Davidsbündlertänze* is slowed and straitjacketed to accommodate the physical needs of legs and feet. The first movement of *Serenade* is too slow, and the entire work, as rendered for Balanchine by the New York City Ballet conductor Robert Irving, is too heavily accented and steadily pulsed. It almost sounds like Stravinsky—and Stravinsky, for Balanchine, is home base: the music with which his method perfectly concurs.

It is instructive that Stravinsky is the composer of a concert score—*Danses concertantes*—cast in the form of a ballet including a march, theme and variations, and pas de deux. (It has been choreographed by Balanchine, among others.) What Balanchine, in a well-known essay, termed the "dance element" in Stravinsky is a prevailing feature. "Pulse," writes Balanchine, "is steady, insistent yet healthy, always reassuring. . . . It holds together each of [Stravinsky's] works and runs through them all." Balanchine also writes: "Stravinsky's strict beat is his sign of authority over time." Equally pertinent is Stravinsky's lifelong grounding in the theater, his fascination with ritual and physical movement. In 1911 he wrote to Rimsky-Korsakov's son Vladimir: "If a Michelangelo were alive today, I thought, looking at the frescoes in the Sistine Chapel, the only thing his genius would recognize and accept would be the choreography that is being reborn today. . . . For the only form of scenic art that sets itself, as its cornerstone, the *tasks of beauty* and *nothing else,* is ballet." Stravinsky's son Theodore wrote of his father's "kinesthetic" response to music and dance. Stravinsky could walk on his hands and enjoyed

ARTISTS IN EXILE

social dancing. The cramped podium style of the aged composer is misleading; earlier, his conducting was typically likened to "dancing." Visiting Stravinsky in Hollywood, Nicolas Nabokov reflected:

> Frequently, in fact, while listening to his music, I have closed my eyes and seen in front of me a characteristic Stravinskian gesture. At other times, when seeing him pace the floor on tiptoe in the middle of a discussion, his upper body bent forward like that of a frog-fishing stork, his arms akimbo, I would be struck by the parallel between his physical gesture and the inner gesture of his music. His music reflects his peculiarly elastic walk, the syncopated nod of his head and shrug of his shoulders, and those abrupt stops in the middle of a conversation when, like a dancer, he suddenly freezes in a ballet-like pose and punctuates his argument with a broad and sarcastic grin.[42]

And Stravinsky was of course both in France and the United States eagerly susceptible to jazz, most literally in the eleven-minute *Ebony* Concerto (1945) he composed for Woody Herman and his band. The swagger and muscle of the jazz influence in his Symphony in Three Movements is notably more American than Parisian; in Stravinsky's premiere recording with the New York Philharmonic (1946), the flying syncopations (try the seventh measure of movement one) really swing.

The physicality of gesture in Stravinsky's music is made tangible by Balanchine's choreography. As Denby put it, the "mechanics of momentum," not "expression," is what a Stravinsky/Balanchine ballet primarily conveys. "The force of dance momentum derived from the score is a resource of ballet that he has developed further than anyone anywhere. . . . With twelve dancers he finds a momentum that feels like forty dancers; with forty, it feels like a

hundred. His company dances three times as much per minute as any other."[43] As often as not, such choreography less complements than completes a Stravinsky score. As ear and eye may discern, and as the composer's sketches corroborate, Stravinsky is an additive composer. He does not, like the Germans, begin with a structural mold governed by directive harmonic logic. Rather, he builds with cells; as with other ballet composers, repetition is central to his method. A weak patch of development in, say, a Dvořák symphony is ameliorated by thrust toward the tonic. In Stravinsky a patch of chugging ostinato, or of alternating motivic blocks, risks sagging interest and momentum.

Even so splendid a work as the Symphony in Three Movements—one of the most bracing products of Stravinsky's American period—is in places so stripped that extra ballast seems merely prudent. To Craft, Stravinsky confided that his "musical imagination" had here been excited by concrete impressions of war, "almost always cinematographic in origin."[44] These included newsreels of goose-stepping soldiers and of war machines, and a documentary of scorched-earth tactics in China. Applied to the aggressive march beat and brassy instrumentation of the outer movements, these images in fact suggest a Stravinsky-scored documentary in the tradition of the 1930s American socio-political documentaries scored by Virgil Thomson and Aaron Copland. But, as Stravinsky told Craft, these points of inspiration remain distinct from a program; their chief significance is confirmation that this music plausibly functions as a backdrop to something else more corporeal.

The something else Balanchine furnishes in his *Symphony in Three Movements* is (of course) neither martial nor military. Rather, his corps of women and men comprises a variegated mass in motion so kaleidoscopically complex and fluid in its forward flow, so free of generic or ancillary matter, that (as a 1972 silent film of a New York City Ballet performance abundantly confirms) its

evolving human configurations constitute a gripping essay in form and proportion. With music added, Balanchine's extrapolation of structure is both supportive and binding: it compensates where the composer's invention flags. Also typical of Balanchine's Stravinsky achievement is a further extrapolation of content. Though Stravinsky, in his *Autobiography* and *Poetics,* dismissed music's associative properties, he later confided that "Broadway," "boogie-woogie," and the "neon glitter of Los Angeles' boulevards" accented his post-European musical abstractions. Balanchine, too, embedded "America" in his plotless ballets.[45] Doing Stravinsky in tights, shirts, and leotards, his dancers uncover pockets of playfulness and sex, jazz and humor, both suspected and not. In the *Symphony in Three Movements*, where Stravinsky hints knowingly at brassy commercialisms, Balanchine winks at Hollywood and Broadway. The rapid strut of his long-legged, athletic beauties intimates intercollegiate halftime rituals. The hair-trigger coordination of their signature diagonal formation, punctuating the work's brash beginning, teasingly insinuates a chorus line. Such is the nature of this spare "symphony," with its motor rhythms, constructive modules, and skeletal sonics, that these embellishments are never a distraction. Rather, they add a dimensionality to which the mutual experience of American sights and sounds is not irrelevant.

The Balanchine dimension is crucial, finally, to Stravinsky's late nontonal works. More than any conductor, Balanchine enables listeners to follow the narrative of musical gesture and form in such esoteric music as *Agon. Movements for Piano and Orchestra,* six years later in 1963, was Stravinsky's first unadulterated serialist exercise; he called it his "most advanced work to date." Of Balanchine's choreography, Stravinsky wrote: "This visual hearing has been a greater revelation to me, I think, than to anyone else. The choreography emphasizes relationships of which I had hardly been aware—in the same way—and the performance was like a

tour of a building for which I had drawn the plans but never explored the result."[46]

Considered on its own terms, *Movements* may suggest an aged composer taken in by fashion, or the final attainment of an intellectual respectability long pursued, or a bona fide feat of heroic renewal. Even more ambiguous is the case of Stravinsky's musical play *The Flood,* commissioned for commercial television by the Columbia Broadcasting System, with choreography by Balanchine. All who remember the broadcast, on June 14, 1962, remember "Beautiful Hair Breck." An hourlong Breck Golden Showcase presentation introduced by Edgar J. Breck, this ostensible Stravinsky show featured five commercials, each a "portrait of loveliness," extolling Breck shampoos to make dry hair beautiful, to make oily hair beautiful, and to make normal hair beautiful; Breck hairset in two new types ("every day women ask what hairset is right"); Breck cream rinse and hairspray; and special Breck summertime offers—all with a special Breck theme song sung by solo violin (dry hair), solo flute (oily hair), and soap-opera organ (normal hair). Laurence Harvey, a grim tuxedo visage, appeared to ponder the human condition ("Man is sensitive, often witty, sometimes sad"), the "world's greatest living composer" ("All periods of history produce a few great artists who give to their fellow man a new beauty . . . for more than 50 years Igor Stravinsky has composed music that has made men be still"), and "the contemporary world's most original and fertile choreographer" ("George Balanchine composes dances that speak for all of us"). Suddenly, someone said, "Ladies and gentlemen, Igor Stravinsky"—and there he was, a stranded face with bony features, laboriously intoning, "Good evening, I am very glad to be here." Swallowed up by so much packaging was the present itself, a thirty-minute enactment of Adam and Eve, God and Noah, the Flood, and the Covenant of the Rainbow, all fearlessly allusive and schematic.[47]

In later years, Balanchine praised *The Flood* as a sterling achievement undone by American TV.[48] In truth, so potent and naked was the machinery of mass entertainment, as here imposed, that a true reading of *The Flood* was impossible to extrapolate. The Breck strategy of repetition defeated Stravinsky's strategies of economy. Stravinsky was reduced to a manipulated article of prestige. *The Flood* revealed the actual marginality of Stravinsky and Balanchine in greater America—and the necessity of a guardian angel to keep this disclosure under wraps. Lincoln Kirstein, who played no role in *The Flood,* chronically mistrusted television. Alone among the Lincoln Center constituents, his New York City Ballet resisted instructional cant when showcased by the Public Broadcasting System's grandiosely titled "Great Performances." For Balanchine, Kirstein served a mediating function, ensuring proper relations, neither too distant nor too close, with the larger institutional life of culture. For Stravinsky, often ill used by Americans, the City Ballet was a rare haven.

However one ranks such superior California products as Symphony in Three Movements, the Mass, and *The Rake's Progress*, a glance at Stravinsky's earlier catalogue is humbling: for the theater, *The Firebird, Petrushka, The Rite of Spring, A Soldier's Tale, Pulcinella, Les Noces, Oedipus Rex, Apollo*; for the concert hall, the *Symphony of Psalms* and the piano and violin concertos. If this disparity in achievement comes as a surprise, it is chiefly because of the freshness and enriched fullness of the Stravinsky encounters so steadily produced by Balanchine's New York City Ballet.

A FINAL NECESSARY TOPIC, in considering Stravinsky and Balanchine in relation to the United States, is consideration of Stravinsky and Balanchine in relation to St. Petersburg: their point of origin, so distinctive in culture and affect. In old age,

Stravinsky said: "St. Petersburg is so much a part of my life that I am almost afraid to look further into myself, least [sic] I discover how much of me is still joined to it. . . . It is dearer to my heart than any other city in the world." Balanchine said, "I am often asked, 'What is your nationality, Russian or Georgian?' And I sometimes think, by blood I am Georgian, by culture, Russian, but my nationality, Petersburgian. . . . Petersburg was always a European city, cosmopolitan." Petersburg was also, for Balanchine, "elegant, simple, refined," "light, majestic, balanced"—always in contradistinction to Moscow.[49]

Though the West has mainly correlated Stravinsky's unsentimental Apollonian aesthetic with Paris, it begins with St. Petersburg and its literary patron saint Alexander Pushkin, its straight streets and fine proportions. Every Petersburg intellectual knows that Theater Street is 220 meters long and 22 meters wide—and that 22 meters is also the height of the buildings on either side. Balanchine spoke of qualities of restraint inculcated by Petersburg, and by Theater Street. Petersburg was a home to neoclassicists before they emigrated to France in the 1920s. Stravinsky's teacher Rimsky-Korsakov preached restraint and professionalism.

That Diaghilev's *Mir iskusstva* likewise embodied strong classicist tendencies could not have been lost on either Stravinsky or Balanchine. Lillian Libman wrote of Craft, "Robert always had his defenses up when the Stravinskys were involved in anything directly connected with their native country." Diaghilev does not figure prominently in the Stravinsky-Craft conversations. In a film, Craft once summarized Diaghilev as someone with whom Stravinsky "fought a lot." Stravinsky himself was known to remember Diaghilev as his closest friend. In his autobiography, it is singularly Diaghilev about whom Stravinsky writes lovingly. Of Diaghilev's early death in 1929, Stravinsky says: "His loss moved me so profoundly that it dwarfs in memory all the other events of

that year"; and again: "It is only today, with the passing of the years, that one begins to realize everywhere and in everything what a terrible void was created by the disappearance of this colossal figure, whose greatness can only be measured fully by the fact that it is impossible to replace him." Soulima Stravinsky said of the impact of Diaghilev's death on his father: "It was as if it was a brother or more, even more."[50]

Though Balanchine regarded Diaghilev as an indispensable mentor, his reminiscences—of this and all else—are unattended by feelings of loss. The mutual veneration Stravinsky and Balanchine felt toward Tchaikovsky—an embodiment of sublime craftsmanship and elegance—similarly calibrates similarities and differences. For Balanchine, Tchaikovsky (though he lived in Moscow because "they stupidly did not ask him to teach at the Petersburg Conservatory") was "absolutely Petersburgian." Like Pushkin, whom he memorably adapted, Tchaikovsky was "a European from Russia." And: "There's another example of a European from Russian, Igor Fyodorovich Stravinsky." Like Stravinsky, like Balanchine, Tchaikovsky was religious. Balanchine: "I'm sometimes asked, 'How is it that you are a believer?' You can't come to faith suddenly, just out of the blue. You have to achieve faith from childhood, step-by-step. That's how Tchaikovsky did it, that's how Stravinsky did it." The order of things Stravinsky and Balanchine sought to uncover in art was God's order. Like Stravinsky, like Balanchine, Tchaikovsky was politically conservative. Balanchine's politics were rarely known; his friend the violinist Nathan Milstein called him "a monarchist and a democrat, one does not preclude the other at all." Stravinsky's politics were and are controversial. Of his early works, *The Rite of Spring* and *Les Noces* have been read as protofascist. Later, Stravinsky supported Mussolini and, as a professed anti-Semite, courted favor with the Nazis. Disinherited by the Bolsheviks, jostled by exile and displacement, he acquired a preference for strong right-wing governments.[51]

If Balanchine the immigrant embodies synthesis in equipoise, Stravinsky inhabits a dialectic charged with conflict and loss, with ambivalence toward things past careening between rejection and nostalgia. As often as he denied his Russianness—a denial copiously documented by Richard Taruskin—he helplessly succumbed to it. In the wake of the Russian Revolution, no longer a Russian abroad but a Russian cast off, Stravinsky preoccupied himself as never before with Russian folk culture and song. The chief product of this surge of patriotic remembrance, *Les Noces*, was dedicated to Diaghilev, who wept upon hearing it. In later life, according to Libman, "the mention of *Les Noces* never failed to produce the same smile with which [Stravinsky] greeted those for whom he felt great affection." This side of the composer, remote from his frosty aesthetic pronouncements and often forbidding formality, is equally documented by Libman when she writes:

> He was a deeply affectionate man. . . . And he welcomed signs of affection from those close to him. His Russian-fashion kiss of greeting . . . could be full of love and a need to have it returned. . . . And as for his wife—whom he loved more than anything in the world after his music—when she would return from an excursion or an errand, or even enter a room, he would greet her in this same majestic way, but as though she had just arrived after a long stay in Siberia. At these times he was kindness itself, and whoever happened to be present became the collateral beneficiary. The bequest was normally in the form of an invitation to quaff from his best bottle.

Taruskin calls Stravinsky "the most completely Russian composer of art music that ever was"—by which he means not only that Stravinsky crucially absorbed folk roots and aesthetic dictates via *Mir iskusstva* but that, at the ground level of style and technique, his harmonic vocabulary and penchant for ostinato,

stasis, and discontinuity are equally a product of Russian habit and schooling.[52]

Stravinsky's most confessional love letter to his homeland, and his most emotionally naked music, may be his 1928 Tchaikovsky ballet *The Fairy's Kiss*. More than a dozen Tchaikovsky songs and piano pieces furnish the exquisite musical materials. The story adapts Hans Christian Andersen's "Ice Maiden," in which an abandoned babe is kissed by a fairy; years later, as a young man about to be wed, he dies, reclaimed by the fairy's kiss. The ballet is commonly read as an allegory for Tchaikovsky's fate: kissed by the muses at birth, doomed to an early death. The two Tchaikovsky works most tellingly cited say it all: "Lullaby in a Storm" and "None but the Lonely Heart," both plaintive songs. *The Fairy's Kiss* is Stravinsky revisiting his own childhood, confiding his emotional roots.

With the exception of *Adagio lamentoso*—a setting of the finale of the *Pathétique* Symphony, given once on the occasion of the City Ballet's 1981 Tchaikovsky festival—Balanchine's big Tchaikovsky ballets are never this confessional. He shunned the complete *Swan Lake* and *The Sleeping Beauty*. Instead, he used music more formal and restrained: *The Nutcracker*, the Second Piano Concerto (*Ballet Imperial*), the Third Symphony (*Diamonds*), the Third Orchestral Suite. As often as not, the Russianisms of the choreography are sublimated. Of Balanchine's fourteen Tchaikovsky ballets, only *The Fairy's Kiss* has a problematic history. Balanchine set the entire forty-five-minute score in 1937 for the American Ballet. For the City Ballet, he set the non-narrative, twenty-minute Divertimento Stravinsky extracted from the full ballet (omitting its most sublime, most romantically affecting music: a hypnotic five-minute coda truly inhabiting the Land of Eternal Dwelling). He later revised the Divertimento to incorporate the coda in truncated form. Balanchine doubtless found the full scenario too complicated—"there are no mothers-in-law in

ballet," he famously quipped. But both Balanchine versions of the Divertimento, set beside Stravinsky's achievement, are for once wholly unsatisfactory. As with Stravinsky, Balanchine's professed eschewals of subjectivity were of course exaggerated; such works as *Serenade,* with its Dark Angel and dying girl, obviously convey self-expression. Nevertheless, Stravinsky's searing intimations of abandonment and loss were not for him.

In 1962, both Balanchine and Stravinsky had occasion to visit Russia after decades of absence and neglect. The City Ballet was a foreign sensation in Moscow and Leningrad. It was startlingly different from the insular dance culture of Soviet times. But Stravinsky, ten months before, had seemed a son reclaimed. Balanchine, in Moscow, declared himself an "American." Visiting Georgia, he found Tbilisi "boring and musty." Bernard Taper conjectures:

> By now [Balanchine] had become so accustomed to con-
> cealing his feeling that perhaps he convinced himself that
> he was really feeling as little as he said. Yet those around
> him could see that he was visibly affected by what was
> happening, and he seemed to be suffering from an in-
> creasing strain of which the physical demands on his en-
> ergy were only a part. He looked gaunt.

Robert Gottlieb, long associated with the New York City Ballet, has written:

> According to [the dance critic] Richard Buckle and [the
> choreographer] John Taras, immediately after checking
> into his hotel in Leningrad, "Balanchine grabbed Natalie
> Molostwoff [of the School of American Ballet] and
> rushed out to show her his old home in Bolshaya Mos-
> kovskaya, which was not far away. He was very emo-
> tional." Taras observed how depressed he was. He had

ARTISTS IN EXILE

lost weight, he wasn't sleeping (he claimed that the telephone in his hotel room rang all night long), and . . . he was sure he was being spied on—that his room and maybe even his clothes were being bugged. Suddenly he decided to fly home to New York for a week, before rejoining the company in Georgia . . . what would be more natural? Not only was he exhausted from the effort of leading the company to Russia while having to appear calm and in control, [but] being back in the city of his childhood and youth, where he had endured such emotional and physical hardships, must have agitated his feelings to an unacceptable level.[53]

Taper, in recent years, has speculated that Balanchine in Russia was "about to have a breakdown." Whatever he experienced—to what degree revulsion, to what degree heartache—he kept it to himself. Stravinsky, in Russia, did not conceal his feelings. Nicolas Nabokov, visiting Stravinsky in California around 1950, had perceived no "romantic Ulyssean longing"; "for Stravinsky, Russia is a language, which he uses with superb, gourmand-like dexterity; it is a few books; Glinka and Tchaikovsky. The rest either leaves him indifferent or arouses his anger, contempt, and violent dislike." But in Moscow in 1962, Robert Craft observed of Stravinsky and Vera, "Their abiding emotion is an intense pride in everything Russian." Of Stravinsky in rehearsal with the Moscow National Orchestra: "He is more buoyant than I have ever seen him." After the first Moscow concert, the rhythmic applause would not cease. Stravinsky returned to the stage in his overcoat to tell the insatiable audience: "You see a very happy man." Then came a gala reception hosted by Yekaterina Furtseva, the minister of culture, and selected Soviet composers; Stravinsky rose to say,

A man has one birthplace, one fatherland, one country—
he *can* have only one country—and the place of his birth

is the most important factor in his life. I regret that cir-
cumstances separated me from my fatherland, that I did
not give birth to my works there and, above all, that I was
not there to help the new Soviet Union create its new
music. I did not leave Russia of my own will, however,
even though I disliked much in my Russia and in Russia
generally. Yet the right to criticize Russia is mine, be-
cause Russia is mine and because I love it, and I do not
give any foreigner that right.

Craft:

I.S. *does* regret his uprooting and exile more than any-
thing else in his life, which I say not because of a few
emotional speeches, though they have come from the
depths, but because of the change in his whole nature
here. Now, looking back at Hollywood, the perspective
from Russia outside, I can see that his domesticity is
purely Russian; in fact, he will eat his soup only from the
same spoon with which he was fed by his *babushka* sev-
enty-five years ago. . . . I . . . am certain that to be recog-
nized and acclaimed as a Russian in Russia, and to be
performed there, has meant more to him than anything
else in the years I have known him. And when Mother
Russia restores her love, forty-eight years are forgiven
with one suck of the breast.[54]

In Leningrad, at midnight, Craft observed an all-night queue
of 100 people outside Philharmonic Hall. Each individual repre-
sented a block of 100 tickets. The queue was reportedly a year old
and was regularly checked. (An eighty-four-year-old cousin of
Stravinsky secured number 5,001—too high to gain admission to
see and hear Igor Stravinsky conduct.) All his life, Stravinsky
thought in Russian and spoke other languages "in translation."
Upon returning from Russia, he preferred to speak Russian al-

most exclusively for a period of months. But he remained a man with unfinished business: in Leningrad, he had not visited his father's grave because he feared the effect.[55]

When Stravinsky died, in 1971 at the age of eighty-eight, he left no burial instructions. According to Nicolas Nabokov, Stravinsky anticipated being buried in Leningrad, next to his father.[56] Los Angeles, which had ignored him, was out of the question. Mrs. Stravinsky and Robert Craft settled on a site, alongside Diaghilev, in a city that had inspired Stravinsky and which reminded him of St. Petersburg: Venice. Balanchine, who died in 1983 at the age of seventy-nine, also left no instructions. He had disliked Venice, and a European resting place seemed illogical in any case.* It was decided to bury him in Sag Harbor, Long Island—a town he had recently come to know and found charming. In truth, Stravinsky died stateless, still in conflict with his past and its remembrance. Balanchine died an American who had remembered his past with a cool consideration. To the degree that he had reinvented himself in the United States, this was in part an accident of fate; he might have reinvented himself differently somewhere else. In the United States, Balanchine is today remembered exclusively for his American legacy. Stravinsky is today remembered by Americans mainly for the music he composed before undertaking his long American sojourn in 1939.

*And yet when it became apparent that Peter Martins would succeed him at the City Ballet, Balanchine was heard by a Russian acquaintance to comment (in Russian), "At least he's European." (Related to the author by an eyewitness.)

Rudolf Serkin

Rudolf Serkin, Adolf Busch, and the Berlinerisch *spirit—The German-American juggernaut—Strangers in America: Otto Klemperer and Dimitri Mitropoulos—Composers on the sidelines: Arnold Schoenberg, Paul Hindemith, Béla Bartók—Erich Korngold wows Hollywood—Kurt Weill tackles Broadway*

BERLIN BETWEEN THE TWO world wars was the city of *The Threepenny Opera, Wozzeck,* and *The Cabinet of Dr. Caligari,* of Bertolt Brecht and Max Reinhardt, Marlene Dietrich and Josephine Baker, Georg Grosz and Walter Gropius, Fritz Lang and Ernst Lubitsch; a city of broad boulevards and massive stone facades, of street fighting between Communists and Nazis, of topless revues and streetwalkers for every taste, of privation so severe and inflation so rampant that Artur Schnabel could be paid for playing the piano with a suitcase of bills—and could spend half of them on a couple of sausages on the way home. "The Babylon of the world," Stefan Zweig called it:

Bars, amusement parks, honky-tonks sprang up like mushrooms. . . . Along the entire Kurfurstendamm powdered and rouged young men sauntered and they were not all professionals; every high school boy wanted to earn some money and in the dimly lit bars one might see government officials and men of the world of finance tenderly courting drunken sailors without any shame. Even the Rome of Suetonius had never known such orgies as the pervert balls of Berlin, where hundreds of men costumed as women and hundreds of women as men danced under the benevolent eyes of the police. In the collapse of all values a kind of madness gained hold particularly in the bourgeois circles which until then had been unshakeable in their probity.[1]

The spirit that tirelessly survived the times—quick, keen, caustic; stoic, worldly, tireless—was called *Berlinerisch*.

The playwright Carl Zuckmayer likened Berlin to a cold coquette—and yet "everyone wanted her." Certainly aspiring artists and intellectuals did, and Berlin knew it. "What the Berlin theaters accomplished in those days could hardly be surpassed in talent, vitality, loftiness of intention, and variety," remembered Bruno Walter. "A passionate general concentration upon cultural life prevailed, eloquently expressed by the large space devoted to art by the daily newspapers in spite of the political excitement of the times."

"The arguing that went on after the first showing of *The Cabinet of Dr. Caligari*!" exclaimed the pianist Claudio Arrau half a century later. "I'm sure that the twenties in Berlin was one of the great blossomings of culture in history. The city offered so much in every field, and everything had a greater importance than in other places. . . . You see, there was a great misery. Many people were starving. There were no jobs. Such times are always fertile. Everything was so difficult that people sought a better life in culture."[2]

ARTISTS IN EXILE

Many Berliners were outsiders like Arrau—or Christopher Isherwood, who memorably chronicled its arch allure, or Vladimir Nabokov, who inhabited a formidable Russian subculture. If this made Berlin cosmopolitan, it did not therefore result in a deracinated cultural metropolis after the fashion of St. Petersburg. Foreign models were of limited use compared to venerated native traditions, and in no field more so than the German specialty: music. Ferruccio Busoni, whose misty Germanic idealism warred with warmer Mediterranean ideals, could not stay away. Until his death in 1924, he was Berlin's reigning pianist and pedagogue. Busoni was succeeded at the Prussian Academy of Arts by Arnold Schoenberg, who affirmed that his twelve-tone method would ensure the continued supremacy of German music. The Berlin Philharmonic was led by Wilhelm Furtwängler, whose performances of Beethoven, Wagner, and Bruckner upheld the supremacy Schoenberg was talking about. And Berlin supported no fewer than four opera houses, whose conductors included Walter, Otto Klemperer, and Erich Kleiber.

A famous 1930 photograph shows Klemperer, Furtwängler, Kleiber, and Walter standing shoulder to shoulder in concert attire. A hulking six-foot-four-inch giant with mussed hair and an errant, questing gaze, Klemperer tilts to one side. To the other, stiffly erect, stands Furtwängler; he eyes the camera with a lofty yet discomfited condescension. Walter, the softest presence, smiles. Kleiber, the smallest, projects quickness, wit, energy. In action, the four conductors remained a study in contrasts. With their dangerous, careening accelerandos, Kleiber's Berlin recordings of Johann Strauss erase Viennese *Schwung*, Weltschmerz, and gemütlichkeit; if this is dancing, it is dancing on a volcano. Klemperer, early recorded in Brahms, Richard Strauss, and Kurt Weill, is a droll or dour objectivist. Walter's first recorded performances are smooth, warm, pliable, spontaneous. Furtwängler is epic or demonic; his loftiness is unrelenting.

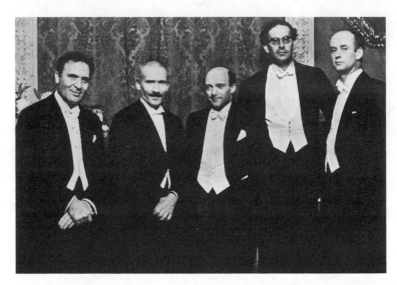

Bruno Walter, Arturo Toscanini, Erich Kleiber, Otto Klemperer, and Wilhelm Furtwängler at a reception for Toscanini in Berlin (1930).

All four conductors suffered disappointment in the United States. In Berlin, Kleiber's special triumph was the premiere of Alban Berg's *Wozzeck*, prepared with 137 rehearsals. This was a kind of dire nontonal music for which America was unready; Kleiber wound up in Havana and Buenos Aires, which if equally unready for Berg were remote from an American celebrity culture into which he did not fit. With his uncompromising allegiance to Mahler and Stravinsky, and his dry-eyed intensities of interpretation, Klemperer, too, was an awkward export. Walter seemed *schwach* to Americans, Furtwängler arrogantly and pretentiously aloof.

A fifth conductor in the 1930 photograph, a visitor to Berlin, is the reason the other four have uncomfortably gathered before a camera. His gaze is dark, vacant, and hypnotic, his presence compact, tense, and unnerving. This is Arturo Toscanini, already enshrined in the United States as music's nonpareil, a paragon of drive and precision, of vaunted truth and "objectivity" whose conservative repertoire was as reassuring as his performances were electrically charged. If Berlin knew a Germanic musician with

qualities of this kind, he was not a conductor but a pianist—and he alone, of the many instrumentalists who in the 1930s departed German-speaking lands, would chart a New World career far eclipsing his prior reputation and influence at home.

In 1951, following a benefit performance for the Philadelphia Orchestra, Rudolf Serkin (here with his son Peter) was presented with a tractor for his Vermont farm. Harvester World reported that he "gingerly climbed upon the seat, flipped his full dress coat tails behind him, and guided his shining red tractor as it was pushed slowly across the stage" at Philadelphia's Academy of Music.

RUDOLF SERKIN WAS BORN in 1903 in a German-speaking town of western Bohemia, just across the border from Germany. His father was from Belarus, his mother from Galicia. The Serkins were poor. At the age of nine, Rudi went to Vienna to continue his precocious piano studies. When Serkin's father suffered bankruptcy, the rest of the family followed. Serkin's sister Maltschi later

remembered "a difficult adjustment—in school we were Russian, Jewish, and Czech: enemies, despicable and ridiculous."[3] Not only were Serkin's parents nomadic and uprooted; Rudi overheard his mother confide that his was an unwanted pregnancy.

Serkin's principal Viennese teacher was Arnold Schoenberg, whose austerity, rigor, and ruthless contemporaneity, at odds with Viennese norms, were passionately instilled and received. For the only time in his life, Serkin concentrated on contemporary music. He came to know Schoenberg's colleagues Berg and Webern, like their mentor breaking away from tonality toward uncharted compositional realms—only in 1920 to break with all of them because he could not play their music "with honesty." Schoenberg was unforgiving and Vienna seemed suffocating. There then occurred the watershed event of Serkin's European career: Adolf Busch, the leading German violinist of his generation, needed a pianist; Serkin auditioned; Busch and his wife, Friede, decreed that Serkin would live with them in Berlin.

In the years that followed, Serkin became a surrogate son in a family religiously devoted to music and music-making. He advised Maltschi to listen only to "real music—nothing modern! Bach, Mozart, Beethoven, Schubert."[4] And he plunged into Berlin's heady concert life, as Busch's partner in the violin and piano sonatas of Beethoven, Brahms, and other Germanic masters. On one occasion—a famous anecdote—he played Bach's forty-five-minute *Goldberg* Variations as an encore to a Bach-Mozart evening in which he had triumphed in the Fifth *Brandenburg* Concerto. When the Busches moved to Darmstadt in 1922, then to Basel in 1927, then to the Basel suburb of Riehen in 1931, Serkin moved with them. In 1935, he married Busch's daughter Irene, still three weeks shy of her eighteenth birthday.

By then, the Nazis had taken over. Busch was an artist they might have wished to keep: tall, good-looking, blond (at least in earlier years). At once charismatic and selfless, he was also possessed

of a remarkable capacity for moral revulsion. It was not his half-Jewish wife, or his Jewish-born sonata partner, who turned him against Hitler. On tour in Stuttgart in 1933, he publicly rebuked an audience member for giving the Hitler salute. In Berlin, days later, he witnessed a boycott of Jewish stores and informed his German agent that he had canceled his remaining German concerts. In Riehen, Maltschi Serkin saw him return: "[Adolf's] sense of shame was difficult for an onlooker to witness. We were all in this chaotic mess, without future and facing every imaginable difficulty. We were the persecuted, but he felt responsible. He was ashamed to be a German." When in 1934 Busch and Serkin received a letter from a music publisher signed "Heil Hitler!" they wrote back: "We strongly object to this greeting. We live here in Switzerland, which means that we find this formulation insulting."[5] Their departure from continental Europe became inescapable.

Serkin's American debut was at a chamber music concert with the Busch String Quartet at the Library of Congress in 1933. Three years later, he appeared three times with Toscanini and the New York Philharmonic in Mozart's Piano Concerto in B-flat, K. 595, and Beethoven's Concerto No. 4. It was always Serkin's opinion that these concerts, the last of which was nationally broadcast, made his American career. Sol Hurok signed him for a major tour, including a Carnegie Hall recital. The Serkins and the Busches emigrated to the United States in 1939. Suddenly, the younger man became the more successful and celebrated. By the 1950s, he was giving up to sixty concerts a season, two-thirds of them in the United States. He had joined the American pantheon of great performing artists.

ALFRED GRÜNFELD, THE PIANIST who had whisked Rudi to Vienna, was a Viennese favorite. Claudio Arrau, who studied in Berlin beginning in 1910, remembered Grünfeld with contempt

as an "elegant" pianist and expostulated: "The music world in Vienna was very limited. The people who had success were people like Emil von Sauer. He played Chopin waltzes very nicely. . . . I remember, all the great German pianists had no success. Edwin Fischer—empty houses. Gieseking—empty houses. But Mr. Grünfeld—sold out. . . . *Schnabel* never had an audience in Vienna. And he was Austrian." Serkin remembered Grünfeld's playing more politely as "incredibly beautiful." But of Vienna itself he said that it was "very—how shall I put it—conscious of its own importance."[6]

In fact, notwithstanding the accident of his Bohemian birth in Eger (now Cheb), Serkin was a German pianist to the manner born—and eagerly subject to an early-twentieth-century German backlash against Romantic largesse in composition and interpretation. The initial landmarks included Schoenberg's aphoristic *Pierrot Lunaire*, premiered in Berlin in 1912. A further *Berlinerisch* embodiment, reaching far beyond Schoenberg's spiky Expressionism, was termed *neue Sachlichkeit* (usually translated "New Objectivity"). Discarding perfume and decoration, angst and self-expression, *neue Sachlichkeit* stood for sobriety, neutrality, practicality, self-discipline. Kurt Weill and Paul Hindemith were for a time *neue Sachlichkeit* composers. Otto Klemperer's angular, nononsense Beethoven, schooled in the impersonality of Hindemith, Weill, and Stravinsky, also fit this picture. (Years later, rehearsing Beethoven's *Emperor* Concerto with Claudio Arrau, Klemperer objected to a slow *espressivo* trill—"A trill is a trill!" he growled.)[7] *Neue Sachlichkeit* registered both the fractious intensity of Berlin and its underside: an intense craving for order, for surcease of world war, economic chaos, and social decay. The Mannheim gallery owner Gustav Hartlaub, who in 1925 coined *neue Sachlichkeit*, advocated the expression of a "healthy disillusionment."

The same aesthetic backlash, more moderately pursued, insisted on objectively faithful renderings of musical texts, versus

the subjectively personal readings previously condoned both by composers—Liszt and Wagner are obvious examples—and such leading Germanic conductors and instrumentalists as Arthur Nikisch and Hans von Bülow. In interwar Berlin, Furtwängler was such a musician, for whom a *piano* might be played *forte* at the service of a grand interpretive design, and so was the pianist Edwin Fischer; so had been Busoni. The new order was more embodied by Artur Schnabel, a longtime Berlin resident who labored over Beethoven manuscripts and early printings in pursuit of performing editions "true to the work"—*Werktreue*—and whose interpretive liberties and subjective recesses of feeling, however imaginatively conceived, never violated the letter of the score.

Falling somewhere in between *Werktreue* and *neue Sachlichkeit* on the objectivity scale was Adolf Busch, whose performer's vision was less radically impersonal than Klemperer's but more impersonally restrained than Schnabel's interior Beethoven probes. A Busch or Busch-Serkin Beethoven performance was absolutely free of affectation or superfluous detail. Its taut lines and lean tone served a seething forward energy even (or especially) at the softest dynamics. A devotional purity of intent conferred a moral dimension that seemed "German" to Germans and non-Germans alike. Busch's American fate is informative. He and Toscanini, united in the quest for an objectivist aesthetic of performance, were mutual admirers. But Busch's American debut with Toscanini's New York Philharmonic in 1931 was not the triumph Serkin's Philharmonic debut would be five years later. After immigrating in 1933, Busch secured relatively few bookings. He suffered a severe heart attack in 1940. His wife described him as "broken" by his hatred for Germany. He retained the loyalty of New York's Central European chamber-music audience, but was elsewhere in America forgotten by the time of his death in 1952. In a letter to a friend in Switzerland, he wrote:

Here in this country everything has first of all to be big—they have the biggest houses, the biggest halls, the biggest orchestra (also the best ones), the biggest virtuosos, the biggest audiences for these virtuosos, etc. However since chamber music is always and everywhere intended for a smaller, though cultivated audience, but the programs have been set for decades by managers and virtuosos (with bad taste and lust for the American dollar), the audience has to suffer, and *does* suffer, quite literally, still today.[8]

The musical New World in which Busch was cast adrift was, to be sure, partly conditioned by German émigrés such as himself. But there was also a formidable Russian presence—and Russians, not Germans, defined what a violinist should be. Compared to a Heifetz or Milstein (neither of whom formed enduring duo partnerships of significance), Busch could easily seem a raw and graceless player, devoid of charm or sensuous allure. Crucially, Busch was not a virtuoso. He shunned the repertoire of display. He composed, he led a string quartet, he led his chamber orchestra in Bach. He contradicted the celebrity template.

Serkin, in contrast, arrived in America not as a rooted German, humiliatingly expelled from his homeland, but a practiced nomad. Also, in comparison to Busch, he happened to be the more brilliant executant, who through endless hours of solitary labor had disciplined and strengthened his thick fingers. In Basel, he had struck up a friendship with Vladimir Horowitz, with whom he played piano duets, and through Horowitz had met and played with Sergey Rachmaninoff. Serkin commanded nothing like the wizardry of nuance of a Horowitz or Rachmaninoff, and he was too much the literalist to attempt their interpretive strategies. But in terms of scale, velocity, and energy, he was a high-powered keyboard presence whose muscular American specialties would include Beethoven's *Appassionata* Sonata (of which he left a titanic

non-rubato recording from 1936) and the Brahms D minor Concerto. Like Toscanini, whose performances he admired as "architecture with passion,"[9] he applied a kind of all-purpose intensity to everything he assayed; he revealed the febrile excitation of Mendelssohn with singular authority; he attacked the Chopin études with an authentic fury.

In any event, Serkin in America was able to turn German lineage to his advantage. His wire-rim eyeglasses, balding pate, angular limbs, and worried expression; his bodily contortions, clattering sound, and foot-stomping accents (audible even on recordings), all contributed to an impression of compelling probity. Behind the scenes, Serkin was known to be an incessant practicer and relentless scourge. Tireless in pursuit of *Werktreue*, he traveled with manuscript facsimiles and first editions. To many who knew him, and to others who only saw and heard, he seemed embroiled in rituals of penance. He would speak of his "guilt" and insignificance in relation to the composers he served. His strict adherence to their wishes extended to repeats other pianists ignored. He would not sanction redistributing the big left-hand skips at the beginning of Beethoven's *Hammerklavier* Sonata; "Whenever I miss," he told a colleague, "I say to myself '*es gesicht dir recht* [it serves me right].'" He once expressed shock that Oscar Levant could demean the coda of Beethoven's Fifth Symphony as "fustian." Levant retorted, "What are you so upset about? You're not even related to Beethoven."[10]

These defining convictions also define what Serkin was not. Schnabel, who felt that Serkin lacked "imagination," once advised: "Dear Rudi, you have practiced enough in your life; I think it is about time you start making music and enjoying it."[11] Serkin had an amicable relationship with Schnabel, but was known to despise their contemporary Edwin Fischer. He seems to have had a falling-out with Wilhelm Furtwängler following a Bach violin concerto performance in which he played the keyboard continuo.

Though Serkin may have distanced himself from Fischer and Furt-wängler partly over politics, their approach to interpretation could not have delighted him. Also, Schnabel and Fischer tolerated acres of wrong notes and scrambled passagework in their own playing. Wilhelm Kempff—in Germany itself, the outstanding pianist of the generation after Fischer and Furtwängler—also disdained "excessive" practicing. In Bach, Fischer was Gothic; with his mastery of touch and pedal, he conjured cathedral tones in the Chromatic Fantasy and Fugue. Kempff's Bach was poetically shaded; in the Gigue to the G major French Suite, he gently smeared the gyrating sixteenth notes to simulate an aureole. If too much the literalist to indulge in such blatant sorcery, Schnabel possessed a pronounced individuality of touch and a genius for structural analysis; his readings remained utterly personal. That Furtwängler, Fischer, Kempff, and Schnabel could be controversial interpreters says in a sentence what set them apart from Serkin.

In Germany, Serkin and Busch were a timely purifying influence in a protean cultural community diversified by a range of aesthetic dictates, and traumatized by political passions and socioeconomic chaos. In the United States—where Schnabel mainly (but influentially) taught, and Fischer never performed, and Kempff toured but thrice, and Furtwängler had last appeared in 1927—the literalist Serkin option was received as a governing norm.

IN THE LARGER SCHEME of things German-American, Serkin followed in the footsteps of legions of beaverlike culture-bearers, building their orchestral and choral societies as necessary props to daily life; of the Germania Orchestra and its progeny; of Theodore Thomas's itinerant Thomas Orchestra; of Anton Seidl, Walter Damrosch, and their touring Wagner troupes. Serkin, too, was a prodigious institution builder and institutional leader. His headquarters were three: the Curtis Institute of Music in Philadelphia,

the Leventritt Foundation in New York, and the Marlboro Festival in Vermont.

For Igor Stravinsky, music was about itself and the United States was a haven in which to work. For Serkin, music was an ethical infusion to be administered with responsibility. "In this terrible struggle against those who would destroy everything we cherish most, the artist has a hard time turning his art to account, finding ways to make what he is able to do directly helpful," he wrote to the pianist Abram Chasins after participating without fee in a 1944 concert for war-bond purchasers. "I am truly grateful to you for giving me this chance to feel that perhaps I am not so useless to my adopted country as I feared. When and where may I again do my little bit?"[12] Serkin also donated his services for the benefit of young musicians, for struggling orchestras, and for the presidential candidacy of Adlai Stevenson. This was, for him, a way of giving back: an obligation. Like Thomas, Seidl, and the Damrosches before him, he bore aloft the trophy of German art for the New World. His special contribution was Germanic chamber music: a legacy of Mozart, Beethoven, Schubert, and Brahms; a remembrance of Adolf Busch.

Thomas and Seidl, the orchestras of Boston, New York, and Chicago, had instilled German symphonies and operas. But they had also notably befriended the American composer. Here, Serkin stood apart. At the age of eighteen, having fled Vienna, he had written to Maltschi:

> I believe that with everything that one does, and with everyone with whom one interacts, one has a *genuine* feeling (for me it's only a feeling), which, however, is usually suppressed by something else (prejudice, habit). What is essential is to recognize that feeling and to liberate it from the others. . . . I believe, then, that one shouldn't be afraid of leaving something to which one is usually bound by habit or other minor things.[13]

With this implicit leavetaking of Schoenberg, Webern, and Berg, Serkin asserted a principled prerogative to embrace what he genuinely believed in—and, if need be, nothing else. Certainly he did not embrace the music of Americans. Though he maintained friendly relations with Aaron Copland, Roy Harris, Leon Kirchner, and Roger Sessions, among others, in his long performing career he seems to have played only two American compositions: Edward MacDowell's Second Piano Concerto, with a New York City training orchestra, and Samuel Barber's Sonata, for a government-sponsored tour of Asia in 1949. Even the patriotic call of wartime did not intrude on his fundamental allegiance to the canonized European masters. Every one of his annual Carnegie Hall recitals, over a period of half a century, included music by Beethoven. Schubert was also well represented. His concerto repertoire leaned heavily on Mozart, Beethoven, Schumann, Mendelssohn, and Brahms. Serkin's programs were more catholic than is sometimes supposed. He played a great deal of Chopin. Reger was a special enthusiasm. The twentieth-century works—a short list—included Debussy, Ravel, Rachmaninoff, Martinů, Bartók (the First Piano Concerto), and Prokofiev (the Concerto for the Left Hand).

It is hard to think of another instrumentalist of comparable American impact and renown whose orientation was at all times this Eurocentric. Schnabel equally resisted American music, but his American career was peripheral. Rachmaninoff did not play American works, and Artur Rubinstein's American repertoire was restricted to Gershwin's Second Prelude, but neither did they teach Americans. Jascha Heifetz even played Gershwin. Vladimir Horowitz even played Sousa. Among conductors, it is true, George Szell and Bruno Walter merely dabbled in Americana. But Toscanini, though criticized for ignoring American repertoire, in old age acquired major works by Copland, Gershwin, and Harris with his accustomed thoroughness and conviction. Typically, America's

foreign-born conductors made a point of finding native-born composers they could live with. The aloof Fritz Reiner befriended Gershwin and programmed Richard Rodgers's *Carousel Waltz*. Leopold Stokowski and Serge Koussevitzky were passionate Americans who also championed the new. In truth, Serkin's was a colonizing influence. If this escaped notice, it is because American classical music had since its inception been mainly Germanic. Stokowski and Koussevitzky were the anomalies. Serkin actually fit in better than they did.

An offer to teach at the Curtis Institute was what specifically moved Serkin to America in 1939. He became head of the piano department in 1941, and served as director of Curtis from 1968 to 1976. Of America's leading schools of music, Curtis is the smallest, most selective, and most rarefied. Serkin introduced to Curtis a new emphasis on chamber music and, via his old friend Max Rudolf, on opera. As a piano pedagogue, he brought to the classroom both harshness and warmth in great measure. The Cuban-American virtuoso Jorge Bolet, who also taught at Curtis and was more a product of Russian-American schooling, taunted that he could tell a Serkin-trained pianist from "the first two notes." Some famous keyboard pedagogues—Theodor Leschetizky, who taught both Paderewski and Schnabel, is a famous example—produced pianists of every stripe. Serkin's students tended to embrace their mentor's intensity, literalism, lean sound, and clarity of texture; as a group, they were not notably sensuous or charming players. Serkin's teaching was more notable for rigor than for intellect: he did not analyze harmonic structure or tone production. He embodied an ideal of selfless, ruthless dedication that many found inspirational or otherwise irresistible.

Serkin played a second crucial role in nurturing the careers of young American instrumentalists through the Edgar M. Leventritt Foundation. Rosalie Leventritt kept company with the refugee musicians who had been friends, clients, and chamber music

partners of her late husband, a prominent New York attorney of German-Jewish descent. According to a pianist's wife who knew her well,

> Mrs. Leventritt was a terrific personality, but not in the public eye; she didn't call attention to herself. I think her happiest moment at a concert would be if Rudolf Serkin was playing Schubert's B-flat major Sonata. That was the kind of thing she liked. . . . She was not a socialite; she couldn't have cared less for bridge. And she wasn't one of these wealthy volunteers who get involved with the orchestra, the ballet, or the opera in order to have something to do.

In 1939, Rosalie Leventritt founded a music competition in her husband's memory. Serkin and George Szell were among Mrs. Leventritt's closest friends; she was on the telephone with them constantly. And Serkin and Szell were the core members of the blue-ribbon Leventritt jury, which might also include the conductors Dimitri Mitropoulos and William Steinberg, the violinist Isaac Stern, and the manager Arthur Judson. There were no rules. The jury was not paid. Some years there was an audience, some years not—it did not matter. Contestants, many of whom were already well known to the judges, were to offer "important" solo works and three concertos, of which one had to be by Mozart, Beethoven, or Brahms. Some years the competition was for violinists. Some years there was no competition. Some years there was a competition but no winner. Of the fourteen piano winners, two, Eugene Istomin in 1943 and Anton Kuerti in 1957, were Serkin students—and Serkin scrupulously refrained from taking part in the verdict. Van Cliburn, who won in 1954, was, singularly, a "Russian" pianist whose specialties were Tchaikovsky and Rachmaninoff. Other Leventritt winners included Gary Graffman, John Browning, Malcolm Frager, Joseph Kalichstein, and Alexis

Weissenberg. The eminence and influence of the jurors was such that many winners quickly secured important careers. Though the Leventritt became the single most impressive professional springboard for major American and American-trained piano talents, the 1976 competition was calamitous. The Cliburn competition in Fort Worth and Moscow's Tchaikovsky competition, among others, had captured the public imagination. In an agonizing move, the Leventritt hired a public relations firm and decided to promote itself—a move that backfired when the jury decided that none of the four finalists deserved the prize. There were no further Leventritt competitions.[14]

Serkin's most important, most enduring institutional legacy was (and remains) the Marlboro Festival. In 1945 and 1948 the Serkin and Busch families bought 125 acres in Guilford, in southeast Vermont. The landscape reminded Serkin of the Vienna Woods; for other émigrés, it evoked the Black Forest, or Switzerland, or Sweden. His Vermont homestead included a small farm that Serkin managed as his schedule allowed. (In 1951, the Philadelphia Orchestra presented him with a much publicized red cub tractor onstage at the Academy of Music.) Upon leaving Curtis in 1976, he moved permanently to Vermont. By that time, the summertime Marlboro School of Music was twenty-five years old. It had been founded as "something for Adolf." But with Busch's death Serkin, with no experience in such a role, took over. He once defined Marlboro as "not a camp nor exactly a school, but rather a gathering of professional musicians for the purpose of studying chamber music."[15] The professional musicians were both old and very young. For the former group, mainly European, chamber music was a way of life—not least in the home, where professional and amateur would intermingle. For the latter group, mainly American, it was an intimate and collegial antidote to the pressurized American classical music culture of celebrity orchestras and conductors, violinists and pianists. From the beginning,

scholarships ensured that no gifted youngster would be denied admission for lack of means. The mentors and mentored convened as duos, trios, and quartets; they comprised a single musical community. Performance was not an end but a sometime byproduct of the rehearsal process.

The impact of Marlboro was incalculable. It spawned important American string quartets and important American chamber music festivals. It also acquired a public it did not court. Though some performances continued to take place in the dining hall, a festival concert auditorium was opened in 1962. Even the annual presence of Pablo Casals, beginning in 1960, did not fundamentally disturb an ambience of informality and camaraderie apparent even to the most casual visitor. Far more successfully than the Leventritt competition, the Marlboro Festival managed to share something of itself with an appreciative American public without fracturing the idealism and regimen of high art. (An analogy to the Kirstein/Balanchine New York City Ballet would not be out of place.) Insulated from commercial pressures, the musicians could perform what music they chose.

Naturally, the repertoire of the eighteenth- and nineteenth-century Austro-German masters was centrally pursued, but merely as a beginning. The French flutist Marcel Moyse, a mainstay from year one, exerted a leavening influence. The violinist Felix Galimir, whose Galimir String Quartet had been closely associated with Schoenberg, Berg, and Webern in Vienna, instilled love and knowledge of their music (and himself remained a peerless chamber musician into his seventies). The composer Leon Kirchner, who studied with Schoenberg at UCLA, powerfully assisted in this enterprise as a conductor and coach; he also brought to Marlboro dozens of distinguished visiting composers, including Elliott Carter, Aaron Copland, Luigi Dallapiccolla, Gunther Schuller, and Roger Sessions. The synergy of Marlboro, finally, was a synergy of cultural exchange—of Europe and America.

And Serkin was, assuredly, an American. Upon first returning to Europe in 1947, he wrote home: "When the first excitement of recognition is over, what is left is a terrible homesickness. I feel like an American tourist here . . . I didn't realize how deeply I have already taken root in America." From Milan he wrote: "The hotel is good, but it used to be the Gestapo headquarters, and I don't like the walls that must have seen such terrible things. Everything is knotted up with the past, wherever you look." The Serkins became American citizens not long afterward. Though Serkin spoke German with his wife, English was the common language at home—and Serkin's English, while heavily accented, was grammatically impeccable. His daughter Elizabeth, one of six Serkin children born in the United States, said: "My father loved America. It was liberating, coming to a country where anything was possible."[16]

The egalitarian musical culture of Marlboro seemed to many uniquely possible in America. To a German journalist, Marlboro exemplified "to what extent a pianist from the heart of old Europe had become an American." If Serkin remained a daunting figure of authority, his was not a remote or pretentious authority. With his wife, he regularly attended everyone's concerts—all of them, four times a week. He shunned publicity. When outsiders needed to be invited, apprised, or solicited, he insisted on an understated presentation. In his place, another musician of comparable eminence could easily have become a cult. "The culture of Marlboro," summarize Serkin's biographers Stephen Lehmann and Marion Faber, "was in fact very much like Serkin himself, a man whose contradictory nature was both elitist and egalitarian, exclusive and inclusive, demanding and generous, controlling and liberating."[17]

The original Marlboro design called for an even more democratic approach: as with Hausmusik in the Old World, the participants were to include amateurs and professionals both. According to Arnold Steinhardt of the Guarneri String Quartet—Marlboro-born

in 1964—even in the 1960s at Marlboro "there were people who were incredible and there were people who were not so good. Nowadays, 'not so good' doesn't do it. People are so anxious to go there that unless you're at the very highest rung of the ladder your chances are nil, forget it. . . . Maybe the performances aren't as spirited, or spirited in a different way, but it's changed. And if it goes on for another decade it will change: it's just inevitable." Steinhardt added:

> But certainly when I was there I had the feeling that it was bathed in a golden light. It was the most amazing, amazing experience. Part of it was a product of my own age: I was in my twenties and in a way I was like an empty blackboard just ready to be written on. There were so many experiences that were meaningful. Learning all that repertoire, most of it for the very first time, and acquiring all those ideas for the very first time from people like Serkin and Moyse and Sasha [Alexander] Schneider, Felix Galimir, these people who were my mentors. It was a great, great experience for me, and I think for many others.[18]

AFTER SERKIN'S DEATH IN 1991, the artistic direction of Marlboro passed to the pianists Richard Goode and Mitsuko Uchida. Goode studied with Serkin at Curtis. Uchida is Japanese and European-trained. Both are widely admired in the Austro-German repertoire. If neither commands Serkin's prestige in the wider world of music, it is partly because American classical music is so much more marginalized than when Marlboro was founded more than half a century ago. Its long dependency on Old World parents, a dependency further prolonged by the twentieth-century immigration of countless eminent European conductors, instrumentalists, and composers (it is estimated that 1,500 musicians en-

tered the United States from Europe between 1933 and 1944),[19] sustained a parochial neglect of native possibilities. Today, at the turn of the twenty-first century, it is newly apparent that the creative side of America's musical high culture is singularly nourished by non-European sources: the music of Africa and Asia; the popular songs and dances of the United States itself. The most significant contemporary American composers—John Adams, Steve Reich, Philip Glass, William Bolcom, the late Lou Harrison, with their roots in gamelan, raga, and African drumming; in swing, rock, and Cole Porter—do not even clearly qualify as "classical musicians." Their lineage begins less with Bach and Beethoven than with pioneer Americans like Louis Moreau Gottschalk, Charles Ives, and Henry Cowell; or Scott Joplin and George Gershwin. From this lineage, moreover, there emerges a vibrant piano repertoire, deeply inflected by slave song, and ranging from Gottschalk's *Banjo* and Joplin's *Maple Leaf Rag* to the Transcendental profundities of Ives's *Concord* Sonata and the jagged urban rhythms of Aaron Copland's Piano Variations.

This new world of American classical music has mainly been cultivated outside the Eurocentric bastions of symphony and opera. The alternative venues have been spaces associated with visual art, theater, or dance. To reconnect with George Balanchine's world of music, at this juncture in our narrative, is to take a cold shower after a long slumber. Gottschalk, Ives, and Gershwin are all there, alongside Bach and Mozart, Brahms and Tchaikovsky, Webern and Stravinsky. Balanchine's individual progeny—an Edward Villella or Jacques D'Amboise, Suzanne Farrell or Merrill Ashley—are not remotely ersatz French or Russian artists. A comparably "American" classical musician might be Leonard Bernstein—a product of Serkin's Curtis Institute (where he studied not with Serkin but with Isabella Vengerova and Fritz Reiner), but also of Broadway, which he adored, of Dimitri Mitropoulos, whose passion for Mahler he imbibed, and of Serge Koussevitzky and the Tanglewood Festival.

If the Tanglewood of Koussevitzky's day, in perpetual quest of the Great American Symphony, was the antithesis of Serkin's Marlboro, the closest thing to Marlboro in Europe is even more antithetical. Gidon Kremer's Lockenhaus, nestled in the mountains of Austria, is a chamber music festival in which venerable sages rub shoulders with adventurous young talents. A wide range of contemporary music, discerningly selected, is a missionary priority. The essential tone of the place is frequently and even boisterously irreverent—a sign of ripeness. Kremer's onetime attempt to settle in the United States was as abortive as would have been his abrasive, demonic Schubert renditions in Vermont. A product of Russian training in a period when such living composers as Shostakovich and Schnittke remained paramount, he is an artist whose acute sensitivity to contemporary aesthetic currents informs all he touches—as was once the case with Otto Klemperer in Serkin's Berlin.

These critical perspectives on Marlboro, informed by hindsight, must be balanced by another, on the opposite flank, in the person of Serkin's closest conductor colleague: George Szell. Serkin appeared as soloist with Szell's Cleveland Orchestra forty-nine times, usually in music by Mozart, Beethoven, and Brahms. Szell was reportedly the most influential of the Leventritt jurors. He studied with Serkin's first teacher in Vienna, Richard Robert. Like Serkin, he was later based in Berlin. Espousing *Werktreue*, he rejected the legacy of Arthur Nikisch and Wilhelm Furtwängler as subjective "to the point of artbitrariness (and/or distortion)." His goal was to combine the objectivity and clarity attained by Toscanini (whose New York Philharmonic he heard on tour in Europe in 1930) with the interpretive authority conferred by Germanic tradition. His organizational gift was dictatorial and shrewd. In Cleveland, from 1946 to 1970, he secured a larger roster and a new stage setting. He annually supervised firings and hirings, and personally negotiated all players' salaries above minimum scale. He

demanded that hair be cut and beards shaved, that socks extend over the calf, that coats and ties be worn on tour. He specified what brand of toilet paper be installed in the Severance Hall bathrooms. And—unlike Furtwängler in New York or Klemperer in Los Angeles, who were inept dinner guests, or Fritz Reiner in Chicago, who disdained social responsibilities—he ingratiated himself with the orchestra's trustees.

For his thick spectacles and control mania, the Cleveland musicians called him "Dr. Cyclops." "He spelled out everything in millimeters and micrograms," according to Daniel Majeske, his concertmaster from 1969. "He certainly could have been a pharmacist." Szell himself said of his drilled nuances: "We calculate the inspiration." He boasted to Artur Rubinstein: "The Orchestra is really TOPS. I mean it and, as you know, I am not in the habit of kidding myself." He once wrote to the musicians (rebuking them for their latest contract demands): "I don't recall a relationship of a conductor and an orchestra in the 50 or 60 years I can remember that could have competed with this." He claimed to have achieved a "chamber music" approach to performance, perfected in flexibility, balance, and ensemble. Like Balanchine with his dancers, he treated his Cleveland ensemble as a tabula rasa on which to inscribe a new template. But what Balanchine inscribed was genuinely new; Szell was reteaching Beethoven to players who had known Beethoven all their lives.

Furtwängler once plausibly likened the relationship of conductor to orchestra to a rider interacting with an intelligent horse. Szell whipped his horse into abject submission. In its time, the horse was a winner: the Cleveland Orchestra's pedigree, at home and abroad, was special. Reencountered today, on studio and broadcast recordings, Szell's American orchestra sounds overtrained, overrehearsed, and overconducted. The many niceties of execution are more programmed than spontaneous. The "chamber music" is commandeered, not egalitarian. Szell once quipped

that he could "lower his pants" on the New York Philharmonic podium and "nobody would notice." He also argued that Hans von Bülow, with his famous Meiningen Orchestra, could achieve standards unthinkable in cosmopolitan Berlin. In fact, no New York or Berlin orchestra would have tolerated Szell's brand of patronizing tyranny. He only rarely conducted important American music—Ives's *Unanswered Question*, the Barber Violin Concerto, Schuman's Third Symphony, some Copland—in Cleveland.[20]

To return, once more, to Rudolf Serkin is to appreciate an entirely different style of cultural colonialism. There was nothing of the smug viceroy in Serkin, subjugating the natives in the service of higher truths. His unstable childhood, write Lehmann and Faber in their biography, produced "a restless and inwardly rootless man" who invested music—"the one stable point in his life"—with "almost divine attributes." Those who best knew him gleaned a man so fundamentally reclusive that music "was probably his only real company"; one friend called him "a wanderer in the desert." He confided at the end of World War II that he "came close to having a nervous breakdown, and only music, work, and my family prevented it." Lehmann and Faber infer a tendency "to deflect aggression in work, or express it covertly, or to transform it in his art."[21] Serkin fully inhabited the fury of his signature concerto, the Brahms D minor (and even Bach, Mozart, and Schubert never smiled as he purveyed them). Such an artist, for whom music served urgent personal needs, was never intended to be its prophet in the New World; this responsibility chose him, not—as with George Balanchine—the other way round. He dispatched it to the best of his ability, fortified by remembrance of Adolf Busch. He was too much immersed in the past, and the requirements and aspirations it dictated, to peer into the future, even had he tried.

ARTISTS IN EXILE

WHEN ARTURO TOSCANINI LEFT the New York Philharmonic in 1936, he nominated as his successor his one true rival in authority and prestige: Wilhelm Furtwängler. And Furtwängler, who had frequently conducted the Philharmonic before Toscanini displaced him, was duly engaged. Boycotts and mass cancellations of subscriptions were threatened. Furtwängler withdrew by cable: "Political controversy disagreeable to me. Am not politician but exponent of German music which belongs to all humanity regardless of politics." *Time* reported: "Nazi Stays Home."

Furtwängler was no Nazi, yet served Germany at Hitler's pleasure: in retrospect, his Philharmonic appointment was impossibly ill-timed: all parties to this attempt were naive.★ Toscanini next recommended Fritz Busch—Adolf's brother, who had headed the Dresden Opera before exiting Germany in 1933. But even German exiles now seemed tainted. Walter Price of the Philharmonic board wrote to Toscanini that with Jews comprising "the largest part" of the orchestra's audience, a German music director remained out of the question "until the resentment of the Jewish people subsides against anything apparently German."

Arthur Judson, the all-powerful Philharmonic manager, supplied the board with a short list of the "most important conductors

★To Toscanini and others, the New York Philharmonic offer seemed an opportunity for Furtwängler to "rescue" himself from Hitler's Germany. What meaning the offer had for Furtwängler is hard to say. His previous Philharmonic experiences, from 1925 to 1927, had not been happy. Olin Downes, of the *New York Times,* far preferred Toscanini. Downes had been puzzled by Furtwängler's conducting; he found it mannered and exaggerated. Versus the "objectivity"—an international standard—variously espoused by Toscanini, Klemperer, and Serkin, Furtwängler remained fused with Germanic traditions: steeped in the past, his way of making music was fundamentally elegiac or religious; it utterly resisted modernism. After the war, further American opportunities—he was offered the music directorship of the Chicago Symphony; Rudolf Bing wanted him at the Met—were again canceled by political opposition. In retrospect, it is obvious that whatever one makes of his brand of cultural nationalism, Furtwängler was neither a Nazi nor an anti-Semite. The German conductor Heinz Unger, who resettled in London in 1933, later wrote:

of Europe and America with some indication of their availability."
He further wrote:

> In giving consideration to this list, I think it would be
> well to bear in mind our recent difficulties and to weigh
> carefully whether it would be advisable, or even possible,
> to import either an Aryan German or a Jewish conductor.
> In case we brought over the former, it is almost absolutely
> certain that we would run into the same difficulties as
> with Furtwängler. Should we try the latter, I do not think
> we will have a public boycott but I do expect that we will
> alienate the support of an appreciable number of impor-
> tant members of this community.

Judson then proposed that for 1936–1937 Fritz Reiner be assigned
ten or twelve weeks and Artur Rodzinski eight weeks, with guests
for the intervening four of six weeks. Reiner, he added, was "50%

Furtwängler knew that he was likely to be welcomed everywhere in
the world, if he should decide to turn his back on Germany. . . . But—
would he be understood? Understood in the way he wanted to be
understood? All his roots were in German music; leaving Germany
would set him adrift. Not that he would not continue to serve that
art to which he was most closely and most naturally bound; but
would *his* way of playing music go to the hearts of his listeners in the
same way as it did in Germany? Who outside Central Europe would
realize or appreciate the difference between the message of
Beethoven's Ninth Symphony as he felt it and—let us say—Toscani-
ni's Beethoven? No, he needed his German audiences and orches-
tral players as much as they needed him, more than ever, in fact, in
those dark years; and so he stayed within the community into
which he had been born.

 The Nazis used Furtwängler but mistrusted him; in January 1945 he fled to
Switzerland to avoid arrest by the Gestapo. Yehudi Menuhin, who played with
Furtwängler after the war, likened Furtwängler's chosen wartime fate to "a kind
of living suicide." Versus "artists in exile," Furtwängler embodies the condition of
those who felt they could not leave—artists for whom cultural exchange seemed
not an option. (See Joseph Horowitz, *Understanding Toscanini* [1987], pp. 94–98,
146–148, 317–320.)

ARTISTS IN EXILE

Jewish" and Rodzinski "25% Jewish." The "guests" he recommended included John Barbirolli, Otto Klemperer, Dimitri Mitropoulos, and Bruno Walter, all of whom would figure significantly in the Philharmonic's future. An additional list of conductors Judson felt did not "fit" the orchestra's plans included Fritz Busch and Erich Kleiber. Though Judson did not say so, it was appreciated that both Reiner and Rodzinski enjoyed established American careers. Reiner, born in Budapest, had worked in Budapest and Dresden before taking over the Cincinnati Symphony (1922–1931) and teaching conducting at Curtis. Rodzinski, born in Dalmatia, had led the Los Angeles Philharmonic (1929–1933) before moving to the Cleveland Orchestra in 1933. But the board passed over both in favor of a conductor neither Jewish not Central European: the thirty-six-year-old Englishman Barbirolli.[22]

Barbirolli was a failure in New York; his eventual successor was Rodzinski. Reiner wound up in Pittsburgh, then in Chicago, where beginning in 1953 he autocratically honed an instrument comparable in finish and virtuosity to Szell's Cleveland Orchestra. Toward his players, he was tyrannically aloof, with none of Szell's wheedling and boasting: his show of superiority was personal, not cultural. Eugene Ormandy, a Hungarian, was music director in Minneapolis (1931–1936) and Philadelphia (1936–1980). William Steinberg, a Cologne native whom the Nazis removed from the Frankfurt Opera, was music director in Buffalo (1945–1952), Pittsburgh (1952–1976), and Boston (1969–1972). Erich Leinsdorf, a Viennese, was music director in Cleveland (1943), Rochester (1947–1956), and Boston (1962–1969). By comparison, the Central European conductors most established in Central Europe itself when Hitler came to power were greatly disadvantaged in the United States. Fritz Busch spent the war years in Buenos Aires. We have already noted the disappointing American careers of the four Berlin conductors photographed with Toscanini in 1930: Furtwängler, Kleiber, Walter, and Klemperer, each a greater name

in Europe than Reiner, Rodzinski, Ormandy, Steinberg, or Leinsdorf.

That Klemperer and Walter were Jewish-born was less decisive than that they were German-born. Before 1915 American orchestras had been Germanic, and so had been their conductors—Theodore Thomas, Leopold Damrosch, Anton Seidl, and Gustav Mahler in New York; Wilhelm Gericke, Arthur Nikisch, and Karl Muck in Boston; Thomas and Frederick Stock in Chicago. World War I turned German culture-bearers into agents of an insidious, exogenous *Kultur*; Muck, notoriously, was interned as an enemy alien. America's conductors of choice were now Toscanini, Leopold Stokowski, and Serge Koussevitzky. Less than two decades later the Nazi menace redoubled Germanophobia in American musical circles. Germans like Furtwängler and Walter in any case were not objectivists in the Toscanini mold. And Kleiber and Klemperer were activists for the new and recent— and, in America, unpopular—music of Berg, Hindemith, Janáček, Krenek, Mahler, Schoenberg, Stravinsky, and Weill, all of which figured prominently in the New York Philharmonic programs they offered between 1930 and 1936.

The case of Klemperer singularly illustrates the hostile second homeland the United States could seem to eminent and well-intentioned musical newcomers. As conductor of Berlin's Kroll Opera from 1917 to 1931, he had been the performing musician who most symbolized progressive Weimar culture. The Kroll influentially championed Stravinsky's *Oedipus Rex*, Janáček's *From the House of the Dead*, Schoenberg's *Erwartung*, Hindemith's *Cardillac*. Klemperer overthrew naturalistic stage conventions; his designers included László Moholy-Nagy. His stripped presentation of Wagner's *Flying Dutchman* was denounced as "Bolshevist." The Kroll was a subversive, "anti-Christian" cause. Thomas Mann credited it with restoring opera as "a subject of intellectual discussion." Three decades later, with the passing of Furtwängler and Tosca-

nini, Klemperer would become the most lionized exponent of the German classics in Europe. The nadir of his implausible career occurred in the United States. As conductor of the Los Angeles Philharmonic (1933–1939), he endured an auditorium in which Baptist hymns were audible from an adjoining church. He led Easter Sunrise Services at Forest Lawn Memorial Park. He conducted student concerts for which he wrote and delivered commentaries in English. He was not unappreciated, yet earnestly desired the New York and Philadelphia podiums awarded to Barbirolli and Ormandy. He was a more important conductor than they were, but willfully independent. His eschewal of personal glamour and musical sheen was no oversight but a statement of principle. He rightfully regarded the Barbirolli appointment, in particular, as an affront to his stature and reputation. In a letter of rage and resentment unique in his career, he wrote to Judson:

> You made it clear to me in different letters, that you wished to establish for me a *permanent* situation in New York. . . . Because I was convinced that the situation would become for me a permanent one as musical director, that the society did not reengage me is the strongest *offence* [sic], the sharpest *insult* to me as artist, which I can imagine. You see, I am no youngster. I have a name and a good name. One could not use me in a most difficult season and then expell [sic] me. This non-reengagement will have its very bad results not only for me in New York but in the *whole world*. . . . This non-reengagement is an absolutely unjustified *wrong* done to me by the Philharmonic Symphony Society.

Four years later, a huge tumor was removed from Klemperer's brain, leaving the right side of his face and body partly paralyzed. He had at all times been a formidably ungainly presence, physically and temperamentally. He now wore an eyepatch, ate

irregularly, and walked unsteadily with a stick. In 1941 he agreed to enter what he did not realize was a mental institution in Rye, New York. When he angrily left, the police were informed. The *New York Times* ran a front page story headlined: "Klemperer Gone: Sought as Insane." His American citizenship, obtained in 1940, proved a liability: apprised of his leftist sympathies, the State Department refused to renew his passport in 1947. He was rescued by London's Philharmonia Orchestra, which rediscovered in him a conductor of genius, and the West German government, which redesignated him a German citizen. He afterward returned to the United States once, in 1962, to lead the Philadelphia Orchestra. Late in life, he was asked: "Do you think there is a connection between great gifts and great suffering?" He reached for his Bible and read from Ecclesiastes: "For in much wisdom is much grief; and he that increaseth knowledge increases grief."

And yet, of the conductors on Judson's list, it was Dimitri Mitropoulos who in the United States fell the furthest: an American tragedy that reads like a Thomas Mann novella. Born in an obscure Greek village to a family of monks and priests, he spent his formative years as a musician in 1920s Berlin, where he affixed himself to Busoni. He attained sudden celebrity in 1930, conducting the Berlin Philharmonic in Prokofiev's Third Piano Concerto from the keyboard. Seven years later, he became music director of the Minneapolis Symphony, which he proceeded to reinvent. Like Klemperer, he rejected the Romantic cathedral sonority of recessed winds and percussion supporting a warm blanket of strings; more than Klemperer, he was a full-blown Expressionist, a Dr. Caligari of the podium, clawing the air with huge hands, clenching his anchorite features into a demonic gargoyle. In Mendelssohn and Dvořák he discovered the same jagged outlines and slashing accents as in Mahler, Berg, and Schoenberg. He spent the summer of 1943 as a full-time Red Cross "blood custodian." He

told his Minnesota audience to support Henry Wallace's leftist third-party presidential candidacy in 1948. He guest-conducted the Boston Symphony and Philadelphia Orchestra with such electrifying results that the New York Philharmonic chose him, in 1949, to end its years of post-Toscanini disarray and drift. His private correspondence discloses a pronounced streak of religious masochism; on this occasion, he confided to a colleague, "I am probably going to my doom." The Philharmonic needed discipline; Mitropoulos supplied challenging programs and "obeisance full of love." He ate in Beefburger Hall and refused to act the maestro. When in 1950 he assayed Webern's atonal Op. 21 Symphony, the Philharmonic's harpist flung his part at Mitropoulos's feet and bolted offstage. Two years later, Mitropoulos suffered a heart attack. Four years after that, he was undone by the chief music critic of the *New York Times* under a headline reading: "The Philharmonic—What's Wrong with It and Why"; the orchestra's principal violist supplied ammunition for this attack. Mitropoulos was eased out of his job beginning the following fall. He was on the cusp of a resurgent European career—in parallel with Klemperer's—when he died of a second heart attack, an old man at sixty-four.

Klemperer and Mitropoulos revered in common the example of Gustav Mahler, whose symphonies and musical ideas they championed, and whose own American career had also proved humiliating. Like Mahler, they were not manicured personalities: Klemperer would upset his coffee at receptions; Mitropoulos refused to conceal his homosexuality by taking a wife. Like Mahler, Klemperer and Mitropoulos were read in America as "intellectuals," the one a product of the Berlin avant-garde, the other partial to dog-eared volumes of Kierkegaard carried in a rucksack. Like Mahler, they embodied a beleaguered moral intelligence, scarred by twentieth-century adversities. As I have elsewhere written of these exiles in kind:

Mahler's understanding of tragedy as endemic to human-kind—an understanding that permeates his music even (or especially) when it scales the heights—was Klemperer's understanding and that of Mitropoulos; it underlies the discomfort they experienced in America. Klemperer fled Berlin and the Nazis. For Mitropoulos, Athens seemed (as Vienna seemed to Mahler) corrupt and inbred; even his mother's death in 1941 did not draw him back. A transcendental condition of worldliness and suffering was for Klemperer and Mitropoulos, as for Mahler, a tragic yet indispensable European condition. They were fatalists at odds with American smiles and "can do" optimism, with the enterprise of perfectability.

They were not technocrats after the fashion of Szell and Reiner. They could never have superintended a music festival in rural Vermont. The sensualists Stokowski and Koussevitzky, the ferocious Toscanini—all subjects of a later chapter—remained strangers to the world of existential strife that Klemperer and Mitropoulos endured. Their efforts to fit in—to find common ground with American audiences and composers—were pathetically conscientious, ultimately futile.[23]

UPON SETTLING IN NEW YORK in 1929, Vladimir Dukelsky, the Russian-born composer eventually known to Americans as Vernon Duke, realized that his recent successes in France and England meant nothing in the United States. He had

come to the painful realization that the composer, the man who supplies the very stuff without which music-making would be a physical impossibility, was indeed the Forgotten Man, the pariah of the music world which he alone created. The *Maitre* of France, the *Maestro Compositore* of Italy became [in the United States] little more than

a woefully underpaid handy errand boy of the Almighty Interpreter, the virtuoso, the prima donna, the star—the trusty meal tickets of thriving concert managers.[24]

That Klemperer and Mitropoulos both composed bears on their estrangement from the American culture of performance. With Dvořák's return to Prague in 1895, no composer was ever again the most famous and influential classical musician in the United States. Even a wave of musical nationalism cresting in the 1930s and '40s produced no American classical composers—not Aaron Copland, not Roy Harris—as celebrated as the foreign-born maestros, instrumentalists, and singers dominating American orchestras, concert halls, and opera houses. As for Dukelsky and other foreign-born composers new to the United States, they bitterly understood that the German creative pantheon, beginning with Bach and ending with Richard Strauss, enjoyed a central significance not even a Stravinsky could hope for in the New World. What is more, America's own composers were welcoming but wary toward these sudden new colleagues disembarking in droves. For one thing, European styles were uncomfortably more "advanced" than the American norm. For another, the newcomers would inevitably compete for what limited attention living composers could expect alongside the dead masters Americans revered. Howard Hanson, director of the Eastman School, warned in a 1941 *New York Times* article: "We must not solve the problem of providing opportunities for our foreign guests by curtailing the already meager opportunities for the young American. There is some evidence that exactly this situation is occurring."[25]

Hanson's own music had acquired a niche in the American repertoire beyond its modest merits; to European ears, its simplicities were banal. Ernst Krenek, whose music had been much performed in Central Europe, minced no words in assaying

"America's Influence on its Émigré Composers" two decades after his own emigration in 1959:

> In keeping with the American tradition, the emigrant composers, as victims of oppression, were received with open arms and given warm assurances of readiness to help. But even without their being told so directly, they could feel that in regard to the professional situation people would have been happier had they not been forced to come. Thus the immigrant was pushed, from the outset, into a certain defensive attitude that was hardly conducive to a far-ranging, adventurous creative spirit. . . . There is little doubt that America has sharpened the sense of reality of the European composers who came to its shores. Yet at the same time it seems to have made them neglect what Robert Musil set up as a contrasting sense, the "sense of possibility."

Krenek listed himself, Schoenberg, Bartók, and Kurt Weill as composers who in America cultivated "modes of writing conditioned by their surroundings," risking an "unethical compromise" in pursuit—conscious or not—of greater "comprehensibility." Only renewed contact with Europe after World War II, he maintained, had ameliorated this baneful loss of nerve. "Yes, the land of unlimited possibilities taught us to be more attentive to reality. Yet it was reserved for the old continent of limited reality to awake in us anew the desire for the impossible."[26]

A native Viennese, Krenek had in 1926 composed the phenomenally popular "jazz opera" *Jonny spielt auf,* given in more than 100 cities and translated into eighteen languages. The Nazis denounced him as a "nigger" and (though he was Roman Catholic) a "Jew." In the United States, he found a teaching job at Vassar College. As he confided to his diary, he was there almost unbearably depressed: "I am so completely terrorized by the insecurity of

my future that I am in a state of real despair. . . . I have the terrible feeling that all the 'right' people agree definitely that I am not good at anything they care for." Krenek lost his job at Vassar and wound up at Hamline University in St. Paul—where he found a local ally in Mitropoulos. He eventually languished in obscurity in Palm Springs, California. At the age of ninety, in 1990, he was invited to describe his "feelings about America." He responded: "Well, you could say I'm ambivalent. Because there are lots of things here which I don't approve of, which I don't like. Of course, in Europe I'm not at home anymore, either. I've waited too long. Things have changed. I don't belong there. I don't know the people." Asked "What do you like about the United States?" he could find no words.[27]

Other eminent composers from Germany and former Hapsburg lands were in many cases no better off. Hanns Eisler, a one-time Schoenberg disciple who in Hollywood assisted Charlie Chaplin, was deported in 1948 for his politics. Paul Dessau, like Eisler a leftist artist, made do as an obscure Warner Brothers composer before in 1948 resuming his partnership with Bertolt Brecht in Berlin. Jaromir Weinberger, who achieved sudden fame with his opera *Schwanda* (1927), in America composed a *Lincoln* Symphony in a burst of patriotic enthusiasm; he died a suicide in Florida in 1967. Alexander von Zemlinsky, in Europe closely associated with Schoenberg and Klemperer, died in 1942 following five years of American anonymity. Ernst von Dohnányi, a lordly presence in Budapest, taught at Florida State University. Ernst Toch, greatly admired by his fellow émigrés, was otherwise ignored except for his Hollywood film music. Stefan Wolpe, though greatly influenced by progressive jazz, only achieved renown within a coterie of students and colleagues. Bohuslav Martinů's American circle of advocates included prominent orchestras and conductors; his American sojourn was a mainly ephemeral interlude in a career always peripatetic.

Of all the immigrant composers from Central Europe, Schoenberg, Hindemith, and Bartók commanded the biggest reputations. These three could not, like Stravinsky, support themselves in the United States as freelancers, earning a living through commissions, royalties, and performing engagements. They had never composed music as popular among Americans as *The Firebird*, *Petrushka*, or *The Rite of Spring*. They did not enjoy the mediating services of a Balanchine. Though they were not outsiders to the degree Krenek was and felt himself to be, neither were they significant practitioners of cultural exchange. Rather, they embody three varieties of cultural estrangement.

Schoenberg, the first to arrive, was dismissed by the Nazis from his Berlin professorship in 1933. He returned to Judaism and emigrated to America the same year. The southern California climate suited his delicate health. He taught at UCLA until he was compelled by university statutes to retire in 1944 upon turning seventy. With a wife and three children to support, and a monthly pension of $29.60, he applied for a Guggenheim Foundation fellowship and, notoriously, was turned down. He died, an American citizen, in Los Angeles in 1951. His staunch American allies—mainly immigrants—included Carl Engel, his publisher at G. Schirmer, and Rudolf Kolisch, whose Kolisch and Pro Arte quartets kept the flame for Schoenberg, Berg, Webern, and Bartók in the United States. The Los Angeles "roof concerts" of Frances Mullen and Peter Yates featured nine all-Schoenberg programs between 1939 and 1954. Schoenberg held in contempt the conductors of the major American orchestras with few exceptions, most notably Reiner, who performed only three Schoenberg works, Mitropoulos, whom he barely knew, and Klemperer, with whom he often feuded (and to whom he inimitably wrote in 1940: "The fact that you have become estranged from my music has not caused me to feel insulted, though it has certainly estranged me"). Stokowski, who more prominently championed him than any

other conductor in the United States, was not even an acquaintance.

Schoenberg Anglicized his name (which had been Schönberg), adapted English as his primary language, watched *The Lone Ranger* and *Hopalong Cassidy* on TV, and for his children prepared peanut-butter-and-jelly sandwiches cut into animal shapes. He was both warmhearted and abrasive, quick to pledge help and to take offense. He counseled his Austrian son-in-law: "Here they go in for much more politeness than we do. Above all, one never makes a scene; one never contradicts; one never says: 'to be quite honest,' but if one does, one takes good care not really to be so." Of his American exile, he once wrote that he "came from one country into another, where neither dust nor better food is rationed and where I am allowed to go on my feet, where my head can be erect, where kindness and cheerfulness is dominating, and where to live is a joy and to be an expatriate of another country is the grace of God. . . . I was driven into paradise." He also wrote, to Kolisch: "Fundamentally I agree with your analysis of musical life here. It really is a fact that the public lets its leaders drive it unresistingly into their commercial racket and doesn't do a thing to take the leadership out of their hands and force them to do their job on other principles." And, to Oskar Kokoschka:

> You complain of lack of culture in this amusement-arcade world. I wonder what you'd say to the world in which I nearly die of disgust. I don't only mean the "movies." Here is an advertisement by way of example: there's a picture of a man who has run over a child, which is lying dead in front of his car. He clutches his head in despair, but not to saying anything like: "My god, what have I done!" For there is a caption saying: "Sorry, now it is too late to worry—take out your policy at the XX Insurance Company in time."

Schoenberg denounced the "boundless surfeit of music" on the radio as evidence that "things will always find a way of getting worse somehow." He was approached to compose for films but, as he informed Alma Mahler-Werfel, "fortunately asked $150,000, which, likewise fortunately, was much too much, for it would have been the end of me." Schoenberg did not disdain the new medium, but his expectations were unrealistic: he wanted to take control of dialogue and music in tandem. A supreme pedagogue, he considered his awed UCLA students ill-prepared but passionately enjoyed teaching them. His private students included Hugo Friedhofer, Alfred Newman, David Raksin, Leonard Rosenman, and Franz Waxman—all leading film composers. (It was Newman who initiated the Kolisch Quartet recordings of the four Schoenberg string quartets.) His ferocious reputation was supported by scowling photographs evoking Boris Karloff in suit and tie, and belied by Ping-Pong and tennis matches with George Gershwin, among other neighbors. His music, little heard or known, was box office poison.[28]

Hindemith, by comparison, was an ivory-tower exile who minded his own business. As a non-Jewish non-Nazi, he had responded to the Third Reich less decisively than Adolf Busch. Like Busch, he had family connections with Jews; unlike Busch, he sought to satisfy the new government that he was "neither a half nor any other fraction Jewish." Privately, he did not conceal his distaste for Hitler from his Jewish students at the Berlin Hochschule für Musik. When the Nazi press denounced him, Furtwängler came to his defense—which united the Nazis against Hindemith and Furtwängler both. In September 1938—four months after the "Entartete Musik" exhibition in Düsseldorf prominently featured Hindemith's "degenerate" books and scores—he relocated to Switzerland. When Switzerland seemed threatened, he embarked on an extended 1939 visit to the United States. As he had recently been impressed by Walt Disney's feature-length cartoon *Snow White and*

the Seven Dwarfs, he toured the Disney studios but found the artists "so tightly regulated that it makes you ill. . . . They draw only Mickey Mouse and Donald Duck." He further wrote to his wife:

> I spoke with the great music god Stokowski and had the feeling that in spite of his friendliness he was very insecure and did not particularly like my being there. When I saw what kind of trash he was making and that he was wearing an ultramarine blue silk shirt and a lemon-yellow cravat with his albino-like face I really could not muster up the proper feeling of awe. . . . Here are all the means at hand for a great film art and you have a scoundrel like [Disney] ruining everything.

In another letter to his wife, Hindemith appraised Los Angeles:

> One can hardly speak of a musical life in this gigantic town apart from the movies. There isn't even a proper music school. Klemperer conducts the orchestra, but that stands as isolated as the famous tree in the Odenwald. There is no sort of musically educated society . . . , apart from the usual baggage-train of fat old women, board of trustees and the rest. I feel quite unwell when (as I repeatedly saw) a dolled up lump of flesh stands in front of the orchestra and deals with duties, wages and artistic matters. . . . Schoenberg teaches harmony to beginners at the university (serves him right!), and for the rest all the one-time bigheads fumble around like a city music director in Kyritz an der Knatter.★

In 1940, Hindemith abandoned Switzerland for a professorship at Yale, where he worked systematically—one might also say,

★Kyritz an der Knatter is a small town celebrated as the epitome of provincialism. The "famous tree" is from the folksong "Es steht ein Baum im Odenwald."

Germanically—to raise standards and expectations. Outside of Klemperer, whose interest in Hindemith began to wane, the prominent conductors who performed his music in the United States were not personal friends—as Furtwängler, Hermann Scherchen, Paul Sacher, and Hans Rosbaud had been in Europe. But his fourteen American commissions were the highest such total for any composer, native or immigrant, during the years of his Yale appointment. Hindemith's Yale Collegium Musicum was a pioneering American early-music ensemble, and his influence as a teacher and practitioner of composition was substantial. In 1946, having composed a major Walt Whitman setting for Robert Shaw—Whitman's requiem eulogy for Abraham Lincoln, here standing in for FDR—Hindemith impatiently resisted overtures to return to Germany:

> Everybody seems to know exactly what I ought to do now. The musical needs of Germany at the moment are all that matters and they must be tended to at once! It never seems to occur to any of them that perspectives change, that people who have been thrown out are neither willing nor capable of building up a new life for themselves every few years, that there might be things to do other than trying to rebuild a ruined musical culture.

Hindemith took American citizenship the same year. A 1948–1949 European visit, however, shifted his gaze. He moved back to Switzerland in 1953. Looking back, he observed, "Nobody ever bothered to call me an American musician. I always remained for them a foreigner." Even his Whitman requiem achieved a European success it had not enjoyed in the United States, where at all times Hindemith was more esteemed than popular. He died in Frankfurt in 1963.[29]

Béla Bartók's American exile has typically been written off

as a martyrdom. On his first visit to the United States, a 1927–1928 concert tour as a pianist, he received a standing ovation upon taking the stage of Carnegie Hall. Participating in the American premiere of his First Piano Concerto, he found Reiner's Cincinnati Symphony more precise and assured in this difficult music than orchestras in Budapest and Berlin had been. He expressed admiration for jazz, and in 1938 produced a trio for clarinet, violin, and piano on commission from Benny Goodman. He returned to America in 1940 and gave a Library of Congress recital with Joseph Szigeti. Preserved on record, this imperishable landmark in the art of performance includes an explosive reading of Beethoven's *Kreutzer* Sonata that with its raw emotion and bold play of tempo is everything Serkin and Busch were not. A fervent democrat, Bartók left Hungary forever the same year. Though he secured a grant from Columbia University for ethnomusicological research, his concert career collapsed, nor could he obtain a teaching post. In the view of his friends, the humiliation of his situation—of indifferent audiences and bad reviews—contributed to his physical decline, eventually diagnosed as leukemia. His financial decline was such that the music critic Irving Kolodin publicly appealed to New York's musicians to come to his aid. His last public performance took place in 1943. Notwithstanding the support of Reiner and Szigeti, his music was little played. He died in New York, age sixty-four, in 1945. Yehudi Menuhin, who championed his Second Violin Concerto, summarized: "Exile made of him [an] unaccommodated man, solitary, intense, requiring for material support only a bed, a table to write at and—but this might be considered a luxury—absolute quiet in which his inner concentration might bear fruit."

At the same time, Bartók was an unlikely candidate for accommodation. A withdrawn and fastidious personality, he would retreat into himself in concert with nature while pursuing his

research into peasant song and dance. He typically traveled with cigar boxes filled with insects which he scrupulously and compulsively collected; he could study a beetle for an hour. In New York he fled Manhattan, where even the traffic disconcerted him, for leafier Forest Hills. His homesickness—in Hungary, he had worn national costume for years and hectored his mother and sister for speaking German—remained acute. His conscientious attempts to "become Americanized" in his eating and speaking habits were poignantly irrelevant. "I cannot live in this country," he testified. "In this country—*lasciate ogni speranza.*" His solo recital repertoire clung nearly exclusively to his own works, including up to twenty or even thirty short movements on a single program. He refused to teach composition, including highly paid positions offered by the Juilliard and Curtis schools, and would only accept employment as a piano pedagogue— which he could not find. Above all, he proudly rejected asking for help. Privately, confidentially, the American Society of Composers, Authors and Publishers (ASCAP) secured the necessary doctors, medication, and nurses, and later a new and better apartment. The crowning irony of this unlikely saga is that, thus supported and terminally ill, he proceeded in his waning years to compose his Sonata for Unaccompanied Violin, Concerto for Orchestra, and Third Piano Concerto. Rarely has concert music of such quality and enduring interest been composed on American soil. Suddenly the recipient of American commissions and American fame, Bartók wasted away in a single week. At his funeral a separate room was required for the flood of journalists. By 1948–1949, his works were more performed by American orchestras than those of any twentieth-century composer except Strauss and Prokofiev.

Krenek, in his unforgiving 1959 essay on the émigré composers, carps at "concessions" in these last Bartók compositions. In fact, Bartók's once radical style had softened and sweetened for

some time before his emigration. The nihilistic or bleak affect of his ballet *The Miraculous Mandarin* (1919), or of the Sixth String Quartet (1939), had partly registered the impact of two European wars. With his escape from Europe, Bartók's music grew less harried. The Concerto for Orchestra (1943) was commissioned by Serge Koussevitzky in a hospital room. Composing for Koussevitzky's Boston Symphony, Bartók miraculously fended off his illness. The Boston performances (one of which was broadcast, and remains available on CD) were superb, and superbly received. The Third Piano Concerto—a birthday present for the composer's wife, the pianist Ditta Pásztory-Bartók—still lacked the final seventeen measures when Bartok's cancer claimed him. These may be the two mildest and most melodious of Bartók's major works. One explanation is documented by the piano concerto's *Adagio religioso* slow movement, modeled after the slow movement ("Sacred Hymn of Thanksgiving from a Convalescent to the Deity") of Beethoven's Op. 132 String Quartet. Bartók was not exactly convalescent in America. But his Boston concerto had triumphed, his leukemia was in modest remission, and the war was finally over. Krenek may have been correct in implicitly surmising that Bartók was to a degree courting success—who could blame him?—with his American concertos, the one a showpiece for orchestra, the other a vehicle for his soon-to-be-widowed wife. For all that, his idiom remained steeped in the inflections of his native land (one cannot imagine him setting English even though he spoke it). His essential condition remained incurably outcast. He is one of those émigrés whose United States residence was an irreducible, implausible quirk of fate.[30]

Ironically, neither Hindemith nor Schoenberg—both of whom composed prolifically in the United States; who interacted professionally with Americans and with American institutions—achieved a comparable communicative success. Like Bartók, Hindemith had sown his oats in the modernist 1920s: as an enfant terrible, he

created scandalous stage works flaunting sexual fantasies; his concert music bristled with borrowings from Dada and jazz. Somewhat later, in his *neue Sachlichkeit* mode, he conceived a functional *Gebrauchsmusik* ("music for use") repudiating art for art's sake. Concomitantly, he adopted a more lyrical, more tonal idiom. His newly pronounced social consciousness typified the times: like Shostakovich in the Soviet Union, like Copland in the United States, he reached out to a broader public. His restless stylistic fluctuations eventually led, in the mid-1930s, to a moment of pivotal change. Afterward, he mapped a strategy for permanence, simplicity, and clarity, based on a personal tonal system cherishing the triad and its connotations of closure yet half jettisoning the notion of "key." This later Hindemith idiom theoretically generated a timeless, sometimes mystically exalted music that sounded neither "traditional" nor "modern." *Mathis der Maler*—the symphony (1934) and the opera (1934–1935)—consolidated the change. It not only defined Hindemith's later style, but served to redefine his social role as an artist.

Loosely based on the life story of Matthias Grünewald, "Mathias the Painter" describes a conscience-stricken artist who is quite willingly buffeted by political storms, yet opts for tranquil seclusion. This parable enshrined a real-life parable in which the same predicament yielded the same result: one subtext of *Mathis* is that fascism had shattered Western ideals of progress; henceforth, the artist could not advance in step with progressive social and political causes. In refusing to permit the staging of *Mathis*, the Nazis precipitated Hindemith's exile and disengagement. Like Mathis, Hindemith suffered disillusionment; like Mathis, he ultimately craved withdrawal into art.* In

*The well-known view that Hindemith strategized an apolitical "inner migration" has been challenged by Michael Kater, whose *Composers of the Nazi Era* (2000) finds an expedient resignation to authority embodied by *Mathis* and Hindemith both.

Connecticut, impervious to his surroundings, he continued the series of duo sonatas for gifted amateurs that he had begun in Germany. Queried on the impact of emigration, he replied: "The Rhine is not any more important than the Mississippi, Connecticut Valley, or the Gobi Desert—it depends on what you know, not where you are." He took no active role in the war effort or political causes.[31] With a single exception, he permitted himself nothing remotely confessional. The exception, the aforementioned Whitman requiem, is a massive English-language setting for soloists, chorus, and orchestra, steeped in learned Germanic polyphony, stocked with proper Germanic forms; for all Hindemith's impressive gravitas and evident sincerity—just before starting, he presented the manuscript of an earlier Whitman setting to the judge who had presided at his United States naturalization ceremony—it remains for most tastes a stillborn tribute to Whitman, to FDR, to its composer's wartime American haven. Hindemith's most popular American work, the *Symphonic Metamorphosis on Themes by Carl Maria von Weber* (1943), is an orchestral showpiece as carefree as the times were not. The second movement, the theme of which is a Chinese tune adapted by a nineteenth-century German (who discovered it in an eighteenth-century French musical dictionary), unexpectedly interpolates a jazz fugue—a veritable jam session for brass, winds, and percussion (Hindemith even expected the players to stand)—as happy as his earliest jazz essays had been dour. As with Bartók, Hindemith in America disappointed his European champions, who remembered his feisty past. Like Bartók, he had paid his dues, had endured Hitler and the pressure of exile.

The music Schoenberg composed in California, by comparison, furnishes no settled picture of compositional style. There is no lifting of the clouds of wartime, as with Bartók, no anchored detachment such as Hindemith embodied. As ever, Schoenberg the

musician proved as complex and contradictory as Schoenberg the man. Of the three famous emigrants we are currently considering, he is at once the most estranged and interactive in America, the most bitterly aloof and vigorously meddlesome. Only Schoenberg could have engaged in an exchange of letters with the chief music critic of the *New York Times* in which he questioned that writer's competence. Only Schoenberg could have proclaimed himself in possession of "a discovery which will insure the superiority of German music for the next hundred years." Schoenberg's "discovery"—twelve-tone composition—dissonantly flavors most of his American output. And yet Krenek, in his 1959 essay, truly observed—as evidence of an urge toward "greater comprehensibility"—"simplified writing" in Schoenberg's *Ode to Napoleon* (1942), with its intimations of E-flat major, and Piano Concerto (1942), with its frequent consonances and quasi–C major close. Other products of Schoenberg's American years are wholly tonal; these include the inspired orchestration of Brahms's G minor Piano Quartet we have encountered via Balanchine, as well as German folk song settings (Op. 49) for college choruses, a suite for college orchestras, a variations set for band requested by his publisher, and an unfinished a cappella setting of the Appalachian folk tune "My Horses Ain't Hungry."* Schoenberg felt the need to comment in a 1948 essay: "A longing to return to the older style was always vigorous in me; and from time to time I had to yield to that urge." Of his tonal "lapses" in twelve-tone terrain, he wrote in 1945 to the composer/theorist René Leibowitz: "I would not consider the danger of resembling tonality as tragically as formerly"; and, again, to Leibowitz in 1947: "It is true that the Ode at the end sounds like E-flat. I don't know why I did it. Maybe I

*Discovered in 2004, this densely contrapuntal rendering was subsequently completed by Allen Anderson and first performed in 2006. (I am indebted to Sabine Feisst for bringing this music to my attention.)

was wrong, but at the present you cannot make me feel this." It was, however, sometimes Schoenberg's opinion that "If immigration has changed me [as a composer], I am unaware of it."[32]

The wartime *Ode to Napoleon*, a winning anomaly, charts the limits of Schoenbergian cultural exchange. The poem, by Byron, salutes George Washington, "Cincinnatus of the West," as Napoleon's antipode: a conquering democrat. The hero of Schoenberg's ode, of course, is not Washington but Franklin Roosevelt. His nontonal setting—the *Sprechstimme* baritone, the piquant and mercurial string quartet and piano—abounds in vivid Expressionist description; as in *Verklärte Nacht* (1899) or *Pierrot Lunaire* (1912), he memorably seizes dark hypnotic detail: "starless night," "twilight of all time." The work's British, American, and Germanic resonances, its eighteenth- and twentieth-century allusions, remain unblended and mutually incongruous. As with Hindemith's FDR requiem, that even at his most "American" Schoenberg is proudly and incorrigibly German makes this patriotic gesture the more touching.

It may further be observed that in response to Hitler's war Schoenberg also composed—again in English—*Kol Nidre* (1938) and *A Survivor from Warsaw* (1947), music more obvious in gesture and affect than the *Ode*; that his rate of production dropped substantially in the United States; that he proved unable to finish two big works—the oratorio *Jakobsleiter* and the opera *Moses und Aron*; and that his tone rows, when deployed, were used less rigorously and abrasively than before. Was he, as Krenek implied, trapped by America into a friendlier posture toward the listener? And was this a concession (however minute) to an uncultivated public? Or was it a proper mitigation (however begrudging and incomplete) of a theory too severe for anyone's good?

In 1909 and 1910 Schoenberg—at the age of thirty-five well and fairly recognized as a major contemporary voice—wrote a series of letters to Gustav Mahler upon hearing Mahler's Seventh

Symphony. "I am now really truly yours," he said. "To express very clearly one thing that I principally felt: I reacted to you to a classic. But one who is still a *model* to me." He also wrote: "In earlier days I so often annoyed you by being at variance with you. I feel that I was wrong to try to thrust my opinions on you instead of listening when you talked and letting myself be enriched by what is more important than opinions: the resonance of a great personality." And most memorably: "Extravagant emotion is the fever that purges the soul of impurity. And it is my ambition to become as pure as yourself, since it is not permitted to me to be so great." The letters are signed "With very cordial regards and deep veneration" and "With affectionate veneration and devotion." Schoenberg would often find such fearless expression of "extravagant emotion" to be unwelcome among Americans. Nor would he in the United States discover another such creative personality to whom he could so gratefully submit. Mahler the father figure enabled Schoenberg to position himself in the German pantheon as the successor to Brahms and Wagner, and to their successor Mahler ("a classic," "a *model* to me"). Once asked if he were the famous composer, Schoenberg replied: "No one else wanted the job, so I had to take it on." Destiny, he wrote in 1948, compelled him to renew the language of his illustrious forebears—"I was not destined to continue in the manner of *Verklärte Nacht* or *Gurrelieder* or even *Pelleas und Melisande*. The Supreme Commander had ordered me on a harder road." He was alienated by *neue Sachlichkeit*, *Gebrauchmusik*, and neoclassicism, all of which "aimed only for a sensational but futile success." So much was he the traditionalist that when in 1946 the Burgomaster of Vienna—Schoenberg's native city, whose conservatism he had despised—summoned him to return, he could respond with expressions of "profound gratitude." "My time will come," Mahler had prophesied—and Schoenberg jealously guarded every proof of Mahler's posthumous vindication. He confidently awaited the day when "all the American

orchestras will have to perform my works as regularly as they perform today already Debussy, Sibelius, and Ravel." But Schoenberg's day never came—with his death in 1951, the grand lineage he sought to uphold and advance petered out, adrift and echoless in a foreign land.[33]

As Schoenberg never tired of rediscovering to his dismay, American classical music was about performers. If his American exile is fathomless, even the most assimilative European composers could not possibly have attained in the United States what eminence they enjoyed at home—unless they switched to fields less venerable and rarefied. And so the most popular of the immigrant composers were two who forsook high culture, the one to escape into a world of Hollywood screen fantasy, the other into Broadway theater and song. As creative musicians, Erich Korngold and Kurt Weill were lesser talents than Stravinsky, Bartók, Hindemith, or Schoenberg. As practitioners of cultural exchange, however, they were ingenious and resourceful—and for that reason warrant more detailed consideration in this narrative.

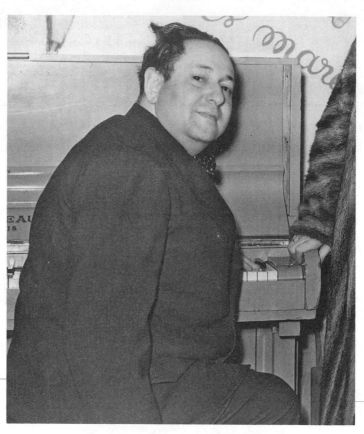

Erich Korngold in Los Angeles.

IT HAS OFTEN BEEN remarked that the most American of industries—screen entertainment—was largely the creation of expatriates and exiles. In the period of Hollywood's early adulthood, the studio heads were onetime shtetl Jews. More than a few of the important directors—subjects of a later chapter of this book— spoke German or Hungarian before they spoke English. Even certain actors—a Dietrich or Garbo, Lorre or Lugosi—benefited from the serendipitous glamour or otherness of a foreign accent. But the most conclusive foreign influence was musical.

When films were silent, the necessary music might be impro-

vised on the spot on a piano or theater organ. A composed symphonic accompaniment, purveyed in a 2,000-seat movie palace, typically comprised a stew of themes from the great composers, sometimes in combination with original music. Even an historical pageant as American as D. W. Griffith's *Birth of a Nation* could invoke Wagner's "Ride of the Valkyries" for its galloping Klansmen without risking incongruity. The advent of "talkies," beginning with *The Jazz Singer* of 1927, spawned confusion. How much music should a movie have? Very little, was the prevailing assumption, unless it was a musical. Otherwise, an organ grinder in the street or a shepherd's pipe in the mountains might be enlisted to ease acceptance of an unseen orchestra.

The composer who most influentially established the centrality of a musical sound track was Max Steiner, whose early landmark scores included *King Kong* (1933) and *The Informer* (1935). Steiner demonstrated that music could pervasively inflect talking pictures, shading the dialogue, guiding the transitions, coloring the locales, clarifying pace and structure. It was Steiner, too, who more than any previous musician fabricated the "sound" of Hollywood. Even though he did not quote *Scheherazade* or *Peer Gynt* after the fashion of the silent-era pastiche accompaniments, he relied on the conventions of late Romantic concert music, upholstering the action with big tunes, lush harmonies, and sonorous timbral agglomerations. Steiner was both a synthetic and self-made composer who in London and in his native Vienna had precociously inhabited the world of musical theater. In 1929 he arrived in Hollywood via Broadway a practiced arranger and conductor schooled in the Viennese Johann Strauss Jr. and Franz Lehár, the immigrant Americans Victor Herbert and Sigmund Romberg, and the American-born Jerome Kern and Vincent Youmans.

Other immigrants would also become important Hollywood composers—Franz Waxman (*Rebecca, The Philadelphia Story, Suspicion,*

Sunset Boulevard, A Place in the Sun) from Silesia, Miklós Rózsa (*Spellbound, Ben Hur*) from Hungary, Dimitri Tiomkin (*High Noon, The High and the Mighty, Giant*) from the Ukraine. Still others—Ernst Toch is an example—applied major gifts to minor Hollywood careers. Erich Wolfgang Korngold was something else: an immigrant composer as famous and established—albeit after a fashion far different from any prevailing in Paris or Berlin— as Stravinsky, Bartók, Hindemith, or Schoenberg. And his fame came famously early. The cantata *Gold*, which he wrote in 1907 at the age of nine, moved Mahler to exclaim "ein Genie!" Bruno Walter was the pianist in the first performance of Korngold's Trio, Op. 1. His Piano Sonata in E (1910) was performed throughout Europe by Artur Schnabel. His *Schauspiel* Overture (1911) was premiered by Arthur Nikisch and the Leipzig Gewandhaus Orchestra; this work and the four-movement Sinfonietta for large orchestra (1912) caused Richard Strauss to remark: "Such mastery fills me with awe and fear." Korngold's great international success, the opera *Die tote Stadt*, came in 1920 when he was all of twenty-two; at the Metropolitan Opera a year later, it was the vehicle for the American debut of the luscious Maria Jeritza. A 1932 poll undertaken by a Viennese newspaper named Korngold and Schoenberg the two greatest living composers.

Though, like Richard Strauss, Korngold was initially hailed or condemned as a modernist, he proved, like Strauss, a diehard Romantic. His music was sensuously chromatic, rapturously melodic. He did not hide his fondness for operetta, for manqué tenderness and splendor. As he happened to be the son of Vienna's most feared music critic, the archconservative Julius Korngold, he was doubly resented by the likes of Ernst Krenek (who considered the elder Korngold "an enemy" whose "main interest was his son"). In fact, Julius Korngold prevented Erich from pursuing a friendship with Alban Berg and on one occasion restrained him from applauding Stravinsky's *Petrushka*. Korngold was also better

equipped than Krenek to adapt to American audiences. In fact, Korngold's adaptation preceded his exile. In the 1920s he began accepting commissions to revise operettas for revival. In 1929, he collaborated with Max Reinhardt on a new version of *Die Fledermaus*, including interpolations from other Johann Strauss Jr. scores. When in 1934 Reinhardt went to Hollywood to film *A Midsummer Night's Dream*, he brought Korngold along to adapt Mendelssohn's incidental music with interpolations from the same composer's symphonies and *Songs without Words*. Carpeting Shakespeare's play with music, he not only sewed together disparate swatches of Mendelssohn, but orchestrated or subtly reorchestrated the originals to suit Reinhardt's sumptuous visual aesthetic. He also conducted some of the actors in order to ensure the alignment of Shakespeare's verse with the score-to-come, on one occasion lying on his stomach in the bushes to shape one of Victor Jory's speeches as Oberon. Though Hal Wallis, the executive producer, complained in a memo that "KORNGOLD is stepping in too much as to how the people should speak and how it is going to fit in with his music," Warner Brothers was so impressed by the outcome that they offered Korngold a contract with prerogatives no other studio composer remotely enjoyed.[34] Amid nine-to-five colleagues who began scoring a new film the morning after finishing the one before, Korngold was entitled to work on as few as two films a year. He was permitted to spend at least half his time in Vienna. He could reuse his film music as he saw fit. He completed such assignments as *Captain Blood* and *Anthony Adverse* before Austria fell to Hitler in 1938—in which year, being Jewish, he moved to southern California with his wife, sons, and father.

All told, Korngold scored twenty-one Hollywood films between 1935 and 1954. A pampered star with prominent billing, the winner of two Academy Awards, he was at all times taken seriously by Hollywood. And Korngold took Hollywood seriously. He wrote in 1940:

> When, in the projection room or through the operator's little window, I am watching the picture unroll, when I am sitting at the piano improvising or inventing themes and tunes, when I am facing the orchestra conducting my music, I have the feeling that I am giving my own and my best: symphonically dramatic music which fits the picture, its action and its psychology, and which, nevertheless, will be able to hold its own in the concert hall. . . . Never have I differentiated between music for films and that for the operas and concert pieces.[35]

And these startling claims hold true. A Korngold sound track resembles what Korngold called "opera without singing." For the most part, the music charts a continuous, continuously variegated flow, exquisitely detailed to match action and dialogue. Where silence intervenes, the flow does not merely fade out, as in other composers' movies, but respects its own integrity: the endpoints are plotted. As in German Romantic opera, a web of leitmotifs knits the fabric. These themes—associated with a character, a mood, a place, an event—are subject to elaborate variation and combination. They guide our responses both explicitly and subliminally. And they generate autonomous musical structures—set pieces correlating with episodes of plot.

The Sea Hawk (1940), with one of Korngold's most admired scores, is often happiest when the actors speak little or not at all. Where Errol Flynn, as Captain Thorpe, and Brenda Marshall, as Doña Maria, have their love scene, there is no ardor in the hero's monotone delivery or pretty face, with its trim mustache, firm jaw, and gleaming teeth. All the necessary romance is in the wordless love duet Korngold supplies. In the battle scenes, with their accumulation of dead seamen, Korngold's cheerfulness and gallantry sanitize and redeem the carnage: it is crucially the music that makes into a winning entertainment what would otherwise seem merely silly. That The Sea Hawk remakes a superb 1924 silent

film partly explains why its dialogue is so frequently an encumbrance. This lurch toward verisimilitude cannot possibly be sustained. Korngold's contribution affirms the fantasy of it all; he assists Hollywood in its transition from the silent era. The film is at least as much his as that of the director, Michael Curtiz (born Kertész in Budapest); he matters more than the writers or the actors.

Kings Row (1942), another signature Korngold achievement, is not a swashbuckler but a tale of small-town lives gone awry. The film buckles with revelations of psychosis and suicide, jealousy and homicidal treachery. The title theme, a fanfare, is among Korngold's most memorable (Ronald Reagan, a principal in the *Kings Row* cast, used it as a White House inaugural embellishment). It proves memorably malleable. As the story begins, it generates a series of three variations, each an ABA design. The first variation, a jaunty march, accompanies the children Paris and Cassie into the woods after school. The scampering second variation has them cheerfully disrobing by a pond. During variation three, sections A and B, they frolic in the water; when the A section returns, the action jumps to their clothed departure. A coda seals their goodbyes. This four-minute sequence with minimal dialogue embodies three Korngold hallmarks: he typically begins with an "overture" and a set piece stating the major leitmotifs; he links musical structure with dramatic action; he dispenses with local color. Even embroidering Americana, his music remains ripely chromatic, abjuring primary reds, whites, and blues.* Nothing can sway his fundamental Germanic allegiance. In *The Adventures of Robin Hood* (1938), a Viennese waltz embellishes an English banquet. In *Kings Row*, the variations under review may briefly

*From the film's title, Korngold had assumed that it was a "royal" story—hence the fanfare, which he decided to retain even after reading the script. (See Brendan G. Carroll, *The Last Prodigy: A Biography of Erich Wolfgang Korngold* [1997], p. 303.)

evoke the festivities in act three of Wagner's *Die Meistersinger,* or the waltz Baron Ochs sings at the end of Strauss's *Der Rosenkavalier,* act two—and it matters not at all.

Kings Row peaks with a storm-tossed love scene for Paris and Cassie years later, the one now a young psychiatrist returned from Vienna, the other a hysterical recluse disfigured by mental illness. If Robert Cummings, as Paris, is overmatched, Korngold is wholly in his element. To the *Kings Row* theme, *tremolando* in the minor, he adds a storm motif and a theme for Cassie's psychosis whose slithering chromatic triplets supply a nagging, nervous undercurrent. A subsequent love theme achieves diatonic stability—except that its source in Cassie's neurotic triplets apprises us that this desired outcome is illusory. The escalating passion of the encounter is driven by a musical dialectic whose thematic juxtapositions grow more acute. As in *The Sea Hawk,* this is a romantic sequence whose on-screen participants are in every way secondary to the composer. If the overheated Cassie is "operatic," so is the entire film. As a slice of American life, *Kings Row* is preposterous. As a psychological drama, it is banal. With Korngold's score blanketing over half the two-hour length, it triumphs as a steamy musical melodrama.

That was not Hollywood's view. Like Garbo's accent or Stokowski's hair, Korngold's music was understood to confer an Old World pedigree of quality—as did Korngold himself, with his glossy operatic credentials and Central European English. Paris's pedigree, in the film, is likewise sealed by music: he is an expert amateur pianist whose courtship of his wife-to-be—a Viennese immigrant!— includes instruction in the proper interpretation of Beethoven's *Pathétique* Sonata (strains of which are appropriated by Korngold's omnipresent orchestra). The palatial theaters in which *Kings Row* was seen, a distraction from the rigors of wartime, were yet another variant—another vulgarization—of Europe's worldly imprimatur.

ARTISTS IN EXILE

KORNGOLD'S HOLLYWOOD CAREER IS clarified by the counter-achievements of the two most established American composers to work successfully in film. Virgil Thomson and Aaron Copland scored three seminal 1930s documentaries: *The Plow That Broke the Plains, The River,* and *The City.* All of these films replace dialogue with poetic narration. Each is handsomely photographed in black and white. Each identifies a national ill—drought, flooding, urban blight—and a progressive remedy. And each rethinks the role of music. In short, these are didactic art films for mass consumption, in revolt against Hollywood escapism.

Thomson and Copland disdained Korngold and other Hollywood composers as intellectually bankrupt and aesthetically outmoded. "Most Hollywood scores," Copland complained in 1941, "are written in the late nineteenth century symphonic style, a style now so generally accepted as to be considered inevitable. But why need movie music be symphonic? And why, oh why, the nineteenth century? Should the rich harmonies of Tschaikovsky, Franck, and Strauss be spread over every type of story, regardless of time, place, or treatment?" He used the term "Mickey-Mousing" to deride the practice of mimicking what happens on-screen. "An actor can't lift an eyebrow without the music helping him to do it. What is amusing when applied to a Disney fantasy becomes disastrous in its effect upon a straight or serious drama." Of Korngold specifically, Copland remarked: "Composers who come to Hollywood from the big world outside generally take some time to become expert in using the idiom. Erich Korngold still tends to get overcomplex in the development of a musical idea. This is not always true, however. When successful, he gives a sense of firm technique, a continuity of not only feeling but structure."

The documentary-film music Thomson and Copland composed certainly was not "written in the late nineteenth-century symphonic style." It was lean and pithy. Thomson quoted cowboy

songs with banjo and guitar, and applied bare, neomedieval two-part counterpoint to images of the dust bowl. Copland spiked the popping toast, spilled coffee, greasy mouths, and bolted sandwiches of a frantic urban lunch counter with an equally frantic montage of recombinable motivic shards: a foretaste of Philip Glass. And, versus Mickey-Mousing, Thomson and Copland specialized in irony. The finale of *The Plow* features a parade of rickety cars fleeing bankrupt farms—to the strains of a catchy habanera. In *The City*—a score greatly influenced by Thomson's style and practice—a jaunty march mocks a Sunday still life of choked traffic, in flight from the blighted metropolis. Thomson proceeded to score a third famous film: *Louisiana Story* (1948). Copland proceeded to Hollywood, there to compose *Of Mice and Men* (1935), *Our Town* (1940), *The Red Pony* (1949), and *The Heiress* (1949). The hard sonorities and spare gestures of these heretical scores exerted a counterinfluence to Steiner and Korngold: future Hollywood depictions of prairie vastness and city turbulence would frequently opt for a tougher compositional style.

Copland's Hollywood career was a mixed success. At times his approach proved unduly reticent. The score for *Our Town* skirts banality. In *Of Mice and Men* the music is so sporadic it fails to achieve an organic flow in and out of the picture. *The Heiress*, a nineteenth-century costume drama, is inherently at odds with the Copland sound. The director, William Wyler, felt the need to interpolate hack music by another hand—an intervention that prompted Copland to abandon Hollywood, notwithstanding an Academy Award for this very effort.

That Copland, Thomson, and other highbrows dismissed Korngold is both fully understandable and incompletely warranted. Korngold was both incurably old-fashioned and incurably Eurocentric. He was also, unignorably, a foreigner not only displacing American talent, but—no less than Stravinsky, Schoenberg, Hindemith, Bartók, and countless other musical exiles—indifferent to

what composers like Copland and Thomson had to say. At the same time, no American could possibly have composed as Korngold composed for the movies because no American commanded the specialized, rarefied style of late Romantic German opera. Copland called the leitmotif a "pet Hollywood formula . . . borrowed from nineteenth century opera."

> I can't see how it is appropriate to the movies. It may help the spectator sitting in the last row of the opera house to identify the singer who appears from the wings for the orchestra to announce her motif. But that's hardly necessary on the screen. No doubt the leitmotiv system is a help to the composer in a hurry, perhaps doing two or three scores simultaneously. It is always an easy solution mechanically to pin a motif on every character.

Whether in Wagner or Korngold, the leitmotif serves a higher function than this.[36]

Though Korngold is frequently considered a model for film music in its Hollywood infancy, he is more accurately regarded as an influence pulling Hollywood toward a musical-dramatic whole no other composer could clinch. Steiner's *Gone with the Wind* theme, a truer model, is a saccharine confection alongside the love music Korngold conceived for *Kings Row*. And no Steiner fanfare is as nourished in harmony and timbre as the *Kings Row* title music. Korngold more resembles Richard Strauss—and it is Strauss, not Thomson or Copland, who most pertinently exposes Korngold's limitations. Compared to the composer of *Salome* and *Der Rosenkavalier*, the composer of *The Sea Hawk* and *Kings Row* more limns cartoons than three-dimensional human beings. He cannot shock an audience into new awareness. He possesses nothing like the wicked humor with which Strauss parodies the squabbling Jews and Nazarenes who invade Herod's court.

There is, finally, the abiding suspicion—and here Thomson and Copland are credible—that the art of Korngold is not fully adult. Slavishly bound to tangible, visible detail, he copiously instructs listeners what to think and feel; he embroiders things already understood. Felix Galimir, who knew Korngold in Vienna in the 1930s, remembered him as "child-like, very simple and unaffected."[37] It is said that he was not allowed to cross a road on his own until he turned nineteen, and that his parents sent a chaperone on his honeymoon. Proof of Korngold's enduring naïveté came when he ended his Hollywood hibernation and returned to classical music after the war. He had vowed not to resume composing for the concert hall until "that monster in Europe is removed from the world." He now produced, among other works, concertos for violin and for cello, a Serenade for Strings, a song cycle, and—his swan song—an hourlong Symphony in F-sharp. These works were not altogether neglected. In America, Heifetz toured and recorded the Violin Concerto. In Europe, Klemperer conducted it, and Furtwängler gave the premiere of the String Serenade. But Korngold could never find a conductor for his big symphony. When he returned to Vienna in 1949, expecting to resume the life he had abandoned eleven years before, he discovered himself written off as a Hollywood anomaly, a has-been, an anachronism.

In fact, Korngold seemed untouched by the political and cultural upheavals of his lifetime. The vicious jibe that he had "always composed for Warner Brothers, but he was not aware of it" may have originated with Ernst Toch; Klemperer retold it many times. Just as Korngold had once borrowed from his overture *Sursum Corda* (1921) in composing *The Adventures of Robin Hood*, he now embedded more than four film scores in his Violin Concerto. The result was no pastiche; rather, it confirmed the unlikely unity of his oeuvre.

The deaths of Julius Korngold in 1945 and of Strauss four years later were rites of passage in Korngold's incongruous twentieth-

century odyssey. His own death, in Hollywood in 1957 at the age of sixty, ended in obscurity a career that had begun scarcely less auspiciously than Mozart's, with a stage father to match. His reputation revived, posthumously, with the waning of modernism: the film scores, freshly recorded, proliferated on CD. *Die tote Stadt*—a resilient love song to the past in which the composer's irresistible predilection to look back becomes the dramatic mainspring—was remounted in Vienna (1967), New York (1975), and Berlin (1983). Hollywood, too, rediscovered something like the Korngold style via John Williams. (The scherzo of Korngold's symphony would slip seamlessly into Williams's 1978 *Superman* score.) But Korngold justly rediscovered remains something less than a late Romantic master victimized by unjust neglect. Perhaps California insulated him from his cultural inheritance and thwarted his creative potential. As likely, Hollywood's fantasy world of princes and pirate kings supplied evasions Korngold subconsciously craved. Either way, the crowning irony of his singular exile is that for more than a decade America adapted to Erich Wolfgang Korngold, not the other way round.

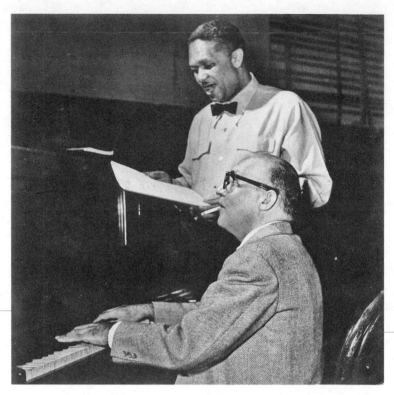

Kurt Weill rehearses Lost in the Stars *with Todd Duncan (1949).*

IF KORNGOLD'S WAS A New World transformation achieved by standing still, Kurt Weill attempted to reinvent himself. In fact, Weill's was from the first a creative identity as attuned to the changeable present as Korngold's was rooted in the unchangeable past. Born the son of a cantor in 1900, Weill apprenticed himself to Ferruccio Busoni in Berlin. "After the revolution in Germany we young musicians also were filled with new ideals, swollen with new hopes," he later wrote.

> But we could not shape the new that we longed for; we could only find the form for our content. We burst the fetters, but we could not begin anything with the acquired

ARTISTS IN EXILE

freedom. We stepped upon new shores and forgot to look back. Thus, through the years of seclusion from the outside we underwent a spasm of excess which lay on the breast like a nightmare and yet which we loved because it had made us free. Then Busoni came to Berlin. We praised him because we believed him to have achieved the goal that we were striving for. But he had become a different person. He recognized no impediments. Through the agility of his clear-sighted intellect and through the transcending vastness of his creative genius, he was able to display a synthesis of all stylistic types of recent decades, a new restrained, sediment-free art, a "junge Klassizität."

A cousin to *neue Sachlichkeit*, Young Classicism overthrew *Innigkeit* and Expressionism in favor of objectivity and simplicity. But Busoni stood aloof from the Berlin of Marlene Dietrich and Josephine Baker—and Weill did not. In parallel with Hindemith and *Gebrauchsmusik*, he espoused targeting a wider public. His 1928 credo, *Zeitoper* ("opera for the times"), foresaw opera as an essential factor in "the end of the socially exclusive 'aristocratic' art."[38] This was not the kind of opulently textured sung theater Strauss or Korngold or Berg composed, but a sparer species defying existing categories. Weill's own musical theater output ceaselessly poked the interstices between known genres, high and low. His most frequent collaborator was Bertolt Brecht, who sang in bars and hated Beethoven. Their fitful partnership began with the *Mahogonny Songspiel* (1927), commissioned by Hindemith's Deutsche Kammermusik Baden-Baden. As Weill was ultimately oriented toward a type of humane, socially relevant opera, and Brecht more interested in a combative theater-with-songs, they eventually parted ways. But the collaboration was historic; it also produced, among other works, *Aufstieg und Fall der Stadt Mahagonny* (1929), *Happy End* (1929), the school opera *Der Jasager*

(1930), *Die sieben Todsünden* (1933)—and their signature creation: *Die Dreigroschenoper* (1928).

Brecht had here set out to adapt John Gay's *Beggar's Opera*, an eighteenth-century "ballad opera" thronged with scheming thieves and whores, as "an opera for beggars . . . cheap enough for beggars to be able to watch": a *Threepenny Opera*. The insidious biblical allusions of his libretto, its tart epigrams and wicked rhymes, constitute a study in irreverence. Weill's songs feed greedily on opera, on operetta, on Romantic largesse. If the work's unquenchable popularity—it ran for 250 consecutive performances, after which it moved to another theater; it satisfied Weill's aspiration to reach "listeners whose number far exceeds the size of concert hall and operatic audiences"—nullified Brecht's savage social criticism, its equally savage send-up of *Kultur* and morality perfectly gauged the *Zeit*. Unforgettably flaunted was the *Berlinerisch* sensibility summarized by the Czech Willy Hoos as "that taking-nothing-solemnly yet taking-seriously of things." Elias Canetti observed in his memoirs:

> It was the most precise expression of Berlin. The people cheered themselves, they saw themselves, and were pleased. . . . Now it had been said, no bug in a rug could have felt snugger. . . . Only those who experienced it can believe the grating and bare self-satisfaction that emanated from this production . . . everything was glorified that one would otherwise shamefully conceal. Most fittingly and effectively derided was sympathy.[39]

It was the Nazis, not the fashionably dissolute bourgeoisie, who understood *Die Dreigroschenoper* as Brecht had intended: a mockery of "respectable" music and theater; a withering assault on capitalism. At the 1938 "Degenerate Music" exhibition in Düsseldorf, an entire room was allotted to *Die Dreigroschenoper*,

excreted by the Marxist Brecht and the Jew Weill. Weill had left Germany for Paris five years before. Though he was Germany's most successful stage composer, his success was not international and his French prospects proved ambiguous. He arrived in Manhattan in 1935. The United States he encountered was a world removed from Weimar culture and politics. The *Threepenny Opera* had already failed in 1933; New York critics found it dreary and perplexing. Not one of the ten other theater works Weill composed in Germany was professionally mounted in America until after his death. And Weill made no effort to promote these Old World entertainments. With his finely attuned cultural antennae, he was off and running in new directions. Both he and his wife, Lotte Lenya, testified that New York felt "like home" from day one—it was the America of their imagination come true. He quickly mastered English. "I totally feel like an American," he commented in the German-language *Aufbau* in 1942. He visited Europe only once, in 1947, and reported: "Wherever I found decency and humanity in the world, it reminded me of America." "Americans seem to be ashamed to appreciate things here," he told *Time* in 1949. "I'm not." According to Lenya (who would not pronounce her late husband's name *auf Deutsch* as *Veill*), "The old-timers were always talking about the past. And Weill never did. Never. Because they would always talk about how marvelous it was in Berlin. And Kurt was always looking ahead. He didn't want to look back."[40]

Though Weill's German field of operation had included the opera house, it was obvious that in New York he could only compose for Broadway. Twentieth-century Americans understood opera less as theater than as a glamorous foreign-language entertainment epitomized by the cavernous Metropolitan Opera House, with its "golden horseshoe" of boxes and starry international casts. In the United States, even more than abroad, *Zeitoper*

could not possibly be grand opera.* Weill's inescapable New World mission was to help forge a species of "American opera" at the same time fresh, popular, timely, and nourishing. The pace and variety of his Broadway output were breathtaking. The musical "fable" *Jonny Johnson* (1936) and the "operetta" *Knickerbocker Holiday* (1938) led to a couple of smash hits: *Lady in the Dark*, a "musical play" with words by Moss Hart and Ira Gershwin (1940), and *One Touch of Venus*, a "musical comedy" written by S. J. Perelman and Ogden Nash. *The Firebrand of Florence* (1944), another operetta, was a failure. *Street Scene* (1946), a "Broadway opera" with words by Langston Hughes and Elmer Rice, and *Lost in the Stars* (1949), a "musical tragedy" written by Maxwell Anderson, were Weill's most serious Broadway undertakings. He also produced a much-performed "college opera," *Down in the Valley* (1948), and a "musical," *Love Life* (1947), before a heart attack felled him in 1950 when he was all of fifty years old.

No ventriloquist could rival the alacrity with which Weill assimilated the lexicon of American voices flavoring these scores. His long affinity for jazz, which in Berlin he had hailed for its "essential role in the rhythmic, harmonic, and formal relaxation we have achieved today," was of course put into play. In *Down in the Valley*, western songs and square dances were the clay of his musical imagination. He absorbed blues, jitterbug, Gershwin, Rodgers and Hammerstein. He revisited the European forms—and, unlike any other Broadway composer, orchestrated his scores rather than turning them over to an assistant. At the same time, his American pieces were, all of them, mediated by commercial considerations unknown abroad. Time and again, he would cut or revise a number others believed did not fit. Europe, he thought, had succumbed to

*Maurice Abravanel, who conducted at the Met in addition to conducting four Kurt Weill shows on Broadway, once proposed to Edward Johnson, the Met's director, that he consider something by Kurt Weill. According to Abravanel, Johnson "thought I was crazy" (see Lowell Durham, *Abravanel!* [1989], p. 23).

"an almost diseased passion for musical originality." "It would be much healthier for an American musical theater to make certain concessions to Broadway showmanship," he believed, "than to cater to a traditional opera form which is European in concept and purpose." And: "I want to use whatever gifts I have for practical purposes, not waste them on things which have no life, or which have to be kept alive by artificial means. That's why I've made the theater which exists without benefit of subsidy my life work." And again: "My success here (which people usually ascribe to 'luck') is mostly due to the fact that I took a very positive and constructive attitude towards the American way of life and the cultural possibilities in this country of which most of the German intellectuals who came here at the same time, were critical and doubtful."[41]

American informality, egalitarianism, and eclecticism were all factors in the more casual, friendlier musical idioms toward which Weill was now predisposed. Schoenberg was driven by historical necessities oblivious to what audiences might understand. Hindemith charted his strategy for permanence. Bartók was wedded to the strains of his homeland. Korngold stayed stuck in the past. Though Stravinsky's *Soldier's Tale* inspired Weill in his quest for a simplified opera substitute, Stravinsky in Hollywood remained too much the artiste to embrace the high-low synthesis Weill alone, of these eminent immigrants, pursued in America. As with Dvořák, as with Balanchine, he was indifferent to the highbrow pedigree that ruled the thinking of every classically trained American composer, whether populist or modernist, Aaron Copland or Roger Sessions.

In his 1959 diatribe on "America's influence," Krenek of course reserved special opprobrium for the "sumptuousness, the mundane sentimentality, and the, if at all, circumspect irony" of Weill's "Broadway manner." Otto Klemperer, who in Berlin premiered and recorded the *Kleine Dreigroschenmusik* Weill extrapolated from *Die Dreigroschenoper* (and who also reneged on a

promise to conduct *Aufstieg und Fall der Stadt Mahagonny*), opined in the 1980s that "Weill got too involved in American show business and all the terrible people in it. Weill's last pieces I find awful." (To Lenya, Weill wrote from Hollywood in 1937: "I went . . . to Klemperer's concert in Los Angeles [very bad]. . . . In the greenroom with Klemperer was the wunderkind Adorno grown old. I put on my haughtiest face and stayed for only two minutes. All of them are abundantly disgusting.") Of all the German immigrants, Theodor Adorno was the harshest of those detractors who felt Weill had peaked in partnership with Brecht. In a supremely patronizing obituary, Adorno summarized Weill's American fate accordingly:

> He became a Broadway composer modeled on Cole Porter and talked as if concession to the commercial field were no concession, but only a pure test of "skill" which made everything possible even within standardized boundaries. . . .
> Perhaps he had something of the genius of those who lead the great fashion-houses. He had the ability to find melodies appropriate to the annual shows; and this supremely ephemeral thing in him may last.[42]

Among Americans, critical opinion was kinder, less governed by memories of what Weill had been before 1935 than by appreciative impressions of Weill—the musician and the man—in New York. Broadway reviewers, especially, were delighted to have so talented and productive a newcomer suddenly in their midst. Brooks Atkinson of the *New York Times* called *Lady in the Dark* "the finest score written for the theater in years." He also called it a "catalytic agent," Weill being "not a song writer, but a composer of organic music that can bind the separate elements of a production and turn the underlying motive into song." Behind the scenes, George S. Kaufmann sent Weill a telegram after opening night. Alluding to the song "My Ship," which weaves through the entire

Lady in the Dark score, Kaufmann wrote: "Your ship has sails that are made of gold, relax." When Weill struck a heavier note, in *Street Scene*, Atkinson anointed him "the foremost music maker in the American theater." Other critics called *Street Scene* "Broadway's first real opera" and "the most successful projection of the American scene, musically and dramatically, that this reviewer has ever witnessed." Weill received a Tony, in the inaugural year of the awards, for his *Street Scene* score.

In classical music circles, the response was more varied. Olin Downes, the chief music critic of the *Times* and a man whose great enthusiasms did not include modernism, impulsively wired Weill his congratulations upon attending the opening of *Street Scene*. In print, Downes wrote: "*Street Scene* . . . is the most important step toward significantly American opera that the writer has yet encountered in the musical theatre." Glancing at Weill's German career, Downes suggested that only a newcomer could achieve the necessary clarity of vision to seize and sing the American experience:

> We recall his satirical piece, *Mahagonny*, heard at a modern music festival in Baden-Baden in the 1920s. It was the work of one of the bold, bad musical intellectuals of the advanced European group of the day. A war has intervened, and experiences too, since that time, including Mr. Weill's arrival here. . . . In view of what he has done: the complete discarding of the aesthetic snobbery of earlier days; the evolution . . . from the sophistications of the (professed) avant-garde to the plain, direct emotional expression which he has sought and so largely attained . . . we are given to wonder whether it is not the very artist coming here from a European social and cultural background who will be quickest to perceive in its full significance an aspect of American life; and feel it as those who always have been in its vicinity might not, and, in communicating it, take a historic step in the direction of genuine American music-drama.

Virgil Thomson, Downes's antipode at the *Herald-Tribune*, was himself an American composer of American opera—and a Francophile gadfly intellectual who embraced a more rarefied brand of populism than Downes's soapbox variety. His *Lady in the Dark* review read in part:

> Weill's finest creative period, that of his collaboration with the poet Brecht, is characterized by satirical writing both melodically and harmonically. In parodying cheap sentiment to the utmost he achieved a touching humanity. His characters expressed their self-pity in such corny terms that we ended by pitying them their corn. . . .
>
> Those sentimental days are gone and Mr. Weill seems ever since to have avoided working with major poets as he has avoided all contact with what our Leftist friends used to call "social significance." His music has suffered on both counts, it seems to me. It is just as banal as before; but its banality expresses nothing. Nothing, that is, beyond the fact that Mr. Weill seems to have a great facility for writing banal music and the shamelessness to emphasize its banality with the most emphatically banal instrumentation.★

Weill confided to Ira Gershwin that he felt wounded by Thomson's "violent attack" and added: "Well, I am used to this kind of attacks [*sic*] from the part of jealous composers. In some form or another it happens every time I do a new show." Two years later, Weill was nominated for membership in the American Academy of Arts and Letters. But the academy's president, the composer Douglas Moore, opposed Weill's candidacy: "Weill has

★Thomson's obituary for Weill, nine years later, was complimentary: "Everything he wrote became in one way or another historic. He was probably the most original single workman in the whole musical theatre, internationally considered, during the last quarter century. . . . Every work was a new model, a new shape, a new solution of dramatic problems" (April 9, 1950).

marvelous techniques and impressive facility but heart and con-
science I can't find anywhere." Weill was never elected.[43]

This cacophony of opinion, pro and con, was eventually me-
diated by a superior authority: the British music historian David
Drew. His knowledge of Weill, at every stage of his transatlantic
odyssey, was unsurpassed. Taking stock of the whole for the 1980
New Grove Dictionary of Music and Musicians, Drew weighed the
two Kurt Weills without prejudice. The German Weill felt him-
self "part of the modern movement and one of its leaders in the
younger generation"; he measured himself against Hindemith.
The American Weill felt responsibility to "the American musical
stage in its popular form"; he regarded Richard Rodgers as his
chief rival. Drew summarized:

> Whatever one may think of the creative results, it is clear
> that Weill's Broadway achievements called for at least as
> much human courage and determination as any of his
> earlier ones, and perhaps more. It is equally clear that they
> exacted from him a degree of self-sacrifice greater than
> any that would have been demanded by a totalitarian
> ministry of culture. The difference between Weill up to
> 1934 and Weill after 1940 is not attributable to any devel-
> opment which could be described as normal, or even as
> clinically predictable. While some notable artists have
> simply stopped creating at a certain stage in their careers
> and a few have put an end to their lives, Weill is perhaps
> the only one to have done away with his old creative self
> in order to make way for a new one.

Drew's scholarship and advocacy helped to put an end to the
conventional wisdom that, minus Brecht, Weill was a toothless
talent, and that, minus Germany, he was a lost soul. A subsequent
wave of Weill scholarship went beyond Drew in positively reap-
praising the Broadway Weill—and, moreover, reconnecting the

two Weills as a refortified twentieth-century master. Crucial to this revisionism was the Broadway score on which Weill worked longest and most painstakingly, the "Broadway opera" Weill himself predicted would "be remembered as my major work"[44]—and which, of all the pieces he produced for the New York stage, most ambitiously brokered the cultural exchange between newfound American opportunities and inherited Old World practices.

BEFORE IT WAS A Broadway opera, *Street Scene* was a Broadway play by Elmer Rice, winner of a 1929 Pulitzer Prize. Anna Maurrant, trapped in a loveless marriage, is having an affair with Mr. Sankey, who takes milk delivery orders door to door. Her husband, Frank, is a stagehand. Sam Kaplan, a bookish student, is in love with their daughter, Rose. Frank's work requires that he go to Pittsburgh. Suspecting his wife's infidelity, he returns home the same day and discovers her in bed with Sankey. He shoots them both and is swiftly captured by the police. Rose resolves to get away. Sam wants to go with her. Rose tenderly admonishes him that this elopement would be premature—he needs to go to college; she needs to find herself. As important to Rice's play as this story is a larger slice of life transpiring on the stoops and sidewalk outside a New York tenement from evening to the following afternoon. Sam's father is a socialist who reads the Yiddish press. Lippo Fiorentino teaches violin. The Hildebrands are about to be evicted for nonpayment of rent. The Buchanans are expecting a baby any moment.

Weill saw the play in Berlin as early as 1930 and began asking Rice about adapting it years before an agreement was clinched in 1945. They then enlisted, as an additional lyricist, the black poet Langston Hughes. A further ingredient was *Porgy and Bess*, which Weill attended in rehearsal within a month of landing in New York and about which he exclaimed: "It's a great country where music like that can be written—and played."[45] Gershwin's exam-

ple helped Weill to envision what a Broadway opera might look and sound like; it also memorably evoked a community of individuals: what Rice had sought to achieve in his play.

The three collaborators were fired with enthusiasm both aesthetic—the subject matter and its treatment would signal a bold departure for a show with music—and political: even though the *Street Scene* residents feud, they comprise a vignette of immigrant cohabitation, of American tolerance. But there was also a divergence of agendas among the show's creators: in typical Broadway fashion, they continued to tinker, dropping or adding a number, well into the tryout period. A Harlem Renaissance activist, Hughes took Weill and Lenya on a tour of New York tenement neighborhoods, black and white. Rice was eager to secure a treatment faithful to the "realism" of his play—including characters and expository details that others might find less than essential. The show's director, Charles Friedman, brought a musical-comedy perspective to the creative team. Weill's fascination with the ethnic diversity of the dramatis personae predisposed him to apply a diversity of musical styles, even of musical genres; *Street Scene*, he reasoned, "lent itself to a great variety of music just as the streets of New York themselves embrace the music of many lands and many people. I had an opportunity to use different forms of musical expressions. From popular songs to operatic ensembles, music of passion and death—and, overall, the music of a hot summer evening in New York."[46]

And so *Street Scene* begins and ends with an ensemble with wailing clarinet—"Ain't It Awful the Heat?"—owing something to the Yiddish theater (also a potent influence on Gershwin). When Lippo shows up with ice cream cones whose flavors he extols, the result fondly parodies an operatic sextet; the lyrics begin: "First time I come to America / First thing I see is the ice cream cone! / The ice cream cone!" Rose's boss, Mr. Easter, wants to sponsor her on the stage; Weill here composes a soft-shoe seduction song, "Wouldn't You Like to Be on Broadway?" Rice's Dick

The ice cream sextet from Street Scene, in the original Broadway production (1947).

and Mae enter late in act one to flirt and cavort. Weill gives them a jitterbug number, "Moon Faced, Starry Eyed," to bring down the house. The opposite extreme, temperamentally and compositionally, is formidably defined by Anna's self-revealing Scene and Aria (so identified by Weill) "Somehow I Never Could Believe." Other *Street Scene* numbers add to the characters and events in Rice's play. To expand the melting pot, there is a black janitor, Henry Davis, with a bluesy credo, "I Got a Marble and a Star," Porgy might have sung. And to satisfy Friedman's insistence on a bright Rodgers-and-Hammerstein-style production number, Weill supplies "Wrapped in a Ribbon and Tied in a Bow" for Jennie Hildebrand's high school graduation.

Musically, this opera cum musical cum revue comprises a tour de force of sorts. Still the excited newcomer for whom the immigrant experience is the American experience, Weill relishes his eclectic range. But the show's trajectory is imperiled by the multi-

plicity of characters, who mainly appear in lockstep with the action of the original play. Show tunes crowd arias cheek by jowl. There is a confusion of tone: are these "real people" singing, or musical-comedy cartoons? With so much subsidiary activity, much of it amplified and prolonged by the addition of music, it takes Weill, Rice, and Hughes a perilously long time to foreground the central tragedy.

For Weill, Anna Maurrant's seven-minute scene and aria was a touchstone. In Philadelphia, before the Broadway run, Billy Rose heard "Somehow I Never Could Believe" and, as Lenya would recall, told Weill: "You have to shorten it. Nobody will listen." Weill replied: "If that aria doesn't work, then I haven't written the opera I wanted to write. I will not change a note."[47] At opening night on Broadway, the aria won an ovation. Weill was right: it anchors the show's emotional core. Weill empathizes with this self-portrait of a life gone awry; he has his beleaguered housewife pour out her heart: "There's got to be a little happiness somewhere." And he is a practiced operatic craftsman who knows how to simulate a spontaneous flow of feeling; Billy Bigelow's soliloquy in Rodgers and Hammerstein's *Carousel* (1945), by comparison, is a faux operatic song sequence in which every stitch shows.[48] Nowhere in his previous American output had Weill so exercised his suppressed creative energies. Especially in a strong production— one that permits the audience to take the characters seriously★— the Maurrant family tragedy furnishes a spine strong enough to bind the show's too disparate elements. *Street Scene's* peak lyric inspiration is an extended love duet—again, more than a song—in which Rose and Sam quote words Sam adores: the same Walt Whitman poem, "When Lilacs Last in the Dooryard Bloom'd," so

★Of Weill's compositions for the American stage, *Street Scene* is the most produced. A superb staging, preserved on DVD, is Francesca Zambello's: a coproduction of the Houston Grand Opera and Staatsphilharmonie Rheinland-Pfalz. An earlier New York City Opera staging fatally underlined the work's tendency to stereotype character and situation.

painstakingly set by Hindemith the same year. (Weill's mini-cycle of four Whitman songs [1941–1947], whose dark Civil War poems become fresh Broadway numbers, is unjustly neglected.) In fact, the music Weill composes for all three of these trapped individuals is consistently memorable. But this binding action remains superficial: not an integration, but an italicization of the show's strongest numbers. As "Broadway opera," *Street Scene* is a work in progress.

That Weill earnestly aspired toward an integrated American musical theater cannot be doubted. Suddenly, many Broadway composers did. A landmark catalyst was Rodgers and Hammerstein's *Oklahoma!*, which opened in 1943—four years before *Street Scene* was launched—and closed after *Street Scene* had ended its run. Weill himself, discussing *Street Scene*, mentioned as exemplars of the new trend *Porgy and Bess*, *Carousel*, and *Carmen Jones*—the last a 1943 Bizet adaptation. Other Broadway operas and near-operas of the period included Marc Blitzstein's *Regina* (1949), Frank Loesser's *Most Happy Fella* (1956), Leonard Bernstein's *Candide* (1956), and a series of works by Gian Carlo Menotti including *The Medium* (1946), *The Telephone* (1947), *The Consul* (1950), and *The Saint of Bleecker Street* (1954). One writer has counted eighteen Broadway productions that "presented themselves as operas or were immediately labeled as such by critics" between the 1942 revival of *Porgy and Bess* and closing night for Bernstein's *West Side Story* in 1959.[49]

Though he barely lived long enough to witness its beginnings, Weill could only have observed this trial-and-error spectacle with frustration and impatience. Writing to Weill, Lenya called *Oklahoma!* "that Hillbilly show" whose music "gets dummer [*sic*] and dummer each time I hear it." Writing to Lenya of the success of *Carousel*, Weill confided: "So Rodgers 'is defining a new directive for musical comedy.' I had always thought I'd been doing that— but I must have been mistaken. Rodgers has certainly won the first round in that race between him and me. But I suppose there will be a second and third round." Even the magnificent composer

ARTISTS IN EXILE

of *Porgy and Bess* did not escape Weill's private scorn; from Hollywood, he wrote to Lenya in 1937: "Here Gershwin comes off as even more of a nebbish," and "this bumpkin is just too dumb ever to bother with." However much he may have forced himself to forget the past, Weill in weaker moments must have felt infantilized by his new surroundings, reexperiencing growing pains already endured in a previous life.[50]

IT IS TEMPTING TO assume that, had he lived a normal span of years, Weill would have figured out how best to mate opera with American popular taste. But the quasi-operatic *Lost in the Stars*, coming after *Street Scene*, is again not altogether integrated, stylistically, and the musical inspiration is uneven. The songs Weill had completed at the time of his death for a proposed *Huck Finn* are nothing special. Ignoring Weill's own conviction that *Street Scene* was a breakthrough, Drew cautions: "Since from [Broadway] show to show there is no observable development on any level—melodic or harmonic, formal or stylistic—it is impossible as well as unhelpful to speculate about the course Weill might have followed had he lived on into the 1950s."[51]

But two posthumous developments would necessarily have weighed in. In 1958, the New York City Opera undertook an unprecedented five-week season of "contemporary American operas." The composers included Weill, Blitzstein, Bernstein, and Menotti. The company's low ticket prices, and the stark, no-frills decor of its City Center home, set it apart both from Broadway and the Met. Julius Rudel, its music director beginning in 1957, was a galvanizing force. Weill, had he lived, might have found a home at City Opera (at least until the company lost its way upon moving to Lincoln Center). The impact of the second post-1950 development could only have been mighty. In 1954, the *Threepenny Opera*—a non-event in New York in 1933—opened at Greenwich Village's

Theatre de Lys in a tart translation by Blitzstein. As Jenny, Lenya, singing in English, repeated the role she had originated a quarter century before. The production played for 2,611 consecutive performances, surpassing *Oklahoma!* as the longest-running musical in the history of the American theater. In Berlin, *Die Dreigroschenoper* had mirrored a decadence Berliners fondly recognized. Of its fabulous off-Broadway success, the producers remarked: "Neither of us did [*Threepenny Opera*] because we liked Brecht's social criticism. We did it because we thought it was a great show."[52] But in fact the time was ripe. The Depression and World War II had summoned an optimistic resolve; the Cold War and McCarthysim now alienated and embittered artists and intellectuals.

Actually, the *Threepenny* revival had begun in 1950 with—a revelation—a Town Hall concert featuring Lenya singing Weill in German. Two years later, she took part in an acclaimed *Threepenny* production at Brandeis University, with Bernstein conducting. In 1955, she returned to Berlin to record *Die Dreisgroschenoper, Aufstieg und Fall der Stadt Mahagonny, Happy End*, and *Die sieben Todsünden*— the last (*The Seven Deadly Sins*) being a caustic and melodious Weill-Brecht concert work that steadily and deservedly acquired a life of its own in the late twentieth century. Born in Weimar Berlin, whose authentic voice Lenya preserved, *The Threepenny Opera* will retain pungency unless or until the human condition proves perfectable. In short, it was reencountered after the composer's death as a classic.

Nearly as sudden as this rediscovery was the obliteration of the American Weill. Of *Jonny Johnson, Knickerbocker Holiday, Lady in the Dark, One Touch of Venus, Street Scene*, and *Lost in the Stars*, only a few numbers—"September Song," "Speak Low"—remained. Newly credible was Adorno's scathing obituary notice of 1950. But it was *Threepenny Opera* itself that furnished the most devastating critique of *Street Scene*. Compared with the technical flaws of Weill's Broad-

way opera, the Brecht-Weill partnership achieved a seamless consistency of tone and style even while charting new terrain. It is an instructive exercise to imagine Brecht—who in America proposed various collaborations unacceptable to Weill—in attendance at the Adelphi Theatre in 1947. He would have been bemused by the predictability of the *Street Scene* plot, nauseated by the bathos of Frank Maurrant's remorse ("How could I have done it? . . . She was so sweet . . . I loved her," etc., etc.). In truth, nothing short of Brechtian distantiation—a *Berlinerisch* weapon—could turn the banality of these elements, the show's soft underbelly, into a virtue.

The verisimilitude of *Street Scene*—the "naturalism" cherished by Elmer Rice—canceled whatever might have remained for Weill of Ferruccio Busoni's beacon light. As a composer whose *Doktor Faust* Weill judged "in every respect" a model for future "musical stage works,"[53] as a mentor Weill considered an exemplar of "consummate purity," Busoni insisted that "the sung word will always remain a convention on the stage, and a hindrance to any semblance of truth; to overcome this deadlock with any success a plot would have to be made in which the singers act what is incredible, fictitious, and improbable from the very start, so that one impossibility supports the other and both become possible and acceptable." Busoni also wrote:

> The artist, if the control over his medium at certain moments is not to be lost, must not be moved when he wishes to move others, and in the same way the onlooker, if the artistic enjoyment is not to be debased to human participation, must never consider it as reality. The performer "acts," he does not experience. The onlooker, being incredulous, is thereby unimpeded in mental reception and keen enjoyment. . . . On such assumptions a future for the opera can well be expected.

Busoni loathed the convention of the love duet, unless it be rendered "openly as a pretense, as nothing but 'acting' and sustained make believe." He considered Puccini—whose *Madama Butterfly* Weill quotes in the act-one love duet of *Street Scene*—"disreputable." Weill's own European writings follow his teacher in prescribing the uses of irony to rouse a self-willed and hence ethical response.[54]

All of which goes to illustrate that Busoni, in Berlin, was a prophet of the "alienation effect" Brecht would make his own—and hence foreshadows the Brecht-Weill alliance. Weill, to be sure, was a democrat, as Busoni was not; and Brecht, unlike Busoni, was an ideologue. But their common strategy was to distance the spectator from direct identification with character and action in order to provoke thoughtful engagement. "The public has a thoroughly criminal attitude to the theatre"; "In order to receive a work of art, half the work must be done by the receiver"; "The opera should take possession of the supernatural or unnatural as its only proper sphere of representation and feeling and should create a pretence world in such a way that life is reflected in either a magic or a comic mirror"—these Busoni precepts apply directly to *Die Dreigroschenoper*.[55]

Busoni was a continued, if sporadic, influence on Weill until the day he arrived in America. Pages and pages of Weill's best pre-1935 music even sound like Busoni: the application of irony and ferocity to vernacular marches and Italian dances, the fondness for fleet, spectral ostinatos to impart direction and sinister or humorous affect, are signature traits of both composers. Weill's most outstanding concert works—*Die sieben Todsünden* and (a composition yet to be "discovered") the Second Symphony of 1933—are dark, seething essays in distantiation. One can hear snatches of the German Weill in the Broadway shows, too, and also ongoing harmonic and melodic propensities, but this resemblance is misleading because the deployment of irony now becomes at best an innocuous

ARTISTS IN EXILE

diversion, not a barbed aesthetic strategy. A battered and worldly irony—a creative and resilient product of European suffering—is what makes the Brecht/Weill pieces matter. No wonder his European friends and colleagues deserted Weill in the United States.

That the rediscovery of the German Weill would ultimately promote rediscovery of the Broadway Weill was proper and inevitable. But with all of Weill in play, a balanced assessment can only discover that, like every other European immigrant composer we have considered, Weill did his best work at home, before coping with the rigors of transplantation. Weill wrote of *Street Scene* that it fulfilled two "dreams" toward which *Three-penny Opera, Mahagonny,* and *Lady in the Dark* were but "stepping stones." One dream was of an "American opera" on Broadway; the other was "a real blending of drama and music, in which the singing continues naturally where the speaking stops and the spoken word as well as the dramatic action are embedded in the overall musical structure." Judged by the Berlin Weill, Weill's notion that *Street Scene* continues the musical-dramatic lineage of his Brechtian shows, or that it occupies "a niche of its own," can only seem self-deluded. Drew's 1980 balance sheet remains disconcertingly credible: that Weill in Germany was a "composer of genius" who—a singular accomplishment—mined modernism yet rediscovered the virtues of simplicity; that Weill in America willingly submitted to "a long process of collective criticism and amendment which involved the entire production team, together with the financial backers, the publishers and song pluggers, and finally the public itself" and so repudiated "the concept of the composer as a creator of an essentially individualist and sacrosanct oeuvre." Pondering the sacrifices Broadway demanded in terms of subject matter, of compositional originality and sophistication, Drew finds Weill not an apostate but a courageous and resourceful assimilator. But he mercilessly concludes:

Had Weill continued to develop after 1933 as he had in the previous years, he could have become one of the commanding figures in German music—another Weber, perhaps, or even . . . another Gluck. In his own generation he had few peers; but it is with greater composers whose gifts were partly unfulfilled or partly squandered that he is most profitably to be compared.[56]

Weill's professed preference for *Street Scene* will remain an enigma. Perhaps his admiration for wartime America, for the urgent moral leadership of FDR, predisposed him to undervalue his earlier, darker work. Or perhaps he privately harbored suspicions that, as he wrote to his collaborators two weeks before *Street Scene* opened on Broadway, "we have not succeeded in blending the elements of the show." Perhaps forgetting Berlin was not just a cheerful resolve to begin anew, but—as Lenya speculated in 1979—a way of handling the pain of loss.[57] Whatever the cause of his redirection, Kurt Weill remains an anomaly among all the eminent German musicians who washed ashore in the United States in the 1930s— the only one to turn his back on the august musical traditions in which he was raised, and which Berlin had so potently updated.

Unquestionably, Weill figured prominently in the momentous Broadway project of the 1940s: to discover weightier, more sophisticated musical genres. Of the Broadway hands who observed Weill up close, Elia Kazan and Harold Clurman rendered severe judgments. Kazan, directing *Love Life*, observed that Weill in America "was not always as daring as Weill in Germany," that he "wanted success very badly." Clurman, critiquing *Lost in the Stars*, similarly complained of Weill:

There is nothing wrong in adapting oneself to a new environment, but one must adapt oneself upward rather than downward, that is, to the more challenging and difficult as well as to the simpler and safer. Failing, at least, an

occasional effort in the direction of the untried, the hazardous, and possibly even the unpopular, a composer may suffer other than those of the concentration camps. To develop real roots in a chaos such as ours today, an artist must shape some definite ideal for himself of the kind of world toward which he can aspire.

Weill's own claims for *Street Scene*—that it was an "American opera" in which "the singing continues naturally where the speaking stops and the spoken word as well as the dramatic action are embedded in the overall musical structure"—are better and more boldly satisfied by Blitzstein's *Regina*, whose writer, librettist, and composer were one and the same. Among Broadway's immigrants, the kinds of risks and "definite ideals" prescribed by Kazan and Clurman were (as we shall see) notably pursued by Rouben Mamoulian (who, as it happens, directed *Lost in the Stars*). All the same, Clurman's 1949 verdict is unduly harsh. Recent historians of American musical theater have been notably kinder—and kinder than Drew. Ethan Mordden, in *Beautiful Mornin'* (1999), observes Weill as a ceaseless and timely innovator, "the absolute forties composer." Mark Grant, in *The Rise and Fall of the Broadway Musical* (2004), sees Weill as a crucial agent in establishing "the libretto as the fulcrum of a musical."[58]

But Weill's method had always been to seek leading writers—Brecht and Georg Kaiser in Germany; Maxwell Anderson, Elmer Rice, and Langston Hughes in the United States—and to adapt. And Kurt Weill's America, Broadway ferment notwithstanding, furnished neither a Bertolt Brecht nor a *Zeit* comparable to that of the legendary Berlin that likewise nourished and inspired Serkin and Klemperer, Schoenberg and Hindemith, and others yet to be encountered in our narrative of artists in exile.

Edgard Varèse at work in his Greenwich Village apartment.

THE MUSICAL "MARGIN
OF THE UNGERMAN"

Edgard Varèse and the sirens of Manhattan—Leopold Stokowski invents himself—Serge Koussevitzky in search of the Great American Symphony—Arturo Toscanini and the culture of performance

EDGARD VARÈSE WAS SPELLBOUND by the "wonderful musical symphony" wafting from the Hudson River toward his windows on Manhattan's West Side; it moved him "more than anything ever had before." He also thrilled to the "lonely foghorns," to the wailing sirens of fire engines and to the portentous skyscraper walls. "*Ça c'est ma ville*—That's my city," he would say to his American wife-to-be, Louise Norton.[1]

Dvořák, in Manhattan, had suffered from "nerve storms"; he would not even cross the street unattended. Mahler complained of "a sea of meaningless stone." Bartók fled to Forest Hills. For Schoenberg and Stravinsky, Manhattan signified bad weather whose antidote was southern California. For Varèse, in 1915, New York represented an escape to freedom.

He was not the first. Anton Seidl, fleeing inbred Bayreuth, was stirred by the scale and energy of New York.[2] For Kurt Weill and Lotte Lenya, New York was instantly and instinctively "home." But unlike Seidl, Weill, or Lenya, Varèse did not have resounding Old World successes to remember or forget. His baggage upon arrival was neither a rudder nor a burden. He truly could begin anew.

The "Margin of the unGerman" of my chapter heading appropriates a phrase coined in 1903 by the visionary American composer Arthur Farwell to designate indigenous materials that might overthrow the "Teutonic domination" of American music. Farwell had in mind cowboy songs, "Negro melodies," and Native American chants that could inspire a distinctive American concert idiom.[3] I have in mind Slavic and Gallic musical immigrants, in contradistinction to all those from Germany and Austria—the Central European musical heartland—we have just surveyed. One result is an unusually short chapter—the Teutonic domination held. Another, however, is the emergence of three musicians—two conductors and a composer—who, more than any from German-speaking lands, fostered distinctive classical music achievements in the New World, achievements remarkably distant from Europe.

Significantly, none of the three embodies a pure Slavic or Gallic infusion. Rather, their blurred cultural identities proved conducive to further modification. Of the conductors, Leopold Stokowski was an ersatz Slav born in London. Serge Koussevitzky was—like Balanchine, like Stravinsky—a Russian who as cultural interloper journeyed west and connected with Diaghilev's Paris.

Varèse, born in Paris in 1883, was and was not "French." He detested his father, whose family was part Italian. He attached himself to maternal relatives in Burgundy—a region he considered "Germanic." What his wife termed his "search for more acceptable forbears" led him to surmise roots in Corsica. Temperamen-

ARTISTS IN EXILE

tally, he felt close to Russians. He identified as possible musical ancestors the Italians Fabio Varese and Giovanni Baptista Varese—and it was to Turin that his father moved the family in 1893.[4] Back in Paris as a young adult, he fell out with such distinguished but traditional pedagogues as Vincent D'Indy. Next in Berlin, he submitted to the powerful influence of Ferruccio Busoni. In Paris again, he allied with Debussy, Satie, Apollinaire, Cocteau. He placed all his extant music, bearing titles in both French and German, in a warehouse, where it perished in a fire. His tone poem *Bourgogne*, which survived, he later destroyed, so that his compositional legacy would start with his first American work—whose title was *Amériques*.

The move to the United States occurred in 1915. The New York that Varèse encountered was in the throes of aesthetic rebellion, of artistic energies suddenly unleashed. The Armory Show of 1913, with its infamous *Nude Descending a Staircase,* remained a fresh memory. Greenwich Village was astir. All his life, Varèse congregated with painters and writers rather than musicians. His New York friends and acquaintances would include Marcel Duchamp, Francis Picabia, Fernand Léger, and Man Ray, as well as certain Americans including the sculptor Jo Davidson, the painters John Sloan and Joseph Stella, and the sculptor Alexander Calder.

His American career began abortively, as a symphonic conductor in New York and Cincinnati. Was Varèse an exceptional conductor? Impressions vary. But with their obdurate doses of Busoni, Satie, and Bartók, his programs proved unacceptable. No less than Alfred Stieglitz, with his exhibitions of new European and American art, Varèse aspired to press toward a new artistic climate for Manhattan. He would also have been aware of Duchamp's Société Anonyme, founded in New York in 1920, whose six-week exhibitions featured the likes of Picabia, Braque, Gris, Picasso, Kandinsky. But Varèse's temperament—he was "incapable of compromise and unable to endure boredom," writes Louise

Varèse[5]—was an obstacle. His efforts required a smaller, more selective forum—something more along the lines of the Society for Private Musical Performances Schoenberg founded in Vienna. He needed more to operate among adherents. He hit stride in 1921 with the International Composers' Guild, whose six-year history comprised the most personally and professionally satisfying chapter of a long and chequered American sojourn.

A key Varèse ally was the harpist/composer Carlos Salzedo, born in France in 1885 and a New York resident from 1909. He had pioneered in expanding the repertoire and technical capacity of his instrument; he also possessed a pragmatic organizational acumen unknown to Varèse. It was with Salzedo that Varèse cofounded the ICG. A third crucial collaborator was Mrs. Gertrude Vanderbilt Whitney, who with her secretary Mrs. Juliana Force connected Varèse and Salzedo to money. Mrs. Whitney's main residence was an Edwardian mansion on Fifth Avenue. It was however of no small importance—not least to Varèse—that she was herself a sculptress whose Greenwich Village studio was a meeting place for artists. In 1931, she opened the Whitney Museum on West Eighth Street: her primary legacy. It was Mrs. Whitney—whose unhappy marriage impelled her to find personal outlets far from home—who in 1921 furnished Varèse with what Louise considered "an adequate allowance" for him "to go on with his plans." Varèse had been selling pianos at Wanamaker's department store. Louise writes:

> Of course I rushed home to tell Varèse that he could throw all those pianos out of his mind. At first he was inclined to be annoyed with me that I should go begging. . . . When I explained . . . he decided . . . he could give in to the relief he felt, hugged me, and said, "Let's celebrate." So he went out to buy wine and the makings of his *boeuf bourguignon*—no, that would have required overnight marinade—it must have been *veau*

marengo. At any rate, that night we ate and drank and got a little drunk and made love and afterward Varèse talked and talked—then *magic blazed*, to steal the words of a poet, not having any of my own to describe the power Varèse had to cast radiance over being alive. And it had nothing to do with the stimulation of our erotic moment, more gay than passionate. It was Varèse's seriousness that was passionate. . . . Even his rages were wild dithyrambs. At least they were not prose.[6]

The ICG manifesto vowed to "centralize the works of the day"; it disapproved "of all isms" and denied "the existence of schools," recognizing "only the individual." Of course, Varèse and Salzedo were not the only American proponents of a new music. Dvořák's crusade of the 1890s had produced in Arthur Farwell a pioneering "Indianist" whose *Navajo War Dance* No. 2 (1904) amassed a Bartókian dissonance and density. Charles Tomlinson Griffes—whose exotic allure and savage intensity Varèse evidently admired—would have become a leading force had he not died in 1919 at the age of thirty-five. The wild men of the 1910s were Leo Ornstein, whose keyboard specialties included *Suicide in an Airplane* (1913), and Henry Cowell, who pummeled the piano with his fists. The profounder heresies of Charles Ives were not yet known. But the dominant musical modernists emerging in the United States connected not to these currents, but to France and Nadia Boulanger. For Aaron Copland and kindred Francophiles, Stravinskyan neoclassicism marked "the margin of the unGerman." Copland's *Music for the Theatre* (1925) and Piano Concerto (1927), both premiered by Serge Koussevitzky's Boston Symphony Orchestra, were landmark efforts in defining a new American voice freshly attuned to jazz and yet accessible (if barely) to mainstream high-art audiences and institutions of performance.

Varèse detested neoclassicism for its safe Eurocentric moorings. Stravinsky's elegant strategies of ironic absorption—of Bach,

of Tchaikovsky, of Woody Herman—were anathema to his icono-clastic ideals. An imposing and provocative physical presence with flaming eyes and eyebrows, a withering and enraged propagandist, he played the role of heedless interloper, unshackled by allegiance or deference to refined Old World practice. He called American orchestras "mausoleums, mortuaries of musical reminiscences." He privately (but vociferously) denounced their illustrious guest soloists: "They don't give a [shit] about music, only their 'careers'—their interpretations." Upon encountering Arturo Toscanini at an ICG concert , he took part in a shouting match over the merits of contemporary music. According to Louise:

> When [Toscanini] shouted at Varèse that it was a disgrace to make people listen to the kind of music he not only spon-sored but wrote, Varèse met him temper to temper, insult for insult. It was quite a spectacle. From then on, the slight-est mention of Toscanini was like the *muleta* to a bull; Varèse charged. Toscanini, in his sweeping invective,. . . . had the mentality of a coiffeur and looked like one.

Quoting Busoni, Varèse maintained: "Music is born free; and to win freedom is its destiny." He welcomed America as a clean slate on which to inscribe "all discoveries, all adventures, . . . the Un-known." His antipathy to neoclassicism was both visceral and per-sonal: in private correspondence he blamed Copland and his gay male associates for crowding out composers "healthy and white."[7]

The formation of the League of Composers in 1923 signified a rift with and about Varèse. As Copland put it, "The competition between the International Composers' Guild and the League of Composers was such that a composer could not be allied with both." And yet the two organizations had comparable transatlantic man-dates. They both invaluably presented important new music that would not otherwise have been heard: they sponsored Stravinsky

and Schoenberg as well as contemporary Americans. They both began in tiny theaters and progressed to more mainstream venues. They both acquired famous conductors, in particular Stokowski (who led both ICG and League concerts) and Koussevitzky (who only conducted for the League). In terms of American repertoire, both groups were eclectic. The ICG significantly ignored Copland, Virgil Thomson, and Roy Harris—all onetime Boulanger students in France. After the inception of the League, the number of Americans on ICG programs diminished significantly. Upon disbanding the ICG Varèse declared its mission accomplished, leaving "to other organizations the purely managerial task of continuing to entertain a public which now takes pleasure in hearing (thanks to its new ears) the works of its young contemporaries." Privately, he confided that ICG concerts had become "routine like—a snobs' affair—too fashionable and established: no more fighting." It is also true that in terms of audience numbers and frequency of performance, the League had proved a greater success.[8]

If Varèse emerged as a father figure for the American radicals who came to be known as "ultra-moderns," it was partly a function of his seniority and pugnacity. The ultras—conspicuously including Cowell, Carl Ruggles, Dane Rudhyar, and Ruth Crawford Seeger—shared a willful individualism that ensured a range of styles. For the most part, their music was fearlessly dissonant. Its intensities were often visionary. They had no use for populism and required listeners to fend for themselves. They spurned a mentoring reliance on Europe. As it happens, Varèse had no special affinity for the actual music of his American colleagues.* He admired

*But late in life he took an interest in jazz. A venerated figure in the New York jazz community of the late 1950s, Varèse took part in a series of 1957 afternoon "jam sessions" including the trumpeter Art Farmer and the saxophonist Teo Macero. The music historian Olivia Mattis has argued that the "head arrangements"—a kind of collective improvisation—pursued on these occasions directly influenced the "open-ended" compositional methodology of Varèse's *Poème électronique*. (See Mattis, "From Bebop to Poo-wip: Jazz Influence in Varèse's

Ruggles and, later, Ives for their curmudgeonly independence as personalities and composers; as a European, he also found them lacking in craft. What clinched his reputation as a standard-bearer was not his influence or advocacy, but his actual music and the gratifying uproar it produced.

IN THE SUMMER OF 1922, Varèse sent the score of *Amériques* (1918–1921) to Leopold Stokowski. Stokowski was a devotee of the new, and yet—owing to his glamour and the glamorous sound of his Philadelphia Orchestra—enjoyed an ardent popular following; in the annals of twentieth-century American classical music, no other conductor of comparable eminence has been so associated with challenging contemporary fare. Stokowski wrote back to Varèse, "I am eager to study it as soon as I am less busy." When Varèse heard nothing further, he wrote to Louise: "Stokowski, the swine, hasn't answered my letter. Better not say anything. No use pestering him. I myself will ask Stokowski to return the score—and *merde pour lui.*" Finally, in November, Stokowski wrote: "I fear it will be a long time, before I shall be able to come to your work. . . . Personally I regret this very deeply but the [Philadelphia Orchestra] Committee is not able to give me free hand in this matter for financial reasons."[9]

Stokowski would in fact conduct the premiere of *Amériques*—in 1926. But he first led two shorter Varèse scores: *Hyperprism* (1922–1923), in 1924, and *Intégrales* (1924–1925), in 1925. The former was not a premiere; Varèse himself had led the first performance at an ICG concert in a small hall. It was Stokowski's performances, in Philadelphia and New York, that catapulted Varèse to a public no-

Poème électronique, in Felix Mayer and Heidy Zimmermann, eds., *Edgard Varèse: Composer, Sound Sculptor, Visionary* [2006].)

toriety he could only have adored. At Carnegie Hall, Stokowski opened the second half of the program with three excerpts from Berlioz's *Damnation of Faust*. Then the stage was cleared for nine wind and brass players plus a percussion battery including a siren. A program note by the composer—"I should prefer to say only that the title has a geometrical connotation and implies a fourth-dimensional significance"[10]—gave scant warning for what was in store.[11]

The four-minute duration of *Hyperprism*, then as now, in no way correlates with its impact. A deafening percussion onslaught comes first, with the siren wailing discreetly in the background. A tenor trombone stutters and slides on a single note, reinforced by a horn swelling to maximum volume on the same pitch. Tambourine, cymbals, and Chinese blocks beat a sporadic march. Slabs and shards of sound are stranded or piled atop one another amidst a cacophony of rattles, drums, slap sticks, and sleigh bells, not to mention the seismic intrusions of an anvil and a gong. Rather than interacting, the various timbral components maintain a savage and impervious autonomy. Stokowski's Carnegie audience did not respond with indifference. Many tittered. Others applauded vociferously. The critics found it all appalling or liberating. Henry Finck, an old-timer, yearned for the day "when all [such] compositions will be swept violently down a steep place into the sea." Olin Downes of the *Times* was reminded of "election night, a menagerie or two, and a catastrophe in a boiler factory." For Lawrence Gilman, in the *Tribune*, *Hyperprism* was "lonely, incomparable, unique." Frank H. Warren was impelled to compose a poem for the *Evening World*:

> 'Twas the week before Christmas, in Carnegie Hall
> Not a critic was stirring; from every box stall
> Stokowski adherents had lauded the swank
> With which the conductor had led César Franck
> And every one heeding the Stokowski rap

Had just settled back for a good Philly nap
When out on the air there arose such a clatter
We sprang from our seats to learn what was the matter
And up from the program—were all going crazy?
Jumped *Hyperprism*, offspring of Edgar [*sic*] Varèse.[12]

The victims and beneficiaries of *Hyperprism* were reacting to a calculated and calibrated sonic assault—sheer noise, even from a tuxedoed concert orchestra, could never have excited such controversy. Varèse had done away with traditional harmony and developmental structure. He himself characterized his idiom as a "collision and penetration of sound masses." Busoni's futuristic espousal of an "absolute music," without boundaries or divisions, was not irrelevant. And, like Busoni in his writings, Varèse was intent upon finding new sounds. Though the siren of *Hyperprism* doubtless appealed to the composer for its shock value, it equally furnished a singular glissando machine. And its evocation of urban density and commotion was, if incidental, unignorable. The sirens of New York, the shrill whistles of its harbor, the massive cement blocks of its avenues, are all "sounded" in *Hyperprism*. Its impersonality is a reckonable force. If Manhattan is an obvious point of reference, so too are ancient, primal places, or new planets. Charles Martin Loeffler (whom we have briefly encountered as an earlier immigrant composer of exotic bent, and like Varèse a devotee of the pre-Baroque) was interviewed by *Musical America* and said:

> I was fortunate enough to hear the Philadelphia Orchestra when they played Varèse's *Hyperprism*. It would be the negation of all the centuries of musical progress to call this music. Nevertheless I seemed to be dreaming of rites in Egyptian temples, of mystic and terrible ceremonies which history does not record. This piece roused in me a sort of subconscious racial memory, something elemental that happened before the beginning of recorded time.[13]

ARTISTS IN EXILE

A season later, Stokowski had to encore *Intégrales* at Carnegie Hall. Then came the deferred premiere of *Amériques,* scored for fifty-six woodwinds in addition to percussion and—a rarity for Varèse—a conventional complement of symphonic strings. Stokowski's orchestra numbered 142 players. There were sixteen rehearsals. Varèse's title referred not to the United States specifically but to "new worlds" on earth, in space, in the mind. But compared to *Hyperprism* or *Intégrales, Amériques* also evoked older worlds: of Debussy and *The Rite of Spring.* At the same time, Stravinsky's violence and primitivism connect to pagan Russia. And, as in *Hyperprism,* Varèse's siren instantly signals contemporary urban mayhem. The climactic final measures verily evoke— in the words of an anonymous New York critic—"the Fire Department and the Pneumatic Riveters' Union." More than ever, audiences were part of the show. Genteel Philadelphians hissed and booed. In New York, W. J. Henderson of the *Sun* timed a demonstration lasting more than five minutes: "Some men wildly waved their arms and one was seen to raise both hands high above his head with both thumbs turned down, the death sign of the Roman amphitheater." Of the other critics, Olga Samaroff opined: "Mr. Stokowski, who has a distinguished record in the matter of introducing important new works, could scarcely have done anything more detrimental to the cause of modern music than to produce a composition like *Amériques.*" Paul Rosenfeld, ever the diehard modernist intellectual, countered in *Dial*: "It is possible that in Edgard Varèse we have another virtuoso genius with the orchestra in his veins."[14]

Stokowki's final Varèse premiere, *Arcana,* in 1927, proved an anticlimax. At least for the moment, the wave had crested. The Pan American Association of Composers, which Varèse next helped to form, did not have the American impact of ICG; some of its important concerts—including the European premiere of Ives's *Three Places in New England*—took place in Paris and Berlin. After *Density*

21.5 (1936), a four-minute work for solo flute, Varèse completed nothing for nearly two decades. His search for new sounds had led him to electronics, but he could not obtain suitable funding or facilities. This episode in his creative odyssey might have proved quixotic but for the gift in 1953 of an Ampex tape recorder. The result was a landmark composition for two-track tape, winds, piano, and percussion: *Déserts* (1949–1954). The title refers both to "deserts in the mind of man" and to physical deserts, including "empty city streets." The electronically processed sounds included those of factories—hissing, grinding, puffing—visited by the composer. Other sounds were floating intergalactic particles, resonating in a void. *Poème électronique* (1957–1958), Varèse's last completed composition, emanated from 425 loudspeakers at Le Corbusier's Philips Pavilion (since destroyed) at the 1958 Brussels World's Fair. This was a commission registering Varèse's reemergence in the 1950s as a venerable master, honored by composers as diverse as John Cage, Pierre Boulez, Karlheinz Stockhausen, Iannis Xenakis, and Frank Zappa. He was elected to the National Institute of Arts and Letters in 1955. He died in New York, an American citizen since 1926, in 1965. His ashes were scattered by his wife.

Varèse would complain about Manhattan and about America—about the intrusiveness of the almighty dollar. But he could not live anywhere else. His apartment at 188 Sullivan Street, as Louise would recall, became "his own loved anchorage," "something in the nature of a shrine visited by curious pilgrims." He knew his Greenwich Village neighborhood (with its pronounced European accent) and he knew his neighbors. He studied the chessboards at Washington Square Park and was everywhere familiarly addressed as "Professore." He took an interest in the Greenwich House Music School and the New School for Social Research, both nearby. "He was very French as a personality," remembers his longtime assistant and protégé, the Chinese-American composer Chou Wen-Chung. "The moment he spoke French he became a different

person. His English, as he said himself, was learned from gangsters in Little Italy. And he *loved* going back to Paris. I asked him once—would you like to live there? '*No!*' In fact, what is exceptional about Varèse's case as an immigrant is the degree to which he integrated into his surroundings, his commitment to communal involvement. Despite his heavy French accent, despite being French to the core, he intermingled. In the summer, Louise would spend months in the country; Varèse would have to be driven back to Manhattan after a few days. He loved New York, absolutely."[15]

And the American influence on Varèse's music was, as Chou confirms, decisive. Though we do not know what his other pre-1915 works sounded like, there is a surviving Impressionistic song, "Un grand sommeil noir" (Verlaine) from 1906. *Offrandes* (1921), like *Amériques*, echoes with Stravinsky and Debussy. If, as Chou infers, *Amériques* was actually begun sometime before Varèse left Paris, so much more may the American experience be credited with an expunging of nostalgia, and other emanations of the ego, from Varèse's ideal of "organized sound." The screeching whistles, grinding subways, and deafening jackhammers of his composer's world tapped a Manhattan symphony not heard in Paris or Berlin. "Varèse has come into relationship with elements of American life, and found corresponding rhythms within himself set free," wrote Rosenfeld in 1925. Rosenfeld also found "American" Varèse's "grandiosity." However implausibly—he was a man of prejudices as strong as his principles—Rosenfeld even considered Varèse more American than Gershwin.* Varèse himself said that "American music must speak its own language and not be the result of a certain mummified European formula." Of *Amériques* he

*Gershwin himself wrote of the musical influence of the "rhythms and impulses" of "Machine Age America," citing his use of taxi horns (in *An American in Paris*) and George Antheil's use of airplane propellers. (See Merle Armitage, ed., *George Gershwin* [1938], p. 225.)

wrote, "The theme is a meditative one, the impressions of a foreigner as he interrogates the tremendous possibilities of this new civilization. . . . It is the portrayal of a mood in music and not a sound picture." (Of Dvořák's foreign impressions in the *New World* Symphony, W. J. Henderson wrote in his 1893 *New York Times* review, "the [first] movement throbs with activity, flexibility of emotion, and energy.")[16]

The influence of Varèse has proved significant, if mainly intangible. None of the American ultra-moderns, even those most compatible with Varèse in spirit, wrote music that resembles *Hyperprism* or *Intégrales*. His disciple Chou and longtime student Colin McPhee, composers of consequence, do not sound like one another or like Varèse. But it cannot be mere coincidence that they were both notable scholars of non-Western music. Chou undertook a concentrated study of Chinese traditional music (not before, but after arriving in the United States in 1941). McPhee became the leading Western authority on Balinese gamelan. Chou calls Varèse the "first inter-cultural composer"—not merely because aspects of *Déserts* happen to evoke Japanese imperial court music, but because the shedding of Western stylistic referents, of Western harmony and form, link in Varèse to an exploration of sound as such—an exploration that connects to non-Western traditions and otherwise transcends cultural boundaries. However incidentally, Varèse's example both influenced Chou's aesthetics and supported Chou's resolve to investigate his own Asian musical roots.[17] A tidal force, Varèse pedigreed a new world of music not by means of ignoring the Western canon, as in the case of a Ruggles, Cowell, or Cage, but through having acquired and discarded its powers of orientation. Just as Dvořák validated "Negro melodies" as no American could, Varèse's repudiation of neoclassicism and serialism, symphony and opera, validated nascent "intercultural" norms with a transatlantic authority no American could possibly possess.

Leopold Stokowski as he looked in 1912—the year he took over the Philadelphia Orchestra. He claimed to be 25 years old but was actually 29.

VARÈSE FREQUENTLY GAVE PRESENTS to Leopold Stokowski in gratitude for Stokowski's attentions. One of these, for Stokowski's daughter Sonya, was a large doll in Polish costume. Some time later, Stokowski was hosting the Polish ambassador to the United States. He produced the doll and said: "Was it not charming, the people in my family's village sent me this wonderful doll—an authentic costume, is it not?"[18]

What is chiefly illuminating about this anecdote, told by Louise Varèse, is that both Louise and Edgard were within earshot of Stokowski's little story—and that Stokowski evidently did not

care. The pianist Abram Chasins, who knew Stokowski better than most, confirmed that Stokowski "really did believe his fantasies when he recounted them."[19] He improvised moment to moment; "truth" and "fact" became fluid narrative ingredients. The fantasies Stokowski felt the need to invent and believe were a kind of aesthetic pastime. When he had something to hide, they could also be a pragmatic strategy.

Part of the Stokowski mystique—or, as some would have it, a dimension of his fraudulence—were his blurred origins. He sometimes claimed to have been born in Kraków in 1887, or said that his family came from "Stoki" or "Stokki" near Lublin. He told one historian of the Philadelphia Orchestra that his Polish paternal grandfather took him to a London club where songs from the old country were sung and played with great feeling; later, Grandpa presented little Leopold with a half-size violin. In fact, Stokowski's grandfather died in 1879—three years before Stokowski's actual birth date. Stokowski told his third wife, Gloria Vanderbilt, that he was sent to England after the death of his Polish mother, Maria. He told his second wife, Evangeline, that his mother was a swan.[20] Actually, Annie Marion Moore, daughter of an Anglo-Irish bootmaker, gave birth to Leopold Anthony Stokowski—not "Leopold Antoni Stanislaw Boleslawowicz Stokowski"; not "Leo Stokes," as some wags maintained—in London; her husband, Joseph Stokowski, was a cabinetmaker.

According to Leopold's brother, Polish was never spoken at home. The maestro's exquisitely exotic pronunciation and syntax were another personal concoction. No other native speaker of English ever uttered such words as *geerahf, archeev, meekraphone, seckological, Eedaho,* or *Hoostohn.* And the accent was itself erratic—which is to say, adaptable. If "Praga" were under discussion, sounds vaguely Czech might materialize. Under stress, the Stokowski accent was even known to veer toward London's lower-middle-class Marylebone district.

Equally untraceable was his singular calligraphy; the Stokowski signature was powerfully incongruous. Cuisine, too, was a Stokowski sideshow. He was known to combine as many food items as possible on his plate, then mix them into a pâté and eat everything with a spoon. He enjoyed drinking pineapple juice sweetened with heavy cream and honey, and secretly spiked with pure grain alcohol. His taste in decor included, in Philadelphia, a chartreuse living room with Navajo rugs, and, in New York, a numberless one-handed clock. He was rumored to have slept with Greta Garbo, with whom he traveled abroad, and with Curtis Institute students whom he called his "nurses." No portion of the Stokowski story was as blurry as his training and professional experience before arriving in the United States. He was, truly, a graduate of the Royal College of Music. That he studied conducting with Arthur Nikisch in Leipzig was a possible invention. An invention of another kind was his debut as a symphonic conductor—an event manufactured for him by the pianist Olga Samaroff, who (having been born Lucy Hickenlooper in San Antonio) knew a thing or two about manufacturing. This was in Paris in 1909, when she appeared with the Colonne Orchestra and the scheduled conductor was indisposed. Stokowski was named music director of the Cincinnati Symphony five days later. He married Samaroff two years after that. He was not yet thirty.

These details would be merely entertaining had not Stokowski's historic tenure as music director of the Philadelphia Orchestra been manifestly part of the same sui generis project. Though Philadelphia already had an orchestra when Stokowski arrived in 1912, he created it anew. No less than Stokowski's accent could the lineage of his Philadelphia Orchestra be documented or otherwise accounted for. The winds were not unknown to sit up front, under the conductor's nose. The strings were sometimes massed entirely to the left. And Stokowski, in search of a seamless musical line oblivious to differentials in bow pressure, disallowed the

uniform up-and-down bow strokes elsewhere considered normal. On one occasion he darkened the stage at the Academy of Music but for a single spotlight on his fluid hands. It also served to illuminate the artful disarray of his pale hair. This last experiment was discontinued, but unorthodox seating plans and "free bowing" were not. The resulting spectacle was both visual and sonic: an aural fantasy come to life. The satin finish of the "Philadelphia sound," its majestic swells and recessions and lavish color displays, the tensile strength and cantabile of its lava flow, were commanded by a hypnotic podium presence enforced by icy blue eyes. "The finest orchestra the world has ever heard," Rachmaninoff called it—and he was not alone.

Like his cuisine, the Stokowski sound was a pâté of ingredients smoothly blended. So, too, were his interpretations unconnectable with known traditions, whether German, French, or Russian. As he ceaselessly reseated his orchestra, he tinkered repeatedly with even the most hallowed or familiar scores, abridging or expanding, adding or subtracting notes, parts, or passages. His once-popular 1934 recording of the *New World* Symphony fashions a new world in some ways different from Dvořák's. A typical Stokowski touch, on the opening page, is to distend the third and fourth horn parts so that their call overlaps the answering woodwinds. (The same procedure may be observed in measure nine.) In the Largo, he compresses the climax by eliminating a measure (just before the final Meno mosso). In the last movement, the culminating *fff* peroration is punctuated by an interpolated cymbal crash. The most Stokowskian intervention occurs at the close of the Largo. Dvořák here writes a chord high in the strings, followed by a moment's silence and then—a famous inspiration—two whispered four-part chords in the double basses. Stokowski adores the stratospheric string sonority—a Philadelphia specialty. So he sustains it all the way through, diminishing to a barely audible *pppp* while the double basses speak.

Conductors of the early twentieth century were not slaves to the text—a Mahler or Weingartner might reassign notes to take into account the capacities of modern instruments, or to clarify a muddy texture. Stokowski's changes are of a different order. A sonic sybarite, he craved the intoxicating fluidity of symphonic sound. Time and again, he violates a notated rest to achieve a seamless line.★ If he went elsewhere to conduct the *New World* Symphony, his *New World* Symphony—the conductor's score, the individual instrumental parts—went with him. The parts would be collected after every rehearsal and performance—never to be taken home, never to be shared or copied. Such Merlin-like flights of fantasy as the Largo's opulent fade-out were his magic tricks.

Naturally, the Stokowski repertoire was unique. A master showman, he made the Philadelphia Orchestra's national reputation by staging—there is no other word for it—the triumphant American premiere of Mahler's Symphony No. 8, the "Symphony of a Thousand," in Philadelphia and New York in 1916. He had heard Mahler conduct the first performance in Munich in 1910, an experience he likened to being "the first white man to behold Niagara Falls." Nine hundred and fifty choristers were engaged, in addition to an orchestra of 110 and 9 vocal soloists. For the American premiere of Schoenberg's *Gurrelieder*, in 1932, Stokowski employed 532 performers. For the American premiere of Berg's *Wozzeck* in 1931, he scheduled eighty-eight preparatory rehearsals and sixty stage rehearsals. All three occasions were both musically historic and sensationally entertaining. Stokowski relished the shock value of wild men like Varèse, Cowell, and Ornstein. He savored the hedonistic indulgences of Scriabin and of the American aestheticists Griffes and Loeffler. With his Slavic name and exotic trappings, he of course specialized in Tchaikovsky, Rimsky-Korsakov, Mussorgsky, Rachmaninoff, Stravinsky, Shostakovich.

★Pianists uncontroversially do this by applying the sustaining pedal.

He did little Mozart. But his predilections could not be summarized as "Russian," versus "German" or "French." He left memorable Philadelphia recordings of Beethoven's Fifth and Brahms's First. He paid special attention to Schoenberg. He was unsurpassed in the riotous festivity of Berlioz's *Roman Carnival* Overture and the evanescence of Debussy's *Nuages*. He led more important American premieres than any other conductor of his time. He was most fully himself in Bach and Wagner: his own transcriptions of the Passacaglia and Fugue in C minor or the D minor Toccata and Fugue, his own symphonic syntheses of *Tristan und Isolde*, allowed him maximum license to revel in his orchestra's voluptuous appetites.*

A final Stokowski incongruity: notwithstanding his glamour, which rendered him remote, and his repertoire, which as often as not antagonized and provoked, Stokowski was a populist. His unassuming parentage and patchy education—he never advanced beyond grade school prior to enrolling in the Royal College— predisposed him toward cloudy visions of cultural democracy. He was himself self-made. "Formerly music was chiefly confined to privileged classes in cultural centers, but today, through radio and records, music has come directly into our homes no matter how far we may live from cultural centers," he wrote in *Music for All of Us* (1943). "This is as it should be, because music speaks to every man, woman, and child—high or low, rich or poor, happy or despairing—who is sensitive to its deep and powerful message." Stokowski's powerful message was reinforced by speeches from the podium, exhorting or rebuking reluctant listeners. He delighted in his Philadelphia Young People's Concerts—for Saint-Saëns's *Carnival of the Animals*, he produced a young elephant, whom he

*Audio engineers from the state-of-the-art Bell Labs notably documented the Stokowski sound in live performance—e.g., a one-of-a-kind November 1931 Beethoven's Fifth, available as part of the Philadelphia Orchestra's twelve-CD "Centennial Collection."

led onstage by the ear. Convinced that "most adults have difficulty absorbing ideas," he also created Saturday afternoon Youth Concerts for audiences aged thirteen to twenty-five. His Youth League members chose repertoire, designed posters, and as "bouncers" evicted overage listeners. A New World original, he challenged routine at every turn.

STOKOWSKI'S PHILADELPHIA ORCHESTRA WAS not for everyone. There were musicians who found fault with his self-made skills—he lacked the keen ear for wrong notes of a Toscanini or Reiner. For some music lovers, his wizardry held hostage issues of taste; for others, issues of taste prevailed: he was a vulgarian, a desecrator. Many Philadelphia subscribers were alienated by his repertoire excursions. In 1933, when he had his Youth League sing the "Internationale" (in French!), he was denounced by patriots. When rumors of an impending marriage to Garbo circulated in 1937 even before Evangeline divorced him in Las Vegas, he enraged moralists. By 1936, Philadelphia and Stokowski had perhaps exhausted one another. He resigned in a bitter fight with the board, returned in a reduced capacity, then quit for good in 1941.

Among Stokowski's frustrations in Philadelphia were the board's refusal to support or secure a foreign tour or a regular radio showcase—perquisites enjoyed by Toscanini and his New York Philharmonic. Stokowski had for some years set his sights on Hollywood. It seemed a logical destination. He could there propagate music for the masses. And he was of course seduced by the glamour of southern California: its cinema celebrities, with their fabricated names and mysterious personal histories, were kindred spirits. In fact, Stokowski had already appeared in two Hollywood films: *The Big Broadcast of 1937* (1936) and *100 Men and a Girl* (1937). He next inspired Walt Disney—also self-made, also a self-styled popularizer and educator—to produce a two-hour cartoon feature setting

Stokowski-conducted selections by Bach, Beethoven, Schubert, Ponchielli, Mussorgsky, Tchaikovsky, Dukas, and Stravinsky. In *Fantasia* (1940), Stokowski famously shook hands with Mickey Mouse. *Time* commented: "Deciding to go the whole artistic hog, [Disney] picked the highest of high-brow, classical music. To do right by this music, the old mouse opera comedy was not enough. The Disney studio went high-brow wholesale, and Disney technicians racked their brains for stuff that would startle and awe rather than tickle the audience." In 1945, Stokowski became music director of the Hollywood Bowl. His "Symphonies under the Stars" included Beethoven's Ninth with a chorus of one thousand, opera arias sung by Jeanette MacDonald, an "Academy Night" showcasing motion picture composers, and a Gershwin Memorial. There was talk of casting Stokowski as Beethoven in the movies, or as Wagner. But, save a cameo in *Carnegie Hall* (1947), Stokowski made no more films. He quit the Hollywood Bowl. And Disney nixed the *Fantasia* sequel Stokowski anticipated. Stokowski's Hollywood proved a delusion. Hollywood at best mediated between popular culture and art. Stokowski's dream of a democratized high culture was not Hollywood's dream.

Back in New York, it remained David Sarnoff's dream. Born in a Russian shtetl, a self-made magnate, he saw his National Broadcasting Corporation as an agent of mass enlightenment and to that end had in 1937 created an NBC Symphony expressly for Arturo Toscanini. When Toscanini—who bristled at corporate economies much as Stokowski detested frugal Quaker City moralists—abruptly resigned in 1941, Sarnoff hired Stokowski to take his place. Stokowski's reinvention of the NBC Symphony was swift and predictable: challenging new music, challenging American music, supplanted the Toscanini Old World canon Sarnoff also revered. Toscanini's health and "state of mind"—factors cited in his resignation letter—quickly improved. He was reinstated; in 1944, Stokowski was out. In parting, he preached this futile sermon:

If I am an acceptable American conductor who enjoys bringing music of American composers to the American public, it would seem fair that I should have the same consideration as a conductor who has not made himself an American citizen and who very seldom plays American music. . . . The people of the United States have the right to hear the music being composed by young talented Americans as well as all the great music of all countries composed by great masters. The radio stations are permitted by the Government to use certain wavelengths. This gives the radio stations privileges and also *demands* of them to fulfill their *responsibilities* to the American people.[21]

Other short-lived Stokowski directorships included the New York Symphony, the All-American Youth Orchestra, and the Houston Symphony. He expected to be named music director of the New York Philharmonic but was not. In 1962 he founded the American Symphony orchestra at Carnegie Hall. Among his infrequent guest appearances with the major American orchestras was a Boston Symphony program on January 13, 1968. The broadcast recording includes one of the most thrilling Tchaikovsky performances ever documented in sound: a *Hamlet* Fantasy Overture of such lightning velocity, hair-trigger intensity, and opulent upholstery—the plush but tensile string choir is not remotely Bostonian—that a fringe exercise is refashioned as a Romantic masterpiece. Reviewing this astonishing event, which also included Mozart's *Don Giovanni* Overture with Stokowski's own ending, Mussorgsky's *Boris Godunov* in Stokowski's own synthesis, and Beethoven's Symphony No. 7 with Stokowski's special abridgements,* the critics of Boston's *Herald-Traveller* and *Morning Globe* did not think to marvel that their august ensemble was

*The Tchaikovsky and Mozart performances are included in the Boston Symphony's twelve-CD "Centennial Celebration" collection.

mainly entrusted not to a Stokowski, but to Erich Leinsdorf—like Stokowski's Philadelphia successor Eugene Ormandy, a musician as surely destined for posthumous oblivion as Stokowski would survive a legend; instead, their reviews regretted the editorial liberties to which he felt entitled.[22] Incredibly, Stokowski's career had peaked in Philadelphia more than a quarter century before. He had imagined himself the king of music, only to discover he had merely been Philadelphia's embattled king. In Hollywood and New York, Disney and Sarnoff, masters of the entertainment business, were Stokowski's masters.

In his letter to Sarnoff, Stokowski had declared himself an "American." What kind of American was he? He had waited until 1914 to apply for naturalization papers in Cincinnati. He and Olga were vacationing in their villa outside Munich when Archduke Franz Ferdinand was assassinated at Sarajevo. As a Briton, Stokowski would have been interned as an enemy alien had he and Olga not fled: theirs was the last train to cross the German border. Even though he had lived in the United States since 1905, Stokowski was essentially exiled in America because of World War I. His American citizenship was secured in 1915. And yet, according to Nancy Shear, who as Stokowski's personal orchestra librarian knew him as well as anyone after 1964: "If you asked him, he would never say 'I am an American'—it would have violated his image. But any other country would have been too small for him. America was his kind of place—energetic, young. And he loved youth."[23] Compared to Toscanini, whose denunciations of Mussolini and Hitler were militant, Stokowski could seem a quixotic patriot. But during World War II he led Red Cross and USO benefit concerts on both coasts, as well as army bands from Fort Dix, New Jersey, to San Pedro, California.

As with Edgard Varèse, Stokowski's pronounced cross-cultural affinities—in music, in decor, in food—also stamped him an American. Rudolf Serkin was American because he linked

with America's Teutonic musical past. Stokowski linked with America's—and music's—global future. For George Balanchine, for Erich Korngold, for Kurt Weill, all Americanized, the United States signified an incidental opportunity. For Varèse, the escapee, the New World was a necessary inspiration. For Stokowski, the New World was a necessary opportunity: nowhere else could he so completely have reconceived himself. In Britain, he would have been too close to his actual roots. In Eastern Europe or Russia, his putative Slavic roots would have lacked authenticity. As an immigrant to the United States, he could make himself seem as exotic or obscure as he pleased. He enjoyed maximum breathing room for his unfettered imagination.★

But if Stokowski's professional identity proved a lesson in creativity, his personal life suffered the costs of American rootlessness and self-invention. No less than the California screen idols he in so many ways resembled, behind his wizard's mask he was prone to insecurities Evangeline called "inconceivable." He had no confidants. His frequent banality of utterance—not to mention odd patches of ignorance—was cloaked, transformed, or excused by his accent and demeanor. When Glenn Gould mentioned playing Beethoven's Third Piano Concerto (in C minor) and Stokowski remarked, "Is that not the lovely concerto in G major?" Gould thought it "a superb gambit, and my first experience of the harmless games Stokowski liked to play while putting the world, as he would have it, in perspective for his interlocutors." When Vera Zorina introduced Stokowski to Marlene Dietrich in the 1930s and Stokowski inquired, "And you, my dear—are you in the ballet, too?" it was, again, impossible to know what was really going on.[24]

Stokowski, in his performer's trance, could not be addressed

★The European "Stokowski" was the Romanian expatriate Sergiu Celibidache (1912–1996), also a product of murky self-invention; like Stokowski, Celibidache controversially espoused sonic and interpretive ideals wholly his own.

en route to the podium from his dressing room. He did not know his Philadephia players' names, but referred to them by instrument as "bassoon" or "trumpet." They could speak with him by appointment only. His post-Philadelphia vicissitudes made him a vagabond; when he traveled through Philadephia by train (he feared flying), he would draw down the window shade.

The cost of his genius, of his challenging originality and remote authority, was solitude. Shear, who revered him as "the greatest influence on my life," witnessed numerous instances of Stokowski's generosity. She also recalls: "He spelled my name 'Nanci'—it was his way of dominating. No one in his presence could contradict him. Almost all his relationships were based on intimidation."[25]

In 1972 Stokowski, age ninety, made a decision that took Nancy Shear completely by surprise: he returned to Great Britain. Transformed into a country squire, he settled at a venerable homestead in Nether Wallop, near Salisbury. He undertook a series of concerts and recordings with London orchestras. In 1974 he reconnected with his brother, whom he had last seen in 1923 and whose existence he had long denied. Percy John Stock, a retired limousine service operator best known as "Jim," summarized for the world that "Leo was a quarter Polish, English, Scotch, and Irish." He also said, "My father did everything for Leo and spent what little money he had on his music. I am afraid my sister Lydia and I had to suffer, as there was nothing left for us." And: "I think he was ashamed at the way he had treated our family, and wanted to get in touch."[26]

Stokowski's tombstone in Marylebone Cemetery accurately records the dates "18 April 1882—13 September 1977." An inscription reads: "Music Is the Voice of the All." No place of birth or death is given. Soon after, a container loaded with the conductor's personal belongings was washed overboard en route from Britain to New York—and with it perished whatever answers to the mysteries of Leopold Stokowski it may have contained.[27]

Serge Koussevitzky at Tanglewood with his surrogate American sons Leonard Bernstein and Lukas Foss (1940).

SERGE KOUSSEVITZKY WAS BORN in an obscure Russian village in 1874. He moved to Moscow to study music at the age of fourteen and was there baptized a Christian—as a Jew, he otherwise would have had to leave. Only double bass and trombone were taught without tuition; Koussevitzky chose the double bass. Upon graduating from the Philharmonic Institute he joined the Bolshoi Theater Orchestra and acquired fame as—a near oxymoron—a double bass virtuoso. In 1905 he married Natalie Ushkov, heir to a tea merchant's fortune. This enabled Koussevitzky to quit the Bolshoi and move to Germany, there to win further renown as an

instrumentalist and to study conducting with Arthur Nikisch. In 1909 he created a music publishing house; his clients eventually included Scriabin, Stravinsky, Prokofiev, and Rachmaninoff. The same year, he founded his own Moscow orchestra. After the Revolution, he took over the State Symphony in Petrograd.

Like Balanchine and Stravinsky, Koussevitzky wound up in Paris—in 1920. The French modernists exerted a potent influence, as did Diaghilev, with whom he competed for first performances of new Russian works. He again founded an orchestra of his own. The Concerts Koussevitzky famously showcased recent European and Russian novelties. The artistic climate favored what was new.

Like Balanchine and Stravinsky, again, Koussevitzky resettled in the United States, a Russian exile. This was in 1924, when he took over the Boston Symphony. The departure of Karl Muck and of numerous German players, forced by World War I, had destabilized the orchestra. A Frenchman, Pierre Monteux, presided over an uneasy transition further exacerbated by labor strife. Rather than renew Monteux's contract, the board opted for a more glamorous non-German.

From the first, Koussevitzky was a presence. Wealth and privilege—his marital trophies—had instilled in his persona an aristocratic ease and self-possession. Onstage, his bearing was magisterial. Even his bows were potently gracious; with students he used a full-length mirror to teach this subsidiary conductor's art. Backstage, he wore a cape. His speech was laced with malapropisms both exotic and comically endearing. Harry Ellis Dickson, a Boston Symphony violinist, enthusiastically transcribed and recorded such choice ejaculations as: "Gentleman, you play all the wrong notes not in time! And please make important, you play like it is something nothing!" According to Nicolas Slonimsky, Koussevitzky's Russian-born Boston assistant from 1925 to 1927, Koussevitzky's French was "lame, ungrammatical, and often unintelligible," his German ungrammatical and Yiddish-inflected. Slonimsky also

observed: "In all my lengthy association with Koussevitzky I never saw him read a book." But to Charles O'Connell, who produced Koussevitzky's Boston Symphony recordings for RCA, the conductor cut a worldly and cosmopolitan figure:

> He is one of the few musicians who can converse on subjects other than himself and music, and his dinner-table talk, whether we have been alone or *en famille*, has been invariably bright, and witty, sometimes profound, and always interesting. . . . He has a lively appreciation of the arts other than music, and from him I have heard more than one illuminating discourse upon the theater, upon modern architecture, serious literature, the science of advertising, the economic determination of history, the difference between a democracy and a republic. He has an extraordinarily keen political sense, particularly with respect to international affairs, but though his experience and achievement in many lands would qualify him as a world citizen, he is sincerely, warmly and intelligently American in his viewpoint and in his citizenship. In one of his dinner conversations he made it clear that he foresaw World War II more clearly than almost anyone I know.[28]

To his musicians, Koussevitzky was a tyrant whose lordly prerogatives churned stomachs and wounded egos.* His self-made skills—he was a notoriously poor score-reader and had trouble beating complex rhythms—were an additional source of stress. But Dickson was not alone in considering his leader the "world's greatest." Sheer force of personality forged a newfound sonic opulence. Koussevitzky instilled pride, zeal, love of music. Unlike Stokowski, unlike Toscanini, his was a paternal autocracy, imperi-

*Boston's was the last major American orchestra to unionize, a 1942 process in which Koussevitzky, not the management or the board, characteristically took the leading role. Before that, rehearsals could be called or prolonged at will.

ous but not impersonal. He worried that his players eat well and get sufficient rest. The same parental attitude shaped a larger mission to help American classical music grow up: he was an Old World father—most especially to young New World composers.

Already, in Paris, he had in 1923 met the twenty-two-year-old Aaron Copland. Copland was produced by his teacher, Nadia Boulanger. Given Koussevitzky's influential advocacy of new music—of Scriabin, Stravinsky, and Prokofiev; of Ravel and Honegger—Boulanger (as Copland would later recall) "took it for granted that he would want to meet a young composer from the country he was about to visit for the first time." Copland played a piano version of his *Cortège macabre* for Koussevitzky. Koussevitzky announced he would perform it during his first Boston season. The following year, upon disembarking in the United States, Koussevitzky asked reporters, "Who are your composers?" Following an embarrassed pause, a voice called out, "George Gershwin!" Koussevitzky was puzzled by this solitary response. The Copland *Cortège* duly appeared on Koussevitzky's 1924–1925 Boston programs. Koussevitzky's second Boston season included Copland's *Music for the Theatre*, his third the Copland Piano Concerto—music that shocked genteel New Englanders. In all, Koussevitzky programmed eleven Copland compositions in twenty-four Boston seasons. Copland told an interviewer in 1975:

> You can't imagine what it means to a young composer in his twenties, just starting out, to have the conductor of the Boston Symphony Orchestra interested in every note you put on paper. It wasn't just a question of performing music you had written with his great orchestra in Boston, but you knew that he was waiting, anxiously, for the next piece you were going to write. And he worried how you were going to earn a living while you were writing it. He found funds for it. And he genuinely created an air of excitement for the first performance, such as a composer

dreams about. And I got consistently bad reviews in the Boston press and he couldn't have cared less. He wasn't discouraged an iota about it. In fact he felt rather triumphant about it—he was going to stuff this down their throats whether they wanted it or not.[29]

Other Americans Koussevitzky tirelessly promoted included Samuel Barber, Howard Hanson, Roy Harris, Edward Burlingame Hill, Walter Piston, and William Schuman. As George Balanchine would create a dance company to Americanize classical ballet, Koussevitzky, convinced that "the next Beethoven vill from Colorado come," retooled an orchestra into a laboratory for American music. There was nothing dutiful about a Koussevitzky premiere. Elsewhere, Copland experienced "an atmosphere of distrust and indifference" when American works were introduced. For Koussevitzky, each untried composition was "a fresh adventure." The composer would be present for rehearsals and evening discussions. "Throughout the week conductor and composer may run the gamut of emotions from liveliest elation to darkest misgivings," Copland testified in a 1944 tribute. "But come what may, by Friday afternoon the work is ready for its public test. The conductor walks to the podium with a full sense of his responsibility to the composer and to the work. No wonder other premieres seem perfunctory by comparison!" Koussevitzky himself wrote: "I feel a rage and my whole body begins to tremble in a protest against conservatism and lack of understanding that it is the composer who gives us the greatest joy we have in the art of music."[30]

In Boston, Koussevitzky also specialized in the music of Russia and France. Of the immigrant composers, he favored Vladimir Dukelsky and Bohuslav Martinů, whose five symphonies were all products of his successful American years (1941–1953). It was Koussevitzky, too, who commissioned Bartók's Concerto for Orchestra and acclaimed it "the greatest since

Beethoven." Koussevitzky's relationship with Stravinsky was complex yet productive. An early debacle was the 1921 premiere of *Symphonies of Wind Instruments*, with Koussevitzky leading the London Symphony—a performance greeted by vigorous hissing. Stravinsky, in the *Weekly Dispatch*, blamed Koussevitzky for his "radical misunderstanding" of the piece, imposing "an external pathos." Koussevitzky responded in the *Sunday Times* that the work itself represented "a stage of decline in Mr. Stravinsky's art." Diaghilev wrote to Stravinsky: "As your *sincere* friend, I advise you to beware of the services of all these musical Jews. . . . I shook with rage as I read the piece by this swine." Stravinsky responded: "Any answer, clearly, should be not to the malicious idiocies and banalities of Koussevitzky, but to what comprises the essence of that whole Jewish (as you say) German mentality." In Boston, however, Koussevitzky led the world or American premieres of Stravinsky's Piano Concerto, *Symphony of Psalms*, Violin Concerto, *Persephone*, and Ode. Stravinsky, a frequent Boston Symphony guest conductor, led American and world premiere performances of *Oedipus Rex* and *Four Norwegian Moods,* respectively. "With Koussevitzky's Boston Symphony," Stravinsky wrote Boulanger, "I have always been considered a member of the family." The Stravinsky/Koussevitzky correspondence documents the conductor's respect and admiration, but not the composer's.[31]

Koussevitzky may never have changed his mind about the *Symphonies of Wind Instruments*: it is a more radical exercise than any of the other Stravinsky works he introduced. He took no interest in Varèse and the other ultra-moderns. He was stumped by Ives's *Three Places in New England*.[32] He mainly ignored Schoenberg and his school. If this marked Koussevitzky as a conservative alongside Stokowski, he championed Americans far more than Stokowski did, and his style of advocacy was more caring. Stokowski's performances of Schoenberg, Stravinsky, and Varèse were

anything but reliable. Koussevitzky's performances of new works were frequently exceptional. His first Boston recordings, in late 1928, include a sampling of Stravinsky's *Apollo,* not yet one year old; the pas de deux glides on cat's paws, deliciously insouciant. His broadcast premiere of Bartók's Concerto for Orchestra, four weeks after the first hearing, arguably surpasses all subsequent recordings;* the sustained ardor of this reading, underlined by the sheen and fullness of the orchestra's string choir, documents an unrepeatable thrill of discovery. Koussevitzky's studio versions of Copland's *Appalachian Spring* and Harris's Third Symphony are memorable first recordings. His first recording of Copland's *El Salón México,* while vivid, betrays his discomfort with the shifting meters and sharp syncopations. His interpretation of the Copland Third Symphony, according to the composer, could "whip up a storm" even if its Russian "point of view" overweighted passages of "American simplicity."[33] Whatever his shortcomings as a nascent American, Koussevitzky's loving attention and absolute conviction were never in doubt. As an immigrant, he was unconstrained by the prejudices of the many American musicians who assumed Europe knew best.

IN RUSSIA, KOUSSEVITZKY WAS the first conductor to offer student tickets at 50 kopecks. He chartered a steamer to tour the Volga with his orchestra in 1910; they traveled 2,300 miles. The Volga tour was repeated in 1912 and 1914. Many listeners encountered symphonic music for the first time. Koussevitzky resolved to build a music center, including a school, just outside Moscow. The war intervened. "Little did I think," he said in 1940, "that my own early dream of a Music and Art Center in Moscow, in the

*It is included in the Boston Symphony Orchestra's twelve-CD "Centennial Celebration" collection.

heart of Russia, would find its realization in the heart of New England a quarter of a century later. Indeed, miracles cannot be accounted for."[34]

The miracle was the most fine-tuned and original component of Koussevitzky's American mission: the Berkshire Music Center at Tanglewood, on a verdant two-hundred-acre estate. When he first came to Boston, Koussevitzky had intended to maintain a Paris concert series in the summer. As with so many of his colleagues, the war made him a year-round American. Beginning in 1936, the Boston Symphony gave summer concerts in the Berkshires. In 1938, a fan-shaped "shed" was built, seating 5,000 and open to a lawn accommodating another 18,000. A Tanglewood school for more than three hundred young musicians was added two years after that. Koussevitzky taught conducting and was himself one of the conductors of the zealous student orchestra. The composition faculty included Paul Hindemith and Aaron Copland—of whom the latter became an influential Tanglewood mainstay. Koussevitzky settled into a sequestered villa overlooking a vista of lawns and trees stretching to the horizon. On concert nights, he would be driven to the music festival gate—a distance of one-half mile—by a liveried chauffeur escorted by two state troopers. Audiences came formally attired. Hats and gloves were worn at Tanglewood garden parties. Of the students, the men wore jackets and ties, and the women skirts, even to classes.

Ever the seigneurial populist, Koussevitzky called "American freedom" the "finest soil" for his grand summer enterprise. "Rapid growth of American culture dictates its necessity as an historical mission and perennial contribution of America to human art and culture," he told the Boston Symphony trustees. He initially envisioned "first-class" symphonic concerts, "immortal operas," oratorios and ballets, and "classical tragedy and comedy with foremost living actors" in pursuit of a collectivity inspired by ancient

Greece. As any such undertaking was "for the time being impossible in Europe," it became "an added obligation in America." Koussevitzky also aspired to inculcate music-listening "not as a mere pastime, but so that music will penetrate into the living consciousness of the people." He emphasized establishing "fertile and creative contact between youth and their elders in the field of professional musical activity." Weeks before Pearl Harbor was attacked in December 1941, he told the *New York Times*: "In a day when the forces of democracy are joined in a showdown struggle with black reaction, music has a tremendous mission to fulfill. It satisfies a spiritual need because it bestows a spiritual power. But what it has to give must be placed at the disposal of the great masses of men and women of America."[35]

Koussevitzky acquired American citizenship in 1941. At an outdoor "I am an American day" concert, he told an audience of more than 10,000 he was "proud to be an American." His voice shaking with emotion, he continued, "I believe there is no other country today like America, where freedom of life, that vital factor for the happiness of humanity, is preserved." The program opened with "God Bless America." Koussevitzky's concurrent writings and speeches—typically typed in capital letters with stresses and pronunciation fastidiously marked—argued that the New World was the place to democratize "serious music." He repeatedly called for government subsidies via a Department of Fine Arts. This did not come to pass in his lifetime. Nor did Tanglewood ever present tragedies and comedies toward communal uplift and enlightenment. But the array of orchestral and chamber music, choral and operatic activities was instantly distinguished. The festival/school was a mecca for gifted young composers and instrumentalists. The entry of the United States into World War II lent further urgency to Koussevitzky's vision. When the symphony trustees decided to cancel the school and festival during wartime, Koussevitzky unforgettably responded: "I consider it an

act of vandalism. . . . It bespeaks . . . profound misunderstanding of the fundamental duties and aims of a musical institution. . . . I cannot participate in a premeditated destruction of cultural and artistic values or even remain as a passive witness of such an act."[36] He proceeded to subsidize the festival himself via a foundation he established in memory of Natalie, who died in 1942.

Koussevitzky's student orchestra debuted August 1 that summer with a program of Haydn, Beethoven, and Shostakovich. The next day Koussevitzky led a War Bond concert including two Sousa marches. Roy Harris's nationalistic Third Symphony was another August highlight. But the peak public event, on August 14, was Koussevitzky's Russian War Relief concert, featuring a work he had (temporarily) decided was as great as Beethoven's Ninth: Shostakovich's *Leningrad* Symphony, begun the previous year while the city was under siege. Charles O'Connell remarked in another context: "When Koussevitzky's real beliefs and feelings are touched he ceases to be an actor or even a great artist; he becomes a great man."[37] The Shostakovich performance, a topic of awed reportage for its magnitude and intensity, was such an occasion. Meanwhile, in addition to rescuing Tanglewood, Koussevitzky's new foundation initiated a historic series of commissions and stipends in support of living composers, young and old.

Tanglewood limped through the war. Its full resumption in 1946 was saluted by *Time* magazine in an article beginning:

> Dr. Serge Koussevitzky was in his favorite summer pasture last week, and frisky as a yearling. . . . Visitors to Tanglewood, Dr. Koussevitzky's music colony near Lenox, Mass., try to compliment the maestro by calling it "an American Salzburg."
>
> Maestro Koussevitzky thinks it no compliment. He bangs an angry, sun-burned fist down on his piano. "Why a Salzburg?" he snaps. "Let's have courage to say it. In

early stages Salzburg was ideal place—now it is the most commercialized thing you can imagine. Most people who come to Salzburg are snobs who come to say they have been in Salzburg. They must rehearse too quick, in a week, maybe less. Why not a Tanglewood, U.S.A.? We play here something that is more perfect than ever a performance in Salzburg."

Writing for a popular magazine, Koussevitzky expressed admiration for George Gershwin, for Paul Robeson, for *Oklahoma!* He counted energy, gaiety, and freedom essential American attributes. He maintained cordial relations with Franklin Delano Roosevelt, whom he first met in 1929 and whose wobbly signature, late in the war, caused distress. His last wife, Olga—as Natalie's niece, she had been the Koussevitzkys' secretary since 1929—observed him eagerly greeting the Statue of Liberty upon bringing her to the United States for the first time. "From the first I loved Boston and my life with the Koussevitzkys," she wrote in a memoir. Listing the members of the "Koussevitzky family," she mentioned only American names. With both his wives, Koussevitzky was childless. His surrogate American sons were his Tanglewood protégés Leonard Bernstein and Lukas Foss. He called Bernstein "Lenyushka" and made him his assistant. He made Foss (born Fuchs in Berlin) the Boston Symphony pianist so he could support Foss's truer calling as a composer. He also made a habit of handing Foss his tailored suits after four or five wearings. After the war, he reconnected with his Jewish roots, conducting in Israel, signing letters "Shalom." "He was very Jewish," Bernstein later recalled. "There was a certain period of his life when he was trying very hard to live it down and to be the image created for him by Natalie and the whole Parisian period—the white gloves and the capes. Maybe our relationship did reawaken it." At Tanglewood, Bernstein affected white suits and shoulder-slung overcoats à la Koussevitzky.[38]

Was there any element of nostalgia for Mother Russia in the Koussevitzky persona? The household depicted by Olga included a Russian couple: "Ivan and Lisa." Olga found downtown Boston, with its "handsome limestone buildings," evocative of "dear St. Petersburg." When the composer Nicolas Nabokov presented Koussevitzky with an homage to their homeland—a setting of Pushkin's "Return of Pushkin," a poem of exile—Koussevitzky performed the work; but Nabokov's detailed account of this incident records more sentiment on Nabokov's part than Koussevitzky's. "I think he was very happy in America," says Foss, who does not remember hearing Koussevitzky speak longingly of Moscow or St. Petersburg.[39]* In any event, Koussevitzky's death in 1951 denied him the opportunity of returning to Russia after the fashion of Balanchine and Stravinsky. His ashes were buried near Tanglewood following a Boston funeral combining Russian Orthodox and Protestant Episcopal rites.

Koussevitzky had ardently groomed Bernstein to be his successor, but the symphony trustees named an Alsatian, Charles Munch, to take over both the orchestra and the festival. As Foss put it: "Boston, while remaining a city with a great symphony orchestra, ceased from one day to the next to be a mecca for young composers, a center for symphonic premieres that made the nation sit up and take notice." Foss also wrote: "Certainly Koussevitzky was not ahead of his time; he was of his time, full of the prejudices of his time. . . . What was unique about Koussevitzky was not his foresight but his interest, zeal, love. It was this love which made him a great conductor, a great teacher."[40] Though Boston's august

*According to Koussevitzky's Russian-language biographer Victor Yuzefovich, "By all accounts Koussevitzky did not suffer from the same level of nostalgia as for example Rachmaninoff. This however did not prevent him from helping Russia during the war by participating in many fund-raisers to benefit the Red Army. He was very proud of the USSR's victory over Hitler" (in conversation with the author, April 2006).

orchestra undeniably went its own way, Tanglewood stayed identifiably a Koussevitzky enclave. Copland remained a shaping influence. Bernstein, who also maintained enduring Tanglewood ties, was himself a Koussevitzky legacy, as tirelessly—if, as an American working from inside the identity puzzle, more complexly and confusedly—in quest of "America" in classical music. No less than Copland, with his Parisian training, Bernstein was significantly a product of the "unGerman." Marlboro produced no Leonard Bernsteins.

AMID THE RUSSIAN MUSICAL floodtide sweeping the United States in the early twentieth century, not Koussevitzky but Sergey Rachmaninoff was the most complete musician—and the most incurably Russian. Born in 1873, he left Russia for good in 1917, eventually settling on Manhattan's Upper West Side. In Moscow, Rachmaninoff had been an important composer and conductor. In the United States, his vocation shrank: submitting to the New World order, he became first and foremost a performance specialist: a virtuoso. He gave the first piano recital of his career in Northampton, Massachusetts, in 1909. He transformed himself into a touring solo artist, under contract to RCA Victor. His compositional output plummeted. He ceased conducting.

Rachmaninoff the pianist consummated a heroic lineage beginning with Liszt and Anton Rubinstein. His playing singularly combined romanticized freedom and passion with a viselike grip on structure and proportion. Upon hearing him perform Chopin's B minor Sonata in 1930, W. J. Henderson wrote in the *New York Sun*: "The logic of the thing was impervious; the plan was invulnerable; the proclamation was imperial. There was nothing left for us but to thank our stars that we have lived when Rachmaninoff did and heard him." Rachmaninoff the composer had already produced his three sonatas, three operas, three of his four concertos,

two of his three symphonies, and the bulk of his solo keyboard music before the Russian Revolution made him a wanderer. Though the Third Symphony (1936) conveys a whiff of Hollywood and the *Symphonic Dances* (1940)—his valedictory and possibly his masterpiece—uses a solo saxophone, though he admired Art Tatum, his music stayed Russian and so did his household. He remained immune to the deracinated modernisms of Stravinsky and Prokofiev. Alexander and Katherine Swann, who knew him well, reminisced in 1944: "In spite of a deeply affectionate family, in spite of his great success all over the world, and the devotion of his audiences, Rachmaninoff lived shut within himself, alone in spirit, and everlastingly homesick for Russia. The Russian spirit and habits were all-powerful in him."[41]

Of the other Slavs in a crowded field, the Polish pianist Josef Hofmann was a redoubtable if idiosyncratic artist whose technical wizardry bore comparison with Rachmaninoff's, and who served as director of the Curtis Institute from 1926 to 1938. His successor in that position as of 1941 was Efrem Zimbalist, one of the many eminent violinists produced by Leopold Auer at the St. Petersburg Conservatory. Another Russian-American Auer product was the mellifluous Mischa Elman. Yet another was the worldliest of Russian violinists: Nathan Milstein, who like his New York friend George Balanchine could glide from Bach to Tchaikovsky. The most famous Russian-American cellist was Gregor Piatigorsky. But among the Russian immigrants the two biggest American careers unquestionably belonged to Jascha Heifetz and Vladimir Horowitz—the putative "world's greatest violinist" and "world's greatest pianist."

Heifetz achieved an infallible perfection of technique linked to an imperious countenance equally infallible. Horowitz's virtuosity was of the overstrung variety: his power was made the more awesome by the neurotic energies he exercised and exorcised. Both players practiced phenomenal hyperrefinements of execu-

tion. Neither possessed any gift for simplicity. In all repertoire, it was never the composer but always a restless performer's art that riveted the ear. Their American celebrity was wholly unconstrained by these considerations—a reflection of critics and audiences more populist than abroad, of a psychology of possessive adulation excited by rivalry, redoubled by wartime, with the Old War parent culture.[42]

Of all Auer's progeny the most legendary, Heifetz made his American debut in 1917 at the age of sixteen. His instantaneous reputation was international, but his career was American-based. In the United States he commanded the highest fees of any soloist and insisted that on every symphonic program in which he participated, his concerto would come last. His Park Avenue apartment included a concealed bar with a cash register. Horowitz left Russia with Milstein in 1924 as a "child of the Soviet Revolution"; neither returned. He settled in the United States in 1939 at the age of thirty-five. Between 1951 and 1982 he was never heard in Europe. For his rare late-career performances, his piano had to be removed by crane from his fourteen-room Manhattan townhouse. He was paid up to half a million dollars per concert.

If neither Heifetz nor Horowitz abstained from American repertoire to the degree Rudolf Serkin did, neither was an explorer after the fashion of a Stokowski or Koussevitzky. Heifetz commissioned concertos from Louis Gruenberg, and from the California immigrants Erich Korngold and Miklós Rózsa; but the important twentieth-century concertos of Stravinsky and Bartók were not for him. He transcribed excerpts from *Porgy and Bess* and achieved an exquisite amalgam of bejeweled fiddling, sassy insouciance, and Russian/Jewish pathos (in facsimile). Horowitz made a cause of Samuel Barber's Piano Sonata. He said he was "proud to present it" because it was "very American." He also made a specialty of *The Stars and Stripes Forever.* "My main goal in the transcription,"

he explained, "was to restore the music to its purest and correct form." If his Sousa did nothing of the kind—it was brilliantly contrived to wow—this homage to an adopted homeland was nothing if not enthusiastic. Had Heifetz succeeded in getting Gershwin to compose the concerto he sought, America would have immeasurably benefited.

In truth, the artistry of these two mega-performers remained primarily about themselves. One may reasonably inquire whether their astounding instrumental gifts were to any degree squandered in the United States. Heifetz's transcriptions—the harmonic piquancies, the deft piano accompaniments—disclose a pronounced creative bent; had he belonged to the nineteenth century, he would have composed concertos, like his predecessors Paganini and Vieuxtemps. Born to a cultivated family, Horowitz in Russia composed, played chamber music, and partnered singers (he once accompanied Schubert's *Winterreise* from memory). His early solo repertoire was huge and not unadventurous. With no institutional base—no Marlboro, no Tanglewood, no orchestra or conservatory—Heifetz and Horowitz became beneficiaries and captives of an insatiable New World musical marketplace that propelled them toward maximum fame, fortune, and instrumental display. Heifetz offered his formulaic Carnegie Hall program up to five times a season. He played his duo sonatas, even trios and quartets, with submissive nonpartners. Late in life, when he opted to teach at the University of Southern California, gifted students warily stayed away. In one period, Horowitz was playing a concert every two days for Columbia Artists. "Audiences always wanted me to make a big noise," he lamented in 1965. "I could play four or five Mozart concertos and Chopin's Second, but I played the Tchaikovsky." At another time, in another place, he would have composed and made music with colleagues. In sum, Heifetz and Horowitz each charted a stranded orbit, a lonely yet gaudy eminence.[43]

The other transatlantic "unGermans" arriving between the outbreak of World War I and the end of World War II included the pianists Artur Rubinstein and Claudio Arrau, touring cosmopolites who happened to be based in the United States. The harpsichordist Wanda Landowska was already sixty-four when in 1941 she fled Europe; in America, she mainly taught. Among the preeminent interwar violinists, Joseph Szigeti was the most notable champion of contemporary composers—including his compatriot Béla Bartók, whose *Contrasts* he premiered at Carnegie Hall with Benny Goodman. Of the Met's non-German singers, the Russian Alexander Kipnis, the Dane Lauritz Melchior, and the Italian Giovanni Martinelli were among the peerless performing artists to settle permanently in the United States. The conductor Maurice Abravanel, born in Salonika, continued his long association with Kurt Weill and Lotte Lenya before settling in Salt Lake City, where he may be said to have created the Utah Symphony. Vladimir Golschmann and Pierre Monteux, both Paris-born, had notable American careers. An important French composer in America was Darius Milhaud. Of Milhaud's American students, William Bolcom acquired something like his teacher's eclectic range of style and taste; Dave Brubeck, Pauline Oliveros, Steve Reich, and Morton Subotnick also studied with Milhaud in the United States. Ernest Bloch, born in Geneva, was another important immigrant composer of unGerman persuasion. He enjoyed a great but mainly ephemeral American success. Bloch's pupils in Cleveland and New York included Roger Sessions; his American output included *America: An Epic Rhapsody*, composed in 1926—two years after he became an American citizen. Like Schoenberg's *Ode to Napoleon*, Hindemith's *When Lilacs Last in the Dooryard Bloom'd*, or Weill's Whitman songs and *Street Scene*, it is immigrant music, dedicated to the memory of Lincoln and Whitman, flushed with gratitude and appreciation. Its fifty minutes chronicle "The Indians," "The *Mayflower*," the Civil War.

Its materials include "Old Folks at Home," "Dixie," "Battle Hymn of the Republic," and an original anthem—"The Call of America to the Nations of the World"—which the composer hoped the audience would sing standing. The epochal opening—the dawn of a new civilization—recalls Delius's 1903 paean to America, *Appalachia*; so does the chromatic evocation of the languorous South. *America: An Epic Rhapsody* won a *Musical America* award in 1927 and was performed with fanfare in five cities. As "New World" symphonies go, it is, however, surpassed—completely—by Dvořák and Delius.

Eclipsing Milhaud and Bloch—even Stokowski and Koussevitzky, even Heifetz and Horowitz—was the Italian whose vacant and unnerving gaze effaced four Germans gathered round him in the famous 1930 Berlin photograph we have scanned. Topping the New World musical phalanx, with its many great and glamorous names, he was anointed "priest of music" and "vicar of the immortals." Germany had Richard Strauss, Russia Prokofiev and Shostakovich: composers who embodied a nation's musical genius. Only in the United States, with its culture of performance, was the "world's greatest musician" a conductor.

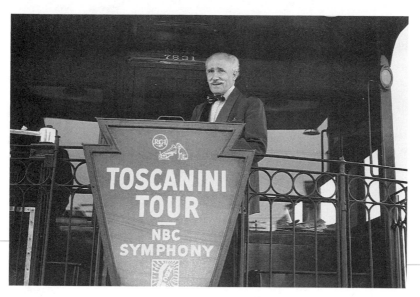

Arturo Toscanini on tour with the NBC Symphony (1950).

IN THE CONTEXT OF the present study, the significance of Arturo Toscanini is simply stated: he had the greatest impact of any musician from abroad, yet was not an immigrant. Stokowski and Koussevitzky became American citizens; Toscanini's primary national loyalty was at all times to Italy. The son of a tailor and sometime Garibaldi redshirt—biographical details that would enhance his American reputation—he first made his name in Turin, where he became music director in 1895 while still in his twenties. Commanding La Scala (1898–1903, 1906–1908), he anchored and invigorated the cultural life of a young nation. At New York's Metropolitan Opera (1908–1915), his influence was more transitory: never again would the Met be entrusted to such fanatic or comprehensive leadership. Toscanini's second La Scala tenure (1921–1929) helped to restore postwar Italian stability and self-esteem. According to the conductor Gianandrea Gavazzeni, "The public with Toscanini, during that era, was educated to consider the theater not as something for amusement, but as something

with a moral and aesthetic function, which enters into the life of a society, into the life of a culture."[44]

Though Toscanini inundated the Met with Italian operas of variable quality, he exceeded other Italians of his generation in his breadth of repertoire. He led symphonies by Beethoven and Brahms, operas by Mussorgsky, Debussy, and Richard Strauss. He was gripped by Wagner. The New York Philharmonic, which he began conducting in 1926, was for him an unprecedented opportunity to explore the great symphonies with—a musical species unknown in Italy—a great symphony orchestra. He repeatedly offered the canonized Germanic masterworks, plus a short list of French and Russian classics. He also favored popular excerpts from *Die Meistersinger, Tristan,* and the *Ring.* He quit the Philharmonic in 1936, but could not abide Hitler or Mussolini. Having dissociated himself from La Scala, and from the festivals of Bayreuth and Salzburg, he accepted David Sarnoff's invitation to lead a New York orchestra of his own: the NBC Symphony. Stokowski in Philadelphia, Koussevitzky in Boston—Toscanini's nearest American rivals—embodied an institutional mission privileging new music and audience education. Toscanini in New York embodied no such mission. Neither with the Philharmonic nor at NBC was he even a music director. Superintending everything, Stokowski and Koussevitzky disdained engaging frequent guest leaders for their orchestras. The Philharmonic concurrently invented the "guest conductor"; Toscanini never led more than fifteen weeks a season. Like Heifetz and Horowitz, he decisively, if unconsciously, propagated performance as an end in itself. At NBC, his wartime sponsorship of Barber, Copland, Gershwin, and Harris was a significant gesture for a musician in his seventies. But, at a time when other American orchestras were more than doubling their quota of contemporary works, he was more than ever linked to Beethoven.

Fortuitously, this proved a patriotic strategy so far as Americans were concerned. Toscanini's skirmishes with Mussolini—his refus-

als to conduct the Fascist anthem, met by restrictions on his musical activities—branded him an intrepid democrat. In 1933, he was one of eleven musicians to challenge persecution of their German colleagues; the *New York Times*'s front-page story was headlined "Toscanini Heads Protest to Hitler." The same afternoon he led the *Eroica* Symphony—part of a five-week Beethoven cycle with the Philharmonic—to a stamping ovation. Two days after that, the Berlin radio banned all Toscanini broadcasts and recordings. He conducted another Philharmonic Beethoven cycle in 1942. Between Pearl Harbor and V-J Day, he led the NBC Symphony in ten all-Beethoven concerts. Mussolini's downfall was announced midway through an all-Verdi NBC concert in 1943; Toscanini clasped his hands and gazed aloft. The day after Italy's surrender, he led a special half-hour broadcast including the first movement of Beethoven's Fifth. Toscanini's raging temper—his most publicized extra-musical attribute—and the relentless hair-trigger intensity of his performances—which required no publicity—italicized Beethoven's curled-lip ferocity and his raging apostrophes to the freedom fighters Fidelio and Egmont. Neither Stokowski nor Koussevitzky regularly conducted in Bayreuth, Salzburg, or Milan: they had no German or Italian ties to sever. More than any other expatriated musicians, more than any American classical musician, Toscanini embodied the American cause. His symphonic rituals of ferocious defiance were the most urgent, most consuming events in the history of American classical music.

After the war, having won his own NBC war with Stokowski, Toscanini elected to stay with NBC. A peak event was the NBC Symphony's transcontinental tour in 1950. Toscanini led the orchestra in twenty-one concerts in twenty states. Though NBC's press department said that Toscanini and RCA "felt a sense of responsibility toward the music lovers of America to make this tour a great and lasting monument to American culture," no American symphonic music was scheduled. For four decades, Toscanini the

man had been celebrated by Americans as the antithesis of cloudy, elitist Old World types: a self-made personality bristling with masculine energy; a self-made musician who efficiently achieved objectively precise results, scorched clean of fancy or fanciful "interpretation." Besieged on tour in New Orleans, where he was observed tapping his foot to jazz; in Richmond, Virginia, where "Dixie," a surprise encore, aroused rebel yells and cheers; in Sun Valley, where he rode the ski lift, the indefatigable eighty-three-year-old maestro endeared himself to his public and his players more warmheartedly than before. For the first time in the United States, he seemed approachable and gregarious. It was in the 1950s, as well, that he was discovered to enjoy watching boxing and wrestling on television, as well as a children's show called *Small Fry Club*. He improbably combined the populist charisma of Caruso with the stormy idealism of Beethoven.

For most musical refugees from Soviet Russia and Nazi Germany, there was no going back. Italy was scarred by Mussolini, but not disfigured. After the war, Toscanini typically spent April to October at his Milan home on Via Durini, with holidays at his island villa on Lake Maggiore. He conducted sporadically at La Scala. He cherished the company of Guido Cantelli, whom he came to regard as his successor (and whose death at the age of thirty-six in a 1956 airplane accident was never disclosed to him). A 1951 letter from New York to his son Wally revealed:

> I am as always—well, according to others—not well, according to me. I'm homesick for my old house on Via Durini. But what can be done? I want to work. I can't in Italy. This alone is my working environment. And work I must, otherwise life is unbearable! I made two records. . . . Next Friday I have another rehearsal. Beethoven Second Symphony and *Don Pasquale* Overture. So you see that your old father has put himself to work with enthusiasm.

That Toscanini could not happily conduct in Italy was well known in the United States. "Toscanini Homesick for U.S.A. Plans to Return Immediately after Final La Scala Concert" was one representative NBC announcement. According to George Marek of RCA, himself foreign born:

> Much as he loved Italy and firmly though he then hoped for its regeneration, [Toscanini] no longer felt at home in a destroyed city and amorally enfeebled country. . . . He was always "a guest," and he observed with increasing bitterness the cleavage between political parties, the infighting, the inability of the Italians to govern themselves, the belief that the substance of liberty consisted of slipping an envelope to the policeman.

To which the music appreciation specialist David Ewen added in 1951: "His long stay in America, since 1938, had transformed him into an American. He could no longer live happily, nor function to his fullest capacities, anywhere else." Toscanini's 1951 Italian biographer Filippo Sacchi had this to say:

> Musically, he was never really happy to be far away from the Scala for too long: and it was in Milan that the true background of his musical life lay. Although he never assumed an official position, he continued to take a fatherly interest in the Scala. . . . His interest in Italian musical life continued to be tireless.

Toscanini died a citizen of Italy, in New York in 1957. Thousands filed past his open coffin at a Manhattan chapel. The funeral was at St. Patrick's Cathedral. A month later, his body was flown to Milan. A La Scala memorial concert was broadcast into the Piazza della Scala, a sea of mourners. They followed the hearse to Via Durini, and thence to the family tomb. At the entrance to the

cemetery, the combined choruses of La Scala, Radio Italia, and the Milan conservatory sang "Va, pensiero" from Verdi's *Nabucco*, once a rallying cry for Italian independence. Fifty-six years previous, at the same spot, Toscanini had conducted the same music in tribute to its composer.[45]

STOKOWSKI REINVENTED HIMSELF IN America. Toscanini was reinvented as an American by Americans. His continued residence in the United States was celebrated as a cultural coup. His supreme American reputation was a source of intense national pride. He became a symbol—revealingly naive—of American achievement in the arts. Vladimir Horowitz, who married Toscanini's daughter Wanda, was briefly the object of comparable appropriative energies. Howard Taubman of the *New York Times*, author of a 1951 Toscanini biography, in 1948 wrote of Horowitz:

> He is slim and well groomed, and he looks more like a man of affairs than the conventional figure of the musician. . . . There are paintings on the walls [of Horowitz's studio] by Manet, Pissarro, Renoir and Degas; there are good books, and with Horowitz and his wife there is good talk, not only about music, but about politics, economics, psychology, what you will.
> . . . Like his father-in-law, he does not like formal interviews. . . . Like his father-in-law, he has a charming simplicity.[46]

But Horowitz was too obviously neurotic and unstable to fit this wholesome New World portrayal. Jascha Heifetz★ was too obvi-

★Heifetz also had a Toscanini connection: his onetime accompanist and subsequent brother-in-law Samuel Chotzinoff was manager of the NBC Symphony.

ARTISTS IN EXILE

ously aloof to embody a reassuring congeniality. The American Toscanini, by comparison, was both necessary and possible.

As an American musical icon, the aged Toscanini set two cultural precedents. Never before had a conductor been widely identified as the world's preeminent classical musician; previously, this distinction had appropriately privileged the creative act: musicians— a Beethoven, a Wagner, a Stravinsky or Richard Strauss—who composed. Never before had a conductor of such influence been so fundamentally divorced from the music of his own time. The high prestige Toscanini enjoyed as a purveyor of nineteenth-century European masterworks made him an unsurpassed torchbearer for Beethoven. During World War I, Americans had banned a great deal of German music. After World War I, Germans (as we have seen) were no longer entrusted with American orchestras. Toscanini's moral authority was such that he could even get away with conducting Wagner at a wartime Red Cross benefit at Madison Square Garden.

In retrospect, all this constituted a holding action. No German could possibly have kept the flame so brilliantly alight among Americans mindful of Kaiser Wilhelm and alleged German war atrocities, of Adolf Hitler and Nazi horrors. As we have seen, even German Jews and antifascist Germans were controversial in New York. Only after 1950 could American classical music reconnect with its Germanic forebears without discomfort. Programming statistics reflect a flurry of interest in native composers during both world wars—and also confirm the resilience of a Germanic bedrock. So it went with conductors and orchestras. The Chicago Symphony, led for half a century by the German-born Theodore Thomas and Frederick Stock, in 1943 tried the Belgian Désiré Defauw, then the Czech Rafael Kubelik before settling in 1953 on Fritz Reiner, a Hungarian of unmistakably Germanic pedigree. The Boston Symphony, first directed by the Breslau-born Georg Henschel and by Wilhelm Gericke, an Austrian, later opted for Monteux, Koussevitzky, and Munch before engaging the Vienna-born

Erich Leinsdorf in 1962 and William Steinberg, born in Cologne, in 1969. The Philadelphia Orchestra's first music directors were the Germans Fritz Scheel and Karl Pohlig; then came Stokowski, Eugene Ormandy, and Riccardo Muti, then, beginning in 1993, Wolfgang Sawallisch and Christoph Eschenbach, both German-born. The New York Philharmonic, long associated with Germanic leadership, opted after 1923 for a parade of unGermans, including Toscanini, John Barbirolli, Artur Rodzinski, Dimitri Mitropoulos, Leonard Bernstein, Pierre Boulez, and Zubin Mehta—then engaged Kurt Masur in 1991.

Though opera in the United States was never this Germanic, a similar pattern holds, as exemplified at the Met. The house's high-water point for German opera occurred under Anton Seidl and Gustav Mahler before World War I; there was even a period (1884–1891) when everything was sung in German. After 1915, the German wing was reconstituted under Artur Bodanzky, a Viennese immigrant barely remembered because his commercial recordings were restricted to operatic morsels (his broadcast recordings, chiefly available in Europe, document a galvanic Wagnerite). Bodanzky's New York casts were anchored by such important immigrant singers as Friedrich Schorr, Lauritz Melchior, and Lotte Lehmann (later a significant pedagogue at the University of California at Santa Barbara). Rudolf Bing, a Viennese who ran the Met from 1950 to 1972, favored Italian opera; Wagner was suppressed. Its more recent resurgence under James Levine paralleled the resurgence of the German music directorships in Philadelphia and New York.

In sum, notwithstanidng Verdi and Puccini, Heifetz and Horowitz, Stokowski, Koussevitzky, and Toscanini, American classical music was and is more a Germanic colonization project than a native undertaking. Its progenitors included Theodore Thomas, Anton Seidl, and the orchestras of New York, Boston, and Chicago. Its latter-day embodiments included Rudolf Serkin and the Marlboro Festival. In nineteenth-century Russia, Leopold

Auer, John Field, Adolf von Henselt, and Henryk Wieniawski played key roles in fostering a musical high culture on the European model; a native Slavic tradition vigorously ensued. In England, "das Land ohne Musik," the colonizers included Handel and Mendelssohn; a native tradition was greatly delayed. In the United States, at first a comparable musical outpost, classical music remained a Germanic crown jewel, its luster sustained by a potent immigrant influx potently renewed in the twentieth century.

A closing vignette: taking part in a 1994 symposium on "Musical Migration," the ethnomusicologist Bruno Nettl recalled the immigrant experience of his father, Paul Nettl, born in the Sudetenland, trained in Prague and Vienna, who fled with his family to the United States in 1939 to become an eminent member of the American musicological community. Though he treasured his U.S. citizenship papers, Nettl, as recalled by his son, never "actually considered himself an American."

> Americans were seen as kind, generous, helpful people who, however, were both childlike and unpredictable. My parents seemed to regard them as helpers in getting through the years of exile, but also as members of a society essentially lacking in culture. These attitudes were shared by many in my parents' social circle. . . .
>
> My father wanted Americans to understand the music of the great German and Austrian composers, and some of the not so great as well. As World War II progressed, and as at the end the extent of the Holocaust began to be known, he seemed to me to increase his focus on making German music known. . . . He didn't want to let the Nazis have any of that good German culture. But a more interesting reason, it seems to me, was the notion that he began to develop that music—proper music—was quintessentially a German phenomenon. In Prague that attitude was part of the general atmosphere, but over here it began to be made explicit. Americans (or Indians, or

Japanese) could understand Western music only if they learned the German language. Classical music was a kind of German domain in American culture. . . .

Illogical as it may seem to us . . . , there is a strong tradition in German thought which holds that although each culture may have its own musical ideas and practice, music in its loftiest sense is essentially a German product. Unconsciously, my father shared this view, I think, and extended it to musicology. Thus teaching Americans about music meant, ipso facto, teaching them about German music. . . .

He also saw himself throughout his thirty-three years in America as a culture broker, a missionary whose job it was to bring his culture to American students. It was perhaps for this reason that, to the end of his teaching days, he affected certain Central European professorial manners, working at home and having students visit him in his study there, playing down the accomplishments of English and American scholarship, trying hard to avoid idiomatic English, and striving to present a portrait of European erudition that his students were supposed to admire but could never hope to achieve.[47]

The scholarly impact of Paul Nettl and other refugee American musicologists was long-lasting. To this day, the American Musicological Society pays insufficient attention to American music.

We have observed Howard Hanson warning in 1941 that "foreign guests" were "curtailing the already meager opportunities for the young American." Earlier, during the Depression, repeated efforts were made to enact legislation that would limit the influx of foreign instrumentalists and conductors; Leonard Liebling, editor of the *Musical Courier*, in 1937 argued that "protection for American musicians . . . would help to create a worthy tradition of American music . . . it is nonsense bred in us that American conductors are not as good as foreign conductors."[48] Clearly, there was justice and injus-

tice in these complaints. Opportunities for young Americans were unquestionably curtailed—by foreign guests in many instances immeasurably more gifted and accomplished than their hosts. The belated emergence of prominent American instrumentalists and con-ductors—of Leonard Bernstein, William Kapell, Isaac Stern, Van Cliburn, and countless others of lesser distinction—was a 1950s phe-nomenon facilitated by wartime isolation: the regular transatlantic crossings of Europe's leading performers had finally suffered interrup-tion. America's composers, by comparison, lacked sufficient isolation. Their heads were turned by European fashions reinforced by Euro-pean visitors. Neoclassicism as practiced by Stravinsky and his follow-ers, serialism as promulgated by Schoenberg and his school, were products of dire Old World upheavals, political and aesthetic, yielding an urgent search for order. That there were no comparably exigent New World causes did not discourage countless New World neoclas-sicists and serialists. In Los Angeles, Schoenberg pertinently com-plained: "American young people's intelligence is certainly remarkable. I am endeavoring to direct this intelligence into the right channels. They are extremely good at getting hold of principles, but then want to apply them too much 'on principle.' And in art that's wrong."[49] Certainly the great American symphony Koussevitzky anticipated from Copland, Harris, and others of that generation was never com-posed. In retrospect, the American composers Koussevitzky most championed remained too European in orientation to fulfill his ex-pectations. This becomes clear from the high achievements of Ives and Gershwin, Ellington and Armstrong, all of whom—not unlike a Melville or Whitman—notably lacked European training and "fin-ishing." It is yet another manifestation of the incurable Eurocentrism of classical music as imported to the United States.

To find a more evenhanded interwar cultural exchange be-tween natives and immigrants, one must look to an art form younger and more democratic than classical music ever was or could be: the movies.

Marlene Dietrich in Josef von Sternberg's The Blue Angel *(1930).*

"IN HOLLYWOOD
WE SPEAK GERMAN"

Marlene Dietrich and The Blue Angel—The New German Cinema relocates to California—Fox's "German genius": F. W. Murnau—The Lubitsch touch—Garbo laughs—Fritz Lang's American exile—Four who came and went: Victor Sjöström, René Clair, Jean Renoir, Max Ophuls—An inside operator: Billy Wilder—Salka Viertel's salon and the blacklist

THE ACTRESS, A SHORT-HAIRED German blonde with provocative eyes, sculpted cheekbones, flaring nostrils, full lips, and a throaty voice she could pitch as low as a man's, flicked an ash from her cigarette, blew smoke from the side of her mouth, spat loudly, and—suddenly flapping her lashes and flashing an exaggerated smile—sang (in English):

> *You're the cream of my coffee,*
> *You're the salt in my stew*
> *You will always be*
> *My necessity*
> *I am lost without you.*

Next, she clambered noisily atop an upright piano. Hand on hip, her spectacular legs crossed and dangling, she crooned (in German):

> *Who's going to shed tears*
> *If we go our separate ways*
> *When just around the corner*
> *The next guy is waiting.*

The pianist repeatedly got lost. "Don't screw up again or I'll kick you," she advised offhandedly.

This was Marlene Dietrich's famous October 1929 Berlin screen test for Josef von Sternberg. She was a twenty-seven-year-old stage and screen actress of middling achievement. He was a notoriously temperamental Hollywood genius about to undertake his first German film: *Das blaue Engel*. It would be only his second film with sound. He had cast Emil Jannings, a renowned specialist in self-degradation, as a fastidious professor who falls for a predatory night-club singer. But Sternberg could not find a singing actress for the lethal harlot Lola. Finally, attending a musical called *Two Bow Ties*, he had discovered the actress of his dreams. Though Dietrich was considered an unimportant German studio player, Sternberg was instantly convinced that, by stifling her formidable effervescence, he could evoke an impassivity insolent, mysterious, and dangerously erotic. He undertook the screen test to demonstrate to others what he already knew. Dietrich's phlegmatic demeanor on this occasion—she told him he was wasting his time—thrilled him all the more. It could only have been Sternberg who instructed the pianist to lose his way three times—so as to provoke three withering volleys of insults. Exercising the skill for which he was most celebrated, he also illuminated his Lola-to-be so that the contours of her face acquired a sultry glow. The outcome was magnetic.

Though born in Vienna in 1894, Sternberg split his childhood between Vienna and New York City. It was Hollywood that changed his name from Jonas to Josef von. Of his Hollywood silent films, *The Last Command* (1928) was a notable Jannings vehicle preceding *Das blaue Engel*. His mastery of atmospheric lighting and composition was one component of his unabashed mania for control. He likened directing to "a process of changing a human being and never allowing that human being to be himself." He likened actors to "tubes of color which must be used to cover my canvas." In Dietrich, he discovered an exemplary "assistant." Patiently, meticulously, in full confidence of his powers, she followed Sternberg's instructions to drop her voice an octave, or to count one-two-three-four *slowly* and look at the lamp. She succumbed willingly and ingeniously to the "outright manipulation of body and mind" Sternberg considered his prerogative.

Jannings jealously observed what was happening. He objected to Sternberg's frequent lunches with Dietrich and other evidences of an infatuation sublimated or perhaps consummated. If Sternberg is to be believed, "He would hurl himself to the floor so that the whole room shook, weep, scream, and shout that his heart had stopped, and I would pick him up, which was not easy . . . then kiss him on the mouth, moist with tears and sticky with glue, and return him somehow to his mirrors, where he would plead to be forgiven."[1]

One reason Dietrich was cast as Lola was that she spoke English fluently—and, as *The Blue Angel*, *Das blaue Engel* was scheduled for release in English as well as German. Scenes of dialogue or song were shot twice. Caressing her left leg while perched atop a barrel, she sang "Ich bin von Kopf bis Fuss" and "Falling in Love Again" with equal nonchalance. Her mannish voice and clipped inflection, her white top hat and exposed garter straps, achieved a sadistic allure in two languages.

The seductive amorality of Lola/Marlene was disquieting.

Germany's Universum Film A.G. (UFA) lacked confidence in its creation and dropped an existing option on Dietrich—whereupon Paramount, in America, signed her to a two-picture contract guaranteeing $1,750 per week with Sternberg as director.

For the premiere, at Berlin's Gloria-Palast, Dietrich arrived in a long white gown and furs. Her innumerable curtain calls, embellished by bouquets and popping flashbulbs, upstaged Jannings as completely as Lola had destroyed the film's hapless Professor Unraut. The same night she left for the boat train and the *Bremen*, which had conveyed Sternberg back to the United States two months before. She had literally become famous overnight.

IN *MOROCCO* (1930), THE first of six Hollywood films Dietrich would make with Sternberg, scene two begins streaked with fog on board a boat from nowhere in particular. Dietrich is Amy

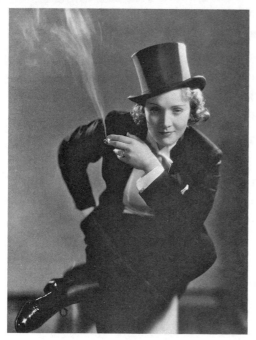

Jolly ("Pretty Girl")—a name so generic it cannot be her own. She speaks not French but English—with a German accent. Stateless, itinerant, she is the embodiment of ennui. In a Morocco cabaret, she sings two songs that furnish further information. "Quand l'amour meurt" is rendered in top hat, white tie, and tails, cigarette in hand. Stalking from table to table, she lifts a flower

Dietrich in top hat and tails (1930s).

from a woman's hair, then locks her gaze on the woman's eyes. She takes the woman's chin in hand and plants a kiss on her lips. The woman retreats behind a fan amid giggles and nervous laughter. Amy flings the flower to an American soldier of fortune—Tom Brown, played by the laconic Gary Cooper—then walks off, hands in pockets. For her second song she reappears with bare legs and feather boa:

> *What am I bid for this apple*
> *The fruit that made Adam so wise?*

The flaunted fruit shines lasciviously in her hand. The original script called for Amy to auction it for her room key. The Hays Office, which as Hollywood's moral watchdog administered the Motion Picture Production Code beginning in 1930, demurred—so Amy simply slips her key to Tom, who later that evening scoops Amy off her feet and takes her for a walk. Were this film to take cues from *Das blaue Engel*—or from Bizet's *Carmen*, with its tossed flower for the entrapped Don José—Amy would shed Tom for the local aesthete, Le Bessier (Adolphe Menjou), who lives in splendor and can give her everything but requited love. Instead, she deserts her wedding dinner at Le Bessier's mansion to follow Tom into the desert: a famous Hollywood ending, with Dietrich discarding her high heels in order to trudge through wind and sand until, with sundry goats and native women, she disappears over the horizon. The frisson of this Dietrich scenario is doubled by a gender reversal: she is, and will remain, a Flying Dutchwoman who with her shady past is condemned to wander the earth; she wins redemption through true love for a man, courageously asserted in repudiation of past lassitude.

Because Paramount was intent on making Dietrich an "American" star, *Morocco* was released before *The Blue Angel* was shown in the United States. But first, Dietrich's image appeared on billboards

and walls on both sides of the Atlantic as "Paramount's New Star." The *New York Times* said, "Marlene Dietrich Expected to Become Screen Star Overnight." And *Morocco* in fact broke box office records and turned a phenomenal $2 million profit. Dietrich "*immediately* became an American icon," one Paramount executive recalled decades later. "I don't think I've ever seen anyone explode on the American public as much as Marlene Dietrich did."[2]

In the next Dietrich/Sternberg collaboration, *Dishonored* (1931), the woman without a name or a past (she is introduced as a pair of legs) becomes X-27: a top Austrian spy. She callously tempts men to their deaths. Then Colonel Kranau, a Russian captive, seduces *her*—and she permits his escape. For betraying her country—for not betraying her lover—she faces a firing squad with intoxicating aplomb. When a smitten soldier hesitates to give the order to fire, she takes a moment to renew her lipstick. In *Shanghai Express* (1932) Dietrich languorously intones: "It took more than one man to change my name to Shanghai Lily." Who is she really? No man can say. But her ex-lover, gentlemanly Doc Harvey, loves her still. Her insouciant eroticism and predatory promiscuity somehow cloak a wholesome core—a core he refuses to trust. Instead, she trusts him. In a final embrace, Sternberg has her appropriate his riding crop. Emanuel Cohen of Paramount wanted Dietrich "to get her man"—and so, calling every shot, she does.

If *Shanghai Express*, seamlessly binding moody oriental locales and calculated ambiguities of sentiment with mysterious events on board a speeding train, is the most elegant realization of the scenario of Dietrich redeemed, *Blond Venus* (1932) is the messiest. It is a film memorable for the star's emergence from a gorilla suit to sing the number "Hot Voodoo" in a blond Afro wig to a swaying accompaniment of tom-toms, palms, and black "native" girls. Dietrich is Helen Faraday, who cheats on her husband, kidnaps their child, flees to New Orleans, and finally transforms herself from a slut to a high-class Parisian showgirl. The movie ends à la *Morocco*

with Helen rejecting a wealthy playboy in favor of the long-abandoned husband. The sanitizing influence of the Hays Office inflects the plot's twists and turns—including a dizzy rationale for Helen's adultery and subsequent independence: her husband needs $1,500 to go to Germany, where his fatal radiation illness can be cured.

An anomaly of these three post-*Morocco* vehicles is the absence of plausible leading men. Cooper's on-screen chemistry with Dietrich was such that it smoldered offscreen. But Victor McLaglen, her hulking co-star in *Dishonored*, was a onetime boxer. Clive Brook, Dietrich's *Shanghai* Doc Harvey, was so stiff his climactic lover's kiss looks faked; Dietrich's daughter, in her memoirs, confirms what all on board could plainly see: that Shanghai Lily preferred Anna May Wong, here a Chinese whore. In *Blond Venus*, the Englishmen Herbert Marshall and Cary Grant (his mature aplomb as yet unsettled) are miscast as Americans. In *The Scarlet Empress* (1934), finally, there is no male lead, only Dietrich as Russia's Catherine the Great. So solipsistic is this treatment, so claustrophobically indifferent to historical fact or locale, that the Hollywood redemption scenario is scuttled. Glorifying Catherine's ascent to the throne, Sternberg glorifies Dietrich alone: her costumes, her hauteur, her wedding and coronation, all of it blithely extravagant and synthetic in equal measure.*

Critics and public had by now rejected Dietrich and Sternberg.

*In his wickedly intelligent autobiography, Sternberg offers an apologia: "The film was, of course, a relentless excursion into style, which, taken for granted in any work of art, is considered to be unpardonable in this medium" (*Fun in a Chinese Laundry* [1965], p. 265). Thus, Andrew Sarris: "What probably disturbed socially conscious critics of the thirties even more than Sternberg's ruthless eroticism was a detached view of power as an orgiastic experience. . . . Dietrich's rapturous ride up the palace steps at the head of her Imperial Cavalry is the visual correlative of soaring sexual ecstasy. . . . The tyranny of a subhuman superego has been replaced by the tyranny of a superhuman libido" (Sarris, *You Ain't Heard Nothin' Yet* [1998], p. 229). More typically, critics of *The Scarlet Empress* are, like ordinary audiences, disturbed by its many gaucheries: byproducts, if not symptoms, of the tyranny of Sternberg's own libido.

Dietrich and Sternberg had for some time spoken of rejecting Hollywood, and one another. For their last film, *The Devil Is a Woman* (1935), the redemption scenario returns as a tattered remnant: as the inhumanly capricious Concha Perez, "the most dangerous woman you'll ever meet," Dietrich abandons a young lover for an older one she has abused far more. Lionel Atwill and Cesar Romero are equally impossible as Spanish objects of desire. As for Dietrich, her stylized physical presentation has become that of a lacquered mask atop a curvaceous doll. The movie was reviled by critics. The Spanish government ordered it withdrawn from circulation as a national insult. There was no audience anyway. Dietrich considered it her favorite movie. "One face more beautiful than the next!" she exclaimed to her daughter. "The film is not good, but we all knew that at the beginning."[3]

This curious trajectory from *Angel* to *Devil* documents two ongoing transactions—between a German actress and America; between the actress and her American director. Hollywood had its uses for exotic beauties. No American was permitted the frank sexuality of a Greta Garbo. The sexy Americans Josephine Baker and Louise Brooks made careers abroad. Mae West (a friend of Dietrich's) ameliorated her voluptuous overtures with winks and wisecracks. But there remained a cost if Dietrich were to become an *American* foreign temptress. She could retain the mocking self-assurance of Lola's erotic advances. Even Lola's amorality, even her androgynous appeal, were not problems—so long as there existed a cure. As Amy Jolly, Shanghai Lily, and Helen Faraday, Lola acquired a heterosexual heart of gold, beating furtively under her insolent veneer. She also grew slimmer, more beautiful, and more mysterious. "You can't make out here what people do know," Henry James's Strether says of Europe. More often than not, watching Amy, Lily, and Helen, Catherine and Concha, in action, one cannot make out what she knows and thinks.

But the mysteries are not wholly advertent. In part, they regis-

ter contradictions between the New World Dietrich and Old World Lola. In part, they reflect the foibles of Sternberg's methodology. Sternberg did not ask actors to understand the characters they played; he only asked that they do his bidding. That this "outside-in" approach did not preclude impressions of intense affection is demonstrable in his silent drama *The Docks of New York* (1928). In this tour de force of cinematic art, the blurred vision of a woman unable to thread a needle records deeper sentiment—she is in love with a man with a ripped shirt, who now brusquely threads the needle for her—than may be found in any of the Dietrich/Sternberg films. What clouded Sternberg's vision was his infatuation with Dietrich, which grew to an obsession. To her daughter, Maria, Dietrich complained that her weak male partners were chosen by Sternberg out of "jealousy"—"Ever since *Morocco* and Cooper . . . he gives me either pansies or bores."[4] The actual leading man in all these films was the one behind the camera—and it is Sternberg's eloquent camera that ever more compulsively made love.

That Sternberg off camera and on loved Dietrich cannot be doubted. They held hands throughout the first, private screening of *Morocco*. That night, driving home, she slipped him a note reading:

> You—Only you—the Master—the Giver—Reason for my existence—the Teacher—the Love my heart and brain must follow.[5]

Sternberg was often in residence at Dietrich's Beverly Hills home. He would give Maria afternoon English lessons. On weekends, he would set up his artist's easel in the garden. But the frantic pace of seven films in six years, and the pressure of Dietrich's other love affairs with partners of both sexes (her marriage to Rudolf Sieber being durable but, by that time, platonic), took their toll. The daily studio regime of dressing Dietrich, lighting

Dietrich, manipulating Dietrich, grew fetishistic and weirdly self-referential. Atwill, the perpetually self-debasing Pasqualito of *The Devil Is a Woman*, even looked like Sternberg. Maria later wrote: "His love for my mother left him drained and angry, usually more at himself than at her. Later, I think he hated what he considered a degrading weakness in himself that kept him passionately in love with a woman he had come to despise. He was too intelligent not to realize that his talent was forfeit."[6]

Sternberg's career was effectively over; for a time, he sought refuge in a psychiatric hospital. In retrospect, silent film was his true métier. With fewer performance parameters in play, it allowed him more complete control; it supported his indifference to verisimilitude; it privileged the effects of lighting, framing, and motion that he favored over words to impart meaning. *Docks of New York* remains his most complete, most humanely affecting achievement. *Das blaue Engel,* the most consummated of his Dietrich films, was the closest in technique and feeling to the silent era.

The film historian David Thomson has suggested that although Dietrich "seemed self-possessed, tantalizing the feelings she aroused with her very indifference, it is possible that, more than any other great star, she was a cinematic invention—a message understood by viewers but not by herself." Be that as it may, that Dietrich survived her artistic death pact with Sternberg testifies to the strength of character and personality—not to mention the tornado of energy—underlying the studied and controlled "Dietrich" they mutually fashioned. According to Maria, her mother began to refer to herself in the third person—"as a product, quite removed from her own reality"—within days of beginning to work with Sternberg. All her life, she called him "the man I wanted most to please." She also said: "He gave me the opportunity for the most creative experience I have ever had." And: "I failed him. I was never the ideal he sought." And: "The legend served me well, and I venture to say it served well all the other

directors who took over after he decided that I should go on alone. . . . It has been said that I was Trilby to his Svengali. I would rather say I was Eliza to his Henry Higgins." But Dietrich also remarked: "People have said he cast a spell over me. That is ridiculous. . . . Can you think of anyone casting a spell over me?" She would go on.[7]

THE GERMAN CRITIC SIEGFRIED Kracauer, in his classic study *From Caligari to Hitler: A Psychological History of the German Film* (1946), cited *Das blaue Engel* as a prescient analysis of "the problem of German immaturity," with Professor Unraut personifying the imminent "indiscriminate surrender" of the middle classes, and his ill-behaved students standing in for "Hitler youths." Though Sternberg denied he had anything comparable in mind, the film remains powerfully *Berlinerisch:* tough, smart, caustic, irreverent. It nearly inhabits the wicked cabaret environment of *Die Dreigroschenoper;* Brecht, Weill, Lenya, Klemperer's Kroll Opera, are not so far down the street.

That Dietrich became Germany's most popular cultural export to the United States documents an act of accommodation. Had she retained the toughness of Lola, she would have suffered the same irrelevance as Brecht, Klemperer, or Hindemith. Rather, like Weill to Broadway, she transitioned to Hollywood. This makeover must have perplexed or disappointed many of her German admirers. For other Germans—the National Socialists, with their lethal puritanism and barbarism—she was both a traitor and a potential trophy. Hitler screened her films privately at Berchtesgaden. Doubtless, she represented a prize both erotic and political: like Furtwängler or Richard Strauss, who stuck it out in Germany—like Emil Jannings, who actively supported the Nazis—she could be used to advertise deutsches Kunst.

In 1931, the Nazis promulgated a party ban on *Dishonored* as an

American insult to Austria. This seemed close enough to insulting Germany, and anyway Sternberg was Jewish. In 1938 Dietrich's rendition of "Falling in Love Again" was heard at the much-attended "Degenerate Music" exhibition in Düsseldorf. Meanwhile, Nazi emissaries promised to make Dietrich queen of UFA under Goebbels's protection if she would only return home. To renew her German passport she periodically had to declare herself "thoroughly German"—a formality she could forgo upon acquiring American citizenship in 1939. Though her mother and sister remained in Germany (she had tried to persuade them to leave), Dietrich would have nothing to do with the Third Reich. When Hitler's government signed its nonaggression pact with Stalin, she immediately arranged for her husband and daughter—and also her lover, Erich Maria Remarque, and her husband's mistress—to leave France for Beverly Hills. Though the entire entourage resettled in Hollywood, Dietrich was herself unsettled there. At no time in the United States did she own her own residence. Her screen career was in a tailspin. Sternberg was gone. She was a starlet pushing forty. And Paramount had in 1935 passed into the hands of Sternberg's rival Ernst Lubitsch, whose famed "Lubitsch touch," a byproduct of Viennese operetta, she resisted. Lubitsch directed Dietrich in *Angel* (1937)—after which she was pronounced "box office poison" by the Independent Theatre Owners of America.

The Dietrich career rebounded in 1939 with *Destry Rides Again*, in which Sternberg's redemption scenario was hitched to a tongue-in-cheek Western. As Frenchy, the dance-hall moll, Dietrich raises hell in Bottleneck, helping to dispose of the sheriff and other righteous folk until Thomas Jefferson Destry Jr. comes to town. Frenchy falls for Tom, only to die in a shootout. Though the Hays Office saw fit to excise the line "Thar's gold in them hills" because it observed Frenchy tucking her earnings down her dress front, the film is wholesome; as Destry, James Stewart is—shades of Gary Cooper in *Morocco*—the aw-shucks hero whose innocence

disarms Old Worldlier sinners. The sharp tunes in this confection, including "See What the Boys in the Back Room Will Have," are by Friedrich Holländer, who would shortly become Frederick Hollander. The sharp writers included Felix Jackson, once the Berlin playwright Felix Joachimsohn. The producer was Joe Pasternak, a Hungarian who specialized in musicals.

Over the next forty years, there were eighteen more Dietrich films. Her directors ranged from nonentities to Alfred Hitchcock and René Clair. Her worst movies included *Rancho Notorious* (1951), in which Fritz Lang (an ex-lover) tried revisiting the *Destry* story without a sense of humor. Her classiest included two Billy Wilder creations: *Witness for the Prosecution* (1958), a sardonic variant on the redemption scenario (Dietrich is an outwardly deceitful wife who secretly saves her husband from a murder conviction only to be betrayed by him), and *Foreign Affair* (1948), in which she for once remains unredeemed—a circumstance to which we will return at the close of this chapter.

But these efforts, good and bad, were never consuming Marlene Dietrich vehicles, as in the old days. Rather, her always protean energies were consumed by World War II. For a period of fifteen months—from April 1944 to July 1945—Dietrich's American exile acquired a singular urgency: in Europe. Already, over the course of four national tours, she had become Hollywood's champion bonds salesperson. She had financially assisted many arriving German and French refugees. Now, she boarded an aging army transport plane to cross the Atlantic. In North Africa and Western Europe, she entertained at the front more than any other American, enduring frostbite, body lice, and—in Germany—the not inconsiderable risk of capture or bodily harm. She donned trousers and combat boots, even an occasional helmet—she was an experienced cross-dresser—to visit frontline hospitals, to mingle and dance with "the boys." A German soldier's song, "Lili Marlene," became her signature. At war's end, she tracked down her

sister, who turned out to be a Nazi accomplice in Bergen-Belsen; Dietrich disowned her. In Berlin, she located her mother—only to learn of her death six weeks later. In 1947, at West Point, she became the first woman to receive the U.S. government's Medal of Freedom, for contributing "immeasurably to the welfare" of more than 500,000 American soldiers.

It was tragic, exhilarating, exhausting, cathartic: the Hollywood equivalent of Toscanini's galvanizing World War II Beethoven concerts at Carnegie Hall, the climax of the redemption saga of Dietrich's Americanization. No less than Thomas Mann, Dietrich in wartime America symbolized the "good German." The war years equally embodied an emotional high—"I never felt so happy as in the army," she told her daughter—with no possible sequel. She had announced to a war correspondent during the Battle of the Bulge, "I am through with Hollywood. It was a very difficult place to live anyway." She had returned to a "carefree" United States that "really didn't know what its soldiers had gone through over there on foreign soil." To her husband she wrote from Paris in December 1945, "I have never been so alone and lost."[8]

Believing her film future lay in Europe, she made *Martin Roumagnac* with her lover Jean Gabin: a 1946 disaster. Though more Hollywood work ensued, the final chapter of her career mainly occurred onstage: her initial Berlin métier, her wartime specialty. Beginning at the Congo Room of the Sahara Hilton in Las Vegas in 1953, she became a spectacular nightclub attraction, revisiting Berlin songs, Hollywood songs, and "Lili Marlene," adding fresh material with the assistance of her adroit music director, Burt Bacharach. Engagements in London, South America, and Paris led inescapably, in 1960, to her return to German stages. She was both feted and reviled; in Düsseldorf, amid 200 fans outside her hotel, an eighteen-year-old girl cried "Traitor!" and spat in her face. In the opinion of her friend and factotum Bernard Hall: "I personally think Marlene had gone to Germany in the first place to see if

she might one day go back to retire there, live out her days in her birthplace. We were drinking late in the hotel one night, and she said, 'Just maybe . . .' Perhaps she was drunk, but I don't think so. Not bloody likely after that spit in the face! That made it clear she could never go home again, because they didn't want her."[9]

But she was wanted in Warsaw, and in Moscow and Leningrad. In Tel Aviv, she received a thirty-five-minute standing ovation after shattering the Israeli prohibition against the German language by singing "Lili Marlene." "It's bad enough to lose your Fatherland," she said. "I couldn't give up the language, too." At a benefit concert for Israeli orphans she told her audience, "I have suffered with you through the years. But for tonight, it has been worth it." A year later, in Stanley Kramer's *Judgment at Nuremberg*, she was cast as the cultivated widow of a Nazi officer who, balancing the repulsive defendants in the docket, conferred a more human face on the Germans as a people; Kramer remarked rhetorically of her personification of the "other" Germany, "Who else would you *get?*"[10]

Also in the postwar period, Dietrich survived cancer and numerous broken bones riddling her still-impressive body. When at the 1958 Brussels World's Fair, visitors to the United States pavilion were invited to name "the greatest immigrant to the United States," she came in fourth (Einstein was first). To her eloquent biographer Steven Bach, for whom her concert appearances were "the most perfect of her greatest achievements," Dietrich's was, finally, a heroic life. Maria Riva, in her embittered yet forgiving memoir, remembers her mother in Las Vegas basking in the "nightly adoration" of audiences and of Hollywood celebrities she had previously shunned. She recounts a "dismal pit" of alcohol and loneliness, a "tragic reality" of "picking my mother up off the ground, hustling her quickly into a limousine, having her pass out in my arms, as she snarled invectives at me."[11] After her husband died in 1976, Dietrich increasingly secluded herself in her Paris apartment. If her

glamour was gone, no one could witness it. But she maintained a vigorous surrogate social life on the telephone. Maximilian Schell's 1984 documentary *Marlene: A Feature*, in which she is heard but never seen, preserves her feistiness and acuity in old age. She died at home, on the Avenue Montaigne, in 1992.

The United States, clearly, was more to Dietrich than refuge from the storm. Equally obvious is that her identification with the language and culture of Germany was permanent. When in 1937 she unexpectedly encountered Richard Tauber in Los Angeles, they sang together "all the old songs and Berlin was suddenly with us again—so near, so strong, that we were lost and forlorn." It bears mentioning that Dietrich was a musician, trained as a concert violinist (she later played the piano, zither, and musical saw); that as a young Berlin actress she appeared in plays by Shakespeare, Molière, Kleist, Wedekind, Kaiser, and Shaw; that her devotion to the poetry of Rilke, which she committed to memory for life, was unconditional. To her daughter, she inveighed against American "puritans" who censored her movies and censured her household, with its multiple love-mates. "Fear of the American press," according to Maria, was one reason Dietrich wound up in Paris rather than New York. And the multiple mates were, for the most part, Europeans—Sieber, Remarque, Gabin, Maurice Chevalier—who understood her estrangement in the United States.★[12]

Maria, for whom the United States truly was home, felt her mother never fulfilled the artistic promise of *Das blaue Engel*. Dietrich, in Schell's documentary, was dismissive of all her films. "'Falling in Love Again'—it's ridiculous! Those pictures of me sitting on that barrel with my leg pulled up! . . . I thought Jan-

★Her American lovers included Adlai Stevenson and Edward R. Murrow, as well as assorted actors and actresses. She also enjoyed friendships with Orson Welles and Ernest Hemingway. Maria: "The power of such beauty also being endowed with such polished intellect was, after all, an irresistible combination" (Maria Riva, *Marlene Dietrich* [1994], p. 653).

nings was awful. He was such a ham in that part." Of *Blond Venus*: "Rubbish! Kitsch! But then I didn't understand anything in those days. You see, I was stupid." "I never took my career seriously." As for the United States: "None of us émigrés ever found a home. Of course, America is my real home. They took me in when I arrived. My daughter lives there, my whole family is there." "Wouldn't you say this is a kind of homelessness?" Schell inquired. "I don't have kitschy feelings like that—none of us did. I was born a German. We didn't have kitsch. . . . I'm a practical person, a logical person, no time for dreaming." Schell asked Bernard Hall if Dietrich was a "lonely" person. Hall replied, "Yes." In Schell's film, Dietrich only twice expresses interest in mementos of her professional past. She would like to revisit her 1929 screen test for Sternberg—has anyone found it?★ She would like Schell to hear her 1965 recording *Marlene singt Berlin*. Both were made in Berlin.

Hollywood was not present at Dietrich's funeral at the Église de la Madeleine. The French tricolor draped her coffin. Maria replaced it with an American flag and, according to her mother's wishes as she understood them, had the body flown to Berlin, there to be buried in the Schöneberg district where she was born. Her plot adjoined that of Josephine Felsing Dietrich von Losch, who had brought her into the world ninety years before.

OF THE TWENTY-SIX HOLLYWOOD films in which Dietrich had a starring role, only twelve had American-born directors. The other directors were three Germans (Lubitsch, Henry Koster, William Dieterle), a German-American (Sternberg), a German Austrian (Lang), a Frenchman (Clair), an Armenian Russian (Rouben Mamoulian), a Pole (Richard Boleslawski), and a vagabond Polish

★The Kino Video *Blue Angel* DVD (2001) includes the famous screen test.

Jew (Billy Wilder). The leading actors in these films included a veritable British colony (Brian Aherne, Clive Brook, Cary Grant, Herbert Marshall, Victor McLaglen, Basil Rathbone, C. Aubrey Smith), as well as the Swede Warner Oland, the Frenchman Charles Boyer, and the German Gustav von Seyffertitz. One Dietrich film, *The Garden of Allah* (1936), was a Tower of Babel, with Rathbone as a beturbaned count, Boyer as a Russian monk, and Smith as a French priest. Three Austrians—Joseph Schildkraut, Tilly Losch, and Ernest Dryden—took part as an Algerian, an oasis dancer, and the costume designer, respectively. The director, Boleslawski, was a disciple of the Moscow Art Theatre. The producer, David Selznick, had to hire a "dialogue coach."

If *Allah* was exceptional, Hollywood was nothing if not polyglot. But not at first. Its prime movers were preponderantly home-grown and "American" in wholesome affect. D. W. Griffith, whose *The Birth of a Nation* (1916) and *Intolerance* (1918) were early cinematic landmarks, espoused a sentimental southern moral code. His great star and adherent, Lillian Gish, was ever virginal and true-hearted. Little Mary Pickford (born in Canada), curly-haired and dewy-eyed, played intrepid, self-reliant adolescents well into her twenties. In 1920 she famously married Douglas Fairbanks, the most blithe and graceful of swashbucklers. Cecil B. DeMille, the embodiment of "Hollywood director," was solemnly yet flamboyantly righteous.

An exception proving the rule was Charlie Chaplin, whose training ground was the British music hall in his native London. Chaplin settled in Hollywood in 1914 at the age of twenty-five. He became its richest and most independent star. His powers of self-invention parallel those of Leopold Stokowski, also British-born, a coast away. He did not know who fathered him. His mother died a schizophrenic. His formal schooling was scant. Another immigrant comic happened to be on the same ship that first took Charlie to America; according to Stan Laurel, as the SS *Cairnrona* neared

New York, Chaplin stretched his arms wide at the rail and cried: "America, I am going to conquer you. Every man, woman and child shall have my name on their lips—the name Charles Spencer Chaplin!"[13] The indelible screen persona he proceeded to create, an admixture of sentimentality and slapstick, self-pity and aggression, cloaked a private personality equally intractable: as in his comedies, he never quite fit in. His marriage with Paulette Goddard was said to be unsanctioned. His political speeches were called traitorous. He lost a ludicrous paternity suit he deserved to win. Censors and courts, the IRS and FBI, called him Communist and corrupter. Congressman John Rankin of Mississippi attacked him for his "forcible seduction of white girls" and "refusal" to become an American citizen. By 1952 he had endured enough and left the United States for Switzerland. One of his last movies, *Limelight* (1952), nostalgically revisits the British stages of his youth (and culminates in what may be the funniest skit he ever filmed, directly followed by his most bathetic ending).

Before Chaplin was orphaned by his mother's madness, his family was sufficiently well-to-do to afford a maid. A different kind of immigrant commanded Hollywood's studios by 1920. Of the early movie moguls, five were offspring of the Jewish shtetl: Samuel Goldwyn was born Shmuel Gelbfisz in Warsaw; Lewis Selznick was a Zeleznik from Kiev; Louis B. Mayer, born in Minsk, believed that his original name was Lazar; Joseph and Nick Schenck, of Twentieth Century-Fox and Loew's Inc., were brothers from Rybinsk. Carl Laemmle, the founder of Universal, had sold clothes in Germany. Adolph Zukor, the head of Paramount, was a furrier from Hungary. Harry Cohn, who forged Columbia, was the son of an immigrant German tailor. The Warner brothers were offspring of an immigrant Polish cobbler. These men cultivated imagery of a homogenized, sanitary "America" less by instinct—after the fashion of Griffith and Gish, Pickford and Fairbanks, or DeMille—than by reflex: as newcomers, they

were intent, consciously or not, on proving their patriotic mettle. Mayer, who prominently displayed a portrait of Cardinal Spellman on his desk, and at home was partial to Chistmas parties and Easter Egg hunts, even claimed July 4 for his birthday. The nouveau riche moguls were also conditioned to seek expensive acquisitions from abroad. As David Sarnoff, born in Russia, would lure Toscanini to NBC with extravagant resources, his Hollywood brethren, intoxicated by high foreign pedigrees, rolled out the red carpet for Europe's most illustrious actors and directors. Zukor and Laemmle, among others, personally performed these purchases on annual pilgrimages to the Old World.*

The illustrious actors and directors thus obtained in great part came from the European Hollywood: Berlin. In terms of profit and worldwide popularity, Berlin was, to be sure, no Hollywood. Rather, it was a cinematic wonderland unto itself. UFA, founded in 1918 and subsidized by the German government, swiftly became the major European studio, with the greatest European aggregation of cinematic talent. This early golden age of German cinema—supported (as Hollywood was not) by a golden age of theater—produced such astonishing film landmarks as *The Cabinet of Dr. Caligari* (1920), *The Golem* (1920), *Hamlet* with Asta Nielsen

*Lewis Selznick leaked to the American press this probably apocryphal cable to "Nicholas Romanoff, Petrograd, Russia": WHEN I WAS A POOR BOY IN KIEV SOME OF YOUR POLICEMEN WERE NOT KIND TO ME AND MY PEOPLE STOP I CAME TO AMERICA AND PROSPERED STOP NOW HEAR WITH REGRET YOU ARE OUT OF A JOB OVER THERE STOP FEEL NO ILL WILL WHATEVER YOUR POLICEMEN DID STOP IF YOU WILL COME TO NEW YORK CAN GIVE YOU FINE POSITION ACTING IN PICTURES STOP SALARY NO OBJECT STOP REPLY MY EXPENSE STOP REGARDS YOUR FAMILY SELZNICK NEW YORK. The film historian John Baxter comments: "Hollywood missed adding the Czar of all the Russias to its roster of stars, but the assumption toyed with in Selznick's bombastic stunt—that with enough money one could buy the best the old world had to offer—took increasing hold as the post-war slump in movie-making was replaced by a new confidence on the part of the thriving studios. They could afford the best, which to them meant only one thing, the artists of Vienna and Berlin, capitals of the culture that had rejected them and to which they longed to return" (Baxter, *The Hollywood Exiles* [1976], pp. 17–18).

ARTISTS IN EXILE

(1921), *Nosferatu* (1922), *Dr. Mabuse* (1922), and *Nibelungenlied* (1924). Wartime blockades and postwar inflation meant that UFA initially flourished in creative seclusion, cut off from America. Only in 1924, with the stabilization of the deutschmark did Hollywood films become widely known in Germany. Two years later, Paramount and MGM acquired substantial control of German film production. With the linkage of Hollywood and UFA, Hollywood's talent pool was increasingly Germanized and Germany's increasingly decimated—an outcome possibly suggesting a strategy.

An early turning point in this confluence, in 1920, was the first postwar American distribution of a German film: Ernst Lubitsch's *Passion* (known in Germany as *Madame DuBarry*), starring Emil Jannings and Pola Negri. Hollywood was not innocent of foreign-born actors and directors. But with the 1921 arrival of Lubitsch himself, accompanied by his own creative entourage, an émigré community of unprecedented size and impact was begun, with Lubitsch at its center. Negri—born in Poland, schooled in St. Petersburg, a star in Berlin—arrived in Los Angeles a few weeks after Lubitsch did. The first European actress wooed by Hollywood, she anticipated Garbo and Dietrich as its premier foreign siren. Following an abortive engagement with Chaplin, she was rumored to be engaged to the Italian Romeo, Rudolph Valentino; on the day of Valentino's funeral, in 1926, she was twice observed emerging from her home in mourning when a cameraman complained about the lighting the first time through. Jannings moved into a Hollywood Boulevard mansion teeming with birds and toys. Paramount, which had clinched a three-year contract for this "greatest actor in the world," announced that he was born in Brooklyn, having moved to Europe at the age of one.[14]

The advent of talking pictures, with *The Jazz Singer* in 1927, complicated cultural exchange. Hollywood's industry dominance ensured that the primary cinematic language would be English.

The victims included Negri and Jannings. Both briefly achieved great American success in silent films: Lubitsch's *Forbidden Paradise* (1924), in which Negri played Catherine the Great; and Sternberg's *Last Command* (1928), for which Jannings won an Academy Award for his groveling portrayal of a discarded Russian general. Jannings's first Paramount film with sound, *Betrayal* (1929), had to be released as a silent. Ironically, sound penalized many an American actor chosen for face or physique; the Europeans were likelier to have theatrical training. Actresses, especially, were potentially enhanced by a foreign accent. "Garbo speaks!" shouted MGM, promoting *Anna Christie* (1930). As would be Dietrich, Greta Garbo was multilingual and sultry-voiced; her American silent stardom was a beginning, not an end.

With the coming of Hitler, the German film community migrated to California in yet greater numbers. Hollywood more than weathered the Depression. As of 1939, more than fifty million Americans went to the movies every week. There were more than 400 new films every year. There were more movie theaters than banks. In terms of assets, the movies were the nation's eleventh biggest business. Hollywood's response to the European crisis, however, proved notoriously timid. Following a trip to Germany in 1934, Irving Thalberg observed that "a lot of Jews will lose their lives."[15] But Thalberg, MGM's Jewish "boy wonder," thought Hollywood should stay out of it. Rather than jeopardize lucrative overseas markets, studios often shot alternative endings to potentially offensive films. The early moguls' sentimental regard for the Old World, and for Old World pedigrees, had been replaced by a harder-nosed mind-set reinforced by the isolationism of the U.S. Department of Immigration. Even Fritz Lang, in 1934, enjoyed nothing like the welcome and support accorded Lubitsch thirteen years before. Other refugees—eminent as playwrights and novelists—were fortunate to find $100-a-week sinecures in obscure Hollywood bungalows. Their meager jobs,

which enabled them to secure life-saving visas, were often engineered by the European Film Fund, which tithed the pay of successful émigrés.

More than 5,000 Jews alone settled in Los Angeles between 1933 and 1945. The *New York Times* saw fit to print, "Not yet at the alarming stage, Hollywood's refugee problem is nevertheless giving some concern to certain people here."[16] Alarming or not, the Hollywood immigrants were more than ever ubiquitous. We have already encountered great numbers of them inhabiting Dietrich's American career, and also Erich Korngold's. Among the most distinguished German-speaking actors to speak English in American films were such Max Reinhardt alumni as Albert Basserman, Elisabeth Bergner, Paul Henreid, Jannings, Luise Rainer, Joseph Schildkraut, and Conrad Veidt. Fritz Kortner was another mainstay of the Berlin stage who found a niche of sorts in southern California. Hedy Lamarr had been a Reinhardt script girl and bit player. Oscar Homolka had been a German-language stage and screen star. Though Lamarr was a modest MGM success, though Rainer won Academy Awards in 1936 and 1937, few of these artists sustained really prominent Hollywood careers.* Better known were two Hungarian-born character actors: Peter Lorre, whose signature part, in *Casablanca*, was that of a harried, scheming refugee, and Bela Lugosi, forever identified with Dracula. Lugosi's partner in horror, Boris Karloff, was one of countless important British film actors prominent in the United States, most of whom—Ronald Colman, Cedric Hardwicke, Leslie Howard, Charles Laughton, and David Niven, to name but a few not already named—remained conspicuously British. Of Colman and Howard, the film historian John Baxter remarked that as "spuri-

*Bergner, Homolka, and Oscar Karlweis all achieved some stage success on Broadway. Kortner, by comparison, was faulted for his poor English and "exaggerated" gestures when he toured opposite Katharine Cornell in Christian Friedrich Hebbel's *Herod and Marianne*.

ous sons of Empire" they "became so immersed in their Hollywood roles that real life seldom intruded."[17] An exception was the biggest of all Hollywood's British stars: Cary Grant, an Englishman remade. In parallel to the reinvented British immigrants Chaplin and Stokowski, he exercised phenomenal self-discipline in transforming himself into an aristocrat of untraceable origin. Having begun in Bristol music halls as the tumbling and stilt-walking Archie Leach, he expunged his cockney brogue in exchange for a clipped, urbane dialect of his own invention. He paid close attention to his attire and, on the advice of Sternberg, parted his hair on the right rather than the left. "When I was a young actor, I'd put my hand in my pocket trying to look relaxed," he once recalled. "I was trying to imitate what I thought a relaxed man looked like."[18] His models, by his own account, included Fred Astaire, Hoagy Carmichael, Noel Coward, and Rex Harrison. Whatever his considerable private demons, his public dream life was strictly debonair.

As we have seen, foreign-born composers were a defining influence on Hollywood film music. Karl Freund, who shot such German classics as *The Last Laugh*, was an important Hollywood photographer (and sometime director), effecting a linkage between Expressionism and the American horror genre in addition to supporting such top Americans as George Cukor and John Huston. A surprising number of Europeans became successful screenwriters in a foreign tongue. Most remarkable of all, however, was the continued proliferation of foreign directors, including some of Europe's biggest.

ERICH POMMER, THE UFA producer of *The Cabinet of Dr. Caligari*, was convinced the movie would fail because of its extreme style and story—the crooked Expressionist sets with their painted shadows, the pale makeup, the evil hypnotist and homicidal sleepwalker. Against their wishes, the writers—Hans Janowitz and Carl Mayer—were instructed to frame their lurid story as a madman's delusion. But *Caligari* closed after a two-day run at the Berlin Marmorhaus. Pommer undertook a six-month publicity campaign, after which the film triumphed in the same theater. America was even more resistant. New York audiences required an elaborate dramatized "Prologue" underlining the harmlessness of *Caligari*'s plot: the murdering somnambulist, harrowingly overplayed by Conrad Veidt, was reassuringly described as "a man suddenly awakened from a bad dream and unable to remember any detail of its horror"; he had subsequently become "a prosperous jeweler in Holstenwal, happily married, with a couple of healthy, normal children." Outside New York, *Caligari* failed.

In fact, what Siegfried Kracauer would term the "psychological dispositions" of the new German cinema were not readily exportable to the United States. For some Americans, the films were a revelation. Alien to most audiences, however, were the claustrophobic psychic landscapes so relished by the first important German filmmakers, and also the brutal fatalism of their tales, diminishing individual humans to ants in a tragic or deranged cosmos. The American Legion, guarding morals, and Actors Equity, guarding jobs, both called for a ban on foreign films. If the Germans acquired a Hollywood following, it was in great part because their technical prowess amazed: the stylized or supernatural pictorial effects, the virtuosity of camera and lighting, the visual imprint of an all-powerful directorial vision. The skewed perspectives, camera gyrations, extreme close-ups, and exaggerated shadows of many a German film influenced Hollywood practice, especially when dreams, inebriation, or derangement

were at play; but these were incidental effects, not fundamental templates.

In the cultural exchange that brought German directors, designers, photographers, and costumers to Hollywood, New World ingredients ameliorated harsh Old World practices. And the first and most ubiquitous of the new ingredients—eventually to be darkened by film noir in the 1940s—was southern California itself, whose sunlight, ocean breezes, and wide horizons contradicted the gloomy interiors, twisting topographies, and airless courtyards and forests of many a German movie. German Expressionism was plainly a product of history and tradition: spent Romanticism and the Great War contributed to black ironies and a disillusioned worldliness. Hollywood, by comparison, was ahistorical, placeless, blithe. It offered eateries in the shape of a derby hat, a famous nightclub festooned with palms and coconuts, lavish private homes imitating or exceeding venerable manors and chateaux. Defusing the notion that Paramount might knowingly give offense, Adolph Zukor earnestly pronounced: "We do not make pictures with any idea of depicting real life." A different kind of pronouncement was uttered by the British director Michael Powell:

> California is a hell of a place to live. Miles from anywhere. In those days it was much further than it is now. We were Europeans. We liked to be near theaters and opera and ballet and galleries and people. There weren't any of these things in California. The reason why these highly intelligent people who went to Hollywood immersed themselves in work and just made film after film after film was, I think, because . . . well, what could they do in California? No theatre, no opera—until radio and television came in it must have been the end of the earth. And people too . . . Europeans love people. It's talk as much as anything that keeps things going in Europe, particularly

central Europe, where most of these people came from. Where was the café life in California?[19]

Another pervasive Hollywood influence, forcibly cleansing urbane refugee sensibilities as of 1930 (and more stringently beginning in 1934), was the Motion Picture Production Code, which the studios inflicted upon themselves in support of "good taste" and an enhanced national image. The code decreed that audiences should never "be thrown to the side of crime, wrongdoing, evil or sin." It upheld "the sanctity of the institution of marriage and the home" and forbade "excessive and lustful kissing," "sex perversion," and the outright depiction of "seduction or rape." Few producers were willing to countenance a film lacking the Production Code seal of approval. We have already seen the code in action via its implementation arm: the Hays Office, which forbade Amy Jolly to auction her room key and had Sternberg "explain" Helen Faraday's adultery in *Blond Venus*. Hostile scrutiny of the nontraditional marriages, or nonmarriages, of Dietrich and Chaplin, which we have also observed—and of Ingrid Bergman (who did not play the foreign femme fatale), which we have not—was another manifestation of the code mentality.

It follows that the three most established German-language directors to settle in California furnish absorbing case studies in cultural exchange. Of these three, Ernst Lubitsch was the most productive, amassing twenty-six American films. Fritz Lang made twenty-two films as an American, F. W. Murnau four. That Murnau's post-Berlin output was the smallest reflects his early death. But his transplanted career had already gone astray.

Overhanging Murnau's American fate is a great unknown. Arguably, he created the most memorable Hollywood film of any German; it has also been argued that Hollywood destroyed him. Like so many others, he trained under Reinhardt in Berlin. He began making films at the age of thirty-one in 1919. *Nosferatu*,

two years later, sealed his reputation; its grotesque, otherworldly Dracula, whose extreme physiognomy casts shadows even more extreme, embodies a force of negation metaphysical in intensity. At the same time, Murnau's macabre film, unlike Robert Wiene's *Cabinet of Dr. Caligari*, is populated by real people: its juxtaposition of everyday reality with reality heightened or distorted is a Murnau signature. *The Last Laugh* (1924) and *Faust* (1926) are famously ripe Murnau achievements featuring star turns by Emil Jannings. In the first, Jannings is a hotel doorman demoted to lavatory attendant. Stripped of his massive uniform, the old man becomes a relentless study in pathos not ameliorated by the happy ending imposed by UFA. In *Faust*, Jannings is Mephisto, visiting death and destruction, ultimately vanquished by the force of love.

F. W. Murnau as featured in Photoplay magazine (May 1927). The caption read: "There's no dog about Herr Murnau, Germany's finest contribution to our screen personnel. The director of 'The Last Laugh' and 'Faust' uses mechanic's overalls as his studio smock, and won't work with a gallery. He has just finished 'Sunrise' for Fox and is notable by his absence at gatherings of Hollywood celebrities. Twelve hours' work a day is his idea of a rattling good time. There is just a slight possibility that may have something to do with his reputation as one of the few, very few, great directors."

ARTISTS IN EXILE

Common to both these silent classics is a visual virtuosity paralleling Sternberg's rare achievements in Hollywood—of molded light and shade, of ingenious strategies for mobilizing the camera. Many effects are supernatural or stylized. Notwithstanding their harmonized endings, both films pursue a fateful trajectory hurtling mere mortals toward their downfall. Even while incorporating ingredients more human and "realistic"—Murnau is ever a variegated stylist—they frequently typify German Expressionism. The doorman lives in a sordid apartment complex fronting an urban landscape the more coldly forbidding for being, plainly, a painted backdrop. When his humiliation becomes known, gossiping wives fling the news across the sad courtyard, their jabbering mouths and excited faces a series of lurid close-ups. When Mephisto, on high, spreads the plague, his encroaching black cloak shadows an entire village, its steeples and streets rendered with exquisite detail. Other Murnau effects are breathtakingly lyrical. *Faust* begins in heaven, with archangel and devil, plaster whiteness and fathomless black, illumined by existential blasts of light. Murnau's training as an art historian (born Friedrich Wilhelm Plumpe, he renamed himself Murnau after the Bavarian town associated with the Blue Rider collective) informs the Rembrandt darkness of Faust's study, dramatized by angled light shafts painting his furrowed brow and blazing book of magic. This lofty aesthetic vision maximizes Murnau's tales; they attain the poetry of fables.

Like many another German in Hollywood, Murnau sought fresh creative opportunities in the New World. When he met Mary Pickford and Douglas Fairbanks in Germany, he seized the opportunity to hire Pickford's cameraman, Charles Rosher, as a consultant on *Faust*. "How would you do this in Hollywood?" he would inquire. Rosher, meanwhile, absorbed many a lesson from Murnau's photographer, Carl Hoffman. Though Murnau had failed to interest Hollywood in distributing *The Last Laugh*, its

American critical success persuaded William Fox—born Wilhelm Fried in a Hungarian village, later an eleven-year-old garment worker on the Lower East Side—to offer Murnau a four-year contract. Murnau was to be paid $125,000 for year one, rising to $200,000 by year four. Murnau's regular designer, Rochus Gliese, was engaged to plan Murnau's first film for Fox. Carl Mayer, staying put in Germany, was paid $50,000 for the script. Rosher was to be the principal photographer. Fox called Murnau his "German genius." He was, writes John Baxter, "anxious to hold up his head in a film community briefly obsessed with foreign genius." *Motion Picture* magazine more cautiously observed:

> F. W. Murnau, famous German director, has just arrived in Hollywood with a great fanfare of trumpets. The film colony is wining him and dining him and making an all-around hullabaloo in general.
>
> The funny part of all that is, that the same F. W. Murnau was in Hollywood no less than two years ago. And he had under his arm the now famous picture *The Last Laugh*. But there was no brass band to meet him at the train, and there were no dinners given in his honor.[20]

Murnau's first film for Fox was titled *Sunrise: A Song of Two Humans*. A Man and his Wife are peasants in a village on a lake. The Man is seduced by a Woman from the City. She persuades him to drown his Wife. The Man invites the Wife aboard their small sailboat for a trip to the City. On the water, he rises to murder her. Suddenly, he is stricken by conscience. In the City, his solicitous attentions overcome her terror. They become like newlyweds. Sailing home at night, they encounter a storm. The boat capsizes. The Man swims ashore to the village. The Wife is missing. The Woman from the City whistles to him. He seizes her by the throat, only to hear a distant shout: his Wife lives. He rushes to her side. The sun rises on the village.

The painterly marsh in Murnau's Sunrise (1927) is an indoor poetic artifice. The man (George O'Brien) is seduced by the Woman from the City (Margaret Livingston).

The characters have no names. Neither the village nor the City is identified. ("This song of a man and his wife is of no place and every place," reads a brief preface.) The glacial pace of the simple story weights its pivotal events: the reconciliation, the storm, the apparent drowning, the miraculous close. There are few titles, and even these are mainly superfluous—as in a great Romantic opera, the action is carried forward by the "music," never the dialogue. In fact, the film's universality is sealed by the absence of the spoken word: talking would introduce a delimiting verisimilitude, a confining national identity.*

Even for Murnau, *Sunrise* is a technical tour de force. The village was built from scratch on California's Lake Arrowhead. The marsh in which the Man wanders is an indoor poetic artifice: the mist, the undifferentiated horizon, the artificial full moon, are scanned by a camera suspended from an overhead railroad track. Among the many superimpositions is a sequence in which the Woman from the City materializes, in shadowy apparition, over the Man's left shoulder, caressing his chest; he moves his head away only to find her leaning on his right shoulder, pressing her lips to his mouth; she next appears in gigantic profile in the screen's upper-right-hand corner. To articulate the seminal transition from forest to City—a famous sequence—Murnau laid almost a mile of track and built a streetcar (on an automobile chassis) to traverse the full distance. The camera, from inside the vehicle, documents a gathering momentum of pedestrians, bicycles, and cars emphasized by the play of light and reflection on the car's various internal and external windows. The angle of vision shifts as the track twists and turns. Fields and meadows rapidly give way to an industrial tableau, then verdant suburbs, then the teeming metropolis. The latter, built on a Fox lot, relies on miniature sets and

*Released after *The Jazz Singer*, *Sunrise* is not technically a "silent" film. Its sound track comprises music and sound effects.

midgets to convey an impressive depth of field. The urban scenery teems with activity: at an amusement park, belly dancers, an elephant, ballrooms, fireworks, blend into a cacophony of dense background activity. Montages redouble the clamor and excitement. When the Man and Wife set sail for home, they sight a distant barge with revelers and a bonfire. A vertical plume of smoky light, through which they pass, illuminates the black sky and, in reflection, the black water. The exquisite flickered night imagery of the barge's passengers has been plausibly likened to the shadow world of Goya. When the villagers rush to the shore to search for the Wife, their lanterns cast flashing or gliding streaks of light on windows and walls, mapping a crescendo of suspense more potent and lyric than whatever words might convey. All this cost money and more money. When during the shooting of the storm the rain machine prematurely flooded the City, preempting the twenty-second dust storm intended to come first, Murnau dismissed 3,000 extras and waited three days for the set to dry; on the next take, the wind machine started on cue.

In terms of cultural exchange, *Sunrise* is a rarefied fusion of New World and Old, America and Germany. No previous Murnau film is as buoyed by air and light. Shining or warmly molded glass surfaces—in the trolley, in restaurants, in a barbershop, at a railroad station—are a virtual motif. George O'Brien and Janet Gaynor, as the Man and Wife, are by German standards naturalistic actors; their reconciliation, the husband sobbing convulsively in the Wife's arms, is made plausible by a seemingly unself-conscious spontaneity of gesture and expression. Their "song" is, ultimately, a lyric effusion escaping the dark teleologies of many a Germanic film narrative. But the song's first verses are contorted by a vortex of oppressive circumstance. Here, O'Brien as predator is Expressionist: his leaden, stiff-legged gait, his hunched, hulking shoulders, his fixed downward gaze, do not simulate actual human behavior. The moonlit marsh in which he wanders resembles

the befogged moonlit nightscape upon which Murnau's Faust en-croaches to summon the Spirit of Darkness, or the "forest path by a pool," lit by a blood-red moon, in which Wozzeck stabs his wife in Berg's opera (whose 1925 premiere was a landmark Berlin event). In contrast to the city's brightness, the village's stylized peasant interiors, with their slanted tables, raked floors, barren walls, and creeping shadows, again are Germanic—as are the ga-bles and steep thatched roofs. The peasants' gnarled, bearded faces look "European." Vermeer is an obvious influence on certain ex-quisitely studied domestic interiors, lit from the side. The rectilin-ear glass partition in the city restaurant where the Man and Wife dine registers a Bauhaus influence on Gliese's art design.

Absent language—even the City's glimpsed signage is indistinct—this intermingling of wholesome pleasure and tortu-ous interiority, America and Europe, light and shade, sunrise and sunset, is most often surprisingly seamless. It has been objected that a sequence of cheerful escapades following the reconciliation scene is overlong, slowing the film and imbalancing its trajectory. Man and Wife visit a barber, a photographer, and an arcade in which the Man captures a runaway pig and the two of them regale the urbans with an exuberant peasant dance. But *Sunrise* earns its sunlit finis.* If the happy endings of *The Last Laugh* and *Faust* seem tacked on, the *Sunrise* ending is optional and yet integrated: we have observed for some time how the two humans, challenged by external events, can power their own destiny.

A greater problem with the film was not aesthetic but financial. Though it was the succès d'estime Fox desired, though it was voted a "Unique and Artistic Picture" by the Motion Picture Academy, though Gaynor and Rosher won Academy Awards (as did Karl

*A startling instance of the American penchant for happy endings, ameliorating Germanic tendencies, may be observed in American Wagnerism before World War I (see Joseph Horowitz, *Wagner Nights: An American History* [1994], especially chapters 8 and 10, on the *Ring of the Nibelungs* and *Parsifal*).

ARTISTS IN EXILE

Struss, who wound up sharing the cinematography), though Gliese received an Academy Award nomination, though Murnau's visual style impacted on a range of Hollywood directors (John Ford even used sets from *Sunrise*, and the Murnau writer Herman Bing, for his 1928 *Four Sons*), *Sunrise* was not a commercial success. Fox did not give up on his German genius, but he rebalanced the equation in search of the elusive marriage of high art with popular entertainment. The outcome was a pair of now-forgotten films—*Four Devils* (1929) and *City Girl* (1930). The first is the story of four orphans—two girls and two boys, including Charles (Charles Morton) and Marion (Janet Gaynor)—who become a famed circus act: the Four Devils, performing their "Leap of Death" through a ring of fire. But the bonding of these sheltered innocents is shattered when Charles is smitten by the "Lady," a city sophisticate (Mary Duncan). The film ends with a spectacular trapeze debacle. In *City Girl*, Lem (Charles Farrell), a Minnesota farm lad, is sent to Chicago to sell the wheat harvest. He falls in love with a waitress, Kate (Duncan again), and they marry on the spot. Back on the farm, Kate feuds with Lem's suspicious father. The farmhand Mac attempts a violent seduction. An emergency evening harvest in the face of a looming storm sets the charged finale.

Fox insisted that Murnau make *Four Devils* "at a reasonable cost." When it did not turn out reasonably commercial, a happy ending was tacked on, after which reels were reshot with the addition of banal dialogue and a sanitized plot revision. For *City Girl*, Fox agreed to purchase an Oregon farm. Entranced by wide American horizons, and by the equally American spectacle of elaborate farm machinery illuminated at night, Murnau mounted his camera on a sledge and plowed acres of ripe wheat. The outcome was as much a lyric essay as a traumatic story: audience poison. Rereleased as *Our Daily Bread*, the film was again substantially reshot with sound. Compromised by box office considerations, neither *Four Devils* nor *City Girl* rivals *Sunrise* as a magisterial labor

of love. But Murnau's sovereign stamp—the visual poetry, the dire trajectory—remains evident.*

Murnau was not even in the United States when these films were misshaped as talkies. In 1929, he had left Hollywood aboard his yacht *Bali*. This exotic turn of events arose from a meeting with Robert Flaherty, director of the pioneer documentaries *Nanook of the North* and *Moana*. Both directors resolved to leave Fox in favor a joint film venture in the South Seas. When the producers went bankrupt, Murnau agreed to finance the project himself. *Tabu*—directed by Murnau, coscripted by Murnau and Flaherty—would juxtapose an unspoiled tropical paradise with the inroads of Chinese merchants and American jazz. On the island of Ua-Pu, Murnau discovered a population "witty and pure." The young men dove to harpoon fish. They shared with him the ancient ritual dances and songs the missionaries had forbidden. They were "like pictures of Gauguin come to life." From his headquarters in Tahiti, Murnau scoured Ua-Pu and other islands for his cast. Intent on using amateurs, he tested hundreds of natives before selecting a group of first-

*Though *Four Devils* does not survive, it has been reconstructed with stills and script excerpts by the film historian Janet Bergstrom as an ancillary feature of Twentieth Century-Fox's DVD reissue of *Sunrise*. Bergstrom includes audience responses to a Fox questionnaire distributed at screenings of an early version that ends with Charles and Marion plunging to their deaths. One reads:

> My general impression: "Four Devils" is one of the greatest if not the greatest motion picture that I have ever seen. I say this because "Four Devils" is truthful and honest and goes relentlessly to its inner conclusion. It does not say, "This is all a good joke" and then give us a perverted happy ending, which is the usual Waterloo of most motion pictures leaning toward tragedy. I have a plea. For God's sake, don't change the ending of the picture. Let Pollyanna fans and Sunshine Fans come to you in a body, place a revolver against your chest and demand that you change it.
>
> Tell them to go to Hell.

A rare ninety-minute silent version of *City Girl* has been released on DVD by Grapevine Video.

time actors whose "childlike charm and grace," he wrote, "would be a sensation if they entered European or American studios."[21]

Tabu documents Murnau's exhilarated response to halcyon seascapes and simple lives—especially those of the bronze-bodied pearl fishers, models of Grecian poise. As in his previous films, a fable pits fate against freedom. The lovers Reri and Matahi are sundered by the ancient priest Hetu. An impassive, implacable presence, he declares Reri the "chosen one" and hence "tabu": never to be touched by man. Reri and Matahi flee, but cannot escape. Hetu seizes Reri. Matahi perishes.

Tabu's vision of paradise dispenses with studio props, costumes, and cosmetics. The indigenous cast easily evinces a vulnerable state of nature—of wholesome instinct unfettered by demons of civilization or the psyche. The simple story, patiently plotted, is schematic. Indelible is the closing image of the ocean, inexorable and becalmed, having swallowed Matahi as the single sail of Hetu's boat disappears over the horizon.

The eschewal of the virtuoso touch is a mixed blessing: this is a less polished film than *The Last Laugh*, *Faust*, or *Sunrise*. Its most debilitating crudity is the sound track. Even more than in *Sunrise*, the absence of dialogue makes a timeless tale the more poetic. But Hugo Riesenfeld, whose *Sunrise* score aptly appropriates the brooding beginning of Liszt's *Les Préludes*, is here adrift, blighting fragrant exotic tableaux with snatches of Chopin, Schumann, and Smetana. Schubert's "Death and the Maiden," a literal Viennese transliteration of Hetu's intervention, is laughably out of place. The island dances Reri, Matahi, and the others reconstructed as authentically as memory permitted are symphonically embellished, like nightclub acts.

Salka Viertel, who with her husband (who cowrote *City Bread*) helped Murnau to pay Riesenfeld, favored the use of "native music." But according to Viertel, Murnau's agent "and other Hollywood people" advocated "a great symphonic score" as "a last

desperate attempt" to secure distribution of a silent film four years postdating *The Jazz Singer*.[22] As it happens, Paramount picked up *Tabu*—and offered Murnau a ten-year contract. The New York premiere took place on March 18, 1931. But Murnau had died seven days previous at the age of forty-two, thrown from a car being driven at high speeds by a handsome young Filipino. As Murnau's homosexuality was well known, Hollywood tongues wagged maliciously about the circumstances of the tragedy. Only eleven people turned up at the funeral parlor. Murnau's body was shipped to Berlin for a more elaborate ceremony, attended by UFA luminaries.

In a letter from the South Seas, Murnau had written:

> When I think I shall have to leave all this I already suffer all the agony of going. I am bewitched by this place. I have been here a year and I don't want to be anywhere else. The thought of cities and all those people is repulsive to me. I want to be alone, or with a few rare people. When I sit outside my bungalow in the evening and look at the sea, towards Moreo, and see the waves break one by one and thunder on the reef, then I feel terribly small, and sometimes I wish I were at home. But I am never "at home" anywhere—I feel this more and more the older I get—not in any country nor in any house or with anybody.

Before his fatal accident, Murnau was about to leave for Germany to visit his mother, to whom he was very attached. He had purchased a house in the South Seas and shipped his library there. He intended to "study the development of talking pictures in Germany, France, England, and the United States," having been "far away from civilization when the talkies came in." He also wrote that talking pictures had arrived "too soon—we had just begun to find our way with silent film." He conjectured that the silent cinema would never wholly die. Could Murnau's art, schooled in slow rhythms and poetic indirection, have accommodated sound?

Was he too much the European auteur ever to have found a home in California? To the German film historian Lotte Eisner, "All Murnau films bear the stigma of his inner discord; they give evidence of his conflict with an alien world, forever inaccessible to him. Only in *Tabu* does he find some peace, some happiness . . . where European morals and feelings of guilt don't exist." But David Thomson writes: "It was in America that [Murnau] felt liberated," that Paramount was "the studio most likely to encourage him." To John Baxter, Murnau's was "perhaps the brightest talent ever to be ruined by Hollywood"; he responded to America, Baxter writes, "by retreating, as many others had done, into the distant haughtiness of the offended artist. Although his homosexuality would have gained him entry to the highest Hollywood circles, [he] remained aloof,★ surrounding himself with a coterie of Latin servants and intimates." Viertel, who knew Murnau well, observed "his conviction that a dedicated film maker could not express himself in a Hollywood studio." Fritz Lang, at Murnau's Berlin funeral, struck and held a German chord:

> It is clear that the gods, so often jealous, wished it to be thus. They favored him more than other men and caused him to rise astonishingly quickly, which was all the more surprising because he never aimed at success nor popularity nor wealth.
>
> Many centuries hence, everyone will know that a pioneer had left us in the midst of his career, a man to whom the cinema owes its fundamental character, artistically as well as technically. Murnau understood that the cinema, more than the theater, was called to present life as a symbol: all his works were like animated "ballads," and one day this idea would be triumphant.

★The cameraman Paul Ivano recalled that the scriptwriter Herman Bing, after introducing him to Murnau, left by walking backward, as if from royalty (Lotte Eisner, *Murnau* [1973], p. 195).

Emil Jannings touched the coffin, but did not speak. He later said:

> Of all the great personalities of the cinema, Murnau was the most German. He was a Westphalian, reserved, severe on himself, severe on others, severe for the cause. He could show himself outwardly grim, but inside he was like a boy, profoundly kind. Of all the great directors, he was the one who had the strongest character, rejecting any form of compromise, incorruptible. He was a pioneer, an explorer, he fertilized everything he touched, and was always years in advance. Never envious, always modest. And always alone.
>
> His successes and failures both arose from the same source. Each of his works was complete, authentic, direct, logical. If one ever seemed to be cold, it was still fundamentally lit by the fire of his artistic will, which always remained incorruptible. It was harsh and absolute, like Gothic art.[23]

Undoubtedly, these testimonials were partly about the testifiers: the notion of films as fateful ballads was more Langian than universal; the emphasis on Murnau's severity better fitted his UFA output, not *Sunrise* and *Tabu*. Taken as a group, Murnau's four post-German films, notwithstanding the "happy endings" of the first three, elaborate a single archetypal theme—innocence defiled or unmasked. In *Sunrise* and *Four Devils*, it is a city girl who disrupts a prelapsarian state of nature. In *City Girl* and *Tabu*, it is the natural state itself that proves a false hope; "I used to think the country was clean—that men out here were decent," Kate exclaims. The archetype is that of Murnau's own fate, migrating from Germany to the New World, from America to the South Seas, in a futile quest for paradise. Wracked by his inner demons, his saga cannot be reduced to that of a German ruined by Hollywood. In truth he had several homes, or none.

Ernst Lubitsch and Greta Garbo on the set of Ninotchka *(1945).*

IF GRIFFITH, CHAPLIN, STERNBERG, and Murnau were Hollywood directors who in their various ways incompletely negotiated the transition to sound, Ernst Lubitsch was one who adapted to the talkies as he had earlier adapted to America: his career was triumphant on both sides of the ocean.

Born in Berlin in 1893, Lubitsch played character and comedic parts for Max Reinhardt before becoming a successful film comedian; his great nose, twinkling eyes, and short stature supported vigorous exercises in Jewish ethnic humor. He soon dropped film acting for film directing and achieved fame for his historical epics and comedies of manners. He settled in California in 1922 and became an American citizen fourteen years later. More than any other German film immigrant, he was both a leading figure in Hollywood's German film community and an icon

for all of Hollywood: his authority, reputation, and influence as Hollywood's prize immigrant seemed ever increasing. His films were contractually protected from tampering by studio heads like Jack Warner and Darryl Zanuck. For a short time, in 1935–1936, he became the only major director to run a large studio: Paramount. When his health failed, in 1947, he received a special Academy Award. He died the same year at the age of fifty-five.

Lubitsch's adaptability connected with his temperamental buoyancy. Neither his nature nor his films partook of the convolutions of a Sternberg, Murnau, or Lang. A cigar-chomping extrovert, he was likened by the playwright Robert Sherwood to a combination of Napoleon and Pulcinello:

> He is dominant, aggressive, emphatic and decisive—thereby bearing out his Napoleonic exterior. His kinship to the little figurehead on the jester's bauble is evident in the nimble alertness of his wit, the indefatigable irreverence in his attitude toward all the musty traditions, all the trammeling fetiches [sic] of his profession. He has no use for hokum, splurge and exaggerated bunk and he says so to everyone (his employers included). He still speaks with a musical comedy German accent, but it doesn't seem to bother him to any great extent. He is supremely voluble and forges confidently ahead through the intricacies of an alien language, without regard for the obstacles of speech which continually confront him.[24]

Lubitsch considered his move to America "the finest thing that ever happened to me." His appreciation of his new homeland was untempered by the reservations of other immigrants. He not only enjoyed the southern California sunshine; he liked the motley ersatz architecture. After enduring Berlin's fuel shortages, which limited working hours and lighting resources, he found Hollywood lavishly endowed with equipment, facilities, and dollars. He

returned to Germany only twice, in 1927 and 1932. "I'm almost out of place in this hotel," he told a reporter on the first of these visits. "I'm like a stranger, and yet my entire existence is rooted in this city. All I need now is for the porter to tell me which tourist attractions I should visit." He of course regretted the absence of anything like European café society in America. He therefore entertained frequently at his Beverly Hills home, where German cuisine and July 4 fireworks were equally entrenched. "In Hollywood he could do what he wanted and make a lot of money besides," his niece Evie Bettelheim-Bentley testified. "Not that money was the important thing to him; he was never poor, so if you're never poor, money doesn't have that fascination. But I think everything was too small in Europe for him. In Hollywood, he had so much more of a free hand to do what he wanted to do. He could never have gone back to Europe."[25]

Lubitsch's earliest films are comedies and historical epics—of a sort. *Madame DuBarry* (1919)—which, as we have seen, was the first postwar German film to be distributed in the United States— falls into the latter category. Louis XV's decadent court furnishes a succulent backdrop to drawing room fun and intrigue. As the king, Emil Jannings kisses the feet and trims the fingernails of Madame DuBarry, played by Pola Negri. Hordes of extras storm the Bastille—a mob mainly provoked by anger at the former king's mistress. Five other German productions directed by Lubitsch were nationally shown in the United States. Upon moving to Hollywood, Lubitsch pursued the same genres as before. He told the *New York Times* in 1927 that "the people of Europe are more seriously fundamentally than those in America," that "a story must be complete and logical to achieve success in Europe, while here the story can be perfectly illogical so long as it amuses."[26] But his adaptation was subtle. It is true that with the advent of sound, and English-language dialogue, Lubitsch in Hollywood stopped making historical costume dramas. He continued, however, to situate

his amusing tales in Europe, and to use European plays and stories for his plots.

Operetta was ever part of the Lubitsch sensibility. The sophisticated wink was his stock in trade. He adored the naughty erotic escapades of well-mannered lovers—to which he applied sentiment and foolishness with an equally light touch. Lubitsch himself played the piano (there was usually one on the set) and cello (badly). He was swiftly infatuated by American musical comedies and revues; "they are superior to anything in either Berlin or Paris," he reported. He also considered "American dancing" the "best and most beautiful in the world."[27] His first film using the spoken word is also sung and danced. In fact, *The Love Parade* (1929) is already a finished exemplar of the genre it helped to create: the screen musical. A seamless cinematic experience, it transcends—completely—the staginess of such slightly earlier musical films as *Rio Rita* (1929) and *Whoopee!* (1930), both based on Ziegfeld hits.

Queen Louise (Jeanette MacDonald) of Sylvania seeks a husband but not a king. Count Alfred Renard (Maurice Chevalier) is a Sylvanian roué with a French accent. He seduces and weds her, but chafes as her underling. When he threatens to bolt, she abdicates and joins him. The film begins with a phony murder: the gun has no bullets. And *The Love Parade* remains cheerfully artificial. With his easy smile, cheeky charm, and debonair physical grace (qualities lacking in many an American romantic lead in Lubitsch films to come), Chevalier perfectly partners his director. The gags include a singing dog and a tour bus exhorting: "SEE SYLVANIA FIRST!" The transitions from music (by Victor Schertzinger) to dialogue are always deft. The credits—score, screenplay, design—intermingle European and American names. Of the principal cast members, Alfred's "French" servant, Jacques, is played by a British song-and-dance man, Lupino Lane. The others, save Chevalier, are Americans. As cultural exchange, *The Love Parade* marries Broadway, Hollywood, and Vienna.

Lubitsch made four more musicals: *Monte Carlo* (1930), *The Smiling Lieutenant* (1931, based on Oscar Straus's *A Waltz King*), *One Hour with You* (1932), and *The Merry Widow* (1934). The froth and exuberance of these efforts furnished a Depression-era escape. With their brisk, unsentimental "lovers," they notably eschew Viennese schmaltz and weltschmerz. Even *The Merry Widow*, an Austrian-American cultural exchange mediated by Chevalier in his final Lubitsch assignation, disdains operatic voices (unless MacDonald's New World soprano qualifies). But Lubitsch yenned for a more serious métier. *The Man I Killed* (1932), a Lubitsch anomaly, is a war drama about a French soldier's guilt. Critics liked it, but audiences stayed away—even after Paramount, citing "the greatness of its drama and magnificent love story," retitled it *Broken Lullaby*. Less than a year later came what would prove Lubitsch's favorite among his films: *Trouble in Paradise* (1932). Whatever the famed "Lubitsch touch" may have been (opinions differ), it is doubtless to be found here. The ingredients are money and sex, superb repartee, and aristocratic characters situated somewhere in Europe. The Lubitsch authority Herman G. Weinberg shrewdly observed:

> Lubitsch recognized sex, which is to say, the tradition of erotic sensibility, as the first delightful fact of life, to be treated sportively, frivolously, like Fragonard and Boucher did, or with tenderness, as Watteau did, as the occasion dictated. Although this was primarily a French tradition . . . it became also an American tradition, especially in the sex comedies made by Lubitsch in Hollywood. Note that in Europe, where sex was taken as a matter of course, Lubitsch was very decorous and serious about the subject. But in America, with its taboos and repressions, its surface Puritanism, he became facetious on the subject and decided to make American audiences laugh at something they took so seriously. Actually there were two American fetishes he satirized—sex and money. . . .

... films like his American sex comedies would never have been made in Europe—they were possible only with the "ooh-la-la" attitude toward sex in America—nor would they have been made by Lubitsch had he remained in Europe. He would have had little reason to make them. Indeed, this kind of film was not made by anyone else there after his departure. In short, the filmed "sex comedy" began as a distinctly American institution.[28]

In *Trouble in Paradise* (1932), a couple of smooth-talking jewel thieves—Gaston (Herbert Marshall) and Lily (Miriam Hopkins)—swindle Madame Mariette Colet (Kay Francis), a rich widow. Gaston and Mariette fall in love. He confesses his theft, then departs with Lily and various unreturned possessions of Mariette, who is also being robbed by her perfume company director. Lily at one point exhorts Gaston: "Steal, swindle, rob—but don't become one of those gigolos!" The action takes place in Venice and Paris. The decor, by Hans Dreier (brought to Paramount from Germany in 1923, and later head of that studio's art department), alternates between art deco and Bauhaus. The actors are British and American. It has been suggested that the amorality of *Trouble in Paradise* passed muster because it preceded the stringent implementation of the Motion Picture Production Code in 1934. But the film is so synthetic that its swapped lovers and unpunished crimes fail to shock. Crucially, there is no emotional tension between the three principal players. And the European locale has a distancing effect: these shenanigans would play out differently in "Boston." Weinberg calls *Trouble in Paradise* a "masterwork of sardonic humor." But Samuel Raphaelson, Lubitsch's peerless collaborator on this and eight other scripts, thought the characters came off as "puppets."[29]

Raphaelson preferred *The Shop Around the Corner* (1940)—

another of Lubitsch's most admired films—for limning "romance on a level that I felt and respected . . . that had more body to it."[30] Set in Budapest in the late 1930s, this is the rare Lubitsch movie about ordinary people. Its subject matter is not sex but love. Alfred Kralik, head clerk for Matuschek and Company, and Klara, a salesgirl, are antagonists. Both are pursuing love affairs by mail. They discover that they are themselves the mail-lovers. Their hostilities melt; their affections are consummated. A subplot: Hugo Matuschek, who owns the little leather goods store, thinks his wife is having an affair. He discovers her lover: his sycophantic employee Vadas. Matuschek attempts suicide but is stopped. He promotes Kralik, whom he had suspected of seducing his wife, to manage Matuschek and Company.

The film is itself gentle and affectionate: a fit. But it suffers from a confusion of accents at every level. Its cut-and-paste "Budapest" features signs in both English and Hungarian. Both Vadas and the clerk Pirovitch are played by Germans: Joseph Schildkraut and Felix Bressart. Matuschek is Frank Morgan, best remembered as the Wizard of Oz. James Stewart, as Kralik, is a strong central presence. But Stewart's gangly frame and informality of gesture (hitching up his pants), ingenuous countenance and slow drawl, clash with an undercurrent of worldly despair: if this movie is more than charming, it is because it subtly conveys the tenuousness of a job, or a business, or a marriage, or of life itself. In *The Love Parade*, a mishmash of ingredients is part of the fun— Chevalier's French accent is treated as a joke. In *The Shop Around the Corner*, Old World experience and New World innocence are mismatched.

Lubitsch's best-known effort to transcend entertainment is *To Be or Not to Be* (1942)—part of a wave of anti-fascist Hollywood cinema largely engendered by displaced Europeans. Jack Benny plays Josef Tura, a famous Polish actor. Carole Lombard is his actress wife, Maria. Robert Stack is a Polish officer chasing Maria.

Hamlet is in rehearsal. All this take place in Warsaw under Nazi occupation. The Tura troupe must outwit Colonel Ehrhardt (Sig Rumann, a German specialist in comic roles) in order to knock off Professor Siletsky (Stanley Ridges), a German agent posing as a Polish patriot. The role of Tura, a preening egomaniac, arguably deserved an authentic stage star—Jannings (had he remained in Hollywood and acquired adequate English) might have been ideal. But a "realistic" reading of this kind would have entailed realistic Nazis: unbearable in a comedy. Many found the film unbearable anyway, especially when Colonel Ehrhardt says of Tura: "What he did to Shakespeare, we are now doing to Poland." Lubitsch defended the film as a satire on "the Nazis and their ridiculous ideology" and also—referring to Tura's wounded vanity in response to Ehrhardt's critique—"the attitude of actors who always remain actors regardless of how dangerous the situation might be, which I believe is a true observation." To the cinema historian David Thomson, *To Be or Not to Be* is a black comedy the funnier for being serious. Others have found in the film's humor a sophisticated aesthetic strategy resembling Brechtian distantiation. But it is as credibly regarded as the most extreme of Lubitsch's questionable hybrids.[31]

Thomson has also observed that Josef von Sternberg possessed "exactly the gravity beneath bitterness that Lubitsch scared off the more resolutely he tried to lay hands on it." Sternberg himself, in his autobiography, remarks: "When Lubitsch was serious, not trying to indulge in his little drolleries, he could make something unbelievably bad, like *The Man I Killed*." According to Raphaelson: "Whenever you hit a stronger emotion than was called for in usual high comedy, Lubitsch was in danger of going wrong." Whatever the justice of these observations, Lubitsch's adaptability— to sound, to Hollywood, to America generally—may be read as a lack of depth.[32]

Raphaelson and other American associates characterized Lu-

bitsch as a man consumed by his work, whose cleverness, charm, and exuberance—rather than personal warmth—facilitated his success. By Hollywood standards, he was a cerebral director—he dreamed of filming Richard Strauss's *Der Rosenkavalier.* He was also an efficient director, who stuck to his budget. And he was a prestigious director, whose films were especially lucrative in Europe: before Word War II, a vital market for the studios. But many of his fellow émigrés saw Lubitsch differently. He was not at ease in the presence of a Thomas Mann or Max Reinhardt. According to Reinhardt's son, Gottfried:

> There was actually much more common ground between Lubitsch and the Americans than between Lubitsch and the Europeans. . . . He was very natural. . . . And he was unreflective, like most Americans. . . .
>
> His interest in films was enormously limited. Basically, he [adapted] Hungarian comedies, and that was the extent of his knowledge. He never read a book in his life, which was another misunderstanding between Hollywood and Lubitsch. If someone has an accent, the average Hollywoodian thinks he's very cultured. But Lubitsch wasn't. He had no idea about anything. Politically, he was liberal, but naïve.

Lubitsch was also observed to be uncomfortable with personal intimacy. Raphaelson testified: "He would run empty after a while because he had no lifeline to emotion; his life outside of his work was an increasingly empty one. He had . . . a wretched, meaningless home life."[33]

An undeniable defect of Lubitsch's films is the absence of memorable star turns by Americans. He used Stewart and Lombard, and also Claudette Colbert and Gary Cooper (twice). But these powerful screen icons are more powerful in the films of other directors. Combined with his outsider status, Lubitsch's

personal limitations may have impeded his capacity to extract something personal from an actor. In fact, he was known to prescribe every detail of a performance. "Every player that ever worked for him played Ernst Lubitsch," said the director Clarence Brown. "He used to show them how to do everything. . . . He would take a cape, and show the star how to put it on. He supplied all the little movement. He was magnificent, because he knew his art better than anybody. But his actors followed his performance. They had no chance to give one of their own."[34] One need only glimpse Lombard playing off William Powell in Gregory La Cava's *My Man Godfrey* (1936) or opposite John Barrymore in Howard Hawks's *Twentieth Century* (1934), or watch Stewart fall in love with Katharine Hepburn in George Cukor's *Philadelphia Story* (1940), to recall what these great American stars could achieve in their native milieu, directed by gifted Americans in American settings. Or consider Preston Sturges's *Lady Eve* (1941), with a story line resembling *Trouble in Paradise*. As the crook and the stooge who fall in love, Barbara Stanwyck and Henry Fonda are plausible: both funny and emotionally taut. And American: no Lubitsch romantic lead would fall victim to such a comically redundant series of pratfalls as Fonda endures. No Lubitsch love scene would combine a sunset and sweet violins with a rambunctious horse.

With a single exception, Lubitsch's post-Chevalier output lacks a suitable vehicle for a Continental actor who really fits the Lubitsch style, with its suave Old World stories and locales. The exception is his most enduring film, one whose central star is the most famous, most glamorous of all Hollywood's expatriate Europeans in her most enduring performance.

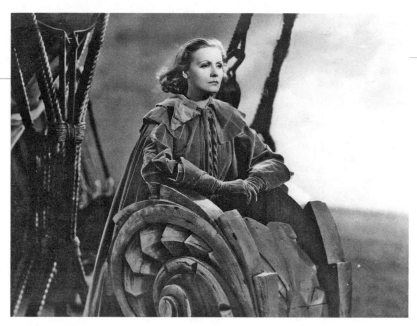

Greta Garbo in the final moments of Queen Christina *(1933), before the camera panned to her face; Rouben Mamoulian instructed her to "become as blank as a sheet of paper."*

GRETA GARBO WAS BORN Greta Gustafsson in Stockholm in 1905. She left school at fourteen to work as a lather girl in a barbershop. She subsequently enrolled at the Royal Dramatic Theater Academy. Her film career began, impressively, in Sweden and Germany. MGM brought her to Hollywood in 1925. *The Torrent* (1926) made her a star. No fewer than nine more MGM silents followed over the next three years. Her sound debut was in *Anna Christie* (1930). But the last of her twenty-four American movies, *Two-Faced Woman* (1941), was a disaster; she announced, "I will never act in another film." Though her fame abroad was undiminished, World War II had decimated the European market. In America, her more limited following—only cities liked her films—was waning. Her moody presence did not suit wartime cinematic needs; her aristocratic roles and remote public image were not to all tastes.

And Garbo herself was tired of Hollywood. Various "comeback" projects were considered and abandoned. She began to spend time in Manhattan. In 1953—two years after belatedly becoming an American citizen—she moved into an East Fifty-second Street apartment that remained her residence until she died in 1990.

Like Marlene Dietrich, Garbo in Hollywood was unfathomably foreign: risqué, androgynous. Like Dietrich's, her accented English was purveyed in a man's low voice. Dietrich's Svengali was Josef von Sternberg; Garbo's was the director Mauritz Stiller, who with Victor Sjöström embodied the "golden age" of Swedish cinema. Stiller discovered, renamed, and mentored her. He also accompanied her to Hollywood. Stiller was a perfectionist: traceable to his influence were Garbo's career-long habit of arriving on the set dialogue-perfect, and her refusal to let outsiders observe. According to her biographer Barry Paris:

> It was mental, not physical, sex Stiller was having with Garbo. For years, he'd been developing the Ultimate Screen Woman in his mind and viewfinder, with a kind of pent-up cerebral lust. . . . Stiller was not a man to abuse any woman sexually. But he was a chauvinist, a megalomaniac, and a psychological tyrant who liked to give orders, and he was . . . in charge of a beautiful girl who liked to take them.[35]

How much of "Garbo" came from Stiller, and from other revisionist influences, is one of the Garbo mysteries. In her early Swedish and German films, she is a little pudgy and her front teeth need fixing. At MGM, extra weight was shed and errant teeth were repositioned. In Stiller's *Saga of Gosta Berling* (1924), as an abused countess who redeems a shiftless minister, Garbo is magnetically virtuous. In G. W. Pabst's *The Joyless Street* (1925), she is a wholesome working girl who sinks to prostitution. In Hollywood, by comparison, Garbo embodied the vamp. "When

the devil cannot reach us through the spirit, he makes a woman beautiful enough to reach us through the flesh," reads a title prefacing *Flesh and the Devil* (1927). As the temptress Felicitas, Garbo sunders the friendship of Leo (John Gilbert) and Ulrich (Lars Hanson). Her love scenes with Gilbert are searing at every stage: the galvanic exchange of glances, the long, thirsty kisses, the languorous aftermath. When Felicitas takes communion alongside lover and husband, she slowly rotates the chalice back to the spot where Leo's lips had moistened it. Even playing the virtuous victim, as in *A Woman of Affairs* (1928), Garbo is otherwise perceived. Promiscuity, realized or suspected, is ever her keynote. But she fits no stereotype. Whereas Pola Negri had been a malignant enchantress, Garbo is restless, insecure, displaced. Dietrich's sexuality was teasing in its sophistication; Garbo's is disturbingly unwilled. Her weaknesses made her the more universally seductive.

It cannot be denied that, with few exceptions, her Hollywood films are less distinguished than *Joyless Street* or *Gosta Berling*. They are also less distinguished than she is. Not that her artistic stature was altogether unnoticed in the United States: Tennessee Williams called her "the greatest actress we have ever had." It was Salka Viertel's plausible opinion that Hollywood would not value Garbo's "artistic integrity" until she made another foreign film. Garbo herself often expressed displeasure with her films; she correctly preferred the German-language version of *Anna Christie* (1931); she wanted *Queen Christina* (1933) made in Sweden. According to Paris, the last ten minutes of *Camille* (1936)—the dying courtesan—"constituted the only rushes Greta Garbo ever asked to see."[36] The director of *Camille* was George Cukor, who towered above the mediocrities normally assigned to her by MGM. As for her male partners: Gilbert notwithstanding, they are typically as miscast as Dietrich's screen lovers. The costume dramas, especially, suffer from cardboard ceremony, schematized history,

stilted language, and a Babel of accents. Even the music, usually by Herbert Stothart, is banal: sentiment and pomp in the Korngold manner, but without anything like Korngold's tangy chromatics and timbral flair. All too often, Garbo is a ripe Old World interloper, weary with experience, engulfed in the glare of New World kitsch. She surmounts the tinsel and cliché through an undeflectable force of presence, inured to such unworldly facsimiles as Fredric March's wooden Vronsky in *Anna Karenina* (1935) or, opposite her exquisitely caring Camille, Robert Taylor's insipid Armand.

And then there is The Face, of which Kenneth Tynan famously quipped: "What, when drunk, one sees in other women, one sees in Garbo sober." It complexly registered a provocative indolence, an undertow of withdrawal and intensity. Boldly juxtaposed were the flaring Garbo brow, exquisitely creased (not furrowed) under stress; the sad Garbo eyes (their grayish blue not disclosed in any film) and long lashes (which were real); the sculpted prow of the Garbo nose; the classical severity of the Garbo mouth. This visage, capable of a withering disdain, grew worldlier and more sorrowful with age. As Queen Christina, Anna Karenina, and Camille, Garbo was compassionate to the degree her fatalism allowed. Alistair Cooke observed in her as of 1935

> a softening of the eyes, a hardening of the mouth. . . . Before she has even chosen her lover, her look tells you it doesn't much matter who he is, they all go the same way home. . . . She sees not only her own life, but everybody else's, before it has been lived. . . . [Her] quality of gentleness, a gift usually of women over fifty, is an overwhelming thing when it goes with the appearance of a beautiful woman of thirty.[37]

At the same time, Garbo's chaste lips and full jaw, her short neck and broad shoulders, her oddly swaggering gait and frequent male

costumery (on camera and off), always conferred an undeniable masculine dimension.

Garbo's remoteness and grandeur were supported by what was known of her personal life. She did not pretend to be happy in Hollywood. When Cole Porter told her he was fairly content there, she mused, "That must be very strange." Billy Wilder called her "as incongruous in Hollywood as Sibelius would have been if he had come to write incidental music for Warner Brothers." She changed California residences eleven times. She would not talk to Louella Parsons or Hedda Hopper. Her no-interviews policy exacerbated obsessive public curiosity. She was observed to have a number of "affairs," including a long one with Gilbert, whose torrid lovemaking in *Flesh and the Devil* continued after the cameras stopped rolling. In 1926 Gilbert arrived at a festive Beverly Hills hacienda expecting to marry Garbo; she never showed up. Leopold Stokowski, with whom she traveled in 1938, was in some respects a plausible mate, as displaced and concealed as Garbo herself. At a rare press conference, which Stokowski naively thought would lift the siege of reporters, she remarked:

> I haven't many friends. I haven't seen much of the world, either. My friend, Mr. Stokowski, who has been very much to me, offered to take me around to see some beautiful things. I optimistically accepted. I was naïve enough to think that I could travel without being discovered and without being hunted. Why can't we avoid being followed and examined? It is cruel to bother people who want to be left in peace. This kills beauty for me. I live in a corner. I am typically alone, but there are so many beautiful things in the world that I would like to see before they are destroyed.

She took Stokowski to Sweden. He left before she did. They never saw each other again. Garbo's intimate companions also

included the health guru Gayelord Hauser and the photographer Cecil Beaton, who was normally observed to be gay. Other Garbo intimates were female. It was said that she was predominantly lesbian and increasingly asexual. Mainly, she was solitary. "She lives in the core of a vast aching aloneness," testified the actress Marie Dressler. "She is a great artist, but it is both her supreme glory and her supreme tragedy that art is to her the only reality. . . . It is only when she breathes the breath of life into a part . . . that she herself is fully awake, fully alive."[38]

Unlike her rival Dietrich, Garbo was not spurred to public displays of patriotism by World War II (though she seems to have linked the British secret service to the Swedish royal family). Her feelings toward America remained concealed. She traveled remarkably little within the forty-eight states. She was heard to express ambivalence toward Manhattan. She likely regarded Sweden as "home," but rarely visited.

If Garbo had a California anchor, it was the Santa Monica home of Salka Viertel: the favored salon of the Hollywood immigrants. Murnau, Wilder, Chaplin, Reinhardt, were among the regular house guests. Viertel herself, an ex-actress born in Poland, was not only an unusually trusted and disinterested Garbo friend, but a co-scriptwriter for five Garbo films who once summarized, "what the [Hollywood] producers wanted was an original but familiar, unusual but popular, moralistic but sexy, true but improbable, tender but violent, slick but highbrow masterpiece"; when they have that, she continued, they " 'work on it' and make it 'commercial.' "[39]

It is a point of no small interest that in only two of her sound films are the contradictions and incongruities of Garbo in Hollywood—the effects of kitsch and cliché, of clumsy lovers and pompous music—sufficiently effaced that she befits her surroundings, and that these are the films that most consistently evoke the urbanity and cosmopolitanism of the Viertel circle. One is *Grand Hotel* (1944), grandly directed by the Englishman Edmund Gould-

ing, in which Garbo is a moody ballerina amid complementary star turns by John and Lionel Barrymore, Wallace Beery, and Joan Crawford, all in peak form. But this is not a "Garbo film." The other, featuring Garbo's most remembered performance, is *Ninotchka* (1939)—her one film for Ernst Lubitsch.

GARBO ADMIRED LUBITSCH'S WORK and had met him at Viertel's. Lubitsch had long been eager to cast Garbo in a comedy. One afternoon, Garbo was walking on the Santa Monica beach with Mercedes de Acosta, the lesbian poet and dramatist dubbed by Paris "one of the great celebrity collectors of the century." As de Acosta later recollected, Garbo said, "That's Ernst Lubitsch's house. He is the only great director out here. Let's go and see him." She knocked on the window. Lubitsch seized Garbo and kissed her wildly. "Mein Gott, mein Gott, Greta!" he exclaimed. "Gott, such a surprise . . . Greta, Greta, sit down and never go away. . . . Greta, why don't you tell those idiots in your studio to let us do a picture together. Gott, how I would love to direct a picture for you."[40]

And so *Ninotchka* was born. Melchior Lengyel wrote the three-sentence scenario (for $15,000): "Russian girl saturated with Bolshevist ideals goes to . . . Paris. She meets romance and has an uproarious good time. Capitalism not so bad, after all." The eventual plot had Garbo, as Ninotchka, flying from Moscow to Paris to check on three inept comrades entrusted with selling the former jewels of the Grand Duchess Swana. Swana, herself in Paris, conspires with her lover, Count Leon d'Algout, to steal back her jewels before they can be sold. But Leon and Ninotchka proceed to fall in love. All four Russians abandon Russia; Leon abandons the grand duchess.

The screenplay, by Walter Reisch, Billy Wilder, and Charles Brackett (with many an assist from Lubitsch), is ingeniously, unfalteringly droll. A prefatory title reads: "This picture takes place in

Paris in the wonderful days when a siren was a brunette and not an alarm—and if a Frenchman turned out the light it was not on account of an air raid!" Garbo's previous MGM scripts had incorporated self-referential intimations: "I do not wish to marry," says Sweden's Queen Christina. The queen also says, "I shall die a bachelor" and "Great love is an illusion." In *Ninotchka*, these ironic declarations are themselves deliciously parodied. Caricaturing herself, Garbo resorts to a severe monotone. "Must you flirt?" she asks d'Algout. D'Algout: "I don't have to, but I find it natural." Ninotchka: "Suppress it." When d'Algout declares his love, Ninotchka observes, "You are very talkative." When three cigarette girls prance into the lavish hotel suite recklessly booked by the envoys, Ninotchka observes: "Comrades, you must have been smoking a lot." Her humorlessness serves as a foil for the film's famous turning point: in a restaurant d'Algout tips back his chair and sprawls to the floor; the entire room—Ninotchka included—erupts with laughter. Lubitsch knew that getting Garbo to laugh would be crucial.

> I said to her, "Do you often laugh?" And she said, "Not often." And I said, "Could you laugh right now?" And she said, "Let me come back tomorrow." And then next day she came back and she said, "All right. I'm ready to laugh." So I said, "Go ahead." And she laughed and it was beautiful! And she made me laugh, and there we sat in my office like two loonies, laughing for about ten minutes. From that moment on, I knew I had a picture.[41]

The role of d'Algout was first envisioned for William Powell. Later, Cary Grant reportedly turned it down. Melvyn Douglas is not a Powell or Grant (ideally, d'Algout is of course a role for a Frenchman). But neither is Douglas a Robert Taylor. In a costume drama, he would be in trouble; in *Ninotchka*, he is a good apparatchik.

Garbo was ambivalent about Lubitsch. De Acosta called her "a changed person," deliriously happy during the shoot. But years

later, in conversation with Cecil Beaton, Garbo called Lubitsch "a vulgar little man."[42] No matter: for Garbo, Lubitsch was, at last, a Hollywood director who could sustain a stylish continental tone; his ear for dialogue, and also for music (by the prolific German import Werner Heymann: a top-notch contribution), excludes every gaucherie. For Lubitsch, Garbo was, at last, a proper European star for his "European" pictures. More than that: she remains Garbo. The brisk delivery and ironic lightness Lubitsch typically secured—as from Douglas—are not for her. A luminous presiding presence, she is not synthetic because she is never synthetic. Lubitsch does not even attempt to explore d'Algout the degenerate aristocrat becoming human. Garbo, by comparison, is always multidimensional, always human—she need only shed her dour one-liners to clinch a trajectory from inhibition to the helpless self-disclosure of a woman in love.

"Garbo laughs!" exclaimed MGM's ads. *Ninotchka* "finds the screen's austere first lady of drama playing in deadpan comedy with the assurance of a Buster Keaton," wrote Frank Nugent in the *New York Times*. That *Ninotchka* is Garbo's most enduring film must be considered a disappointment. She deserved to attempt Hamlet or Joan of Arc—roles she occasionally pondered. Her Camille, Anna Karenina, and Queen Christina were all substantially squandered by MGM. But no Hollywood studio of the 1930s could have properly seized these weighty opportunities, with their black streaks of hopelessness, folly, and human frailty. That *Ninotchka* is Lubitsch's most enduring film is merely just: he fit into Hollywood. The German conductors who led foreign-born Americans in Beethoven and Brahms produced credible performances but stood outside the realm of indigenous American creativity. Lubitsch, directing American actors in English-language screenplays, adapting foreign stories and locales, produced a hybrid product that changed Paramount, Fox, and MGM. Counteracting the black-and-white moralism of the Griffith/DeMille

tradition, he steered America cinema toward the musical and the romantic comedy, even toward screwball comedies whose manic pace and ridiculous caricatures were not for him. "He converted the Hollywood industry to his own way of expression," wrote Jean Renoir.[43] Like Erich Korngold, Lubitsch altered Hollywood by staying the same. Like Korngold, he was a clever middlebrow craftsman mistaken for a highbrow genius.

As for Garbo, a final reckoning of her American career must begin with her intractable outsider status, whether on the set or off. Compared to other immigrants in the performing arts, she was less an exemplar of cultural exchange than of a stark alien sensibility—call it "Swedish"—that produced its particular frisson in juxtaposition with MGM's lavish hokum. She was typecast as an adulteress: on American screens, still a foreign vocation. If, unlike Dietrich, her rival in amoral movie romance, she was not typically redeemed by wholesome Hollywood endings, her irredeemable qualities of remoteness lent a compensatory poise. Never was she sluttish or crassly materialistic. She obeyed a morality of love, and as she grew older her morality grew more reassuring. In addition to conferring dignity, her aloofness of course conferred glamour, stardom. But the goddess-on-a-pedestal pose whose emblematic embodiment is Queen Christina's faraway gaze was—unless ameliorated by self-parody, as in *Grand Hotel* or *Ninotchka*—equally an artistic liability. Speaking German—as in *The Joyless Street* and the German-language *Anna Christie*—she is a fluent partner, not a distant star. The critic Richard Schickel, in a shrewd analysis, asks:

> Would she have prospered better had she not been so closely bound to MGM? Is it possible that under contract elsewhere, or as a freelancer, she might have found projects that would have extended her range, stimulated her imagination, thus encouraging her to lengthen her career? Is it possible, most important of all, she would have ob-

tained immortality as an artist rather than as a curiosity, a phenomenon, if she had not been locked into films that were already anachronisms as they were being made?[44]

One may equally ask: Would she have prospered better had she not been so closely bound to the United States?

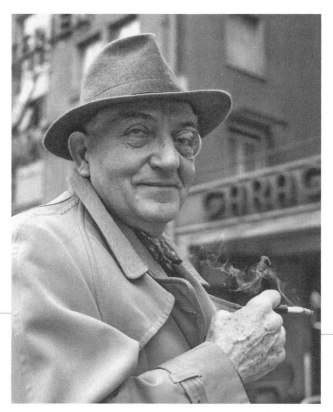

Fritz Lang, with his signature monocle (1950s).

THOUGH HE SEEMED TO many quintessentially "German" for his caustic temperament and autocratic ways, Fritz Lang was actually born in Vienna in 1890. Turbulence was ever a leitmotif of the Lang odyssey. He trained as an artist, then ran away from

home to study in Munich and Paris. He served in the German army in World War I and was wounded four times. After a year of convalescence in a Vienna hospital he took up cinema in Berlin. In 1920—a year after Lang directed his first film—the writer Thea von Harbou began collaborating with him on his screenplays. They also became lovers. In 1924 Lang's wife committed suicide (though some believed he shot her). He married von Harbou and continued his ascent as a towering figure in German film. He left Germany in 1933; von Harbou remained to make films for the Nazis. In the United States, beginning in 1934, Lang directed twenty-two movies for a variety of studios and producers. In the early 1950s, he was blacklisted for a time; his association with the likes of Bertolt Brecht, and the scathing social commentary of his dark tales, branded him politically suspect. In 1956 he announced he would "never make another film in America." In Germany, he directed three more films, but they were not warmly received and neither was Lang himself. He died in Beverly Hills in 1976.

As a necessary perspective on the complexities of Lang's long Hollywood exile, the magnitude of his Berlin achievement bears stressing. He and von Harbou worked with a team of superb actors and technicians. "Everything was new," he once recalled. Experimentation was constant; "No one said, 'you're wasting time, you're wasting money.'" Lang's seventeenth film, *Dr. Mabuse: The Gambler* (1922), was already a landmark achievement. In two parts lasting nearly five hours, it embodied—as the title of part one put it—"A Picture of Our Times." Extravagant wealth and dire poverty, prostitution and cocaine, gluttony and greed, violence and occultism, are among its themes. Its personalities are exaggerated or grotesque. Mabuse himself, harrowingly played by Rudolf Klein-Rogge, is a mega-villain for whom material gain, by whatever means, is incidental to an insane project of domination and destruction. In the Sodom and Gomorrah of 1920s Berlin, Ma-

buse seemed a metaphor: as would *Die Dreigroschenoper*, *Dr. Mabuse* enthralled Berliners with its heightened self-portraiture of depravity.

Lang's *Nibelungs* (1924), also in two massive installments, is a film as stately as *Mabuse* is frantic. Dedicated "to the German people," it revisits the Teutonic past as a means of counteracting the pessimism of the present. Lang was now a German citizen; he consciously sought to bolster German self-esteem. He also sought to distance himself from Wagner's *Ring of the Nibelungs*: the magnificent visual vocabulary of *The Nibelungs* conveys not only the atmospheric romanticism of Arnold Böcklin and Caspar David Friedrich, but the precise ornamentalism of Gustav Klimt and the spare rigor of the Bauhaus: a high German lineage stretching to the present day. Wagnerian, however, is Lang's masterful control of pacing and tone: few films attain climaxes as punishing in their cumulative weight. Rare, too, is the unity of means and ends. The film's glacial motion—many scenes unfold in real time—is supported by the elegance of its framed imagery, the formal bearing of its actors, and a symphonic score (more Straussian than Wagnerian) by Gottfried Huppertz, superbly calibrated to reinforce the dirgelike dramatic rhythm.★ Epic spectacle is achieved not via DeMille-like masses in motion but via grandeur of tableau. The forest is a haunted still life whose vaporous mists, cloaking or disclosing Siegfried astride his white steed, were produced by fire extinguishers in the presence of wan sunbeams pouring through the glass walls and roof of a studio. Brunhild disembarks in Worms along a bridge of shields whose human pylons are armored warriors standing waist-deep in water. Every set, every movement, was discussed in detail. Shoots could last fourteen hours without a break. A typical Lang directive to an actor might specify: "On one-two-three you bend your upper body slightly forward—turn

★The Kino Video DVD (2002) features a fresh recording of Huppertz's music.

your head toward me; four-five-six-seven, you raise your left arm slowly. You open your clenched fist, hold it as high as your head. As astounded expression comes over your face, your mouth opens slightly; then, you fling both your arms forward and spread out your fingers, you fling your body backward, you scream." With his trademark monocle, Lang supervised the crowd scenes on horseback, wearing jodhpurs, shouting orders through a megaphone. He personally ignited the final conflagration, consuming Nibelungs and enemy Huns, with a magnesium arrow shot in a high arc onto the roof of the Hun palace. In Lang's American films, human destiny would become an implacable backdrop to contemporary urban dramas. In *The Nibelungs*, this fate theme assumed its purest, most apocalyptic form. The film's political overtones have always disturbed—on the right, for ostensibly reducing Germans to a pack of murderers; on the left, for purportedly jingoistic depictions of German strength and honor. Siegfried Kracauer found foreshadowings of *Triumph of the Will*: "an ocean of flags and people artistically arranged . . . absolute authority asserts itself by arranging people under its domination in pleasing design." However experienced, *The Nibelungs*, no less than the Murnau fables *Sunrise* and *Tabu*, epitomizes the poetry of the silent cinema; dialogue could only diminish its spell.[45]

Lang visited New York City in 1924. His experience of the Manhattan skyline was one ingredient of the powerfully imagined city of the future in *Metropolis* (1927)—a vision by turns lifelike, Expressionist, and surreal. Tableaus of formal design are again used to overwhelming effect: they imprint the impersonal throb of industrial might, the sleek urban caverns, the depersonalized human masses. In later years, Lang felt the need to apologize for lapses into kitsch and political naïveté: the overacting; the facile ending, promising that the heart (personified by Woman) can mediate between the hand (Labor) and brain (Capital). Lang's first film with sound, *M* (1931), requires no such apologies. In Peter

Lorre, he discovered a character actor of genius, whose imperson-ation of a compulsive child-murderer is as searing in its empathy as in its pathology. Lang called *M* "the only time I had complete control of a film"[46]—and the palpable presence of a controlling artistic intelligence makes the more chilling this tale of a maniac hunted and tried by the underworld. Even where the film entreats sympathy for the killer, it remains dry-eyed. The shrewd "defense attorney" (Rudolf Blümner), himself a bedraggled criminal, is a mordant portrait worthy of Grosz or Brecht. Scanned with excru-tiating deliberation through the eyes of the petrified defendant, the "court"—a rogues' gallery of thugs and thieves, whores and beggars (including actual lawbreakers known to the director), cry-ing "Kill him! Kill him!"—is another of Lang's signature intima-tions of mob violence. The sanctimonious crime leaders who worry about their "reputations" being ruined ("He's not even a real crook!"), the murderer's own hypersensitivity ("Who knows what it's like inside of me?!"), the parallel paths of organized law and outlawry, point to realms of moral ambiguity Lang would never abandon.

In *The Nibelungs*, a grand symphonic score intended for live performance was a necessary part of the whole. In *M*, Lang's first sound track cunningly eschews music: the police whistles and si-rens, a children's ditty, the murderer's own whistled theme song (Grieg's *Hall of the Mountain King*), furnish "music" enough to complement the tough, pithy dialogue. *The Testament of Dr. Ma-buse* (1933), which begins with the deafening machine noise of money being forged, again dispenses with music. This sequel to *Dr. Mabuse: The Gambler* is not another panorama of Berlin deca-dence. Rather it is a crime drama whose Professor Baum, literally inhabited by Mabuse, strategizes a campaign of millennial fear and terror, including poisoned water and epidemic disease. He apos-trophizes Mabuse as a "great mind," a genius who "could have saved mankind." Lang later said: "This film was meant to show

Hitler's terror methods as in a parable. The slogans and beliefs of the Third Reich were placed in the mouths of criminals. By these means I hoped to expose those doctrines behind which there lurked the intention to destroy everything a people holds dear." (To which Siegfried Kracauer retorted: "It is hard to believe that average German audiences would have grasped the analogy between the gang of screen criminals and the Hitler gang. . . . Lang is so exclusively concerned with highlighting the magic spell of Mabuse and Baum that his film mirrors their demonic irresistibility rather than the innate superiority of their opponents.")[47]

The Nazis quickly banned *The Testament of Dr. Mabuse* as a menace to "law and order and public safety." "It proves that a group of men who are willing to risk all and truly put their minds to it are quite capable of overthrowing any state by violent means," pronounced Josef Goebbels (who knew what he was talking about). But Goebbels the self-appointed aesthete admired Lang's work. Both Hitler and Albert Speer were likewise connoisseurs of *The Nibelungs* and *M*. In later years, Lang said he "came of age politically" when he was refused permission to use a big movie studio for *M* because its provisional title, *The Murderer among Us,* was interpreted as anti-Hitler. He also told and retold the story of being summoned to Goebbels's gargantuan office, there to be offered control of a new racist German cinema—and how he fled Germany for France the following morning. These various claims to prescience and dissidence have been skeptically scrutinized. Lang's American biographer Patrick McGilligan has ascertained from the evidence of Lang's passport that Lang did not leave Germany for good until three months after his meeting with Goebbels. It remains true that Lang's mother had Jewish parents, that his girlfriend Lily Latte was Jewish, and that his departure, however delayed, was permanent.[48]

And it is equally true that Lang arrived in Hollywood (via France) with a great name, but little else. He was not a celebrated

1920s newcomer, like Murnau, Lubitsch, or Jannings, but an unnecessary 1930s refugee. He did not arrive with an entourage of assistants. His battles with studios, producers, writers, and actors were instantly notorious. On shoots, he used abusive language; he would not break for lunch; he drew footprints on the floor to specify where his actors were supposed to walk. He had to make do with casts he mistrusted and scripts he disliked. He directed a Western, *Rancho Notorious*, in which a wretched painted backdrop substituted for the majestic western landscapes so adored by John Ford.

In Germany, the film was the star and its director held sway. In Hollywood, studios and producers influenced lighting and camera styles. Directors were assigned staff writers, designers, and editors. Visual experimentation was discouraged. Glamour was preferred. It is no wonder that Lang bounced from MGM to Paramount to Fox to myriad studios and distributors of lesser renown. He was rarely paid more than $50,000 per picture. All this was inflicted upon a personality already contentious, obsessive, and impulsive, already racked by years of traumatic upheaval. He carped endlessly about a conspiracy of studio bosses. In retrospect, he likened the machinations of producers to the work of the Watergate burglars.[49]

And yet, after a fashion, Lang accommodated to the United States. Without the leverage of box office success, he hustled tirelessly to get his movies made. He never forgot, or let others forget, his grand place in the history of world cinema. He was not too headstrong to realize that Hollywood's technical faculties—such as cranes to mobilize cameras—were "ten thousand times" what he had known abroad.[50] He did not deny himself the opportunity, however fortuitous, to apply the psychological experience of Hollywood entrapment to the larger enterprise of applying his stark Germanic vision to America and to Americans. The outcome, if often odd or ambiguous, was nothing if not substantial.

LANG ONCE SAID, "EVERY serious picture that depicts people today should be a document of its time." His *Mabuse* films and *The Nibelungs* were documents about Germany. *Metropolis* ponders the future of mankind. *M*—partly triggered by a wave of German sex criminals and murderers—documents psychological and psycho-pathological tensions endemic to Lang's Berlin. It follows that, in contrast to Murnau or Lubitsch, Lang in Hollywood would forgo European or Polynesian locales in favor of documenting America. MGM's first Fritz Lang press release stated: "His principal diversion is driving to small towns and large cities, absorbing the detail of the lives of the American people." Lang delighted in long automobile journeys, in speaking with "every cabdriver, every gas station attendant."[51] He visited Indian reservations. As much as possible, he stopped speaking German. Eulogizing Murnau, he had (as we have seen) likened films to "ballads." His Hollywood films are not generic fables of the Murnau variety. Rather, they are harsh American ballads typically combining feckless destiny and urban anomie. In interviews, Lang called for films more "mature" and "realistic" than the Hollywood norm, films confronting "the largest life and death questions—war, fascism, depression."[52] Contemporary audiences, he argued, did "not want the traditional happy ending." Some critics and trade journals called his American films "honest" and "adult." Others found them merely brutal and melodramatic.

Fury (1936), coming first, is among Lang's better-known American pictures. Joe (Spencer Tracy) is en route to his fiancé Katherine (Sylvia Sydney) when he is stopped in a small town and detained as a kidnapping suspect. An hysterical crowd surrounds the jailhouse. The governor is paralyzed by political considerations. The crowd surges unchecked and burns the building to the ground. Joe, presumed dead, escapes and vows revenge. "I could smell myself burning," he tells his brothers. The real kidnappers are identified. Twenty-two men are tried and convicted of murder. At the eleventh

hour, Joe decides to reveal himself to the court, voiding the convictions. But this "happy" ending in no way soothes the bitterness of *Fury*. Reunited in the courtroom with Katherine—an awkward scene not edited by Lang—Joe expresses no remorse; essentially, he could not abide the solitude of a clandestine existence.

The film's critical success took MGM by surprise. Its undeniable crudity—the Lang touch is here as heavy as Lubitsch's is light—mattered less than its astonishing savagery. The jailhouse mobs laughs, whistles, and taunts. A man eats a hot dog. A baby is held aloft, the better to see. A woman recites, "I am the resurrection and the light saith the Lord." A newsreel photographer exults, "Boy oh boy, what a shot this is!" The Reichstag fire could not have been far from Lang's understanding of this spectacle of pious sadism. The unmitigated exigency of *Fury* conveys an exaggerated emergency message. Like the caustic immigrant social theorists of the Frankfurt School, Lang is an Old World Cassandra debunking New World illusions of democracy, justice, and freedom. Like Theodor Adorno (whom he knew in Los Angeles), he embodies a corrective analysis arguably prescient, arguably acute, but cruelly tendentious and cold.

Considered as cultural exchange, *Fury* occupies a way station between Berlin and Hollywood not only for its surrogate Nazi imagery, but for uncertainties of style. Lang's German films, shaped in collaboration with von Harbou, are patient or epic narratives. *Fury*, at ninety-four minutes, is a Hollywood length—but uneven pacing makes it feel long, not taut. Lang in Germany applied symbols as a stock in trade; in his Murnau eulogy, he called symbolism more inherent to cinema than to the theater. But when the gossiping townswomen of *Fury* are juxtaposed with cackling hens and ducks, the "symbolism" is both superfluous and incongruous: it violates the studio style toward which Lang is otherwise moving.

Lang's next two films—*You Only Live Once* (1937) and *You and Me* (1938)—depict ex-convicts victimized by sadistic agents

of ostensible law and morality; they again impugn American "freedom" and "fairness." *You and Me* uncomfortably recalls *M*. A Kurt Weill ballad to Brechtian lyrics incongruously invades a New York nightclub. A gang of thieves is lamely regarded with humor and irony. A confused criminal mind is excavated with findings as bland as Peter Lorre's child-murderer had proved astonishing in his moment of self-disclosure. Lang told Irving Lerner of *New Masses* that he had here undertaken "something absolutely new" so far as Hollywood was concerned. But the flat Weimar objectivity that pervades the depiction of lowlife types and activities works against the film's central love story. And the acting, with George Raft impossible both as a romantic lead and an ambivalent miscreant, is artificial and stiff.

In the early forties, such anti-fascist Lang films as *Manhunt* (1941) and *Hangmen Also Die* (1943) fell into line with the Popular Front and the Hollywood Anti-Nazi League—with an alliance, that is, of refugees and Los Angeles intellectuals determined to politicize wartime Hollywood entertainments.* The latter film, set in occupied Czechoslovakia, features Nazis (played by émigré Germans) as discomfiting as Lubitsch's, in *To Be or Not to Be*, who are trivial and trivializing; the sordid mob of previous Lang productions is here a fascist mob. Casting *Hangmen*, Lang resisted Brecht's suggestion that the Czech resisters also be played by Germans; the result is a contingent of Czech freedom fighters oddly impersonated by the likes of Walter Brennan.

*As Saverio Giovacchini has shown, the resulting films included not only such explicit efforts as *Confessions of a Nazi Spy* (1939) but, more subtly, William Dieterle's film biographies *The Story of Louis Pasteur* (1935), *The Life of Emile Zola* (1937), *Juarez* (1939), and *Dr. Ehrlich's Magic Bullet* (1940), all packed with refugee talent. "Truth is on the march and nothing can stop it!" exclaims Zola (Paul Muni) in defense of the Jewish Dreyfus (Joseph Schildkraut). A onetime Reinhardt actor in Berlin, a Hollywood Anti-Nazi League activist in California, Dieterle grew disillusioned with the postwar McCarthyist climate. "Hollywood is bankrupt," he wrote to a fellow refugee director, Ludwig Berger, in 1948. (See Giovacchini, *Hollywood Modernism: Film and Politics in the Age of the New Deal* [2001], pp. 86–93, 188.)

In fact, even compared to Lubitsch, Lang evidently lacked rapport with non-Continental actors. Language was doubtless a factor. And Lang overdirected. Henry Fonda, ineffectual in *You Only Live Once* and *The Return of Frank James* (1940), was once observed (by Jackie Cooper) "yelling and pounding and slamming and kicking and screaming, because [Lang] had no respect for actors at all. He wanted everybody to be a puppet. He would tell you when to put your elbow on the table and when to take it off."[53]★ Only once—after *Fury*, *You Only Live Once*, and *You and Me*; after his anti-fascist phase—did Lang come upon an important Hollywood actor who excelled under his supervision. This was Edward G. Robinson, in *The Woman in the Window* (1944) and *Scarlet Street* (1945)—in the opinion of David Thomson "probably [Robinson's] best two films."[54] Born Emmanuel Goldenberg, an immigrant from Budapest to New York's Lower East Side at the age of ten, Robinson was a trained and seasoned stage actor—a résumé common in Berlin cinema, rare in Hollywood. With his short stature, bulldog features, and superbly modulated baritone, he equally excelled as a tender milquetoast and a bestial outsider: a killer. Playing a pair of supremely unlikely killers for Lang, he furnishes an anchoring gravitas; a less self-possessed actor would rob these roles of their needed dignity.

Significantly, neither *Woman in the Window* nor *Scarlet Street* entangled Lang with the workings of a major studio.† In fact,

★The superior functioning of Lang's German casts is underlined by two non-German versions of *The Testament of Dr. Mabuse*, the first with French actors, the second with dubbed American voices. The virtuoso German players comprise a tight but variegated ensemble—a high-pitched unity diluted by the Frenchmen and ruined by the Americans. (The Kino Video DVD includes all three variants.)

†The film historian Nick Smedley has culled documents illustrating Lang's limited role in the planning and development of a series of contract jobs for Fox following the failures of *You Only Live Once* and *You and Me*. (See "Fritz Lang Outfoxed: The German Genius as Contract Employee" and "Fritz Lang's Trilogy: The Rise and Fall of a European Social Commentator," *Film History* 4 [1990] and 5 [1993].)

Diana Productions, makers of *Scarlet Street*, was a creation of Lang, Robinson's costar Joan Bennett, and Bennett's husband, the producer Walter Wanger—a parlous partnership nonetheless resulting in the single most autonomous film of Lang's American career. Bennett was also featured alongside Robinson in *Woman in the Window*. Dan Duryea was the heavy in both pictures, Milton Krassner the cinematographer. Both stories show a "normal" man driven to murder, trapped in a vortex of fate. Lang has here become a different kind of storyteller than in Europe: the narrative is streamlined, the trajectory compressed.

In *The Woman in the Window*, Professor Richard Wanley (Robinson) is smitten by a woman's portrait mounted in the window of a store. The woman, Alice Reed (Bennett), actually appears alongside him. They wind up in her apartment and are there surprised by her jealous boyfriend. The boyfriend attacks Wanley. In a desperate act of self-defense, Wanley kills him with a pair of scissors. A manhunt ensues: the boyfriend, it transpires, was a famous financier. Rather than notifying the police and risking prosecution, Wanley dumps the body in a wooded area north of New York City. The body is discovered. The dead man's former bodyguard (Duryea) blackmails Reed for a large sum of cash. As Wanley is a close friend of the district attorney (Raymond Massey), he is a harrowed witness to the investigation as it nears a successful conclusion. Meanwhile, unbeknownst to him, the blackmailer is killed in a shoot-out. Alice frantically phones Wanley with this news. The film ends with a technical tour de force so patently artificial that Lang's bleak vision remains uncompromised. Wanley has swallowed some pills to stop his heart. We see only his face. The telephone rings. He tries to react but cannot. A hand is pressed on his shoulder. A voice says: "It is half past two, Professor Wanley." The camera pans back to reveal Wanley at his club, awaking from a dream. The necessary change of wardrobe and setting were achieved during the few seconds of the preceding headshot.

In *Scarlet Street*, Christopher Cross (Robinson) is a bank clerk with an impossible wife. He is smitten by Kitty (Bennett), revealed as a prostitute to the degree the Production Code allowed. Johnny (Duryea), her pimp, masterminds a series of increasingly brazen extortion schemes with Kitty's connivance. Cross's amateur paintings, their value inflated by an influential critic with designs on Kitty, are sold as hers. Cross steals from his employer to purchase a studio Kitty can share as his as yet platonic friend. When he discovers her using the apartment as a nest for herself and Johnny, he kills her in a rage. But Johnny, circumstantially entrapped, is executed as the murderer. Fired from the bank for theft, Cross becomes a vagabond, sleeping on park benches.

Both films are densely atmospheric, their rainy black-and-white nightscapes defined by streaked windows and dark doorways. The interiors are tightly framed, claustrophobic. The detritus of daily life—dirty dishes, cigarette butts—is copiously documented. Lang could worry over the contents of an ashtray. During *Scarlet Street*, Robinson recalled, "the light wasn't hitting the floor exactly the way he wanted it to, so he had it washed. It still wasn't right, so he put dust all over it and then swept it himself." A blanket of foreboding is cast by a policeman, an ice pick, a siren, a knife, a thunderclap, a screeching subway. Scripts and sound tracks are calibrated to support the tightening action of the fatal noose. With every extraneous detail expunged, the narratives are nearly schematic. They do not replicate real life. Their reliance on unlikely coincidence is a weakness only where the dramatic action is weak. *Scarlet Street*, especially, is a pitch-black film: with every twist of the plot, Cross falls deeper into an existential abyss. The hopelessness of his final situation—he tries to give himself up but cannot, as another man has already died for his crime—is only equaled by the falseness of Kitty's "I love you, Johnny." In *M*, Lang showed honor of a kind among thieves. *Dr. Mabuse* was inhabited by freaks. Hollywood has produced many films bloodier

and more violent than *Scarlet Street*, but its living nightmare and everyday victim make it more immediate than any *Godfather* or *Exorcist*. McGilligan writes: "Lang never wavered in his high regard for *Scarlet Street*, one of his favorite films, and one of the few that had turned out almost exactly the way he had hoped."[55]

An informative sequel to *Scarlet Street* is its history of censorship. Lang successfully pled his case with Joseph Breen, the chief aide to Will Hays of the Production Code office:

> I said, "Look, we're both Catholics. By being permitted to live, the Robinson character in *Scarlet Street* goes through hell. That's a much greater punishment than being imprisoned for homicide. After all, it was not a premeditated murder, it was a crime of passion. What if he does spend the rest of his life in jail—so what? The greater punishment is surely to have him go legally free, his soul burdened by the knowledge of his deed."

Less tractable was the Legion of Decency, which rated *Scarlet Street* "B" or "objectionable in part." The legion's complaints included Kitty in a slip and negligee (rearranged for a full hour by Lang, according to Robinson),[56] Cross painting Kitty's toenails, and Cross stabbing Kitty many times. Taking their cue from the legion, Atlanta and Milwaukee banned *Scarlet Street*, as did the New York State Board of Censors. Armed with favorable reviews, Wanger negotiated an agreement with the New York Board: one line of dialogue—Johnny asks, "Where's the bedroom?" upon inspecting the apartment procured by Cross—was cut. Goebbels's banning of *The Testament of Dr. Mabuse* was the more rational act of suppression.

Like Marlene Dietrich, Lang tried returning to Germany after the war. Purged of anti-fascist overtones that had briefly exempted Americans from his withering gaze, his Hollywood films had, if anything, turned more bitter. He had endured being

blacklisted. His channels to the major studios were closed. He completed what would prove his final American movie, *Beyond a Reasonable Doubt*, in 1956—and arrived in Germany the same year to discover the West German economic miracle and the memory hole that went with it. In California, Lang had collaborated with Bertolt Brecht on *Hangmen Also Die*. No sooner did he set foot in postwar Germany than he learned that Brecht had died. Though Brecht and Lang had fallen out in Hollywood, Brecht in East Berlin embodied the bygone Berlin heyday of *M* and *Dreigroschenoper*. When Lang was bullied by an airport policeman, he picked a fight. "I said, 'Are we back in Nazi times?'" He told a reporter that Germany was a country he "loved very much and hated very much." He was described as "tired, silent, defensive, beset by memories"; "He is not one of those who repeatedly praises the rebuilding of the cities and industries with astonishment. . . . Now and then he expresses his feelings: 'What do you know about back then?'" Various film projects were mulled over and discarded. He had "retired for good." Then he was cajoled by a German producer into making a pair of 1959 films in India: *Der Tiger von Eschnapur* and *Das Indische Grabmal* (conflated for American audiences as *Journey to the Lost City*). *Die Tausend Augen der Dr. Mabuse* (*The Thousand Eyes of Dr. Mabuse*) followed in 1961. All three films were dismissed by German critics as kitsch. The tone of the reviews was sometimes ugly, as if Lang's departure and return were a provocation. Lang retreated to Hollywood, where he felt no less neglected than in Berlin. According to Patrick McGilligan:

> He didn't feel bitter about Hollywood, only regretful and profoundly chastened. In spite of everything, Lang loved Hollywood—a sentiment that had never been reciprocated. Perhaps he had made mistakes, had misbehaved. Wasn't now the time for forgiveness and acceptance?

Finally, in 1973, the Directors Guild of America offered a formal tribute to Lang. By then the director was over eighty, virtually blind, in altogether frail condition. But it meant a lot to him to be feted by the guild of his American colleagues.[57]

Today, Fritz Lang is most remembered for his German films of the 1920s and early 1930s. His American output has not lacked admirers among cognoscenti, especially in France. To Klaus Mann (Thomas's son), Lang in America shed "hollow monumentality"; his style became starker and more lucid[58]—a view seconded by David Thomson. Unquestionably, Lang in the United States contributed to the film noir vogue of the 1940s and 1950s—although such popular film noir entertainments as Billy Wilder's *Double Indemnity* (1944) are not half as dark on the inside as *Fury* or *Scarlet Street*. If film noir—a debated term—is to be understood with regard to challenging mainstream Hollywood practice, Lang's Hollywood films are a notable embodiment. Their moral ambiguity and tense black-and-white composition, unlovable heroes and treacherous heroines—all elements traceable to German Expressionism*— remain discomfiting. Their narrative style toys with conventional expectations and assumptions; the audience is manipulated and brutalized, as by an outside agitator.

Lang himself frequently mentioned *M* as his peak achievement— a plausible choice. His German films summarize a moment. Their Teutonic "monumentality," secured by the afflatus of von Harbou's scripts, is hollow or pregnant according to taste. They embody a culture.

*Other Germans and East Europeans who contributed to American film noir include the directors Curtis Bernhardt, John Brahm, William Dieterle, Anatole Litvak, Max Ophuls, Otto Preminger, Robert Siodmak, Edgar G. Ulmer, and Fred Zinnemann; the composers Max Steiner and Franz Waxman; and the cinematographers John Alton, Karl Freund, and Rudolph Maté.

OF THE FOREIGN FILMMAKERS already famous before arriving in Hollywood, Lubitsch and Lang sustained the most durable American careers. The potential durability of Murnau in the United States remains unknowable. Other important European directors got lost in the New World. Sergey Eisenstein was lavishly welcomed by Paramount in 1930 only to see his contract terminated months later;* for Joe May, a pioneering figure in German cinema, a sporadic series of Hollywood assignments led to a failed restaurant venture. Paul Leni's brief Hollywood career—he died of blood poisoning in 1929—contributed Germanic black humor to the horror genre to be exemplified by *Frankenstein* (1931) and its progeny. There were also great figures—Sweden's Victor Sjöström, France's René Clair and Jean Renoir, Germany's Max Ophuls—who came, made a handful of Hollywood movies, and left.

Sjöström's *The Wind* (1928) is a silent screen masterpiece. Lillian Gish rounded up the story, the director (known in America as Victor Seastrom), and her Swedish costar, Lars Hanson. She plays a woman displaced in grueling prairie conditions, forced by circumstance into an unwanted marriage and, when the marriage holds, the murder of a would-be rapist. The filming, in Bakersfield, California, took place in 120-degree temperatures. Eight

*With its high-minded marriage of art and radical politics, Russian cinema was a nonstarter in the United States. A partial exception was Pare Lorentz's dust-bowl documentary *The Plow That Broke the Plains* (1936), funded by the New Deal. Lorentz's leftist cameramen—Leo Hurwitz, Ralph Steiner, Paul Strand—pushed unsuccessfully for a condemnation of capitalism. But a montage sequence alternating tractors and tanks is pure Eisenstein. Of the "Russian" directors who tried Hollywood, the most productive was the Armenian Rouben Mamoulian; he was also a highly influential Broadway director (see pages 342–365). Maria Ouspenskaya, a popular character actress in Hollywood, was arguably a significant influence on American theater (see page 338). Lewis Milestone (born Milstein and a cousin of the famous violinist) directed *All Quiet on the Western Front* (1930) and *Front Page* (1931), among sundry less notable Hollywood features.

airplane propellers supplied torrents of wind and sand, translated by Sjöström into human madness and frenzy. Equally remarkable are interior currents first confounding, then binding the two main characters: passions weightier than all the Lubitsch "love" scenes combined. On the wedding night, the groom's thirsty eyes reveal the bride's abhorrence of physical contact, launching a drama unflinchingly intimate and adult. In 1930 Sjöström returned to Sweden, where he abandoned directing. He served as artistic director of Svensk Filmindustri during the period of Ingmar Bergman's first films. He last appeared as an actor as Professor Borg in Bergman's *Wild Strawberries* (1957)—an indelible leavetaking. The father figure of Swedish cinema—an imposing lineage interrupted in the 1920s by the Hollywood defections of Hanson, Greta Garbo, and Mauritz Stiller—he could never have submitted to the code-conscious Hollywood of the 1930s.

If Clair, Renoir, and Ophuls produced no comparable American benchmark, two of their American films are much admired by cineastes. Renoir's *Southerner* (1945) and Ophuls's *Letter from an Unknown Woman* (1948) both show Hollywood stretching to accommodate an exogenous style or sensibility, and equally illuminate the limitations of such accommodation. They are movies in which "art" writ large holds hostage the bustle and glamour of "entertainment."

Renoir's American decade was the 1940s. The most prestigious member of Hollywood's French colony, he even became an American citizen (without relinquishing French citizenship). Shy of urban America, he fashioned as *The Southerner* a leisurely and understated nature poem with music. A farmer (Zachary Scott) and his family settle a homestead; endure hardship; prevail. Ophuls (born Max Oppenheimer) came to Hollywood (where he called himself Opuls) by way of Vienna and Paris. A master of understatement and irony, he was a gentler, more fragile, more philosophic version of Lubitsch (only Ophuls could have said of five years of Hollywood unemployment: "I have never felt myself

abandoned, for I believe in a certain current . . . it is the current of the imagination"). Fluidity of movement—of the moving camera, charting fate's twists and turns, comparing reality and appearance; of time's passage, intertwining past and present—is his stylistic signature. The very texture of his films intimates fleeting pleasures along life's mortal coil. Of his four Hollywood films, only *Letter from an Unknown Woman,* from a Stefan Zweig novella, is characteristic. A young lady (Joan Fontaine) devotes her life to a concert pianist (Louis Jourdan) oblivious of her infatuation; he receives a letter confessing her adoration only after she has died. Notwithstanding a polyglot cast, Ophuls's cameraman, Franz Planer (a native of Karlsbad), limns a fin de siècle "Vienna" notably more atmospheric than Lubitsch's "Paris" or "Budapest," or the "Prague" of Fritz Lang's *Hangmen Also Die.* The film's elegant construction, circling back to a story that inescapably catches up with the moment at hand, supports its philosophic resignation. "I know now nothing happens by chance," the unknown woman writes. "Every step is counted."

And yet these admirable efforts, so different from typical Hollywood fare, require some degree of special pleading if they are to be measured against the more consummated films Renoir and Ophuls made after their American exile. In Renoir's case, *The River* (1951), shot in India, sublimely engages nature as life force and poetic metaphor. It makes *The Southerner* seem synthetic. So, for that matter, do the classic Pare Lorentz documentaries *The Plow That Broke the Plains* (1936) and *The River* (1937), with real rural folk and scores by Virgil Thomson (born in Kansas City) both more homespun and sophisticated than the music Werner Janssens supplied for Renoir's American pastorale.* Ophuls returned to France to make films whose high polish and sunset glow contrast with snatches of kitsch and sugar in *Letter from an Unknown Woman*—including, inexplicably, a Viennese performance

*See pages 133–34.

of *The Magic Flute* sung in French. To American tastes, Renoir and Ophuls might seem dull, precious, or otherwise irrelevant. And these reactions are not insignificant. Their intimate marriage of style and content embodies ideals foreign to the studio system. The worldly ringmaster in *Lola Montès* (1955)—an Ophuls alter ego disillusioned and yet not cynical—discloses a vision particular to postwar Europe. Renoir and Ophuls were not candidates for Hollywood success. That they made Hollywood films as personal as *The Southerner* and *Unknown Woman* is more remarkable than their fated return to France.

Considered in sum, Murnau, Lubitsch, Lang, Sjöström, Renoir, and Ophuls were European directors of great accomplishment whose accomplishments somehow continued in California. The silent cinema—a universal language—afforded the most seamless continuity: *Sunrise* and *The Wind* are films fully worthy of their makers. With the coming of sound, discontinuities proved inescapable. Though Lang's "documentary" aesthetic—a residue of *neue Sachlichkeit* doubled by the subtraction of von Harbou—eased his transition to American cinema, his German films remain more of a piece: better cast, better acted, better scripted; more original; more integral to their time and place. Renoir and Ophuls were artistes at odds with commercial cinema gauged to please a great public. Lubitsch, his continued success notwithstanding, neither abandoned nor clinched his continental locales and bittersweet continental sensibility. And—like Lang, like Dietrich and Garbo—he played games of cat-and-mouse with American censors whose clever outcomes were not always happy ones.

A coda to this chapter brings into sharper focus the transactions negotiated or endured by these eminent cultural outsiders. Younger immigrant directors who arrived on the West Coast without great reputations, or any reputations at all, produced famous films in which the rubbing action of America with Europe was smoothed over, even smoothed away.

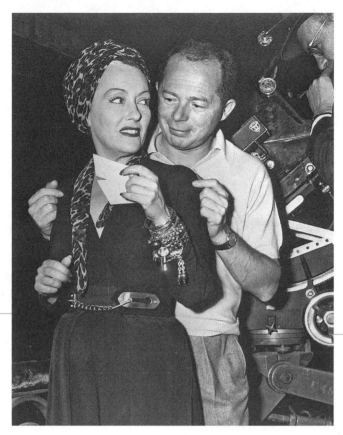

Billy Wilder with Gloria Swanson on the set of Sunset Boulevard.

AS ICONIC AS THE films of John Ford, George Cukor, and How-
ard Hawks, as quintessential to Hollywood as John Wayne, James
Cagney, Bette Davis, or Clark Gable, were such movies as *Casa-
blanca* (1942)—Hollywood's ultimate treatment of exiles and refu-
gees, with a European cast (Humphrey Bogart and Dooley Wilson
excepted) and a director, Michael Curtiz, born Mihali Kertész in
Budapest in 1888. Such essential American films as *Laura* (1944),
The Best Years of Our Lives (1946), *High Noon* (1952), *Some Like It
Hot (1959)*, and *Imitation of Life* (1959), featuring definitive star
turns by the likes of Bogart, Gary Cooper, and Marilyn Monroe,

were directed, respectively, by Otto Preminger, born in Vienna in 1906; William Wyler, born in Alsace in 1902; Fred Zinnemann, born in Vienna in 1907; Billy Wilder, born in a Polish village in 1906; and Douglas Sirk, born in Denmark (or possibly Hamburg) in 1900. All six directors arrived in the United States with a low profile: Wyler, Zinnemann, and Wilder had yet to direct a film; the films of the other three were not famous in America. All but Curtiz were younger men than Murnau, Lubitsch, or Lang; younger, too, than Sjöström, Ophuls, or Renoir.

And they were more malleable. They shunned membership in what Renoir called the "club for discontented Europeans." They eschewed nostalgia for the good old days. Comfortable Hollywood hands, they did not attempt high art. To be sure, Berlin café life, flouting popular culture and unpopular causes, left its mark. Curtiz helped to establish Warner Brothers as the studio most concerned with social issues (he also directed James Cagney in *Yankee Doodle Dandy* and Errol Flynn in *The Adventures of Robin Hood*). Preminger, who had burst into tears at the sight of the Statue of Liberty, "swept by the feeling that a new life was beginning,"[59] broke barriers with his black musicals *Carmen Jones* and *Porgy and Bess*, and with the drug-addicted protagonist of *The Man with the Golden Arm*. In *Advise and Consent*, he administered a 1962 civics lesson buoyed by a refugee's admiration for American checks and balances, and spiced by a European's abhorrence of American red-baiting; the same film sympathetically depicts a blackmailed gay legislator. It was Preminger who famously quipped, upon hearing a group of émigrés conversing in Hungarian, "Don't you guys know you're in Hollywood? Speak German." Sirk, a prized confectioner of American melodramas, applied a distinctive visual aesthetic as elegantly poised and clean as his tales were lurid and contrived—a juxtaposition that, if not Brechtian (as his latter-day admirers have claimed), at the very least suggests the hybrid sensibility of a cultural migrant whose

early German career showed an intellectual bent. His *Imitation of Life*, about the tribulations of a black mother whose daughter passes for white, treats the African-American as a paradigm of grace and morality born in adversity—an outsider's perspective. But compared to immigrant colleagues initially more illustrious, and with weightier foreign baggage, all six directors were centrist Hollywood successes.

Of special fascination, as a study in cultural exchange, is Wilder's Hollywood success. More than any other immigrant filmmaker, he slyly combined critical distance and intimate knowledge. By lineage and disposition a gadfly outsider, he was equally a shrewd inside operator whose expedient mediation of art and entertainment embodied mainstream American cinematic practice. He was born a German-speaking Jew whose father ran a group of cafés. The restless family eventually settled in Kraków. By the age of six, "Billie"—so nicknamed after Buffalo Bill—specialized in three-cushion billiards. As a teenager, he worked as a newspaper reporter in Vienna. At the age of twenty, he moved on to Berlin, where he initially found work as a hired dancer—a gigolo. As a newspaper writer, later a screenwriter, he quickly assimilated the tone and tempo of the city (one of the papers for which he wrote, *Tempo*, was dubbed "Die jüdische Hast": "Jewish nervousness"). He left in 1933: the year of Hitler. He arrived in Hollywood in 1934, a hardened twenty-eight-year-old cynic with outlaw propensities. His *Berlinerisch* fascination with puns, jokes, and slang found a fresh outlet in English, which he wielded with a newcomer's delight. He began cowriting film scripts with Charles Brackett, a wealthy New Yorker with a law degree from Harvard. Two scripts for Ernst Lubitsch—*Bluebeard's Eighth Wife* (1938) and (with Walter Reisch) *Ninotchka* (1939)—led to a string of hits until the partnership dissolved in 1950, by which time Wilder was a director and Brackett a producer. If Brackett added Manhattan polish to the Wilder formula, Lubitsch—also from a

Galician petit bourgeois home—became an Old Worldly mentor. The cleverness of the Lubitsch touch (if not its gemütlich undertones) inspired Wilder; the one-dimensionality of Lubitsch's screen characters, and their avoidance of intimate self-revelation, were equally Wilder traits. Like Lubitsch, Wilder kept his own counsel; even his daughter Victoria found him "a hard person to get to know."[60]

Wilder's twenty-six Hollywood films amassed five Academy Awards. Ten years before his death in 2002, he received the American Film Institute's Life Achievement Award. His signature films include *Double Indemnity* (1945), a film noir flaunting human greed and depravity, *The Lost Weekend* (1948), in which Ray Milland unexpectedly excelled as a self-destructing alcoholic, and *Some Like It Hot* (1959), with Tony Curtis and Jack Lemmon in lipstick, skirts, and high heels. More personal to Wilder's own experience as a cultural immigrant are *A Foreign Affair* (1948) and *Sunset Boulevard* (1950)—informative portraits of his two artistic homes: Berlin and Hollywood.

What became *A Foreign Affair* began with the United States Office of War Information and the Publicity and Psychological Warfare Section of the Supreme Headquarters, Allied Expeditionary Forces: Wilder was to oversee the reconstruction of German film and theater, including de-Nazification proceedings. He was also to engage in propaganda efforts. And he wanted to find out what had happened to his mother. He left for Europe in May 1945. About his mother, he could only establish that she could not be found; he came to believe that she had died in the Kraków ghetto or in Auschwitz. He abandoned a plan to make a government documentary about Nazi atrocities in favor of a fictional romance set in postwar Berlin, to be produced by Paramount as propaganda with mass commercial appeal. He found Berlin "mad, depraved, starving, fascinating."[61] His Berlin story featured a prissy American congresswoman, Miss Phoebe Frost (Jean Arthur), on a fact-

finding mission. She falls in love with Captain Johnny Pringle (John Lund). Pringle's girlfriend is the Nazi nightclub singer Erika von Schlütow, whose squalid living conditions do not diminish her glamour. For Erika, Wilder secured Marlene Dietrich: a coup. And he engaged Frederick Hollander to compose some Dietrich songs; Hollander also appears in the movie as her pianist. The tale ends, properly, with Johnny and Phoebe in love; Erika is led away by a couple of MPs.

In the editing room, viewing aerial footage of the devastated German capital, Wilder was observed screaming, "To hell with those bastards! I hope they burn in hell!" And yet *A Foreign Affair* is full of naughty touches. Pringle rides his jeep through acres of rubble crooning "Isn't It Romantic?" Erika, in a lovers' embrace, calls him her "new Führer"; "Heil Johnny," she says, giving the Nazi salute. Other Wilderisms include the "perfect honeymoon": Hitler and Eva Braun committing suicide together. *A Foreign Affair* was denounced in Congress for treating Germans and Americans with equal irreverence. The Defense Department issued a statement denying that GIs behaved as Captain Pringle did. American authorities banned screenings in Germany on the grounds that "Berlin's trials and tribulations are not the stuff of cheap comedy, and rubble makes lousy custard pies."[62]

During the shoot, Jean Arthur tearfully accused Wilder of favoring Dietrich. And he does: *A Foreign Affair* is one of Dietrich's best films. For once, she plays a sinner unrepentant and unredeemed. Not only is she irresistible as Eve to Pringle's Adam; she exudes a maturity and wisdom alongside which Congresswoman Frost is impossibly callow. At the same time—as in *Judgment at Nuremberg*—as "Dietrich" she humanizes a Nazi role. Also weighing in is Hollander's "I Want to Buy Some Illusions"—one of his best cabaret songs. In short, *A Foreign Affair*, which Wilder in later years called one of his favorite creations, may privilege cynical

Berlin over innocent America. But for its contradictory impulses, it would be as amoral as *The Blue Angel*. It seemingly admits a lingering romance with Germany. But its wiseguy antics do not serve any consistent strategy of immigrant subversion or patriotic duty.

Wilder's Hollywood movie, *Sunset Boulevard*, tells a sordid tale. A onetime silent movie queen, Norma Desmond (Gloria Swanson), inhabits a darkened mansion with her valet, the onetime silent movie director Max von Mayerling (Erich von Stroheim). She engages a young and unemployed screenwriter, Joe Gillis (William Holden), to doctor a screenplay she has written: a treatment of the Salome story as dated and extravagant as its author. She falls for Joe but he loves another. So she shoots him.

A recluse trapped in a make-believe world of her own flamboyant invention, Norma has no visitors except for other Hollywood has-beens (played by Buster Keaton, among others) who materialize like wax-museum mummies for an occasional game of cards. Her pet monkey has recently died; she conducts a properly solemn funeral. For a New Year's Eve party with a hired band, the only diners and dancers are herself and Gillis. Max plays along with exquisite courtesy. He and Norma watch their old films together. He answers her fan letters—which he himself has secretly written. He plays Bach on the living room organ. The film's polyglot ingredients include the émigré composer Franz Waxman, whose Academy Award-winning score draws on bebop for Joe and Richard Strauss for Norma's closing Salome impersonation. There are cameo appearances by Cecil B. DeMille and Hedda Hopper as themselves. A final verisimilitude: Swanson and von Stroheim were actual discards from another Hollywood era.

The Hollywood of *Sunset Boulevard* is in fact as morally vacuous as the Berlin of *A Foreign Affair*. But, as with *A Foreign Affair*, the film's subversion is no deeper than are its characters. At the premiere, Louis B. Mayer, still in charge of MGM, shouted at

Wilder: "You bastard! You have disgraced the industry that made you and fed you!" Everyone else seemed to like *Sunset Boulevard*. "That this completely original work is so marvelous, satisfying, dramatically perfect, and technically brilliant is no haphazard Hollywood miracle but the inevitable consequence of the collaboration of Charles Brackett and Billy Wilder," gushed the *Hollywood Reporter*.[63] Paramount sent Swanson on a national promotional tour. Cecil B. DeMille, a chronic meliorist, was not heard to complain. But then DeMille, though a ready target for ridicule, was treated with respect by Norma Desmond and *Sunset Boulevard* both. In Hollywood, Billy Wilder, born in Sucha Beskidska on the Vienna-Lemberg line, had become one of us.★

OF THE HOLLYWOOD ÉMIGRÉS, Salka Viertel, born in Poland in 1889, left the most intimate memoir of life in southern California. We have already encountered her Santa Monica salon and the movie scripts she coauthored for her friend Greta Garbo. Her brother was the pianist Eduard Steuermann, who championed Arnold Schoenberg. Her husband was the writer/director Berthold Viertel. Her lovers included Gottfried Reinhardt, Max's son. Her friends were legion.

In Europe, Salka was an actress of consequence. But she was neither beautiful nor young enough for Hollywood—"It made me miserable that I, who had started to act at the age of 17, had to be idle in my best years."[64]† Writing in English for films with European stories and locales, featuring newcomers and old-timers under

★Wilder's most bitter film, *Ace in the Hole* (1951), depicts a mob as savage as Lang's vigilantes and eager bystanders in *Fury*. Stylistically and pictorially, however, Lang's treatment is grimmer: it more readily acquires a menacing existential dimension.

†She excels opposite Garbo as the alcoholic Marthy Owens in the German-language version of *Anna Christie* (1931).

the supervision of studio bosses sometimes literate, sometimes phi-
listine, she adapted again and again. Her New World fate unfolded
in counterpoint to Berthold's. He came first, summoned by Fox,
then fled into a nomadic existence. Known and admired by Erwin
Piscator, Thomas and Heinrich Mann, Jean Renoir, Alfred Döb-
lin, and Bertolt Brecht, he could not find a California niche. He
finally achieved renewed success after the war as a theater director
in London and Germany, only to die in 1953 at the age of sixty-
eight.

The Los Angeles German colony Berthold abandoned was
split into factions, each knit with durable loyalties. A rare conflu-
ence occurred at Heinrich Mann's seventieth birthday dinner,
overflowing the modest Viertel living room. After the soup,
Thomas Mann rose and put on his glasses. As Salka recalled:

> Taking a sizeable manuscript out of the inner pocket of
> his tuxedo, he began to read. . . . It was a magnificent
> tribute to the older brother, an acknowledgement of
> Heinrich's prophetic political wisdom, his far-sighted
> warnings to their unhappy country, and a superb evalua-
> tion of his literary stature.
>
> We hardly had time to drink Heinrich Mann's health
> before he rose, also put on his glasses and also brought
> forth a thick manuscript. First he thanked me for the eve-
> ning then, turning to his brother, paid him high praise for
> his continuous fight against fascism. To that he added a
> meticulous literary analysis of Thomas Mann's oeuvre in
> its relevance to the Third Reich. I no longer remember all
> the moving and profound thoughts expressed in both
> speeches. It gave one some hope and comfort at a time
> when the lights of freedom seemed extinguished in Eu-
> rope, and everything we had loved and valued buried in
> ruins. At the open door to the pantry the "back entrance"
> guests were listening, crowding each other and wiping
> their tears. . . .

ARTISTS IN EXILE

> I said to Bruno Frank how touched I was by the
> wonderful homage the brothers had paid each other.
> "Yes," said Bruno. "They write and read such ceremonial
> evaluations of each other, every ten years."[65]

Heinrich's wife Nelli committed suicide in 1944. Heinrich himself died in Santa Monica in 1950; he was to have become president of East Germany's new Academy of the Arts.

Salka's memoir is titled *The Kindness of Strangers*. But her California sojourn was increasingly shadowed by McCarthyism. Of the death of Franklin Roosevelt, she wrote to Berthold: "My knees gave way . . . it is as if one had suffered a great personal loss." Months later, Salka found Truman's decision to drop atomic bombs on Japan "loathsome, horrifying as all the atrocities of the Second World War."[66] Two years after that, J. Parnell Thomas, a New Jersey Republican, became head of the House Un-American Activities Committee (HUAC) and announced that "hundreds of very prominent film capital people have been named as Communists to us." He took his investigation directly to Hollywood, where he declared that White House pressure had forced the studios to produce "flagrant Communist propaganda films." A group of subpoenaed Hollywood witnesses, mostly writers with leftist ties, were summoned to Washington. At the HUAC hearings of fall 1947, these "unfriendly witnesses," known as the Hollywood Ten, jousted with Thomas and other committee members. The "friendly witnesses" included Louis B. Mayer, who named names and declared, "I will not preach any ideology except American"; Mayer claimed never to have been in Russia even though he was born there. Jack Warner said he favored outlawing the Communist Party. About fifty of Hollywood's chief executives and producers, meeting in New York, agreed to the firing of the Hollywood Ten and declared: "We will not knowingly employ a Communist or a member of any party or group which advocates

the overthrow of the government of the United States." Hollywood began producing titles like *The Iron Curtain, The Red Menace, The Red Danube, I Married a Communist,* and *I Was a Communist for the FBI.* The Hollywood Ten were convicted and sent to prison. (Two wound up serving time in the Danbury penitentiary, whose other inmates included ex-congressman J. Parnell Thomas, convicted of padding his payroll and taking kickbacks from employees.)[67]

Salka Viertel gradually realized that she was no longer employable by the major studios—that was how the blacklist worked. She observed her Russian-born friend Samuel Hoffenstein, whose many script credits included Preminger's *Laura* and Lubitsch's *Cluny Brown,* growing "embittered, disgusted with Hollywood" before dying a lonely death. The immigrants knew a different political culture, in which fascism was an evil greater than Communism. In 1947, Thomas Mann broadcast an American radio message reading in part:

> The ignorant and superstitious persecution of the believers in a political and economic doctrine which is, after all, the creation of great minds and great thinkers—I testify that this persecution is not only degrading for the persecutors themselves but also very harmful to the cultural reputation of this country. As an American of German birth, I finally testify that I am painfully familiar with certain political trends. Spiritual intolerance, political inquisitions, and declining legal security, and all this in the name of an alleged 'state of emergency' . . . that is how it started in Germany.

Earlier, Mann had keenly admired Roosevelt. In 1952 he left the United States to resettle in Switzerland. "The sick, tense atmosphere of this country depresses me," he told a friend. He yearned "to go back to the old earth."[68]

Others who left, friends of Salka Viertel, included Hanns Eisler and Bertolt Brecht. The former, having composed music for Broadway and Hollywood, was deported to Czechoslovakia in the wake of a 1947 HUAC ordeal. The latter, having worked briefly in Hollywood, left the United States hastily after answering questions from Thomas's committee. Salka Viertel, who admired Brecht both as man and artist, did not yet consider "going back." "The only place I had become attached to was that small promontory above the Pacific Ocean with winding Mabery Road"; it seemed preferable to countries where even people with Jewish friends "had tacitly accepted their disappearance."[69] In 1953, she attempted to visit her ailing husband in Vienna but was denied a passport on the grounds that she was an alleged Communist. With the help of a highly placed lawyer, she obtained temporary permission to travel abroad—but by then Berthold was dead and buried. She ultimately died in Switzerland in 1978.

Of the immigrant directors whose American careers we have followed, Fritz Lang claimed to have been blacklisted for as long as a year and a half. Not only had Brecht coscripted Lang's *Hangmen Also Die*; Eisler had composed the music. Lang had also worked with two of the Hollywood Ten: the writers Ring Lardner Jr. and Albert Maltz. And he had made movies, most notably *Fury*, whose cynicism seemed to target the United States. He lent his name to the Committee for the First Amendment, which attempted to counteract HUAC. At a 1950 meeting of Hollywood directors, he was heard to admit that speaking with an accent made him feel "a little afraid." According to Patrick McGilligan, Lang was paranoid—convinced that his phones were tapped no matter where he worked, that secret agents were writing confidential reports to undermine him with producers. Government files reveal that federal agencies began compiling information on Lang as early as 1939. None of the evidence was decisively incriminating. McGilligan cites, as "on-target," reports that "Fritz

Lang always used politics in any way in which he thought it would benefit him" and that Lang was "a talented director, but politically a child, a 'sucker' for organization, sponsor, and donor lists." Alternatively, Saverio Giovacchini, in his study of Hollywood and the Popular Front, situates Lang within a politicized German émigré community determined not to repeat the Weimar failure of artists and intellectuals detached from a manipulable bourgeoisie—hence, Lang's crusade for more "honest" and "mature" Hollywood fare confronting social and political wrongs. In any event, once Lang persuaded Harry Cohn of Columbia that he was not a Communist, Cohn interceded on his behalf and restarted his American career. But Lang chafed; like so many artists in exile galvanized by the war against Hitler, he experienced 1950s America as an alien land.[70]

To return to Billy Wilder: of Hollywood's ten "unfriendly witnesses," Wilder quipped, "only two of them have talent; the rest are just unfriendly." His biographer Ed Sikov pertinently observes that "like other Hollywood refugees, [Wilder] walked a thin line between politics and survival. Unlike some other screenwriters of his generation, he came down on the side of survival and therefore enjoyed a long and productive career in the United States. Wilder's political sympathies lay with the left, but as a refugee he knew he was vulnerable. He wanted to continue working."[71] Wilder's films could be malicious, but they were never dangerous. Viertel, amid her émigré friends, cast loving but conflicted glances at the Old World. Even in their California-made films, Lubitsch and Ophuls could not escape Berlin and Vienna. Lang, ever turbulent, assimilated less than he wished to; his abortive return to Berlin showed he could not help looking back. Wilder—a cocky free agent, a Hollywood hand, an American—looked wherever he pleased.

If Ophuls was the supreme ringmaster whose placid outside perspective bred a civilized irony, Wilder's circus act—juggling

ingredients as venerable as Lubitsch's coy humor, Lang's sordid tales, the glamour turns of Dietrich and Sternberg, as diverse as Brackett's urbanity and Marilyn Monroe's legs—was restless and inconstant, in the ring one moment, outside the next. His edgy dialogue with the American experience yielded no clear judgment, no finished outcome. His high visibility and verbal panache made him—more than any other director of his generation, save Hitchcock—a Hollywood star in his own right.[72] Berliners of the late 1920s were enthralled by the wicked mirror images cast by *Die Dreigroschenoper*; in *Sunset Boulevard*, Hollywood likewise delighted in itself. The one is a theater piece so original that, notwithstanding its enduring popularity, it still defies categorization; the other is a well-turned anecdote more conventional than brave.

With its dual German-American beginnings, Hollywood embodies a New World variant of cultural exchange, dizzily mixing art and entertainment. With its Germanic beginnings, American classical music embodies an aloof and prestigious exercise in colonization. With its deracinated beginnings, Balanchine's American ballet—alas, a more ephemeral achievement—negotiates a dialectic exquisitely balanced and controlled. We come now to theater, and a transatlantic transaction delayed by complacent American beginnings.

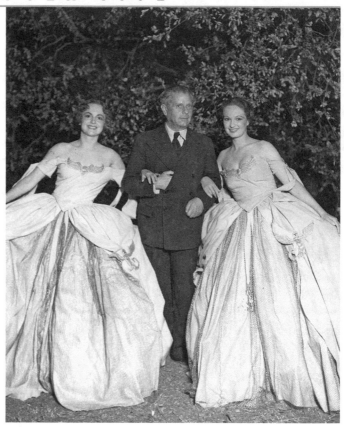

Max Reinhardt with Olivia de Havilland (left) and Evelyn Venable,
Hermia and Helena in his American touring production of
A Midsummer Night's Dream.

DELAYED REACTION:
STANISLAVSKY, TOTAL
THEATER, AND BROADWAY

Max Reinhardt: An unattainable opportunity—Bertolt Brecht and HUAC—Alla Nazimova inhabits Hedda Gabler—The Stanislavsky influence—Rouben Mamoulian's choreographic touch—Boris Aronson and the Meyerhold ideal—Immigrants and American musical theater

WEIMAR BERLIN, CITY OF music and cinema, was also a city of theater. The Deutsches Theater and Kammerspiele played Shakespeare and Molière, Galsworthy and Shaw, Hauptmann and Werfel. The Tribune specialized in French, English, and Hungarian comedies. The State Theater was Expressionist. The Volksbühne was a hotbed of Marxist proletarian theater. Elevated Germanic traditions were honored. Experimentation was zealously pursued. "There were oddities," wrote Bruno Walter, "and occasionally even absurdities, but the common denominator, the characteristic sign of those days, was an unparalleled mental alertness. And the alertness of the giving corresponded to the alertness of the receiving."[1]

When in *William Tell* Leopold Jessner dressed the tyrant Gesler as a Prussian Junker, shouting, whistling, even fistfights, erupted. The imperious Alfred Kerr, at the drama desk of the *Tageblatt*, called the age Periclean.

The central figure, before and after World War I, was neither a playwright nor an actor but something new: a protean director. His breakthrough, in 1905, was a *Midsummer Night's Dream* production for which a grass carpet was imported from London and a revolving stage disclosed in glimpses ever more astounding a life-like forest of trees and shrubs, mist and moonlight, populated by trolls, elves, and spirits. Siegfried Jacobsohn, whose new theater magazine *Die Schaubühne* heralded a new German theater, breathlessly testified:

> Does anyone remember having experienced in the theatre such a degree of exultation—not on the part of single individuals, not of certain groups, but of the entire mass of the audience? . . . Moonlight shimmered and the morning light dawned splendidly. Here and there a glowworm shone. Leaves rustled, you could almost smell the moss, twigs cracked, and the forest seemed immeasurable. . . . Technique is transmuted into art and art into a higher form of nature.

At the final curtain, the public roared for "Reinhardt! Reinhardt!"—and for the first time Max Reinhardt, once an actor, appeared onstage out of costume. According to the memoirs of his son Gottfried: "Never before in the history of the theatre was a person who had not tangibly taken part in the production—by writing, acting, designing, making music—ad hoc discovered by the audience and called before the curtain. . . . This clamor for 'Reinhardt!' to show himself after every Reinhardt opening, this fervent evocation of the reigning spirit, rang on in my father's ears throughout his life."[2]

All accounts of Reinhardt's achievement variously acknowledge him a magician or sorcerer. No less than Diaghilev, an object of his fascinated admiration, he forged an enthralling artistic synthesis, seamlessly invoking music, gesture, and visual design, a world unto itself holding the spectator in thrall. Inspired by the visionary theorists Adolphe Appia and Gordon Craig, his manipulations of color, light, and shade were both atmospheric and scenic. He expanded the playing area at will. With his actors, he imposed no method or ideology. Gently but decisively, he choreographed their every movement. In Goethe and Shakespeare, he shunned declamation. He achieved an ensemble of star performers, intimate or gargantuan in scale.

Though not personally flamboyant, Reinhardt was a celebrity. A dense entourage enveloped his public persona. At his favorite restaurants, conversation ceased when he was escorted to his table. His empire, overseen by his brother Edmund, comprised ten theaters in Berlin, Salzburg, and Vienna, plus the Reinhardt Drama School in Berlin. He was credited with up to four dozen productions annually. Some were in factories or cinemas or ballrooms. His celebrated *Jedermann* was played on the steps of the Salzburg Cathedral. His Grosse Schauspielhaus seated 3,000.

Born Max Goldmann in Vienna, Reinhardt shared the fate of countless Jews in the arts: with Hitler in office, he wound up in America. His reputation preceded him. In 1924, Reinhardt's *Miracle*, a medieval fable in pantomime, had transformed Broadway's Century Theater into a Gothic cathedral. George Jean Nathan's review, in the *American Mercury*, was merely typical; he called it "the most vividly impressive and thunderously beautiful spiritual spectacle, not that [the American theater] has ever known . . . but, more, that it has ever dreamt of." *The Miracle* toured the United States for five years after a New York run of 198 performances. Concurrently, in 1927, Reinhardt's Deutsches Theater presented a Broadway run of Schiller, Buchner, Goldoni, Tolstoy, Shakespeare,

and Hofmannsthal—in sum, seven Reinhardt productions, all in German, to capacity houses, necessitating a three-week extension of the eight-week schedule plus additional matinees. "Titanic," said the press. "Sublime." "The most rousing and stupendous piece of stagecraft ever contained within a theater." The company was feted at city hall by Major Jimmy Walker. Nicholas Murray Butler, president of Columbia University, attributed to Reinhardt a "contribution of essential beauty which lies at the base of everything." *Time* magazine put Reinhardt on its cover.[3]

Reinhardt promised to return and did: to Hollywood in 1934. A showman of genius, a master of illusion, he sought communal rites, a vast audience. His enthusiasms included Gershwin and jazz, Eugene O'Neill, Broadway, FDR. Hollywood signified for Reinhardt the ultimate realization of what he had attempted at his mammoth Schauspielhaus: a "Gesamtkunstwerk for the masses." "America was Max Reinhardt's love at first sight," writes Gottfried.[4] Settled in Los Angeles, he adored the landscape and learned to ride a horse. He was dazzled by Hollywood's technological resources. He did not disdain Louis B. Mayer or Jack Warner or Sam Goldwyn; his own German theaters had been commercial enterprises, geared toward profit and dependent on it. Goldwyn presided at a welcoming banquet hosted by the Los Angeles Chamber of Commerce. Not unlike Murnau, Reinhardt was entrusted—by Warner Brothers—with a lavish debut project: a $2 million *Midsummer Night's Dream*. This was after he had staged the same play, to great effect, at the Hollywood Bowl in 1934. A torchlight parade for the last act proceeded from the heights of the Hollywood Hills to the bottom of the valley; its arrival at Theseus's palace coincided with the final cadence of Mendelssohn's Wedding March.

But Reinhardt's 1935 Hollywood film was not a masterpiece of cultural exchange after the fashion of *Sunrise*. For his Holly-

wood Bowl *Midsummer Night's Dream*, Reinhardt had envisioned a cast reveling in the diversity and glamour of American movie art: Charlie Chaplin (Bottom), Greta Garbo (Titania), Clark Gable (Demetrius), Gary Cooper (Lysander), John Barrymore (Oberon), W. C. Fields (Thisbe), Wallace Beery (Lion), Walter Huston (Theseus), Joan Crawford (Hermia), Myrna Loy (Helena), Fred Astaire (Puck). Though he failed to secure any of these stars, thirteen-year-old Mickey Rooney, as Puck, and nineteen-year-old Olivia de Havilland, as Hermia, were standouts. Reinhardt retained both for his Warner Brothers film. The other players included Jean Muir, Dick Powell, and Ross Alexander as the other lovers, Victor Jory and Anita Louise as Oberon and Titania, James Cagney as Bottom, and Joe E. Brown as Flute. Erich Korngold, an old Reinhardt hand, was in charge of adapting Mendelssohn's score. Bronislava Nijinska was the choreographer. William Dieterle—the former Reinhardt actor who persuaded Jack Warner that Reinhardt could counter the prestige offerings of MGM and Paramount—codirected; unlike Reinhardt, he had substantial cinema experience. As was his custom, Reinhardt assiduously plotted the actors' movements. He spent long hours with his scenic and costume designers. Dieterle was in charge of shooting the results.

From the perspective of cultural transference, the film is not without interest. The absence of refined Broadway or London stage actors—Reinhardt reasoned that their style was too broad for close-ups—is a potentially delicious strategy of renewal. Two actors Reinhardt especially sought—Cagney, cast against type, and Brown, a stranger to Shakespeare—memorably invigorate the thrice-familiar tale. More telling is a Reinhardt touch more typical: nightfall, set to Mendelssohn's Nocturne. Amid shadows and heavenly firmament, Theseus astride his black steed trails a great billowing cloak; a retinue of winged creatures follows onfoot. The rightness of this supreme poetic inspiration, its thoroughness of

detail and precision of execution, its keen attunement to Mendelssohn's gliding horns, enable us to glimpse what a Reinhardt staging looked and felt like.

No expense was spared to realize Reinhardt's vision. Oberon and Titania fly on a moonbeam weighing half a ton. For rain and dewdrops, 10,000 glass beads and 800 droplets were woven into scrims and sprinkled on plants. And yet Shakespeare's words are not beautifully rendered. Korngold's Mendelssohn adaptations, especially when they interpolate massed high sopranos, more than verge on kitsch. With its pedestrian camera work and stagey settings, the film is not filmic. Gottfried, in his memoirs, complains that his father was "a captive, not only of his co-director and the camera he did not control, but also of his employers, who saddled him with a cast chosen almost exclusively from their contract players." Dieterle himself testified that Reinhardt felt he needed more time with the actors, that "working in the film studio was not very easy for [him]. . . . [He] was too clever not to realize that the film was not his métier. . . . I think that he was actually relieved when the film was finished." It came in $250,000 over budget.[5]

"Warner Brothers have the honor to present a MAX REINHARDT production," trumpets the opening credit heralding Reinhardt's Hollywood debut. But Warner Brothers elected to forgo future such honors. Reinhardt proposed to Warner such projects as *Tales of Hoffmann, Die Fledermaus, Everyman*, and *Danton's Death* (which the studio thought was to be about Dante). The *Midsummer* notices did not lack warmth and the public was not unresponsive. But Reinhardt never made another movie. He was thought to lack popular commercial flair. Unlike Murnau, he did not escape to the South Seas. Rather, he returned to the theater, where his career petered out painfully, pathetically. Though a planned Reinhardt Theater was scuttled by the Depression, he masterminded

one more New York spectacle: *The Eternal Road*, in 1937, with a book by Franz Werfel (adapted into English) and music by Kurt Weill. The production, designed by Norman Bel Geddes, required the reconstruction of the Manhattan Opera House to accommodate four-story sets extending nearly an acre, twenty-six miles of wiring, thousands of special lights, and a forty-two-foot mountain that when removed was replaced by the temple of Solomon and Joseph's Egyptian palace. A popular and critical triumph, the show lost $7,000 a week and closed the night the electricity was shut off by the Department of Water and Power. Attempting to accommodate to more modest American norms, Reinhardt subsequently directed two Broadway flops: Thornton Wilder's *Merchant of Yonkers* and George Bernard Shaw's *Sons and Soldiers*. His most sustained activity was an actors' workshop in Los Angeles. Seeking patrons for a *Jedermann* production by the Reinhardt Academy, he wrote to Garbo, Lubitsch, Chaplin, Goldwyn, Huxley, Disney, and scores of other luminaries, politely imposing on their "precious time"; none attended. Dietrich's daughter, Maria, was then a Reinhardt student. She recalled: "Why Dr. Reinhardt, now one of the illustrious refugees, thought that his elite drama school had a chance always astounded me. No one, in those days anyway, came to Hollywood to 'act.' Handsome boys and pretty girls flocked to California to be seen, to be discovered sipping ice cream soda at Schwab's drugstore. . . . So pupils in the once-renowned academy were few." Josef von Sternberg, who had hoped to film Pirandello's *Six Characters in Search of an Author* with Reinhardt as director, even more painfully observed:

> A better school never existed. . . . When watching him, which I did frequently, . . . I envied his indifference to his own welfare, as well as his great ability to conceal impatience behind inspiring masks. Standing before

some trembling oaf whom his skill would soon transform, . . . the master would bathe this object in unbelievable flattery. . . . Should this stratagem fail, he would shed copious tears or laugh uproariously, encouraging the quivering mass like a man who trains a dog with a stick or a lump of sugar until it jumps through the hoop of his cunning.

The most notable of Reinhardt's Hollywood students was Robert Ryan, who became a superb film noir heavy. "Everything he touched became alive," Ryan had occasion to remember.

Scripts, actors, periods of history, scenic designs were given an immediacy and joyous (even in tragedy) urgency that they often never reached with any other person. . . . It is unfortunate that the great productions of *The Miracle* and *Everyman* should remain in these later years as the hallmark of his artistry. . . . His own obsession was the inner life of man. . . . How to release and reveal it was his artistic dedication and the creative purpose of his life. . . .

I last saw him thirty years ago (just before his death) and I have noted ever since the efforts of conscientious but pedestrian artisans to reshape theater into "contemporary" forms. If he were alive he could well instruct them. But I can only hope that they are ploughing through a dull morass that will finally lead them back to the life, joyous, vital and profound that I first saw in those years and have never seen since.[6]

In Europe, the Reinhardt empire was famously headquartered in Salzburg's Leopoldskron castle, an international mecca for artists and statesmen. In Los Angeles, Reinhardt kept an elegant house he could ill afford; Gottfried would save the day by

paying the valet or hiring a housemaid. His father was never without plans, possibilities, excited dreams: a New York repertory theater, an American Salzburg in California. But he lacked the toughness and shrewdness his new homeland demanded of practical dreamers, and the homeland offered neither the audiences nor the resources his painstaking methods courteously demanded. In a memoir of "Reinhardt's Last Years" more bitter than sweet, the designer Harry Horner, who knew Reinhardt in both Europe and America, recalled Reinhardt on Broadway directing *The Merchant of Yonkers* (based on an Austrian folk comedy that later gave birth to *Hello, Dolly!*) for the producer Herman Shumlin.

> Reinhardt sat in the auditorium, calling up to the stage in his quiet voice, telling an actor his concept of a reading of lines. Shumlin was watching in the background. Not understanding what Reinhardt had intended, not knowing or even caring what Reinhardt's approach was to the play, Shumlin whispered something to one of his assistants, who was sent down front to correct Reinhardt. . . . I could not believe my eyes. The young man moved behind Reinhardt, who was in the middle of a sentence, bent forward over Reinhardt's shoulder and spoke loudly enough for me to hear. "Max," he said in a half-whisper, "don't you think the way the actor did it before was better than what you suggest?" It was a moment in which a world collapsed. Even Reinhardt felt it.
>
> Reinhardt turned, staring at the whispering face behind him, so close to his own. Then in an angry outcry which showed his complete bewilderment and helplessness, he gasped, "GET AWAY FROM ME—PLEASE GET HIM AWAY FROM ME," turning to one of his own assistants, who sat nearby. Reinhardt seemed so

shaken that he leaned back and remained totally silent for a few seconds. . . .

Soon after this event, I asked the professor to come with his son Gottfried to have dinner at our house. In Europe somehow I would not have dared to ask Reinhardt for dinner—here, however, he was merely a lonely man in a gigantic city, which offered him no warmth, no love. I discovered my own awe in his presence. I understood how easy it was to fall into this mood of protective adulation which I so criticized in the protective wall of his European friends. I wanted so much to be less formal to and to make him feel the informality of our gathering. I am sure that with all my formality of bowing, which I still carried in me from my Viennese days, I gave him little of the "American" informality and intimacy which I thought he needed.

Horner later encountered Reinhardt at his Los Angeles actors' workshop.

[I] enjoyed the activities of the busy corridors, the young students running from class to class. There was a great thrill in seeing these open faces, these enthusiastic eyes which are so refreshing in American youth. Finally I met the Professor. I felt then, and I feel now, remembering his meeting, that something was missing, something had disappeared from the aura with which I had surrounded him, at least in my imagination. . . .

One of the kids came to our group, slapped Reinhardt on the back, and said, "Hi, Prof," and left laughingly to join some others. I cringed. Yes, there was a different freedom here and, yes, this was a democracy in which the ARISTOCRACY of Reinhardt's royalty was not recognized. But somehow I feared that Reinhardt needed that magic to counteract the corroding effects of those businessmen at the film studios who measured his merit in terms of film profits.

Reinhardt's death in 1943, at the age of seventy, was as odd as Murnau's. He was walking his terrier Micky on the beach. A solitary boxer attacked the smaller dog. Reinhardt sought refuge in a telephone booth. Micky, in a frenzy, attacked his owner. Reinhardt suffered a stroke from which he never recovered. He was buried, an American citizen, in a New York City suburb. He had recently begun an autobiography titled *I Am a Jew*. He wrote in German, of which language he said in a 1942 letter: "It [signifies] the longing—despite everything, despite everything—for a beloved mother-tongue by one alien race that wholeheartedly belongs to yet cannot live in that land: a Jew."[7]

Reinhardt's influence on individual actors and directors prominent in the United States was inestimable. Ryan called him "the most tremendous and important person who has ever influenced my career and my work." Olivia de Havilland was a Reinhardt discovery. Another was Gregory Peck, whom he directed in *Sons and Soldiers*, and who eulogized:

> Dr. Reinhardt was profoundly wise and gentle. . . . The human condition, as he seemed to see it, was one which called for stoic acceptance on the one hand, and playful enjoyment when circumstances permitted.
>
> There was much more about him that was striking, unforgettable. A devilish sense of fun, for example. But the one thing that has stayed with me, as though he said it yesterday, was this: One day in rehearsal, I had trouble with a laughing scene. I was too green and self-conscious to be able to sustain it. . . . Max came up slowly up from the orchestra seats and took me aside. He looked into my eyes and said very quietly, "But why should you be afraid? You should be glad, now that you are grown up, to be able to play like a child again. . . ." It relieved me of self-consciousness, and I was able to do the scene to his satisfaction. It was the best advice I've ever had, and to this day, I tell myself, when things seem a bit difficult, how lucky I

am to be still playing at my age, and I can still recall the expression of his beautiful, powerful old man's face, as he said it.

It was Reinhardt who brought Korngold to America, who in Berlin had mentored Murnau and Lubitsch. Otto Preminger both acted and directed under Reinhardt in Berlin; he believed that "Reinhardt knew more about actors and about the nature of acting talent than anybody in the history of the theatre." Of the many Reinhardt-trained actors who worked in Hollywood, Paul Henreid was an elegant leading man; most of the others had to make do in "foreign" character parts. His influence even extended to the American actress who worked most intensively with the Reinhardt antipode Konstantin Stanislavsky: Stella Adler. No one memorialized Reinhardt more gratefully:

> When I was in high school and the Reinhardt company finally came to America, naturally, I was in the audience watching his plays. Anybody who saw the productions he brought had to go on remembering them all his life. . . .
>
> The years passed and I happened to be in Hollywood at a moment when I finally was offered the opportunity to meet Reinhardt himself. . . . I met and came to know a man who had eyes that were a soft touching blue—a yielding blue with great distance in them. One saw there a kindness and wisdom, a quiet, an ability to think, reflect and understand. His eyes upon you had a hypnotizing effect. He gave you the theme of what you yourself were about to think or say. He kept you quiet within, and seemed to make you part of his life. . . .
>
> What struck you most about Reinhardt was that he was without tension, without inner strain. . . . I played in a production in which he directed me, and so I can speak of Reinhardt the Director. . . . He was without the hard-

ness that one had got used to in the American theater . . . it gave him a quality beyond time. . . .

In production, you worked as hard as you could for Reinhardt; you wanted to give him everything . . . you were a better person around Reinhardt. . . .

Occasionally, I was his guest at dinner. . . . I introduced him to my mother who passed by my table and who was herself an actress of great formality and style. I said; "Mother, I would like you to meet Professor Reinhardt." She didn't hear, and wanted to pass on. I caught her arm and said again: "Mother, this is Professor Max Reinhardt!" There, in the restaurant, she screamed: "Oh, my God! Oh, my God!" and bent down to him. It was a moment which eloquently expressed everyone's attitude of "How well we know you, Reinhardt! How much we respect and love you!"[8]

The last word on Reinhardt's American fate belongs to the most eloquently spoken of twentieth-century American practitioners of the theater. Harold Clurman was never a Reinhardt acolyte. Eulogizing Reinhardt at a 1943 memorial meeting, Clurman articulated why he was not—and, commensurately, what Reinhardt was. Reinhardt, he began, was from the first a "great name" in the United States—meaning "someone to gape at, envy, slander, and forget." He was mislabeled "an aesthetic Barnum," oblivious to the financial realities imposed by a free enterprise culture. More fundamentally, Clurman continued, "Reinhardt's contribution to the modern theater was that he brought back to it the fullness of its means." The play became "the sum of all the theatre's possibilities in terms of mimetics, improvisation, make-up, costume and a fluent dance-like interrelation of parts. . . . In Reinhardt's theater life's comedy and tragedy were served as at a sumptuous banquet at which all of us might sit down and enjoy the fare with easy dignity, light decorum and good appetite." It follows that Reinhardt, with

his warmth and glow, was the product of a stable Old World society. To interwar Americans, he seemed a fine relic of a remote past. "Ours was a more strenuous time; our needs more attuned to moral, social, even political factors. We were a noisier, hungrier, angrier, more ascetic generation."[9]

And so there was never a Reinhardt theater on Broadway, never a Reinhardt festival in Hollywood. Of the great creative spirits who resettled in twentieth-century America, few offered an opportunity so tangible and yet so unattainable.

SO VAST WAS MAX Reinhardt's onetime empire that he was unaware of the existence of a Reinhardt dramaturg named Bertolt Brecht until he encountered him in the United States—at Salka Viertel's Santa Monica salon. The shock waves Brecht had inflicted on German theater were unknown in New York or Hollywood. "Whenever I go, they ask me, 'Spell your name!'" Brecht wrote, "and oh, that name was once accounted great." Brecht's obscurity in America was unsurprising. His Marxist politics, and the "alienation" aesthetic of his epic theater, intended to "smash the introspective psychology of the bourgeoisie," were ill attuned to American mores. Brecht's reciprocal disaffection was lively. Of his Hollywood sojourn he wrote:

> Every day to earn my daily bread,
> I go to the market, where lies are bought,
> Hopefully
> I take up my place among the sellers.

Brecht's views and associations brought him to the attention of the House Un-American Activities Committee. He offered testimony on October 30, 1947: a chilling theatrical specimen less Brechtian than absurdist. With his military crew cut, German ac-

cent, black spectacles, rank cigar, and borrowed suit, he was the committee's most incongruous witness. "Have you attended any Communist Party meetings?" Brecht was asked.

> Brecht: No, I don't think so. . . .
> Chairman J. Parnell Thomas: Well, aren't you certain?
> Brecht: No—I am certain, yes.
> Thomas: You are certain you have never been to
> Communist Party meetings?
> Brecht: Yes, I think so. . . .
> Thomas: You are certain?
> Brecht: I think I am certain.
> Thomas: You think you are certain?
> Brecht: Yes, I have not attended such meetings, in
> my opinion.

Questioned about plays his questioners had never read, Brecht directed the proceedings toward tangents and entanglements. He also dissembled. Were his plays "based on the philosophy of Marx and Lenin?" "No, I don't think that is quite correct." In a taxi afterward, he grieved that he had recanted and explained his fear of being jailed as a dissident alien. He fled to Paris a day later.[10]

Brecht's five Hollywood years were not wholly unproductive. His film with Fritz Lang and Hanns Eisler, *Hangmen Also Die*, was at least a finished product, if far from what he had envisioned (an insult added to injury was that he was denied credit as coauthor of the screenplay). He also wrote while in California *The Caucasian Chalk Circle* and a new version of *Galileo*. Both plays may be said to bear witness to exile in America. Grusha, in *The Caucasian Chalk Circle*, flies into exile to escape her persecutors; at one point, she is betrayed by a stranger. Another character muses, "Why does a man love his country? Because the bread tastes better there, the air smells better, voices sound stronger, the sky is higher, the ground is easier to walk on." The tastelessness

of American bread would become one of Brecht's most publicized complaints about the United States. Rewriting *Galileo* with Charles Laughton, who played the title role in a much touted but tepidly received 1947 Los Angeles staging, Brecht was inflamed by Truman's bombings of Hiroshima and Nagasaki. Reassessing "the father of the new system of physics," he made Galileo's recantation (ironically anticipating Brecht's HUAC testimony that he was not a Marxist) an act of cowardice rather than a shrewd strategy of survival. And science itself was reconsidered in view of its potential to produce "a universal howl of horror."

But these covert allusions to Brecht's experience of America, and of American war diplomacy, pale beside the exceptional engagement of the two other most important writers exiled in the United States: Thomas Mann and Vladimir Nabokov. Brecht admired FDR and Chaplin, and even had something relatively nice to say about "the Broadway musical which, thanks to certain fiercely competing groups composed of speculators, popular stars, good scene designers, bad composers, witty if second-rate song writers, inspired costumers, and truly modern dance directors, has become the authentic expression of all that is American."[11] Fundamentally, however, Brecht not only lacked sympathy for America; he lacked the very shrewdness of understanding his *Refugee Dialogues* and "Letter to an Adult American" purported to possess. This lack of sympathy and understanding was returned: in 1956 and 1963, Brecht's East Berlin–based Berliner Ensemble galvanized London with an approach to ensemble and interpretation unknown in British theater. It was of course denied entrance to the United States.

Brecht's notion of theater as a fount of moral instruction to some extent resembled Erwin Piscator's Marxist proletarian theater in Berlin. Polemically eschewing naturalism, Piscator espoused a technologically ambitious "total theater," frequently linked to film, to arouse a charged political response. "For Pisca-

tor," Brecht once said, "theater was a parliament and the audience a legislative body." Exiled to America in 1939 following a stint in Soviet Russia, Piscator created a school—the Dramatic Workshop at New York's New School. His students included Harry Belafonte, Marlon Brando, Tony Curtis, James Dean, Ben Gazzara, Judith Malina, Rod Steiger, Elaine Stritch, and Shelley Winters. He left in 1951 after receiving a HUAC subpoena. Though his New York Workshop, with a repertoire ranging from Shakespeare to Sartre, was not a commercial venture, the existence of a Piscator theater in Manhattan was no small achievement; Gazzara remembered the Workshop productions as small miracles, "the first time I saw a director work creatively with light and space." A far greater achievement was the Piscator experience as reinstated in West Berlin. Harold Clurman visited in 1956 and saw a Piscator version of *Danton's Death*, about which he reported:

> The total production is a stage event of which most of us in New York, London and Paris are largely unaware—as if the theatre itself were an experience still to be discovered by us. . . . The setting . . . is a triumph of eclectic methods. Revolving platforms are used, and certain devices of constructivism: the main architectural feature of the setting is a scaffolding which resembles a modified scenic railway, itself frequently in motion, so that when people promenade on it . . . we get the sense of constant mobility. Images of places and people are fluently projected against screens on three sides of the stage. The result is a feeling of complete freedom.[12]

A third iconic theater director in Weimar Berlin, also exiled to America, was Leopold Jessner. His signature, at the State Theater, was a huge staircase, creating a series of platforms for his stylized, Expressionist productions. Like Brecht and Piscator an

avowed leftist, Jessner disappeared in Hollywood. At one point, he read scripts for the producer Walter Wanger. In 1939 he re-staged his once-famous *William Tell* production in English with German actors; it was a two-week fiasco. He died in Los Angeles in 1945.

Late in life, Max Reinhardt told his son that he had waited too long to come to America—that he "bitterly regretted" ignoring a 1911 invitation from Otto Kahn, the Mycaenas who lent support to Paul Robeson, the Provincetown Playhouse, and the Broadway runs of Jacques Copeau's Theatre du Vieux-Colombier, of the Moscow Art Theater, of Reinhardt himself. "It is not idle to speculate what direction the American theater might have taken if Reinhardt had accepted," Gottfried later reflected;

> He might have revitalized it and brought it into line with the European trends of the period, a process that was delayed by America's isolation during World War I and by the boom years of commercialism and self-satisfaction that followed. . . . With Kahn's financial and moral support, the thirty-nine-year-old, without the language and energy problems of a sexagenarian, might have formed ensembles, replaced *shows* by *theatre*, by planned repertoires and companies operating throughout the season, might have founded schools, generated a Shakespeare renaissance, turned classics into long-running hits, stimulated playwrights and composers and perhaps erected modern playhouses . . . , thus introducing the studio stage and the thrust stage and the theatre in the round long before they became the fashion of the American day.[13]

But Reinhardt, Brecht, Piscator, and Jessner, whatever they may have had to offer, all arrived late—decades after Heinrich Conried's Irving Place Theatre and the heyday of German-language drama in New York; decades after World War I and the concomi-

tant demise of New York's *Deutschtum* and other "German-American" cultural enclaves that dotted the United States with their *Singvereine* and theaters.*

German music—a song without words—had long been inculcated in the United States. German cinema infiltrated Hollywood before the movies acquired sound. American theater remained a provincial enterprise rooted (naturally) in English words and dominated by standardized melodrama. German theater, by comparison, was not a string of commercial hits but a living tradition feeding national identity. Great German writers typically produced not novels (a genre in which American writers early excelled) but plays. And the plays, following the hallowed examples of Goethe and Schiller, were often written in verse: they celebrated the spoken German word. By the time Reinhardt produced an English-language *Faust* in Los Angeles in 1938, Goethe and Schiller were certifiably nonexportable to the United States in any language, and German theater more persisted in America not as high art but in the guise of Germanic English-language operettas early exemplified by such Victor Herbert favorites as *Babes in Toyland* (1903) and *Naughty Marietta* (1910). These warrant a brief digression.

Herbert, who also wrote musicals, was more versatile than is popularly recalled, and the same holds true for his chief successors: Rudolf Friml, who arrived in New York in 1906, having once studied composition with Dvořák in Prague, and the Hungarian-born Sigmund Romberg, whose career was based in Vienna before he came to America in 1909. For the most part, Friml and

*Ambitious émigré attempts to revive German-language theater and cabaret in New York in the 1930s and '40s led nowhere. Ernst Toller, once Germany's most famous playwright, wound up a suicide in southern California. Carl Zuckmayer, another eminent writer for the stage (he also scripted *Das blaue Engel* for Josef von Sternberg), abandoned Hollywood for Vermont, where he became a successful farmer.

Romberg are today remembered—vaguely—as transplants, cloning Strauss, Kálmán, and Lehár. Romberg's *New Moon* (1928), the last operetta to enjoy a long initial Broadway run, survives in the form of a 1940 Nelson Eddy/Jeannette MacDonald film so turgid that Romberg is made to seem neither durable nor endurable. But a 2002 New York revival disclosed a winning light touch amid acres of terrific tunes—one of which, "Softly," happens to be a tango. It bears mentioning, as well, that *New Moon* celebrates the liberation of French New Orleans; it throbs with salutes to equality and democracy. Romberg also absorbed the influence of vaudeville; he even wrote songs for Al Jolson.

In the 1930s, the German operetta found a final New World outpost in Hollywood, where Romberg and Friml were joined by the Vienna-born Oscar Straus. Straus furnished the songs for Ernst Lubitsch's film operettas *The Smiling Lieutenant* (1931) and *One Hour with You* (1934). Lubitsch's final film operetta was Lehár's *The Merry Widow* (1934)—by which time Jerome Kern, born in New York City, had shown the way toward an integrated musical theater form less borrowed than indigenous. In *Show Boat* (1927)— whose librettist, Oscar Hammerstein II, worked concurrently on *New Moon*—Kern intermingles an epic yarn with an informality of tone and address an ocean removed from opera and operetta, with songs unsingable by the likes of Eddy and MacDonald. German operetta more distantly echoes in the scores of Frederic ("Fritz") Loewe, born in Berlin in 1901. All but one of Loewe's popular collaborations with Alan Jay Lerner—including *Brigadoon* (1947) and *My Fair Lady* (1956)—employ foreign settings. But Lerner and Loewe link to Rodgers and Hammerstein, not Friml or Romberg.

In short, the twentieth-century German immigrant, a decisive influence on American musical life and on American cinema, less decisively impacted on American theater. The foreign influence that mattered to stage actors and directors was Russian.

Alla Nazimova in A Doll's House

WHEN MAX REINHARDT DIRECTED *A Midsummer Night's Dream*, he memorably instructed Mickey Rooney, his Puck, to leap and dip nearly three octaves, intoning:

> Up and down
> Up and down,
> I shall lead them
> Up and down . . .

When Konstantin Stanislavsky directed *Othello*, he would invite his Desdemona to imagine her character's life before the action of the play began: her first impressions of Othello the famous general; her first encounter with him on the street. The one was a master choreographer, a Balanchine. The other was more a master catalyst, aiming for a kind of self-motivated acting that rejected "acting."

In America, the first whiff of Stanislavsky's method was furnished by an actress so versatile and true that her own identity was famously unfathomable. She was small, lithe, ageless, androgynous. Born Mariam Leventon to Jewish parents in the Crimea, she was an itinerant Russian who spoke French and later German as her primary language; she subsequently acquired English quickly and well. She introduced American audiences to Ibsen and Chekhov, and to an acting style so new that when she first appeared on Broadway, the other actors would mistake some of her words "for directions I was giving them—just because I simply talked my lines."[14]

This was Alla Nazimova, whose Hedda Gabler gave Eugene O'Neill his "first conception of a modern theater where the truth might live." The first time Tennessee Williams "wanted to become a playwright" was when he saw Nazimova in Ibsen's *Ghosts*, an experience "so shatteringly powerful" he could not bear watching it, and wound up "pacing the corridor of the peanut gallery, trying to hear what was being said on the stage." Tallulah Bankhead considered her "only theatrical training at 17" to be "running away from home" to see Nazimova. Eva Le Gallienne, the British-born actress who would create one of America's few successful repertoire companies, was eighteen when she discovered Nazimova and became her sometime protégée and lover. Stella Adler encountered Nazimova at a theater in the Bowery and found her "one actor in a thousand," "so big and commanding that it made the audience feel smaller."[15]

Nazimova was seventeen when she moved to Moscow in 1896 and apprenticed herself to Vladimir Nemirovich-Danchenko. When Nemirovich joined forces with Stanislavsky, she became a minor member of the Moscow Art Theatre. Sitting alone in the theater, she observed Stanislavsky directing Shakespeare, Ibsen, and Chekhov. Another early influence was the virtuoso actor Pavel Orlenev, through whom she met Chekhov, and with whom she

ARTISTS IN EXILE

appeared as a featured player both in Russia and on tour in Berlin, London, and—finally, in 1905—the United States. Orlenev and Nazimova began unheralded on the Lower East Side—Jacob Adler supplied a theater—and wound up feted on Broadway.

It was under the auspices of Lee Shubert that Nazimova made her landmark English-language debut, as Hedda, at the Princess Theatre on November 12, 1906. Ibsen's play had premiered in New York three years previous and failed to find an audience. Shubert, accordingly, attempted to steer Nazimova toward a milder vehicle—*Miss Pocahontas*. Nazimova prevailed. Her restless energies inhabited Ibsen's portrait of an entrapped wife—bored, angry, cunning. Hedda's suicide, in Nazimova's Medea-like impersonation, was a triumphant act of revenge on the provincial hypocrites who had shackled her. She coached the entire company in the work, insisting on natural speech instead of "singing" declamation. The incorrigibly genteel William Winter of the *Tribune*, who considered Ibsen's "a disordered brain," deplored the "reckless violence" of Nazimova's "twisting, turning, grieving, serpentine" performance. But Alan Dale of the *American* wrote: "Here at last, in the very flesh, was that nightmare-lady, Hedda Gabler." The *Times* enthused, "Great creative acting. . . . One of the most illuminating and varied performances which our stage has seen in years." *Hedda* played to capacity houses, and so, in 1908, did *A Doll's House*, with Nazimova as Nora. Other stage icons of the day—the wistful Maude Adams, the dignified Ethel Barrymore—offered variants on a fixed identity. Nazimova's Nora, in frilly blouse and skirt, was as small and childlike as Hedda, resplendently gowned, had been "tall" and imperious. Shubert toured Nazimova in both plays, plus *The Master Builder*. In Connecticut, she lectured at Yale's Drama Department and observed: "Ibsen has no heroines; he has women. Shakespeare has heroines. There is a simplicity and grandeur about them, [and] perhaps women really were like that three hundred years ago. . . . But the position of women

has changed so much since then. . . . The modern woman is more complex. She knows more; her nerves are exaggerated." Of Nora walking out on her family, Nazimova said, "She had to go away to grow up. . . . Her children were better off without her. She saw that. What could she do with them except spoil them as she had been spoiled?" Her talk was published in *Independence* magazine as "Ibsen's Women." It could equally have been titled "Nazimova's Women."[16]

The Shubert brothers, with their many popular theaters, were part of a duopoly. The rival component, known as the Syndicate, included more than thirty of Broadway's forty houses as well as the largest national theater chain; its standardized merchandise even more powerfully resisted new currents from abroad. Yet so potent was Nazimova's appeal that she was next signed by Charles Frohman, the Syndicate mastermind whose roster included Adams, Barrymore, and William Gillette as Sherlock Holmes. For Frohman, Nazimova played not Ibsen, but a banal melodrama titled *Bella Donna*. Her growing mass appeal led in 1916 to Metro Pictures and Hollywood, where she costarred with Rudolph Valentino and built an estate she called the Garden of Alla. In orange groves and cedars, loquat and bamboo, she lavishly entertained the likes of Chaplin, Swanson, and Gish and pursued a lesbian private life while ostensibly married to a stolid British hulk named Charles Bryant. Her silent-movie fame positioned her alongside Negri and Garbo as a lethal exotic. Darryl Zanuck called her Queen of the Movie Whores, "the only time Hollywood let a star come near to orgasm on the screen."[17] She briefly returned to the New York stage to premiere Ibsen's *Wild Duck*, then in 1922 left Metro and formed her own production company to film *A Doll's House* (1922) and Oscar Wilde's *Salome* (1923). Only the latter film survives. It documents a fearlessly decadent realization, with dwarfs in plumed helmets and harem pants, black slaves in silver lamé loincloths, and a Syrian soldier with painted nipples

ARTISTS IN EXILE

amid stylized sets modeled after the Aubrey Beardsley drawings. Her boyish physique trimly intact, the barefoot forty-two-year-old star looks no more than thirty as Herod's depraved teenage daughter.

The capstone of Nazimova's career, redeeming her misspent Metro years, was a distinguished return to the stage. As Ranevskaya in *The Cherry Orchard*, for Le Gallienne's Civic Repertory Theatre in 1928, she anchored a decisive Chekhov moment; the Moscow Art Theater's version of the same play, in New York in 1924, was the only previous major Chekhov production in the United States. The Civic's *Cherry Orchard* sold out for the season within twenty-four hours of opening night. Two years later, Nazimova took the lead role in the American premiere of Turgenev's *A Month in the Country* for the Theatre Guild. In 1931, again for the Guild, she created the role of Christine in O'Neill's *Mourning Becomes Electra*. Returning to Ibsen, she toured both *Ghosts* and *Hedda* in 1937. She last appeared on the New York stage in 1939 in *The Mother* by Karel Čapek, playing opposite the eighteen-year-old Montgomery Clift.

Late in life, Nazimova resettled in Hollywood, where she was cast in a series of supporting roles while unsuccessfully seeking something more. Her final assignment came in John Cromwell's earnest *Since You Went Away* (1944). As old Zofia Koslowska, menially engaged at a wartime shipyard, she tells Claudette Colbert how she and her little son (who subsequently perished) "prayed that God would let us go to the fairyland across the sea." She recites the Statue of Liberty's pledge to the "huddled masses" and tells Colbert—who as Anne Hilton is a country-club wife employed as an apprentice welder—"You are what I thought America was, what I meant when I prayed with little Yanka." Nazimova wrote to her nephew about Zofia, "the woman has something to say, something very near to all of us 'poor storm-tossed emigrés (in one way or another).'"[18] At the same time, Zofia's maudlin

speech exemplifies the degree to which Hollywood wasted Nazimova. As with Garbo and Dietrich, cultural exchange here turned her into an exotic curiosity: a kind of surrogate entertainment masking atrophied artistic potential. It was in Los Angeles that she died in 1945. Interred at Forest Lawn Cemetery, a monument to kitsch, she was reunited with that part of Hollywood she had long despised.

Her biographer, Gavin Lambert, sums up:

> Only a repertory theatre could have provided Nazimova with the great roles she never played, from Miss Julie, the two "Lulu" dramas, and the stepdaughter in *Six Characters in Search of an Author*, to the wife in *The Dance of Death* and Mother Courage. Then as now, Broadway producers were reluctant to take a chance on Strindberg, Wedekind, Pirandello, or Brecht. It was the more practical Eva Le Gallienne, with her Civic Repertory, who was the first in New York to produce plays cold-shouldered by Broadway, and sell tickets at less than half the price Broadway charged. . . .
>
> . . . Yet [Nazimova] managed to create five major Ibsen roles, Madame Ranevskaya, Turgenev's Natalya Petrovna, and O'Neill's Christine Mannon, a record equalled by no other foreign actress and few native ones in the American theatre. And for posterity, a greater loss than the roles Nazimova never played is the movie that [George] Cukor was never able to make of *Ghosts*.[19]

A longer view, starting earlier, suggests that the timing of Nazimova's arrival in the United States was propitious. The waning of the Gilded Age saw the emergence of the "new woman." Opera was a vanguard outpost: most American Wagnerites were women for whom Senta and Sieglinde, Brünnhilde and Kundry—forecasting Hedda and Nora—addressed buried emotional needs and

private emotional lives. New York's leading Wagner soprano of the early twentieth century was Olive Fremstad. Born in Stockholm, raised in Minneapolis and Manhattan, schooled in Berlin, she was a singing actress not noble or monumental but shockingly human in moments of sensual or psychological arousal. She was also, in 1907, the Metropolitan Opera's first Salome—a role for which she prepared by visiting a morgue to see what it felt like to carry a severed head. At the Chicago Opera, Mary Garden—born in Scotland, raised in Chicago, seasoned in France—was the new woman. She introduced Chicago to Salome in 1910, a performance so convincing in its depraved eroticism that Strauss's opera—as at the Met—excited opprobrium and dismay.[20]

As with Nazimova, photographs of Garden in a variety of roles do not disclose an ongoing physical identity: she equally fused with Mélisande and Thaïs. In dance, the new women included Isadora Duncan and Ruth St. Denis, both American-born. In James Gibbons Huneker's *Painted Veils* (1921), the lesbian soprano Easter Brandes is largely a composite of Fremstad and Garden. Like Duncan and St. Denis, Fremstad and Garden, Nazimova embodied beauty and moral uncertainty, jarring aesthetic and sociological reform. She oscillated between Ibsen and Frohman, between the Theatre Guild and Hollywood schlock, between the impotent Bryant and a fraught series of same-sex lovers. "Life has been no easy matter for me," she said.[21]

As cultural immigrants go, Alla Nazimova appeared as from another planet, with instincts and talents, bred and inbred, no American actress possessed, but to which Americans were ready to attend. Unremembered today, hers was a necessary contribution.

KONSTANTIN STANISLAVSKY AND HIS Moscow Art Theatre arrived in the United States in 1923—seventeen years after Alla Nazimova and Pavel Orlenev played in Russian on Broadway, four

years before the arrival of Reinhardt and his German troupe. The eight-week New York run, sold out in advance, was extended by four weeks, after which the company headed for Chicago, Boston, and Philadelphia. The opening night performance of *Tsar Fyodor* was attended by Nazimova, who had first seen the production in rehearsal a quarter century earlier; at a reception she was told by a company member, "We have seen everything you did in the movies."[22] New York had not previously encountered so polished a repertoire ensemble supervised by a director of genius. Language, the press reported, was no barrier to appreciation.

Fundamental to Stanislavsky's method was the principle that an actor lives the life of the character he plays, that by drawing on his own experience he can attain interior understanding. Such understanding necessarily informed not only activity—speaking, gesturing—but inactivity. The intended result was a lifelike ensemble down to the tiniest supporting role. New York reviews of the Russians stressed these points precisely: that the drama "is not spoken by the characters so much as it is looked and above all felt by them," that "to look upon it seemed almost like an unwarranted intrusion upon privacy," that "every actor in the scene [from *Tsar Fyodor*] is no less an individual than the Tsar himself."[23]

When the Art Theatre returned to America in 1924, attendance fell off. But its imprint was permanent, and not least on amazed American actors. Some of Stanislavsky's own actors wound up settling in the United States. Akim Tamiroff, Vladimir Sokoloff, and Maria Ouspenskaya became familiar Hollywood exotics, making strong impressions in minor roles. Of the Stanislavsky alumni who taught in the United States, the most important included Ouspenskaya, Michael Chekhov, and Richard Boleslawski. Chekhov, a nephew of the playwright, was considered one of Stanislavsky's most gifted students; his students in America included Yul Brynner. Boleslawski was a successful Hollywood di-

rector until his early death in 1936 (we have briefly encountered him overseeing the polyglot Dietrich vehicle *Garden of Allah*—a film in which Stanislavsky's influence is no more detectable than Madame Ranevsky's orchard or Vanya's estate). Previously, in New York, Boleslawski had founded the American Laboratory Theatre; its early students included Stella Adler (who later said she owed her "whole career" to the Laboratory Theatre), Lee Strasberg (on whom Boleslawski exerted a lesser influence), and Harold Clurman (who remembered Boleslawski as "a man of the theater from top to toe").[24] All three became prime advocates of Stanislavsky's methods in America. This much-discussed achievement climaxed decades of reform challenging the commercialism of the Shuberts, Frohman, and others for whom theater meant spectacle and big-name actors. New plays by Ibsen, then Shaw, then O'Neill, led to new "little theater" and "art theater" companies. The Theatre Guild, created in 1919, became Broadway's most artistically important producing organization.

In Clurman's view, the Guild was in no sense experimental; nor was it a major laboratory for fostering American drama. The Group Theatre, founded by Clurman, Strasberg, and Cheryl Crawford as an offshoot of the Guild in 1931, was both. Gazing abroad at Berlin and Moscow, Clurman asserted that "a true Theatre inspires not only dedication to its idea but generates . . . a characteristic style. A Theatre is the expression of a culture or at least a powerful current with a community. Indeed , it is not too much to say that a Theatre may contribute to the formation of a culture."[25] The Group gravitated to new plays addressing the issues of the day; it was perceived to aspire to social and political reform from the left. It also aspired to a communal purpose and style, and was praised for attaining a degree of ensemble not previously seen from Americans on Broadway. Like the Moscow Art Theatre, the Group even practiced communal living, retreating to rural sanctuaries in summer to polish productions until they were

good and ready for New York. (The 1934 example of Balanchine preparing *Serenade* in White Plains, New York, is not irrelevant.) The Stanislavsky connection, a Group calling card, was reinforced and clarified when Clurman and Adler encountered Stanislavsky himself in Paris in 1934; Adler worked with him for five weeks. Clurman realized early on that the Group's insistence on sustaining an entire company of actors, its exceptional rehearsal requirements, and its eschewal of box office fodder and name-brand stars rendered it "non-commercial." Its fated demise, in 1941, was aggravated by fissures within the Group leadership, and by the Hollywood siren song that lured Clurman and some of his best actors—as it had lured Nazimova, Reinhardt, Brecht, Boleslawski, and countless others—to southern California, not least because their New York income was so paltry. In 1947 the Actors Studio was founded as a Stanislavsky-based training workshop. The founding members, all alumni of the Group Theatre, included Elia Kazan (born in Constantinople and an American from the age of four), Robert Lewis, and Cheryl Crawford. Strasberg (born in the Ukraine and an American from the age of nine) joined a few years later and became director. Their differences with Clurman and related issues of fidelity to Stanislavsky need not concern this narrative: the Stanislavsky method, however interpreted, was a catalyst for reform.

In fact, whereas American classical music was precariously Eurocentric, the European influence, generally, was vital to refreshing American theater. Its agents included not only Stanislavsky and Reinhardt, Nazimova and Orlenev, but the Yiddish theater and Jacob Adler: father to Stella, whom he mentored; father-in-law and child stage hero to Clurman, whose cherished memories included Yiddish performances of Shakespeare, Tolstoy, Gorky, Sudermann, and Hauptmann. Not only the power of the actors ("among the best I have ever seen") but the passion of the audiences ("here the problems of their life, past and present, could be

given voice") spoke to Clurman's ideals. He also powerfully drew inspiration from the "intellectual Dr. Caligari of the theater": Vsevolod Meyerhold, whose productions he devoured while visiting Moscow with Crawford in 1935.[26]

While Gordon Craig and the French director Jacques Copeau may also be cited as notable influences on Clurman and his cohorts, the Russians were paramount. Like Adler and Strasberg, Clurman grew up among Russian Jews on the Lower East Side. This was a milieu unlikely to foster kinship with the refinements of a Reinhardt, embedded in centuries of elevated German tradition, or the "alienation" effects of a Brecht, imbued with dialectical materialism. With its emphasis on self-investigation and true feeling, Stanislavsky's method—even if not inherently "Russian"—connected to an American spontaneity and rawness, to a drama not of class and manners, but of Stanley Kowalski and Willy Loman: American realism.

Russian, too, were the two interwar immigrants who enjoyed the most sustained careers in the American theater. One was a director, the other a designer—and neither, as it happened, was a disciple of Stanislavsky or his techniques.

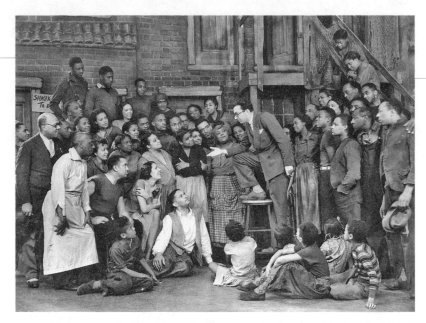

Rouben Mamoulian instructing his Porgy and Bess *cast (1935).*

EVEN COMPARED TO OTHER "Russians" who figure prominently in this volume, Rouben Mamoulian arrived in the polyglot New World already well deracinated. A banker's son, he was an Armenian born in 1898 in the Georgian capital of Tiflis (now Tbilisi). English was his seventh language, after Armenian, Russian, Georgian, French, German, and Latin. As a youth he lived in Paris. He studied in Moscow and in London—where he debuted as a professional stage director at the age of twenty-five. He arrived in the United States a year later.

Mamoulian's early relationship with the Moscow Art Theatre is elusive. It seems he met Stanislavsky but was not his student. He apparently took lessons with Stanislavsky's disciple Yevgeny Vakhtangov for a period of months. The influence of Stanislavsky's method has been inferred from the testimony of William Holden

ARTISTS IN EXILE

and Charlton Heston, who credited Mamoulian with instilling a disciplined approach to acting. But Mamoulian early and emphatically disavowed the naturalism of Stanislavsky's aesthetic in favor of self-described "stylization." Here, Vakhtangov was an undoubted factor. Recalling Vakhtangov's famous staging of *The Dybbuk*, Clurman used terms like "phantasmagoria" and "dream-like." He commented on the creative use of music, on "mask-like" faces and props that "stood askew." Other writers have described "rhythm and tempo" of individual characters in Vakhtangov productions. Mamoulian's Old World hallmark was an all-powerful directorial vision abjuring realism in favor of an ingenious fusion of music, movement, and plot.[27]

An unlikely appointment furnished Mamoulian a kind of paid self-apprenticeship: from 1923 to 1926 he directed operas and operettas for the George Eastman Theatre in Rochester. His American Opera Company comprised students at the Eastman School of Music, entrusted with furnishing live entertainment preceding feature films at the Eastman Theatre. The writer Paul Horgan, a Rochester colleague, remembered the six-foot Mamoulian (who upon arrival in America wore London suits, fedora hats, spats, and a pince-nez) as "a column of energy" equipped with exceptional breadth of learning: about stage production, about music, about visual art. "We felt that he was closer to anyone we ever heard of to embodying Gordon Craig's ideal for the régisseur—that he should know more about the writing of plays than the playwright, more of music than the composer, more of painting than the painter, more of acting than the actor."[28] Mamoulian's Rochester colleagues also included Martha Graham, whom he recruited in 1925. The apex of his Eastman tenure was a production of Maeterlinck's *Sister Beatrice* (appropriated by Meyerhold for one of his signature experimental productions) in a translation by Horgan. To provide a rhythmic base for the actors, and for Graham's choreography, Otto Luening—later a musician

of consequence—composed an incidental score not before or after, but during the rehearsal process. Lucning called *Sister Beatrice* revolutionary; in later life, Mamoulian considered it his most inspired creation. Other American Opera Company productions featured individual acts or scenes from works by Rossini, Verdi, Gounod, Bizet, Wagner, and Tchaikovsky. Beginning in fall 1924, Mamoulian increasingly opted for operetta and for integrated sequences of musical numbers with titles like *A Night at the Inn, The Game of Love,* and *A Corner in Spain.*

Lawrence Langner, the founder of the Theatre Guild, became aware of Mamoulian's work through occasional visits to Rochester, where Mamoulian "walked my legs off, racing the streets . . . , telling me all he planned to do in the theater if I would only bring him to New York."[29] Mamoulian made it to the big city in 1926, and was assigned student productions by the Guild. Now all of twenty-eight years old, he itched to work with professionals. When he was told the Guild was not planning any "European" repertoire, he insisted on staging an American play—George M. Cohan's *Seven Keys to Baldpate*—with his Theatre Guild School pupils. Unlike Lubitsch, with whom he would inescapably be compared, Mamoulian eschewed nostalgic regard for Old World sentiment and locales. With no anchored "past," he enthusiastically lived in the present. For the Cohan play, he applied the rhythmically stylized approach he had perfected at Eastman. As it happened, the Guild was fruitlessly seeking a director willing to undertake a new play-with-music peculiarly American in its requirements: the cast was African-American, and so was the thick and flavorful dialect. This was *Porgy,* by Dorothy and DuBose Heyward. Opening late in 1927, it ran for 367 performances at the Guild Theatre. It made Mamoulian's reputation.

Porgy was first DuBose Heyward's 1925 novel *Porgy.* The sympathy and admiration with which Heyward depicted the Gullahs

of Charleston, South Carolina—a black community peculiar to the coastal South—was bold for its time, and his flights of picturesque poetic elegance, evoking Catfish Row, today retain pungency even as Porgy, Bess, and Crown recede into stereotype. For the stage version, Heyward insisted on a black cast, rather than whites in blackface. The usual comic and vaudeville roles allotted black performers were irrelevant. *Porgy*'s admirers included W. E. B. DuBois.

Mamoulian, too, was bold. For the final scene, beginning at daybreak, the awakening of communal activity calibrated a cumulative "symphony of noises."

> All the activity, the pounding, tooting, shouting and laughing is done to count. First I use one/two time. Then beat three is a snore—zzz!—from a Negro who's asleep; beat four silent again. Then a woman starts sweeping the steps—whish!—and she takes up beats two and four, so you have Boom!—whish!—zzz!—whish!—and so on. A knife sharpener, a shoemaker, a woman beating rugs and so on, all join in. Then the rhythm changes: four:four to two:four, then to six:eight.[30]

Surveying Charleston with Cleon Throckmorton, his set designer, Mamoulian had noted dozens of characteristic sounds, a list beginning with shutters with hooks, windowpanes, and tin, glass, and clay pots on windowsills, to be struck with sticks. He had scanned Heyward's script as a musical score organized into beats and susceptible to shifting tempos. In rehearsal, he propped it on a music stand and conducted with a baton. He also employed a metronome and a whistle.

Mamoulian's "field research" in Charleston may suggest an interest in authenticity. But when reviews praised the production for verisimilitude, Mamoulian was annoyed. He meant to be an artist, not a social critic. In addition to its choreographed sound

effects, *Porgy* was notable for the choreography of its stage pictures and lighting. For the hurricane scene, when Crown flung open the door of Serena's room, a cringing and huddled mass of humanity, arranged as a wedge, fell backward from the thrust of the wind; shadows emphasized the desperation of flailing arms and bodies. Of the spirituals interspersed in the play, Alan Dale of the *New York American* wrote: "All the colored 'folks' raised their voices, gesticulated, gyrated, as they joined in the volcanic choruses. It was something new to most of us—may I say to all of us." Of Mamoulian's method, Howard Barnes observed in *Theatre* magazine that his painstaking attention to detail "does not allow the actors to give their own interpretations to parts. He enters the rehearsal period with the entire course of his direction carefully planned out in advance and waits patiently for his project to be realized, spending an immense amount of time on stage movement." Mamoulian also supervised extensive rewrites of the script.[31]

According to Mamoulian, Maurice Ravel attended *Porgy* and called it "the best opera [*sic*] he'd ever seen." Max Reinhardt, who thought he detected the influence of Vakhtangov in Mamoulian's work, was quoted in the *New York World* calling *Porgy* one of his "great experiences in the theatre," combining "truth with the utmost stylization" and possessing "a luminousness that originates not with single stars but with the intensity of the entire ensemble." New York's critics were not less effusive in ascribing much of the play's popularity to its director. In the *World*, Alexander Woollcott wrote, "In a dozen years of first nights I have not seen in the American theater an example of more resourceful and enkindling direction. . . . in the ballet of the mourners' shadows upon the wall, *Porgy* reaches one of the most exciting climaxes I have ever seen in the theatre." For the scene in question—Robbins's funeral at the close of act one—Mamoulian's instructions read, "they are all on their feet, swaying, shuffling, clapping their hands. . . . Each

Negro 'shouts' in his own individual way, some dancing in place, others merely swaying and patting their hands. . . . the rhythm swells till the old walls seem to rock and surge into the sweep of it." Mamoulian had positioned spotlights at the footlights; as the singing—"Oh, I'll meet um in de Promus' Lan!"—gathered force, so did the ominous shadowplay on the bare back wall.[32] No less than the productions Clurman had admired in Berlin and Moscow, *Porgy* was stamped with a singular and self-evident directorial inspiration. Its sensibility was both African-American and European.

In all, Mamoulian staged twenty New York productions. In addition to *Porgy*, the most notable of these included Gershwin's *Porgy and Bess*, Turgenev's *A Month in the Country* with Nazimova, Rodgers and Hammerstein's *Oklahoma!* and *Carousel*, and, adapting Alan Paton's *Cry, the Beloved Country*, *Lost in the Stars* by Kurt Weill and Maxwell Anderson. Richard Rodgers credited Mamoulian with helping to shape the Rodgers-and-Hammerstein interpenetration of music and plot. For Weill, pursuing a musical theater ideal of his own, Mamoulian was the director of choice. He seems to have been the Gershwins' obvious and uncontested choice for *Porgy and Bess*. Memories of these Mamoulian shows have faded into history. But Mamoulian was also a Hollywood director—and it is his film musicals that most vividly document the choreographic flair that defined his impact on American theater.

MAMOULIAN BEGAN MAKING MOVIES in 1929. He settled in Hollywood two years later. The most original of his sixteen films—his personal favorite, and the one over which he exercised the most complete control—was *Love Me Tonight* of 1932. For some connoisseurs of the film musical, it marks the apex of the genre—and equally subverts it. Originally, George Cukor was to

be the director, with music by Oscar Straus and a script by Lubitsch's partner Samson Raphaelson. Mamoulian replaced Straus with Richard Rodgers and Lorenz Hart. He replaced Raphaelson with a fellow Russian, Samuel Hoffenstein. The outcome was to turn something potentially familiar into an adventure into the unknown.

Love Me Tonight begins with a "Symphony of Noises"—the daybreak sequence from *Porgy* transferred to Paris. Its rhythmic ingredients, added one at a time, include chimes, a sledgehammer, snoring, sweeping, and the pounding of two shoemakers. Eventually, a radio is turned on—and this music, the first we hear, becomes a synchronized symphonic sound track to the growing din. The tailor Maurice (Maurice Chevalier) declares this "much too loud for me" and, without breaking stride, proceeds to sing a song about it.

> *The noise is not delicious*
> *But makes you so ambitious*

He goes for a stroll, his rhyming dialogue with a series of acquaintances embedded in song. He arrives at his shop. The music stops. The first client, Emil, likes his new suit. "It's like poetry in a book. Oh, how beautiful I look." The rhyming continues. An orchestra enters. Maurice sings:

> *My face is glowing*
> *I'm energetic.*
> *The art of sewing*
> *I find poetic.*

A wonderful song, "Isn't It Romantic?", propels Emil onto the street, where a man is hailing a cab.

Emil:
Isn't it romantic?
Oh, no, I need some air.
Isn't it romantic?
Cabdriver: *At last I've got a fare!*

We are off to a railroad station. We are on a train. Our taxi passenger, it turns out, is a songwriter; he is singing and *composing* "Isn't It Romantic?" in a car full of soldiers. The soldiers join in. We see a hill. Bayonets appear. Soldiers in formation break the horizon. They are singing:

> *Isn't it the right foot?*
> *Isn't it the left!*
> *That town is full of dames.*
> *So we lift a light foot!*
> *Marching full of heft*
> *And give your right names.*

The song slows down and acquires dotted rhythms. It has become a march. A passing gypsy violinist picks up the refrain. His languorous *tempo rubato* wafts it to a balcony where Jeanette (Jeanette MacDonald) sings, in dreamy andante:

> *Isn't it romantic?*
> *Music in the night.*
> *A dream that can be heard.*
> *Isn't it romantic?*
> *That a hero might*
> *Appear and say the word.*

No sooner has she cadenced, eyes shut tight, than a ladder plunks into view. The small, elderly Count de Savignac (Charles Butterworth) climbs to the top. He is gripping a flower stem in his teeth.

"Princess? Jeanette? I just came to join you in a little chat
 before dinner."
"Count, why the ladder?"
"Oh, it's more romantic. . . . I brought my flute, hoping
 to entertain."
"No, count, not tonight."

He loses his balance and falls to the ground.

"Oh, I'll never be able to use it again."
"Oh, count, did you break your leg?"
"No, I fell flat on my flute."

And so music has clairvoyantly linked a happy-go-lucky tailor
with a lonely princess. The tailor, it transpires, has been cheated by
the princess's ne'er-do-well brother, Viscount Gilbert de Varèze
(Charles Ruggles). Maurice engages a driver to convey him to the
palace and demand the money due. The car breaks down. Suddenly,
Jeanette rides across the screen in her buggy, singing a terrific waltz
the lilt of which is disturbed by a series of instructions to her horse:

Lover,
When you find me,
Will you bind me
With your glow?
Make me cast behind me
all my WHOA!

She drives into a ditch and falls to the ground. Maurice is ready.
"Pierre, you take the horse," he instructs. "I'll take the lady." And
he does.

The breathless twenty minutes of film I have just described, a
tour de force of relentless invention, may be merely enjoyed or—
even more enjoyable—read as a series of wicked assaults on oper-
etta convention. The French soldiers militarily barking "Isn't It

Romantic?" ridicules the "Tramp! Tramp! Tramp!" of Germanic musical soldiers. The operetta-land of "Lover" is undone by Hart's horseplay (unthinkable from Rodgers's subsequent collaborator Oscar Hammerstein II) even before it runs swiftly aground. The movie's plot has less to do with romance than with sex: the count's fractured flute, the untended creature needs of Jeanette and her sister Valentine (Myrna Loy). Jeanette faints. "Can you go for a doctor?" the Viscount asks Valentine. "Certainly, bring him right in," she replies. Eyeing Jeanette's shapely physique, the doctor diagnoses: "You're not wasted away, you're just wasted." A lyric expunged by the Hays Office here instructed:

> *Bells need tinkling*
> *Flowers need sprinkling*
> *And a woman needs something like that.*[33]

The Symphony of Noises, announcing dawn, also declares the primacy of music in Mamoulian's scheme. It sets the tempo and organizes the narrative flow. Wherever he needed it, Mamoulian had Rodgers compose some, rather than rely on a subsidiary hack to extract subsidiary strains from the memorable songs. Accounts of Mamoulian using a metronome in rehearsal are tantalizingly nonspecific. But beat time to Maurice's rhymed dialogue with Emil, and you will discover the tempo of "Isn't It Romantic?" This cunning transitional device makes *Love Me Tonight* the most fluent musical ever filmed. It also sets up "Lover": *sans* transition, the prevailing andante is instantly erased by Jeanette's swiftly cantering horse and dizzy waltz, an effect irreverent and delightful. A hunting sequence begins with accelerated film; its denouement is shot in poetic slow motion. As in a sonata or symphony, varied recapitulation articulates structure: "act one," with Maurice installed at the palace, slows to a largo, then a distended orchestral reprise of the "Isn't It Romantic?" theme. Mamoulian's

approach bears comparison with Balanchine's genius for illustrating music, or Reinhardt's use of Mendelssohn in *A Midsummer Night's Dream*. Korngold, conducting from the bushes, is practicing the same art as Mamoulian with his metronome and baton. But whereas *Midsummer Night's Dream* resembles a filmed play with music, *Love Me Tonight* is unthinkable except as a movie. With his use of the zoom (rare for 1932), of superimposition, of the split screen, of fast and slow motion, Mamoulian is again pushing the envelope at every turn.

Maurice, taking part in the hunt, winds up befriending the stag. As he cheerfully feeds the animal, Jeanette severely admonishes: "There are things too fine, too sacred to be made ridiculous." Lubitsch relishes the irony inherent in a *Fledermaus* or *Merry Widow*. Mamoulian is a disruptive outsider: like Maurice (the film's only actual Frenchman; the sole commoner at the palace), he finds nothing sacred. *Love Me Tonight* cancels Lubitsch's weaknesses. The incongruous polyglot casting of *Shop Around the Corner* or *To Be or Not to Be* is in *Love Me Tonight* deliciously errant: as French aristocrats, the Americans Ruggles and Butterworth are as loony as the British C. Aubrey Smith and the Australian Robert Greig are "plausible" as duke and butler. When Lubitsch's lovers don't seem in love, his movies suffer. That Maurice and Jeanette aren't really romantic is irrelevant: *Love Me Tonight* revels in the synthetic. A Hollywood masterpiece, it combines an ideal cast with a delectable script and enduring songs. Its German-born art director, Hans Dreier, and photographer, Victor Milner, bend gracefully to Mamoulian's fancy. It shows what Paramount could do.

IF MAMOULIAN NEVER MADE another movie as cheeky or original as *Love Me Tonight*, all his early films are pictorially arresting. Conceptually, technically (with sound in its infancy), they bristle

with ambition. *Applause* (1929), coming first, abounds in novel camera and sound effects, including (though they were against New York City law) the first location shots at Penn Station and atop the Woolworth Building and Brooklyn Bridge. The film's camera eye also ruthlessly records the tawdry milieu of a fading vaudeville queen (Helen Morgen). Its directorial panache transcends a weepy story. According to Mamoulian, he encountered such resistance from his crew that he announced his intention to shoot six feet beneath the studio floor: jackhammers were to smash the concrete foundation. He stopped the workmen at the last moment. It was the twenty-nine-year-old director's lesson in who was in charge. For *City Streets* (1929), a crime drama, Mamoulian invented the voice-over. His *Dr. Jekyll and Mr. Hyde* (1931), widely regarded as the finest film version of Stevenson's tale, is less a horror story than a treatment of instinct suppressed and distorted by social convention. Ivy Pearson (Miriam Hopkins), whom Jekyll/Hyde (Fredric March) cannot resist, is sluttish and yet—a moral blasphemy—undeniably alluring; the film's sexual charge is authentic.

These are the Mamoulian movies preceding *Love Me Tonight*. Coming after was *Song of Songs* (1933), a better-than-average Marlene Dietrich vehicle, but a vehicle at war with itself and the Hays Office: its subversive sexuality is confused and unconsummated. *Queen Christina* (1933) is a better-than-average Greta Garbo film, with two of Garbo's most admired sequences: the one in which the queen caresses the room in which she has found love, and the final, hypnotic freeze on the queen's face as her ship steams toward Spain. Mamoulian directed the first with a metronome; for the second, he instructed Garbo to become "as blank as a sheet of paper. I want the writing to be done by every member of the audience." But elsewhere he succumbs to Hollywood hokum. The lifeless dialogue, insipid music, and wooden ceremony sharply contradict his earlier sophistication. No wonder Garbo wanted the film shot in Sweden.[34]

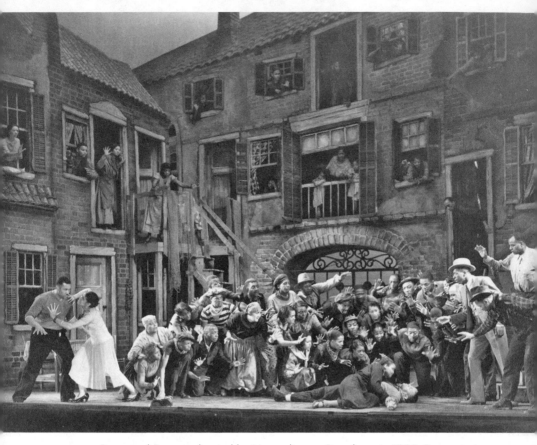

Porgy and Bess *as directed by Mamoulian on Broadway in 1935: Bess restrains Crown moments after he has murdered Robbins (act one, scene one).*

In *Becky Sharp* (1935), the first Technicolor movie, Mamoulian uses color schematically, cued to mood. In the musical *The Gay Desperado* (1936), a tenor sings Verdi's "Celeste Aida" (the whole thing) in a Mexican radio station commandeered at gunpoint by bandits in sombreros; the preceding number, with a female vocal trio, begins:

> *Lookie, lookie, lookie,*
> *Here comes Cookie.*

The residents of Catfish Row try to drown out the hurricane with their singing (act two, scene four). It is possible that no previous New York operatic production had been so elaborately choreographed.

Mamoulian was never again as divinely eccentric. *The Mark of Zorro* (1940), with Tyrone Power, is superior children's entertainment: such banalities as Zorro's tagline ("You're more radiant than a morning in June") or his execrable pronunciation of "buenas tardes" are excused. *Blood and Sand* (1941), with Powers in Spain again, is not excusable.

Mamoulian's final films are two musicals: *Summer Holiday* (1947) and *Silk Stockings* (1957). The first is a coming-of-age saga with the twenty-eight-year-old Mickey Rooney overplaying a

seventeen-year-old, the second a remake of *Ninotchka* with Cyd Charisse, a non-actress, repeating lines immortalized by Garbo. Though *Summer Holiday* is intended as a paean to small-town America, Mamoulian remains synthetic: the July 4 sequence—a fireworks war between neighboring gangs of children—suggests an outsider's perspective on odd native rites. *Silk Stockings*, in Gay Paree, is by far more comfortably situated. A year later, Samuel Goldwyn fired Mamoulian from his lavish film adaptation of *Porgy and Bess*. The ensuing legal battle left Mamoulian shaken and embittered. He next began work on Twentieth Century-Fox's *Cleopatra*, only to run afoul of seemingly all concerned. His resignation was accepted in 1961—two years before the embattled final product was ceremoniously released.

Mamoulian's Broadway career also ran aground. He never again achieved the personal recognition occasioned by *Porgy* in 1927. *Porgy and Bess* (1935) was of course talked about by everyone—but most of the talking was about Gershwin and his music. Nevertheless, the Theatre Guild gave Gershwin and Mamoulian equal billing, and reviewers lavished attention— not all of it appreciative—on Mamoulian's choreographic direction.★ He had even recapitulated, as an "occupational humoresque" mainly forgotten today, the daybreak "symphony of noises" from *Porgy,* an act three, scene one insertion preempting several pages of orchestral continuity.† In rehearsal, Gershwin's score

★It is a matter of interest that the show's conductor, Alexander Smallens, and the designer, Sergei Soudeikine, were also Russian-born.

†Mamoulian's instructions call for the "humoresque" to change meter from 4/4 to 2/4 en route to matching tempo with "Good morning, sister." The occupational sounds continue and crescendo; they end at Maria's "It's Porgy comin' home." (These details come from the annotated piano/vocal score to be found in the Mamoulian archive [carton 2 of the first Mamoulian accession from the Los Angeles vault] at the Library of Congress.) Rarely heard today, the occupational humoresque is restored on a recent Decca *Porgy and Bess* recording, conducted by John Mauceri, resurrecting "the original 1935 production version." Remarkably, the accompanying booklet pays scant attention to Mamoulian's role in that production or in the "humoresque."

was at hand at all times, dictating rhythm and accent. As production photographs confirm, the multiple windows overlooking the Catfish Row courtyard framed a series of visual vignettes of every description: when Porgy sang "I Got Plenty o' Nuttin'," chorus members shook feather dusters and bedding from above; when Crown raised his cotton hook to slay Robbins, they raised their hands as if to intervene. Shutters and doors slammed whenever white men appeared. Mamoulian's annotated piano/vocal score, preserved at the Library of Congress, remains an inspiration: where Serena launches her great lament "My Man's Gone Now," Gershwin instructs the chorus of mourners: "swaying stops." Mamoulian, canceling Gershwin, writes, "Porgy and Bess are back to back, heads together like masks. All others sway ovally." When the women join in for Serena's second verse, Mamoulian instructs that their dotted rhythms be accented. For the chorus's wailing cadential glissando, Serena "sweeps floor with R[ight] hand as she circles and rises to a standing position." With her keening exhalation ("Ahhhh!"), she falls to the floor sobbing.[35]*

"For a symphony in stage movement, with colors, actions, music, synthesized as never before in an attempted American opera, it reaches the ultimate in theatrical production," wrote George Holland in the *New York American*. John Mason Brown of the *Post* marveled that Mamoulian "becomes as much a conductor of Mr. Gershwin's music for the eyes as Alexander Smallens is for the ears. And in the scenes in which Catfish Row awakens and creates a song of its own by the mere rhythm of commencing its daily chores, or in which even two unoccupied rocking chairs begin to respond to the joyous beat of 'I Got

*In rehearsal, Mamoulian was observed finding Bess's swaying motion too vigorous. "You're the accompaniment, not the melody," he instructed. "What we want here is an obbligato." (See Irving Kolodin, "*Porgy and Bess*: American Opera in the Theatre," *Theatre Arts Monthly* 19 [1935], pp. 856–857.)

Plenty of Nuttin','' he gives final proof of how rare and how masterly is his touch." Olin Downes wrote in the *Times*: "If the Metropolitan chorus could ever put one half the action into the riot scene in the second act of 'Meistersinger' that the Negro cast put into the fight that followed the crap game it would be not merely refreshing but miraculous." The forty minutes of cuts visited on this first Broadway production—much-discussed thereafter—were largely Mamoulian's doing. They streamlined the action.* Gershwin presented Mamoulian with some rolled-up pages of the score, tied with a ribbon, as a "thank you for making me take out all that stuff in Boston." He also wrote, in a note preserved in Mamoulian's scrapbooks, "Rouben I've been thinkin' that Porgy and Bess is your masterpiece and that we must get together again—and soon." Ira wrote to Mamoulian, "Thanks to your direction never have I had so many thrills during rehearsals and even more important—after the show opened." Todd Duncan wrote, "I see you as a great moving spirit for a minority group— my group, the NEGRO RACE. Your utterances were so beautiful, so frank and bold, so prophetic. . . . You believe in us. . . . All Negroes will be grateful to you and will speak of you in terms of devotion, sincerety [sic] and reverence in the next century."[36†]

*Mamoulian did not, however, replace Gershwin's recitatives with dialogue, as Cheryl Crawford did in her commercially successful Broadway revival of 1941. Working from a prompt score, the music historian Charles Hamm explored myriad Mamoulian touches not to be found in the published score, and concluded, "Contrary to current mythology, none of the cuts and other changes made for [Mamoulian's] Theatre Guild production had the effect of making *Porgy and Bess* more like a Broadway musical comedy than an opera. Most cuts eliminate set pieces—songs or choruses—or sections thereof, not recitatives or ensemble scenes." (See Hamm, "The Theatre Guild Production of *Porgy and Bess*," *The Journal of the American Musicological Society*, 40, no.2 [Autumn 1987], p. 521.)

†Mamoulian later reminisced:

When I left New York to return to California after *Porgy and Bess* opened . . . the whole cast surprised me at Grand Central Station to

The first *Porgy and Bess* ran for 124 performances. *Oklahoma!*, eight years later, set a Broadway record: 2,248 performances at the St. James Theatre. The show's ambitious integration of music and plot made it a natural Mamoulian assignment. But it was also an embattled assignment. The usual Mamoulian cuts were not welcomed by all participants. And Mamoulian—who insisted on equal billing with Rodgers and Hammerstein and final authority over every detail of stage action—wound up in a prolonged spat with Agnes de Mille, who famously replaced the usual chorus girls with ballet dancers. Mamoulian found her work intrusive. He actually refused to relinquish the stage to her; she rehearsed downstairs. In the opinion of Richard Rodgers, Mamoulian lacked "the security of command that I had remembered from our experience in filming *Love Me Tonight*":

> His clashes with Agnes were unquestionably a result of this insecurity, and it was further apparent when he flew into a rage upon discovering that Oscar [Hammerstein] and I had been shown the costume and set designs before he'd seen them. Gradually, though, he settled down, and his brilliance in weaving together the component parts of the musical soon became obvious to us all.[37]

Joan Roberts, who played Laurey, today recalls Mamoulian as a "magician."

see me off. As I started down the ramp, I saw a red runner of carpet leading to the train. I thought I was crazy when I heard a band playing *Porgy and Bess*'s "Orphan's Band" music. They even had the goat and the cart there. After I had gotten inside, I could see nothing through the large window but a sea of black faces, pressed against the glass and looking at me with such love that, you know, I couldn't help, it, I just broke down and cried.

(See Bennett Oberstein's dissertation, *The Broadway Directing Career of Rouben Mamoulian*, Indiana University Press [1977], pp. 229–230.)

The amazing impact of the "Oklahoma!" song had to do with Mamoulian's direction. "You are farmers!" he told us. "You are pioneers!" We had this visual ideal when singing that song—that's what made it so great. Mamoulian painted a picture: "You know you belong to the land! And the land you belong to is grand!" We had to *see* the corn. We had to *experience* the wind sweeping down the plain. We had to have a mental image of every lyric we sang. And this was in wartime, of course. No American could have made us prouder to be an American.

Carousel, adapting Ferenc Molnár's *Liliom*, was a second Theatre Guild/Rodgers and Hammerstein/de Mille/Mamoulian collaboration; it ran for 890 performances beginning in 1945. Jan Clayton, a member of the original cast, later said of Mamoulian, "He handles large groups magnificently because he acknowledges no 'chorus' per se. Each performer, whose name he knows early on, is directed specifically to have a personality and purpose all his own." Molńar told Mamoulian, "You handle crowds better than any director I've ever known." An indelible Mamoulian signature—in Hollywood, on Broadway—was the prefatory tableau. In *Carousel*, he surpassed himself, setting Rodgers's *Carousel Waltz* with a real carousel and populating the crowded and rotating scene with every principal character of the drama to come. The intensity of Julie's regard for Billy as everyone else at the fair swayed to the rhythm of his carousel barker's spiel—a tragedy in the making—surged with the mounting excitement of the swirling crowd as the waltz mounted its dizzy climax. The Broadway historian Mark Grant comments, "As a microcosmic Gesamtkunstwerk, it is arguably the greatest scene in American musicals." As with *Oklahoma!*, Mamoulian's blueprint for staging *Carousel* was recorded in painstaking detail; as with *Oklahoma!*, it furnished a template regularly employed in subsequent mid-twentieth-century productions.[38]

But de Mille, not Mamoulian, directed Rodgers and Hammerstein's *Allegro* (1947), and Joshua Logan directed their *South Pacific* (1949). In fact, Mamoulian was entrusted with only five Broadway shows subsequent to *Carousel*. Of these, one was an *Oklahoma!* revival (1951), and three others ran for fewer than 150 performances. *Lost in the Stars* (1949) was his last stage production of note. A 281-performance succès d'estime, it was admired and deplored for its sophisticated deployment of flanking black and white narrative choruses, as by John Mason Brown:

> That Mr. Mamoulian has done a stunning, stylized job I have already admitted. . . . What he offers is a treatment similar to that he employed unforgettably in "Porgy and Bess." Although his Negro choruses, carefully posed against the proscenium, are effective they are far too studied to serve as equivalents for [Alan] Paton's prose. His strivings for the simple are strangely elaborate. They are not art seeming to be artless, but art at its most deliberate, hence artful.[39]*

Mamoulian's last hurrah came in 1966, when his "new version" of *Hamlet* was presented at the University of Kentucky. He attended the opening but did not direct. He had eliminated arcane language, added stage directions, turned asides into dialogue—a typical Mamoulian operation. This came nine years after his final film, *Silk Stockings*, and a decade after his final stage productions—four revivals of *Oklahoma!* and *Carousel* mounted between 1950 and 1955. He was sixty-nine years old, and would live another twenty-one years.

*In addition to *Porgy*, *Porgy and Bess*, and *Lost in the Stars*, Mamoulian's "black" shows included the shorter-lived *St. Louis Woman* (1946), with Pearl Bailey and the Nicholas brothers.

MAMOULIAN WAS A DIFFICULT man, and as he got older the difficulties grew. According to his biographer Mark Spergel, "the successes of *Oklahoma!* and *Carousel* only added to Mamoulian's sense of himself as a genius." Spergel also writes, "He was arrogant [and] irresponsible with budgetary constraints." His behavior in retirement grew aberrant.

> After more than two decades of alcoholism, Mamoulian's wife, Azadia, exhibited violent, erratic behavior. Eventually no servants could tolerate her abuse, and these two aristocrats ignored the filth in which they lived, which had accumulated through neglect. Their romantic admiration for cats blinded them to the reality of their unchecked reproduction. When Mamoulian died, the Los Angeles County Sheriff's office reported over forty cats living in the house, their valuable furniture and mementos destroyed by years of cat urination, defecation, and clawing.

Early in his career—at Eastman, in Hollywood, on Broadway—Mamoulian had exercised a productive artistic autocracy. For *Dr. Jekyll and Mr. Hyde, Love Me Tonight,* and *Song of Songs*, he was actually his own producer. Thereafter, though he continued to command with baton and whistle, his mania for control sometimes backfired. His work was criticized for excessive surface allure and deficient depth. In Spergel's opinion, he was not a gifted director of actors; "he often stated his preference for reducing dialogue to the minimum." Richard Rodgers has suggested that Mamoulian was only at his best when faced with a fresh challenge: talking pictures, musical pictures, color pictures, were for him something new; so, too, were *Porgy, Porgy and Bess*, and *Oklahoma!*[40]

That Mamoulian felt increasingly at odds with the world of culture is documented in his private papers.[41] Certainly the Hays

Office and the moral climate it embodied were factors increasingly at odds with Mamoulian. Compared to the insouciant sophistication of *Love Me Tonight, Summer Holiday* is a sanitized and prudish family entertainment in which sexuality is not titillatingly naughty, but actually wicked. In the interim the Production Code had been tightened; *Love Me Tonight* and other earlier Mamoulian films were increasingly off limits. Like those of Murnau, Lang, Renoir, and Ophuls; of Reinhardt and Brecht; of Dietrich, Garbo, and Nazimova, Mamoulian's Hollywood career may be read as a tale of shackled creativity. Moreover, the repertoire ensembles Mamoulian might have directed did not exist in America. Nor did the opera companies: had he been engaged by the Metropolitan Opera during his salad years, his fate would have been no different from that of George Balanchine's American Ballet at the Met. The interwar Met was about spectacle and voices, not (as more commonly in Europe) heightened theater. (Mamoulian's one operatic assignment, post–*Porgy and Bess*, was Schoenberg's *Die glückliche Hand*, for the relentlessly enterprising Leopold Stokowski in 1930.) In this sense, what Mamoulian lacked was a "New York City Ballet": a musical-dramatic laboratory of his own, such as he had once enjoyed in Rochester when he created *Sister Beatrice* with Martha Graham, Paul Horgan, and Otto Luening.

Of the projects mutely preserved in the Mamoulian archive of the Library of Congress, one documents an aborted sequel to the early Rochester adventures. It is of special interest less because it necessarily augured success than because it is so much more ambitious than the likes of *Blood and Sand* or *Summer Holiday*. Mamoulian was an intellectual whose friends and acquaintances included Pirandello and Prokofiev. He landed in Hollywood. He loved music. It is merely logical that he hoped to film a European operatic masterpiece—and that he chose Bizet's *Carmen*, for which, with Maxwell Anderson, he prepared a script aligned with the piano/vocal score. As Mamoulian obviously appreciated,

Carmen is not "grand opera" but something more populist: opéra comique with dialogue, but fathoming depths no other opéra comique attempts. In 1953—the year of the Mamoulian/Anderson script—*Carmen* was still typically performed with recitatives composed by Ernest Guiraud shortly after Bizet's death. The Mamoulian/Anderson *Carmen* interpolates dialogue—a practice unknown on major American stages until Leonard Bernstein (who likened *Carmen* to American musical theater) led a new production at the Met in 1972. Aspects of the script are pure Mamoulian. The Prelude is staged: Carmen gallops toward Seville, late for work at the cigarette factory (whose interior bustle juxtaposes eerily with the sinuous "fate" motif). The flute-and-harp Entr'acte to act three is repositioned and made to accompany the death of Don José's mother (in pantomime). The ending is changed: "The camera holds the three figures, black [Don José], white [Carmen], and red [Escamillo]. Then it slowly moves into a large close-up of Carmen's face framed by red roses." Even the music is altered: the film finishes quietly with the fate theme, as presented in the Prelude against tremolo strings. In the smuggler's retreat, Carmen performs a "castanet soliloquy" of indecision. What is the translation like? Here is the beginning of José's Flower Song:

> *Carmen, since you threw me this flower*
> *You've filled my life, filled every hour!*
> *There was no light in any day*
> *With you away, with you away!*
> *Those long prison hours I spent for you*
> *Were made bright by this flower you threw*
> *Its petals dried, its odor died,*
> *But all my world it built anew!*

The Mamoulian/Anderson *Carmen* was obviously a labor of love. The archive is packed with *Carmen* materials, including a

literal translation of the Henri Meilhac/Ludovic Halévy libretto undertaken by Mamoulian himself. A leather-bound final typescript, in black (song) and red (dialogue), was presented to Mamoulian by his wife as a sixty-sixth birthday present.[42] Among the various *Carmen* scores belonging to Mamoulian is a clipping from the *New York Times*: Olin Downes commenting unfavorably on a new *Carmen* at the Met, staged by Tyrone Guthrie[43]—one of several eminent stage directors (the others included Peter Brook, Garson Kanin, and Margaret Webster) introduced to the house by Rudolf Bing between 1950 and 1954. More than Guthrie, Mamoulian was an obvious candidate for Bing's reformist agenda. And Bing tried to get him. Mamoulian said no. He had just embarked on a *Huckleberry Finn* with Kurt Weill and Maxwell Anderson. Did he assume that he could not rehearse at the Met as he had once rehearsed *Porgy and Bess*? Had he run out of steam? Was his ultimate American fate the same as Jeanette's in *Love Me Tonight*—to be "wasted"?★

In truth, the *Carmen* script is for the most part disappointingly conventional—nothing like the brave Hollywood Mamoulian of the 1930s. But then Hollywood had changed: formulaic studio styles had usurped onetime directorial prerogatives. In sum, the Mamoulian odyssey suggests a traveler's restlessness or fatigue. Schooled in experimental Russian theater after World War I—in a stage world of daring theatricality, ever in quest of the new—he was an impatient innovator for whom the New World meant new opportunities, until those opportunities, or Mamoulian himself, dried up.

★Bing was aware of Mamoulian's *Carmen* film project and wanted Mamoulian to use his Met Carmen, Risë Stevens. Mamoulian (correctly) wanted a more demonic singing actress. No evidence has come to light that Mamoulian found a Carmen for his movie.

Boris Aronson with the set of Follies *under construction (1971).*

THE ODYSSEY OF BORIS Aronson—our final twentieth-century immigrant impacting on the American theater—reverses Mamoulian's decline into obscurity. If Aronson's was a complete American career, it was largely because he lived and worked long enough to allow America to catch up with the seismic scenic innovations in which he was trained.

Aronson was born in Kiev around 1900 (the year is uncertain). His father, a cultivated man, was the grand rabbi. He was permitted to attend art school and was exposed to Kiev's Jewish avant-garde—a group including such soon-to-be-notable artists as El Lissitzky, Iosif Chaikov, and Alexandr Tyshler. He made his way to Moscow and—as would Harold Clurman, who later be-

came one of Aronson's close friends and colleagues in New York—absorbed the influence of Meyerhold's brazen unified productions, in which the designer was a coconspirator in overthrowing Stanislavsky's ideals of verisimilitude. A greater influence was the Moscow Kamerny Theatre founded in 1914 by Alexander Tairov: a comparably iconoclastic enterprise minus Meyerhold's propagandistic "communal" ideology. Tairov's actors were trained in singing, dancing, mime, and acrobatics. To liberate such performers, Tairov favored settings unencumbered by scenery. He also preferred a stage floor of broken surfaces because "an even floor is expressionless." Each play demanded its own scenic solution: "freely created forms which come out of the rhythms of the performance."[44]

Tairov's principal designer, Alexandra Exter, became Aronson's mentor. She was a pioneering Constructivist, schooled in Paris. For Tairov's legendary *Romeo and Juliet* of 1920, Aronson assisted Exter in the execution of costume and stage models. It was of this *Romeo* that the important American designer Donald Oenslager later wrote: "For the first time in any theatre, the stage's total cubic volume was divided vertically into abstract playing areas that did not mean to create any life-like illusion of the Capulets' Great Hall or of Juliet's tomb."[45] In 1922, Aronson moved on to Berlin, where he studied painting and wrote (in Russian) successful books about contemporary Jewish graphic art and about his Moscow friend Marc Chagall. He arrived in New York in 1923 and found employment in the Yiddish theater. He next aspired to work on Broadway, where he mainly discovered himself out of place, to one degree or another, until the 1960s—by which time Brecht's notion of epic theater, and other delayed European influences, had percolated uptown from smaller houses and subverted the reigning naturalist aesthetic. His designs for *Fiddler on the Roof*, in 1964, reconnected with the protean world of Russian and Yiddish theater he had known half a century before. There

followed a series of collaborations with Harold Prince and Stephen Sondheim echoing the Meyerhold ideal that "artists must throw down the brush and compass and lay hold of the ax and hammer for the shaping of the new stage." He died in New York in 1980 at the peak of his fame and influence as a preeminent force in American theater design.

Was Aronson "Russian"? "Jewish"? "American"? According to his widow, Lisa (herself the daughter of the immigrant conductor Heinrich Jalowetz), "Boris would call himself 'European.'"[46] His is yet another instance of a Russian immigrant whose multifarious moorings and early experiences flexed the cultural vocabulary he brought to the United States. And as with Balanchine, Stravinsky, Koussevitzky, Mamoulian, and Nazimova, Aronson's Russian schooling—his schooling in the largest sense—did not engender an aesthetics of continuity. In Kiev, in 1918, he had participated in the construction of artificial facades for the mounting of monumental slogans: "Religion is the opiate of the people," "Long live the Great Proletarian Revolution." Amidst a turmoil of social and political currents, the artist's place was to press for change. Like Balanchine, Koussevitzky, and Stravinsky in America, Aronson influentially embodied conscious strategies of renewal. He was fond of saying, "I grew up at a time of revolt."

Even before the revolution, the Moscow theater embraced a brave range of styles and stylists. Freedom of stage design followed suit. In prewar Paris, Exter's friends had included Picasso and Braque. She absorbed Impressionism, Fauvism, Futurism, cubism. In Russia, she instructed her pupils in painting, book illustration, theatrical design. She had them work in the various styles she had mastered—often on the same day. Her own example, with Tairov, was that of a collaborative creator, not a submissive craftsman. Remembering the Constructivism of Meyerhold and Tairov, Aronson wrote in 1926:

In the naturalistic theatre, there was only one method of stage design; a set always had to be an exact copy of real life. Only on the basis of *external* signs, of differing combinations of details from real life, could one production be distinguished from another. Now, however, the intention is, in principle, to bring out the inner essence of each dramatic work. . . . Instead of one-dimensional painting, which had no organic connection with the stage, [Constructivism] constructed three-dimensional stage sets made up of several levels, platforms, stairs, and ladders, which allow the actor to move about freely and to employ diverse means of expressing his emotions effectively.[47]

In Berlin, where his roommates included Eli Lissitzky and Vladimir Tatlin, Aronson discovered additional aesthetic options. But he was determined to adventure to America. He already sensed Soviet tendencies toward gray masses of people "wearing lapel buttons proclaiming their partisanship," and toward "home-sweet-home calendar art."[48] Just as Tatlin envisioned a steel skyscraper taller than New York's Woolworth Building, Aronson fantasized a new world of towering spires and technological marvels; Moscow, by comparison, barely had electricity. Arriving in Manhattan with "some drawings, two books, a pair of socks, a membership in a union of German artists, paintbrushes, [and] little money,"[49] he swiftly discovered that on Broadway even Stanislavsky was new. Total theater and repertoire theater, as practiced in Europe, were unknown. Equally absent was the consolidated avant-garde that produced a Meyerhold or Tairov, Brecht or Jessner.

But American theater was not without ferment in the field of scenic design. A previous immigrant, Joseph Urban (1872–1933), had introduced a painterly aesthetic of textured pastel surfaces susceptible to exquisite lighting effects. A significant Austrian artist, architect, and designer who relocated in 1911 to superintend

staging for the Boston Opera, Urban influentially created a fluid fairy-tale world for Debussy's *Pelléas et Mélisande*. Later, in New York, he designed more than fifty Metropolitan Opera productions and was as important to the Ziegfeld Follies as the showgirls and comedians. Meanwhile, Robert Edmond Jones, inspired by such European visionaries as Reinhardt, Gordon Craig, and Adolphe Appia, launched an American "new stagecraft" overthrowing the painstakingly detailed three-dimensional sets pioneered by David Belasco. Urban, steeped in the visual world of Klimt and Schiele, was no agent of cultural exchange; like Korngold in Hollywood, he imported Vienna. Jones, with Lee Simonson and Norman Bel Geddes, signified the advent of a distinctive American stage art contradicting the clutter of realism and organic to the work at hand. But Jones was not the dominant mainstream influence Belasco had been.

And so Aronson, like Nazimova before him, gravitated toward kindred spirits in New York's Yiddish theater, beginning with the experimental Yiddish houses of the upper Bronx. His assignments included Ossip Dynov's comedy *The Bronx Express* (1925). Rudolf Schildkraut, who in Berlin had been a leading member of Max Reinhardt's company, starred as a buttonmaker who falls asleep on the subway and dreams of visiting a Florida resort and other places of escape. All of Aronson's sets retained the overhead hanging straps and Wrigley's Spearmint ad of the subway car; at any moment, the buttonmaker could wake up and grab hold.

Next, from 1925 to 1929, Aronson found employment at the mecca of the Yiddish stage: Maurice Schwartz's Yiddish Art Theater on Second Avenue. Like his predecessor Jacob Adler, whose performances had so instructed his daughter Stella's future husband Harold Clurman, Schwartz was a bravura presence in both Yiddish and classical repertoire. He gave Shakespeare, Molière, Chekhov, Shaw, Gorky, Schnitzler. Aronson (and many others) would re-

member him as a scheming virtuoso in character parts and an inde-
scribable ham in heroic roles. When in 1926 Schwartz moved into a
new, more lavish house, he commissioned Aronson to do sets and
costumes for Abraham Goldfaden's *Tenth Commandment*. There were
twenty-five scene changes and 360 costumes, as well as a ballet in
heaven choreographed by Michel Fokine. Schwartz played eight
roles, including a woman. Good and evil angels led the characters
through a gauntlet of temptations. On opening night, the first act
lasted past 2:30 a.m. John Mason Brown, in *Theater Arts Monthly*,
called the show "long-winded." He also wrote of the play that

> the helter-skelter of the method, its mad excesses, its tender
> quiet moments, and its gay seconds of complete confusion,
> suit it admirably to the particular kind of production it re-
> ceives at the hands of M. Schwartz and his actors. These
> players are masters of a strident stylization, and can give to
> this Yiddish *Faust* something of the gusto that such a direc-
> tor as Jessner can give to Goethe's. The stylization . . . has a
> vast energy, a blatant, exciting kind of underscoring that is
> more familiar to Berlin than Broadway. Its writhing devils
> under green lights, its trapdoors, its constant use of actors
> rushing over many perilous levels and its costumed stage-
> hands, shifting scenery in full view of the audience, give it
> that vivid, deep-dyed . . . theatricality, in which the Ger-
> man theater abounds, and which is sadly missing in our
> quiet, everyday theater of parlors and kitchens. . . . The set-
> tings and costumes are the bravest experiments in scenic
> design that the present season has disclosed. [Aronson's]
> endless costumes are thoroughly thought out in terms of
> individual detail as well as being tonal factors in the large
> ensembles. By employing not one, but many constructivist
> settings, which range from heaven to hell, he conditions
> the style of the entire production, and brings a welcome
> vigor and originality to our theater.[50]

Aronson's most famous set was a fuming vision of hell within a human brain. A head in profile disclosed a turbulent matrix of ladders that twenty actors would repeatedly mount, sliding down a fire pole. Heaven resembled an opera house with private boxes. A subsequent Aronson production for Schwartz, of Sholem Aleichem's *Stempenyu the Fiddler* (1929), used a revolving stage with scenery painted on two sides. In Aronson's opinion, it achieved a singular organic unity of acting, direction, and design.

Working in nonunion theaters for a Schildkraut or Schwartz, setting plays that disdained naturalism, Aronson was not unnoticed by Broadway. Schwartz, Brown, and Brooks Atkinson of the *New York Times* were three of nine eminent sponsors who organized a 1927 exhibit of Aronson's Yiddish theater designs in a Park Avenue gallery. In a catalogue essay, Brown wrote that Aronson had "seen behind the ugliness of those gaunt steel ribs which pierce Manhattan's ever-changing skyline and has understood the strength and restlessness and power that they represent. He has been able to see them as symbols of the age." But others, including Yiddish critics, found Aronson's work obtrusive. Lee Simonson, writing in the *Nation*, called Aronson's style "an exotic and transplanted thing." Simonson continued, prophetically:

> We do not breed the Constructivist director as yet because we so rarely need him, nor are symbolic settings often relevant to the work of our most creative playwrights. . . . Once we know ourselves, creative American playwrights will begin to ask what we can make of ourselves, will search for a synthesis of American life, and struggle to find symbols for it. In the meanwhile, I hope Aronson will be able to divest himself sufficiently of his Russian dogmas so that his undoubted talents can be more readily used to express the current realities of the American stage.[51]

Aronson did not wait for the Yiddish theater to die, along with the "exotic and transplanted" neighborhoods it embodied. Like Schildkraut and his son Joseph, like Nazimova, like such Broadway-destined Yiddish stalwarts as Paul Muni, Jacob Ben-Mot, and Joseph Buloff, he set his sights on Broadway.

THE YIDDISH SHOWS ARONSON designed were more Russian than American. But Aronson was schooled in invention, not nostalgia. He itched to see America and to use it. "The kinds of ugliness Staten Island is famous for" excited him.[52]

Beginning in 1935, Aronson found frequent employment with the Group Theatre, and Harold Clurman—who upon encountering the Jewish Art Theatre had resolved that "if I shall ever get to direct a play myself I would have Aronson design it"—became the director he worked with most. Aronson also designed productions for Lee Strasberg and for Elia Kazan. He designed the first stagings of Clifford Odets's *Awake and Sing* (1935), Tennessee Williams's *Rose Tattoo* (1951), Arthur Miller's *Crucible* (1953) and *A View from the Bridge* (1955), William Inge's *Bus Stop* (1955), and the Frances Goodrich/Albert Hackett adaptation of *The Diary of Anne Frank* (1955). For the first of these, a tale of Depression hardship, his sets documented the furnishings and dimensions of a middle-class Bronx apartment. But Kazan additionally observed: "The set had a quality that a painting has—a glow that caught the mood of a remembered apartment, not just an apartment. It had to do with subtle blending of colors. It was the shabbiest of locales, but like a painter, Aronson placed one color next to another—delicate roses and blues—so they all went together in a way that was magical."[53]

More than his friend Clurman, Aronson was a highbrow who was equally lowbrow; his enthusiasms included Charlie Chaplin and the circus. Of his many other early assignments, *Three Men on*

a Horse (1935) was a successful farce, directed by George Abbott, about a greeting-card writer who could pick winners at the track so long as he was sitting on a certain bus seat. To research the Long Island locale, Aronson studied the "exquisite banalities" of an American invention: the five-and-ten-cent store. Selecting a shopper who could have inhabited the play, he bought everything she did, including a cuckoo clock and musical cake plate that played "Happy Birthday." For Abbott, he created a sleazy barroom and cheesy living room, with the latter painted "the brown of a cockroach"—the ugliest color he could think of.[54]

Aside from *Three Men*, the most successful show that Aronson designed during his first Broadway decade was *Cabin in the Sky* (1940). Unlike the vast majority of his assignments, this was not a naturalistic play, but a musical folk fantasy in which a ne'er-do-well scamp was suavely courted by henchmen of Lucifer and God. It was also exotic: all the players were black, and so was the southern locale. *Cabin* is of special interest in this account because, remarkably, the creative team was immigrant. George Balanchine both directed and choreographed. The composer, also Russian-born, was Vernon Duke, whom we have briefly encountered discovering that the composer was the Forgotten Man in American classical music. Born Vladimir Dukelsky, Duke (1903–1969) was a fascinating, if marginal, exemplar of cultural exchange. His homes included Kiev, Constantinople, London, Paris, New York, and, ultimately, southern California. An early success for Diaghilev's Ballets Russes, *Zephyr et Flore* (1925), foretold an important career that never completely materialized. He found American music, compared to music in France, split between highbrow and popular taste; he wanted to serve both. His closest friends were Sergey Prokofiev and George Gershwin. His concert output, as Dukelsky, included symphonies and concertos championed by Koussevitzky in Boston. His Broadway/Hollywood output, as Vernon Duke (a pseudonym proposed by Gershwin), included "April in Paris." His

concert style evinced Prokofiev and Stravinsky. His best songs were insouciant and tangy. Upon Gershwin's death, he became composer for *The Goldwyn Follies* of 1938, and so created the little-noticed music for the much-noticed water nymph ballet of Zorina and Balanchine.

Like Aronson, neither Balanchine nor Duke had even visited the American South before undertaking *Cabin in the Sky*. In his breezy memoirs, Duke recounts how Balanchine liked the book, by Lynn Root, even though he could not understand it "too well." He asked Duke to "decipher it." Duke liked it, too. "Much as I admired the Negro race and its musical gifts, I didn't think myself sufficiently attuned to Negro folklore. Yet . . . I couldn't tear myself away." Duke signed on and proceeded to undertake remedial field research in Virginia Beach, where he gorged on fried chicken and Smithfield ham. Aronson climbed on board and retired to Richmond, where he visited the shacks and hotel rooms of poor blacks. He discovered decoration, witting or not, in old newspapers used for insulation, and old wallpaper samples arranged in collage. He found "nature imitating Utrillo" in the play of daylight, black skin, and tropical vegetation. His sets, with their vivid hues, painterly surfaces, and forced perspectives, aspired to capture "the flavor of poverty mixed with sun, misery, and imagination." As he had for the Yiddish stage, he creatively envisioned angels and devils, heaven and hell; Lucifer's air-conditioned office was the inside of a refrigerator.[55]

The show's headliner was Ethel Waters. Todd Duncan played the Lawd's General. Duke opined that "for all-round musical and dancing ability in the theater, Negroes are immeasurably superior to their white counterparts; they catch on more quickly, are born actors and throw themselves into their work with extraordinary relish." But the black contingent found the Russian contingent bewildering. According to Aronson, the Russians even had "conflicting opinions about Tolstoy." The *New York Telegram* reported

a lingual ruckus approaching bedlam. At least half a dozen times at each rehearsal . . . , Ethel Waters, Todd Duncan, Rex Ingram, J. Rosamund Johnson, Katherine Dunham and her dancers have paused in puzzlement while the argumentative trio of Muscovites [sic] disputed a difference of opinion in their native tongue. The Russian vowels and consonants fly as thick as borsht. After ten minutes of such alien harangue and retort, Miss Waters asks what it is all about. "George," Duke generally interprets, "just said the answer is 'yes!'" and then rehearsals are resumed under a flag of truce until the next vocal flare-up. So, yesterday, one of the "Cabin in the Sky" players with a gag mind went out and had one of those phony headlines made up which he posted near the stage door. The streamer–type screams "DUKE DENIES KNOWING BALANCHINE. NEVER HEARD OF BORIS EITHER."[56]

A more serious conflict arose over the choreography. Balanchine insisted on ballet elements (Duke called Dunham's dances "sinuous, sex-laden writhing"). The producers expected generic hoofing and tapping. Balanchine was delivered an ultimatum. Duke was there:

[Martin] Beck, . . . banged the table with his fist . . . to thunder: "To make it short, Mr. Ball-an'-chain . . . , you either fix these silly dances of yours, or get out of my theater!" "No!" George shouted. . . . It's *my* theater—I am director! You get out!" The tableau that ensued resembled the Moscow Art staging of the final scene of Gogol's *Inspector General*; the producers opened their mouths, but words refused to come out, and we, the three mad Russians, walked out dramatically, heads high and nostrils flaring. Work was resumed with no tap or hoofing to mar our art.[57]

ARTISTS IN EXILE

As there were no funds for an out-of-town tryout, *Cabin* opened "cold" at the Martin Beck Theatre. Duke's best number, "Taking a Chance on Love," stopped the show. Brooks Atkinson wrote in the *Times*:

> "Cabin in the Sky" ranks with the best work on the American musical stage. . . . Musical shows seldom acquire dancing such as [Balanchine] has directed here—motion in many lines set on fire with excitement . . . he has released [the dancers] from the bondage of hack dancing and ugliness. As a matter of fact, the joy of creative work shines out of all the corners of Mr. Root's fantastic cabin. Vernon Duke has written racy music in several veins from song-hits to boogie-woogie orgies. Mr. [John] Latouche has composed crisp and jaunty lyrics. Boris Aronson has done his finest work. Put "Cabin in the Sky" down as a labor of love.[58]

The New York run was modest—156 performances—but George Jean Nathan named *Cabin* the best musical show of the season. It triumped on the road. A successful 1943 film version, also with Waters, was directed by Vincente Minnelli.

Cabin in the Sky was one of Aronson's most personal Broadway efforts of the 1930s and '40s. It was by far Duke's most successful musical. Though his "direction" of performers like Waters was not of the Reinhardt or Mamoulian variety, it was Balanchine's most concerted achievement on Broadway or in Hollywood; he even backed it with several thousand dollars—his last savings. The collaboration was serendipitous not only for the common fascination of three Russians with the folkways of African-Americans; as Aronson was grounded in total theater via Meyerhold and Tairov, so were Balanchine and Duke via Diaghilev (whose designers had included Bakst, Benois, Goncharova, Picasso, and Roerich).

Aronson designed three additional Vernon Duke shows, the most ambitious of which, *Sadie Thompson* (1944), was directed by Rouben Mamoulian. Crossing paths with other eminent immigrants, he designed for Max Reinhardt on Broadway (*The Merchant of Yonkers*, 1938) and also Otto Preminger (*This Is Goggle*, 1959). He designed *Love Life* (1948), with songs by Kurt Weill. *Cabin* notwithstanding, these and other of his Broadway assignments did not remotely connect to the stage aesthetic of Tairov or the milieu of Maurice Schwartz.

Aronson himself remained an odd fit for the Broadway world. Balanchine and Duke, Reinhardt and Mamoulian, were cosmopolites. Of Aronson in his dingy Central Park West studio, Kazan quipped that he "looked as if he had just stepped from an Assyrian frieze and wore a twentieth century coat and trousers under protest." Aronson's heavy Semitic features, his black glasses, his sad, absorbent eyes and wrinkled brow, his balding pate and grizzled beard, created an unfinished Old World impression. His speech, with its soft Jewish intonation, was unhurried and original. According to Kazan, he once "talked 3,000 miles straight" crossing the continent by car. Unlike his American colleagues Robert Edmond Jones and Jo Mielziner,★ he was a painter and sculptor with a second life in the theater, whose studio art was a necessary outlet for experimentation and self-expression. He stayed a bohemian, an intellectual with a weakness for Sears, Roebuck. Jones and Mielziner favored clean lines and lucid methods: a sketch, a floor plan, a set. Aronson had no system. The designer Ming Cho Lee, who apprenticed with Aronson, observed

> He had a very personal reaction to a play. . . . He was not
> well organized. Work piled up; it created a certain ten-

★Like Aronson, Mielziner (1901–1975) was born abroad—in Paris. Both his parents, however, were American, and Mielziner himself lived in the United States from the age of eight.

ARTISTS IN EXILE

sion in the studio. . . . He'd do many rough expressive sketches that would lead to a model. Often, at that time, directors would commit themselves to a set sketch without bothering with a model, if the sketch was beautiful. We didn't do such "presentations"—Boris wouldn't say that word; his sets were always "in work." Even when the set was in the shop [being built], he was always there, working. He'd do the gorgeous sketch afterwards for exhibition. . . . Without Boris, I don't think I would have a sense about the range and possibility of theatre expression. I learned that, in theatrical collaboration, a director must talk emotionally about the work—not the design of it—and *that* is what you reflect in your design.

Aronson wanted to be "inside" his material. He considered the theater anathema to a cinematic naturalism "without poetry, without grandeur." He said, "I'm lost when I get a script. . . . I start like I never did anything." Kazan called him "the king of the unexpected."[59]

Working for Broadway, Aronson was known to reject plays he did not like, or stages he felt he could not master. In 1939 he was fired from the pre–New York run of William Saroyan's *Time of Your Life*; writing for *Theatre Arts Magazine* a year later, he complained that feverishly commercial Broadway conditions discouraged both repertory theater and innovation. Even working for the Group Theatre, which did not rush to production or bow to the box office, he felt estranged by the reverence for Stanislavsky-style realism, which demoted scenic design as a creative component. When in 1959 he was engaged by the Stratford Shakespeare Theatre in England to design a *Coriolanus* for Peter Hall with Laurence Olivier in the title role, he found himself "flabbergasted and bewildered" to be working "without the pressures, without the deadlines" of the Broadway assembly line.[60]

Aronson's career coasted during much of the 1940s and 1950s.

Kazan's important productions of *A Streetcar Named Desire* and *Death of a Salesman* went to Mielziner. Aronson complained of a New York surfeit of living room plays, "plays about relatives" that forfeited the theater's opportunities and responsibilities. "Boris was a gigantic talent who was really poor economically," remembers Oliver Smith, who designed the blockbuster musicals Aronson could not get. "He had a sour view of the theatre because he was not appreciated." Ming Cho Lee calls 1959–1960, when he worked under Aronson, "his low period—not creatively, but in terms of success, where he stood among the theatre community": Aronson's methods "were so far ahead of what other people were doing that they didn't know what he was doing."[61]

IN 1967, WRITING FOR the *World Journal Tribune*, Harold Clurman delivered an encomium beginning, "Unless you are a theater buff or a professional you have probably never heard of Boris Aronson."

> Certain scene designers are merely decorators. They make pleasing arrangements of fabrics, furniture and carpentry. An artist in scene design is one who adds to a play's value as a form of expression. . . . I know of no designer since [Robert Edmond] Jones who more unequivocally deserves the title of master visual artist of the stage than Boris Aronson. . . .
>
> One reason for the comparative public neglect of Aronson's work may be ascribed to the fact that it has no immediately identifiable mechanical or esthetic trademark. Most designers' appeal lies in their setting's prettiness: a candy box or calendar picture sweetness. They remind one of travel ads intended to cajole us with the prospect of a dreamy trip. Aronson's sets rarely reach for glamor. They are not fashionable.

Searching for a general characterization, Clurman proposed that "Aronson's touch is turbulently dramatic." Versus the "pristine, fragrant asceticism" of Jones, Aronson "sets before us the clash of elements in contemporary society."[62] Clurman might have added that the turbulence of Aronson's designs correlated with the unmanicured presence and personality of Aronson the man—and that these qualities, rooted in his formative years abroad, had become more rather than less pronounced in his recent work. In fact, Aronson had in the past decade contributed highly conspicuously to four conspicuous shows.

Shortly after Elia Kazan's production of William Inge's *Dark at the Top of the Stairs* opened in 1957, Aronson told Kazan, "Look, for the rest of your life you can do that type of show. . . . But you have to do something more daring, much more satisfying. Something which also has a good chance of failing." Not long after, Kazan agreed to direct Archibald MacLeish's *J.B.*, which transplanted the story of Job to present-day America. The setting was "a traveling circus which has been on the roads of the world for a long time." Two out-of-work actors, Nickles and old Mr. Zuss, sell balloons and popcorn. One night, they don the masks of God and Satan and improvise their own version of Job's sufferings. The eschatological grandeur of the concept resonated with the dueling angels and devils of Yiddish yesteryears. Capitalizing on Kazan's authority, Aronson, as designer, insisted that the house curtain of the ANTA Theatre be removed and the proscenium painted black—practices unknown on Broadway in 1958—so that "people could walk in as they walk into a circus." The play began with Nickles (Christopher Plummer) and Zuss (Raymond Massey) plying the aisles with trays and balloons while two roustabouts raised a tent enveloping the stage. The collapse of the tent at the play's close revealed a void. The stark, stylized props supported metaphysical impressions. Kenneth Tynan wrote of *J.B.*: "Boris Aronson's setting, a desolate,

cavernous circus tent, is one of the most majestic I can remember; it prepared the heart for events of towering grandeur and cosmic repercussion." MacLeish wrote to Aronson: "You made visible the peculiar tone of the play—half tragic, half ironic—so that no audience could miss it." Kazan wrote to Aronson: "This show, more than any other I've done, requires the designer and director to work hand in hand. It's almost as though the line of demarcation between your work and mine was not clearly marked at certain points."[63]

For the musical *Do Re Mi* (1960), about music-business hustlers, Aronson fixed on the opalescent imagery of the American jukebox—the music and flashing lights of which possessed "a grotesque vulgarity that just sends me." *J.B.* and *Do Re Mi* were modest successes; *Fiddler on the Roof* (1964) was a monster success logging 3,242 performances. Aronson pursued this assignment with a will: the Sholem Aleichem tales feeding the script, the famous Chagall image inspiring the title, were home terrain. Keying on painterly textures and colors, on Chagall's dreamlike asymmetrical draftsmanship, Aronson fashioned vivid but concise sets idealizing the Russian ghetto village. The elusive total-theater marriage of tone and content, surface and affect, was clinched. For *Cabaret* (1966), appropriating Christopher Isherwood's *Berlin Stories*, Aronson was able to mine his early exposure to avant-garde total theater: to the Berlin of Brecht and Jessner. The audience entered the Broadhurst Theatre to discover itself in a huge onstage mirror. The opening "curtain" was a blackout and drumroll, during which a red CABARET sign lit one letter at a time. When Joel Grey entered to sing "Wilkommen," the mirror rose to become a reflecting ceiling under which a garish netherworld of cabaret types sang and danced.

The producer for *Fiddler* was Harold Prince. Prince also directed and coproduced *Cabaret*. Though nearly thirty years Aronson's junior, he was already an old Broadway hand. Initially a

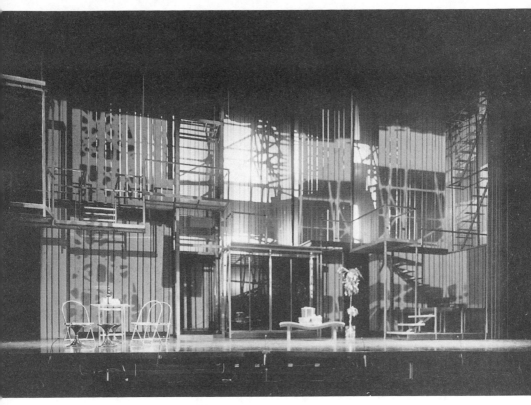

Aronson's "urban jungle gym" for Company (1970) recalled the Constructivists' vision of urban heights and planes.

protégé of George Abbott, he set a new course when during the planning stages of *Cabaret* he visited the Moscow Taganka Theatre and absorbed Meyerhold's total-theater influence at the source. He now aspired to utilize distinctive, adaptable spaces tailored to a particular show. This was the opportunity for which Aronson had long been waiting. *Cabaret* used no curtain and no doors. There were few props or chairs. The set changes were unconcealed. Lighting was used to define the playing spaces.

In 1970, Prince directed and Aronson designed a new musical by Stephen Sondheim: *Company*. This was something newer than before—a non-narrative "concept musical." The concept

was marriage, as ambivalently pursued by affluent New Yorkers. The "story" was a series of thematically related vignettes. The setting was a series of Manhattan apartments, with the city as a background metaphor for melee and anomie. The songs were sometimes parentheses or external commentaries: an oblique, Brechtian element. The musical idiom was a melange of Broadway and nightclub styles. In its entirety, the show was too elliptical and abstract to permit anything like a standard stage design.

Working with Prince early in the gestational cycle, Aronson keyed on the imagery of glass cubes stacked and restacked. His eventual unit set, likened to an "urban jungle gym," was a flexible vertical construction (diagonals were disallowed) of platforms and elevators, supplemented by 600 photographic slides. Its connotations ranged from intimate living spaces to spaces of confinement to a multifarious but antiseptic cityscape. Aronson said that it "gave my feeling of how the city affects people." He also said, "I wanted to give the feeling of total mechanization." His perspective partook of the Old World outsider for whom Manhattan, "constantly demolishing and rebuilding itself," lacked the "patina" of a European metropolis. It also paradoxically recalled the Constructivists' enraptured vision of urban planes and heights, in revolt against Stanislavsky's detailed onstage living rooms. In Lisa Aronson's view, *Company* was the favorite project of her husband's forty-four-year Broadway career.[64]

Aronson was the designer for three more Prince/Sondheim musicals: *Follies* (1971), *A Little Night Music* (1973), and *Pacific Overtures* (1976). The very topic of the last of these was cultural exchange: the westernization of Japan, beginning with Commodore Perry's uninvited visit of 1853. The show's ingredients included haiku and elements of Noh and Kabuki theater. Story and dialogue were spare: an exercise in controlled style. Acting merged

ARTISTS IN EXILE

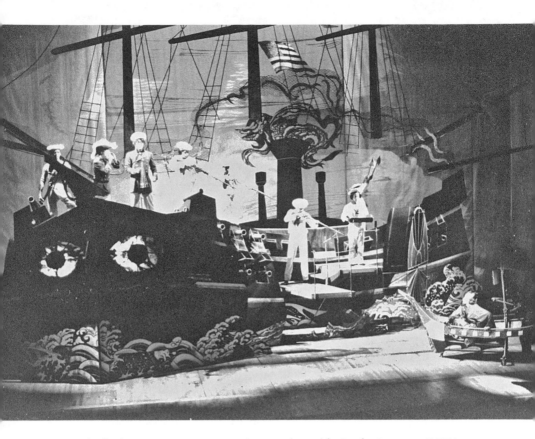

The fluid Japanese stage pictures Aronson devised for Pacific Overtures (1976) included a rendering of Commodore Matthew Perry's warship; walked on in sections by stagehands, it uncurled as it moved toward the audience. The little Japanese skiff (foreground right) was set on wheels.

with dancing, speech with song. Sondheim's pared-down score sampled fragrant Asian timbres and scales—as well as ersatz Offenbach, and Gilbert and Sullivan, for the French and British colonialists. Aronson's contribution was a seamless fundamental fit, a marvel of concision and elegance. The fluidity of his stage pictures was partly achieved with moving screens—an explicit Japanese reference. The pictures themselves were "sketches," as in Asian prints or watercolors. A "house" might be a lowered roof hovering in midair, plus "walls" moved from the wings by stagehands.

In countless ways, explicit or subliminal, he invoked Japanese tropes and an aesthetic—call it "postmodern"—privileging the synthetic, eclectic, and polymorphous. Aronson was awarded his sixth and final Tony Award for scenic design.

Coming last was a 1976 coda: fresh pastel settings for *The Nutcracker,* as produced by American Ballet Theatre. The choreographer and principal dancer was an eminent Russian newcomer: Mikhail Baryshnikov. The work itself owed its phenomenal American popularity to—a closing of the circle— George Balanchine, for whom Aronson had designed and Baryshnikov would dance, and whose 1954 refashioning of Tchaikovsky's ballet for American audiences remains unsurpassed—except for its decor.

WITH THE PRINCE/SONDHEIM MUSICALS, the transformation of the director from stage manager to conceptual visionary achieved a Broadway vogue many decades after Stanislavsky and Meyerhold, Brecht and Jessner, after the truncated American careers of Murnau and Lang, Reinhardt and Mamoulian. Doubtless, *Company, Follies,* and *Pacific Overtures* signify a pinnacle in Boris Aronson's career as a collaborative scenic artist. Prince, in an 1989 interview, called Aronson's designs the "motor" of these shows; "we would talk six months before he put pen to paper."[65] But there are some who find Sondheim more clever than acute, an ocean removed from the Berlin bite of the landmark total-theater musical Aronson never got to design: *The Threepenny Opera.* Nor did grand opera invite total-theater production during Aronson's United States decades; like Mamoulian, he was no longer around when supertitles transformed *Don Giovanni, Carmen,* and *Die Walküre* into full-fledged theatrical experiences. Otto Klemperer, at Berlin's Kroll Opera, had engaged László

Moholy-Nagy and Ewald Dülberg to create radically new settings for old operas. After World War II, Wieland Wagner at Bayreuth and Walter Felsenstein at East Berlin's Komische Opera were dominant forces in recasting opera production; ingenious scenic design was organic to their directorial genius. Such influential opera directors as Götz Friedrich, Harry Kupfer, and Patrice Chéreau followed impressively in their wake. But—as with Meyerhold, Reinhardt, and Brecht—this revisionist influence was long confined to Europe. At the Met, the house designers included Robert O'Hearn, who practiced a plush generic Romanticism, and Franco Zeffirelli, who expended millions on gratuitous spectacles that drew gasps and applause with each raise of the curtain.

Aronson did land two Met engagements—Marvin David Levy's *Mourning Becomes Electra* in 1967 and *Fidelio* in 1970. The first was the premiere of a weak opera. The second was a new mounting with a weak director. In 1974, a distinguished British stage director, John Dexter, was named head of production and pushed the Met toward more creative stagings. The Met wanted Aronson for *The Marriage of Figaro* and for Schoenberg's *Moses und Aron*. And opera excited Aronson as a "completely unnaturalistic" genre. But he had found conditions at the Met not to his liking: the stage was not available for rehearsal, and there was no rehearsal space as tall as the stage.[66] Only after the advent of Met Titles in 1995 did the company embrace something like total theater as an occasional priority. By then, Prince and others had long vanquished naturalism on Broadway—a transformation in which Aronson had played a significant role.

As arts immigrants go, the case of Boris Aronson illuminates certain conditions for cultural exchange. He entered into the American experience—its environmental sights and habits, its professional mores—with a will to know and learn. He equally

retained the convictions with which he arrived. As he had ventured to Moscow when Jews were unwelcome, then to Poland with false papers, then to 1920s Berlin with its epochal music and art, so did he test Broadway. His resilience contrasts with the lost momentum of a Mamoulian or Murnau.

We have seen Elia Kazan, directing *Love Life* in 1948, observing of Kurt Weill: "He wanted success very badly." No one ever accused Aronson of craving success. Success came, but the weathered refugee perspective remained. To the end, he expressed his disappointments and misgivings in theater as practiced by Americans. He found Harold Prince, but never a Meyerhold, Reinhardt, or Jessner, never a repertoire or opera company invested in the ideals he absorbed from Tairov. It could be surmised that—no less than Reinhardt with his *Miracle*, or Murnau with *Sunrise*, or Nazimova in Ibsen, or Mamoulian in Rochester—Aronson did his bravest American work when he first came: *The Tenth Commandment*. At the same time, the United States was for Aronson a bona fide new world. An inveterate New Yorker, he never suffered Hollywood. In a 1975 interview, he complained that American theater reduced to "real estate—three theaters here, four theaters there, but no companies"; that in a period of political and social upheaval, "so dramatic, so tragic, so grotesque," a "renaissance time" for science and technology, a time of unprecedented human and cultural potential, he could see "no reflection of it" on the stage. But he added: "What fascinates me—because I am not a retiring man—[is that] the difference between America and Europe is the dynamism of this country. This power to me, in this country, is very real."[67]

IN SURVEYING THE IMMIGRANT contribution to Broadway, we have encountered an indigenous genre: American musical theater. The genre is a hybrid whose polar points of origin are Old World

opera and such vernacular New World entertainments as minstrelsy and vaudeville. Over the course of the twentieth century, these vectors converged. *Oklahoma!* was a landmark outcome: for its integration of song, dance, and drama; for its "serious" subject matter; for its iconic American self-portraiture. That Richard Rodgers wrote the music and Oscar Hammerstein the words, that Agnes de Mille choreographed the narrative dance sequences, are achievements enshrined in the American cultural memory bank. But the director of *Oklahoma!* was an immigrant. And so were Kurt Weill, George Balanchine, and Boris Aronson, all notable players in the evolution of a distinctly American way of combining story and song.

Rouben Mamoulian is the unsung hero of this tale. He instilled Russian and European ideals of total theater, choreographing the action, aligning music, gesture, and speech, applying the resources of high drama to *Oklahoma!* and *Carousel*, to *Porgy and Bess*, to *Lost in the Stars* and eight other musical plays and films. In fact, once Mamoulian's fingerprint is discerned, it proves ubiquitous.

Early in *Carousel*, Carrie asks, "Julie, Julie, do you like him?" and Julie replies, "I dunno." Carrie next inquires

> Did you like when he talked to you today?
> When he put you on the carousel that way?

Carrie's words are not only rhymed but rhythmic, matched to tunes in the orchestra; swiftly and inevitably, speech evolves into song. The degree to which the music of *Carousel* invades the script—the underscoring of dialogue, the subtle linkage of dialogue to song and of song to song—is new in Rodgers's Broadway output. But it is as old as Rodgers's Hollywood encounter with Mamoulian a dozen years previous in *Love Me Tonight*. Others who "met Mamoulian" included George and Ira Gershwin,

Maurice Chevalier and Jeanette MacDonald, Fred Astaire and Cyd Charisse—as well as his fellow immigrants Weill, Balanchine, Aronson, and Vernon Duke.

If Mamoulian was a pioneering influence on the American musical theater of the 1930s and '40s, Kurt Weill was at the very least a singular contributor to the ferment of the moment. Like Mamoulian, who cut his teeth staging Verdi, Wagner, and Bizet in Rochester, Weill was rooted in Old World practice. He brought to the Broadway musical a new emphasis on the book and a mature capacity to "through-compose" pieces like Anna Maurrant's scene and aria. He also supported a new and higher place for dance. In *Lady in the Dark*, with its three musical dream sequences, choreography is an indispensable dramatic ingredient, not an ancillary diversion.

That de Mille's indispensable dream ballets for *Oklahoma!* two years later are a touchstone for heightened artistry in Broadway dance remains a necessary insight. But the influence of immigrants for whom ballet was integral to opera is underreported. We have observed Balanchine working on eighteen Broadway shows, including—in seasons previous to *Oklahoma!*—*On Your Toes*, for which he created *Slaughter on Tenth Avenue*, and *Cabin in the Sky*, which he also directed. The *Slaughter* ballet (still in repertoire at the New York City Ballet) advances the story at a crucial moment. The orgiastic *Cabin* dances (which do not survive) were a fresh inspiration. The extent to which Balanchine supervised the entire *Cabin* production is unknowable. The dialogue was directed by the coproducer, Albert Lewis. Balanchine himself recalled, "I did all this, the idea, how it looks, and, you know, the whole thing. Only I did not do the conversation. . . . No, I was just placing people and dressing them." Photographs of the production suggest the "pungent attitudes and restless motion" inferred by one Broadway historian.[68] While the evidence does not necessarily sup-

port enlisting Balanchine as an early precursor to such omnipotent choreographer/directors as Jerome Robbins, Bob Fosse, and Michael Bennett, he remains, like Weill, an outside influence who shook and accelerated the process of change on Broadway.

Another immigrant choreographer important to Broadway was Hanya Holm, whom we have encountered as Mary Wigman's New World emissary. With the coming of World War II, Holm's American career gravitated to Americana, including the pioneer sagas of *From This Earth* (1941), to music by Roy Harris, and such Broadway assignments as *The Eccentricities of Davey Crockett* (1948), *Kiss Me, Kate* (1948), *My Fair Lady* (1958), and *Camelot* (1960). The lyricism and humor of Holm's modern dance style (in contrast to that of Martha Graham) contributed to her adaptability. For *Kiss Me, Kate*, a show flooded with dance, she drew upon jitterbug, soft-shoe, acrobatics, and court and folk dance as well as ballet and modern dance. Julie Andrews, who starred in *My Fair Lady* and *Camelot*, cherished her as "a kind of mother figure."[69]

Finally, Boris Aronson ranks with Jo Mielziner as an influential designer of the Broadway musical and with Mielziner, among others, as cocreator of a distinctive American style of stage design. More than Mielziner—more than Robert Edmond Jones, Norman Bel Geddes, or Lee Simonson—he was at the same time (as we have seen) an agent of cultural exchange.*

*The same could be said of the most influential American stage designer of a later generation: Ming Cho Lee. Born in Shanghai to a Yale-educated insurance executive in 1930 (and hence falling outside the purview of this study), Lee moved to California in 1949. His early schooling had included Chinese landscape painting—and so inscribed an aesthetic combining simplicity, grace, and formal composition, with propensities toward the abstract. His later mentors included Boris Aronson. All of this rhymes (to varying degrees) with the signature sparseness of Lee's designs, their elegant planking and scaffolding, their sculptural use of wood and metal.

In retrospect, that Europeans and Russians played a prominent role in fashioning an integrated American musical theater was inevitable, a function of talent, eminence, and undeniable pertinence. As a colonial cultural outpost, America needed at first to stake a distance from Old World practice. Blackface minstrels, vaudeville comedians, and Ziegfeld showgirls variously exemplified an entertainment collaborative, timely, and disposable, versus high-toned individual geniuses at work abroad. "Broadway opera" of the 1930s, '40s, and '50s marked a meeting point still unsettled and transitional. *Porgy and Bess*, in 1935, did not yet suit the Met, but its Broadway run was relatively short; and Gershwin was still learning how to combine songs and opera. Fully two decades later, in 1956, Leonard Bernstein's *Candide*, mixing operetta froth and operatic substance, suffered a confusion of tone, and Frank Loesser's *Most Happy Fella* could stabilize neither tone nor style. Attempting to build on *Guys and Dolls*, Loesser tumbled into an Old World/New World, opera/Broadway cleavage recapitulating family history; he was the black sheep alongside his brother Arthur, the erudite concert pianist. That Loesser insisted that *The Most Happy Fella* was "not an opera" illuminates both the weak underbelly of an endearing show and continued unease vis-à-vis the parent culture. Meanwhile, American opera on the European model—whether attempted by John Knowles Paine and George Chadwick, or Aaron Copland and Samuel Barber—remained nascent.

The Sondheim/Prince musicals to which Aronson vitally contributed coincide, finally, with a liberating release from the snob appeal of exclusionary "classical music" and "opera" as imported by the United States. Like John Adams's *Nixon in China* or Philip Glass's *Satyagraha*, they signify a ripened absorption of foreign influence. One might say that classical music in

America was Europeanized "too soon"—it long discouraged or penalized native practitioners. Theater in America was Europeanized "too late"—in the early twentieth century, immigrant practitioners of genius were discouraged or penalized. But their legacy holds.

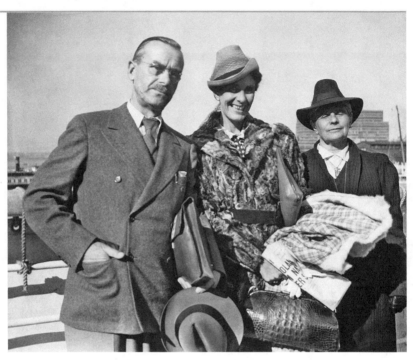

*Thomas Mann arrives in New York with his wife and daughter, Erika,
September 18, 1939.*

C O N C L U S I O N

Summarizing cultural exchange: Thomas Mann and Vladimir Nabokov—Postscript: The Cold War—Cultural exchange and the twenty-first century

NO SOONER DID ANTON Seidl set eyes on Manhattan in 1885 than its tall scale and youthful energies impressed him. "The moment he saw the harbor he was delighted," Mrs. Seidl would recall. "The elevated railroad he found imposing; even the large telegraph poles seemed to him beautiful. We were still in the carriage when he exclaimed: 'This is magnificent! I feel I shall get along well here.'"[1] And Seidl soon discovered a musical public equally youthful and energized.

Seidl's subsequent decision to settle in New York as an American citizen occasioned delight and also some degree of surprise. Not yet forty, he was already established throughout Europe as a master conductor, a protégé and colleague of Wagner himself. Seidl told inquisitive New York reporters and critics that he had come to

the United States as Wagner's emissary at the composer's own suggestion—that Wagner envisioned a virgin opportunity for proselytizing. Other factors were rumored. Half a century after Seidl's death, his onetime disciple Arthur Farwell disclosed a "Bayreuth romance"—that in 1885 Seidl had fallen in love with Wagner's daughter Daniela. But this circumstance "could not reduce the moral fortress of this deep and noble soul. He would countenance no wrong to [his wife] Auguste. Europe would present too close quarters; he must get as far away, in his career of Wagnerian conductor, as opportunity would permit. And so America was immensely enriched by this hidden tragedy of love."[2]

The intellectual migration of distinguished European musicians to the United States early in the twentieth century occasioned no such puzzlement or surprise. Nor was New York a surprise to them. The New World was not as new—as culturally innocent and inviting—as when Seidl and Dvořák stormed New York in the late Gilded Age. In music especially, the interwar immigrants, however distinguished, encountered lots of competition.

The Introduction to this volume proposed George Balanchine and George Szell as polar opposites among twentieth-century immigrants in the performing arts. There is no record of Szell being impressed by New York as Seidl had once been. At the Metropolitan Opera, he was shown the door by Rudolf Bing. In Cleveland, with an orchestra only twenty-eight years old, he discovered a kind of new world. Mentoring young Americans, he told them what tempos to take in Beethoven and when to cut their hair. He delighted in administering snap quizzes to young conductors on the fly: How many bassoons in Mahler 5? Which Wagner tubas in Bruckner 8? In the United States Seidl had spread the gospel for Wagner. He had championed the American Edward MacDowell. Szell had nothing comparably new to impart, but in attitude was twice the colonialist Seidl had been.

Balanchine, unlike Szell, administered no catechism. The bi-

ble he preached, if there was one, was of his own American invention. His American ballets included settings of Ives, Gottschalk, Sousa, and Gershwin, and of the American Stravinsky.

In fact, none of the Russians here surveyed arrived with bibles. Stravinsky was a magpie. Koussevitzky championed Aaron Copland and Roy Harris. Alla Nazimova did her Chekhov—but also Ibsen and Oscar Wilde, *Mourning Becomes Elektra* and *Since You Went Away*. Rouben Mamoulian abetted the pioneering Broadway efforts of Gershwin and of Rodgers and Hammerstein. Boris Aronson hitched his scenic art to Harold Prince and Stephen Sondheim. These were new Americans who seized what opportunities came their way. They were naturally adaptive.

Without exception the Russians mainly featured in my account were more than "Russian." Not unlike Americans, they were products of a polyglot state; unlike America, the Russian state was not unified linguistically, let alone culturally. They came from St. Petersburg, Moscow, Tiflis, Kiev. They knew Paris. Their roots were Armenian, Ukrainian, or Georgian, Yiddish, Jewish, or Russian Orthodox.

The Germans did not come from any one nation. Fritz Lang and Arnold Schoenberg were Viennese. Erich Korngold was born in Brno. Rudolf Serkin was born in Bohemia. Szell was born in Budapest. Their common point of origin was cultural. For the musicians, even those as seemingly antithetical as Szell and Schoenberg, a religion of Bach and Beethoven conferred commonality. The German theater bible was weighted with Goethe and Schiller, and with Shakespeare as translated by August Wilhelm Schlegel and Ludwig Tieck. The filmmakers had no bible— film was too young. And yet for Lang and F. W. Murnau, Faust's dark creative chambers, his supernatural visitors and the fatalistic trajectory of his quest, cast lifelong shadows. For Ernst Lubitsch, the operettas of Strauss and Lehár remained a twinkling Germanic lodestar. Kurt Weill—the exception to the rule—had to flee *Kultur*

completely to flee at all. And yet in America Weill's close friends did not include Vernon Duke's close friend George Gershwin. Weill's letters reveal a prickly arrogance toward his putative American peers in musical theater.

A clinching illustration of these twin German and Russian templates—the first culturally united and prone to preach, the second culturally diverse and readier to change—may be found outside the performing arts, embodied by the two most prominent immigrant writers of fiction: Thomas Mann and Vladimir Nabokov.

Mann, however paradoxically or reluctantly, inhabited the political turbulence of his time. He polemically welcomed World War I as a patriotic *Kultur* crusade against the unGerman; proudly apolitical, he dismissed liberalism, materialism, and optimism as bourgeois shibboleths negating higher, autonomous spheres of art. The catastrophe of war converted him to Weimar democracy as a necessary cause; in *The Magic Mountain* (1924), he tortuously embraced a worldly humanism over the seductive morbidity of Germanic self-immersion. He fled the Nazis to Switzerland, then to Princeton and Santa Monica, becoming a United States citizen in 1944. As America's emblematic "good German," he lectured and broadcast about the Hitler menace and the fate of the world. He idolized Franklin Delano Roosevelt as an "American Hermes," a "brilliant messenger of shrewdness" whose lofty ministrations would guide a "coalescence of the hemispheres," a "unification of the earth" also signaled by the intellectual migration of which Mann was part. At the same time Mann's fourteen American years, during which his California friends and neighbors included Theodor Adorno, Leon Feuchtwanger, Bruno Walter, and Franz Werfel, were among his most productive. He drew inspiration from Melville and Whitman. His manner, according to his son Golo, grew "more at ease."[3] Buffeted by world events and yet stabilized in his writer's lair, he completed four novels, of which

Joseph the Provider, concluding the tetralogy *Joseph and His Brothers*, refracts the topic of exile in America. The New Deal, Mann acknowledged in a foreword, "is unmistakably reflected in Joseph's magic administration of [the Egyptian] national economy." Adjusting to hard times, Joseph/FDR redistributes wealth to "the little people." He exercises "a combination of . . . government usury and fiscal measures such as had never been seen before. His mingling of severity and mildness impressed everyone." His "dislocation of the property concept" is proto-socialist, not capitalistically bourgeois.

And Joseph is also Thomas Mann in exile; his "cosmopolitan existence [was not] that of an outcast, but . . . of a man set apart for a purpose." "Men living in a land which is theirs mainly by adoption sometimes display the national traits more strongly than the native-born," writes Mann of Joseph/Mann. In Mann's fictions, as in Mann's life, ambivalence is ever an intellectual pedigree and prerogative: Joseph also yearns for his tainted homeland—for his brothers who abused him. He thinks daily of his one and only birthplace, "immovable," "inalienable." Withal, in the world of Mann this is a sanguine performance, brightened by California skies "so like the Egyptian." The foreword salutes a newfound "cheerfulness" acquired in what Mann, on another occasion, called his "foreign homeland."[4]

The masterpiece of Mann's California exile is his summa of the German problem, majestically—and necessarily—surveyed from afar: *Dr. Faustus: The Life of the German Composer Adrian Leverkühn as Told by a Friend* (1947). Leverkühn's pact with the devil secures his art in forfeiture of his humanity. Meanwhile—the novel is set during World War II—Germany's self-forfeiture takes its course. Mann's equation of German genius with demons and disease—an equation he ardently excavated at every point in his career—here ruthlessly drives an act of German self-repudiation. Leverkühn's punishment—inflicted by a legacy of hothouse

Kultur, of medieval hysteria and Romantic morbidity—is a case of syphilis that reduces him to a state of helpless infancy. *Faustus* becomes a rite of purgation—of extracting, examining, and expelling the German demon become Hitler. Mann's need to let go—his exile's heightened critical animus against the homeland—propels him into the embrace of an idealized New World as wholesome, sane, and mature as Leverkühn is not. In an epilogue to *Doctor Faustus*, Mann—in the person of Dr. Serenus Zeitblom, Ph.D., the novel's pedantic narrator—worries about its fate in the United States: Is it translatable? Will it not "arouse puzzlement in that cultural sphere"? And he expresses other fears:

> I fear the youth of my country have become too alien to me for me to be their teacher—and more: Germany itself, this unhappy land, is alien to me, utterly alien, precisely because I, certain of its ghastly end, held myself apart from its sins, hid from them in my solitude. Must I not ask if I was right in doing so? And again: Did I actually do so? I have clung to one man, one painfully important man, unto death and have described his life, which never ceased to fill me with loving fear. It is as if this loyalty may well have made up for my having fled in horror from my country's guilt.

In one of *Faustus*'s magnificent set pieces, Mann invents the international impresario Saul Fitelberg, who attempts the futile task of prying Leverkühn from festering seclusion. As he takes his leave, Fitelberg proposes:

> Gentlemen, this is now truly the doorknob, I am already outside. I have only this to say yet. The German should leave it to us Jews to be pro-German. The Germans, with their nationalism, their arrogance, their fondness for their own incomparability, their hatred of being second or even

placed on a par, their refusal to be introduced to the world and to join its society—the Germans will bring about their own misfortune, a truly Jewish misfortune, *je vous le jure*. The Germans should allow the Jew to play the *mediateur* between them and society, to be the manager, the impresario, the agent of Germanness—the Jew is definitely the man for the job, he should not be sent packing, he is international, and he is pro-German.[5]

Mann's FDR was a similar invention: an ecumenical world-rescuer—not a Churchill or de Gaulle, but a leader apart, transcending sectarian Europe. As with other German immigrants, if more decisively, the Cold War and McCarthy shattered Mann's willed American dream; the devil was not German after all. Mann protested the jailing of the Hollywood Ten and the firing of schoolteachers suspected of Communism. The Library of Congress canceled a Thomas Mann lecture; the Beverly-Wilshire Hotel refused to rent its facilities to a political group in which he participated. "I have no desire to rest my bones in this soulless soil to which I owe nothing, and which knows nothing of me," he wrote to a friend in 1951. "My books remain desperately German," he wrote the same year. He abandoned the United States for Switzerland in 1952. He died in Switzerland in 1955, having dismissed California as an "artificial paradise."[6]

Nabokov's American odyssey was superficially similar to a degree. Born in St. Petersburg in 1899, he left Russia with his family in 1919 for England and later lived in Berlin. With the coming of Hitler, he went to Paris. He settled in the United States for twenty-one years beginning in 1940, teaching at Stanford, Harvard, and Wellesley. *Lolita* (1955) made him an American literary celebrity. He moved to Switzerland in 1961 and died there in 1977. His American novels do not ignore the topic of exile. *Pnin* (1953) is about an immigrant professor of Russian at a small American college. A comedy streaked with heartbreak and

nostalgia, it portrays a life uprooted, distorted, and unfulfilled. In *Lolita*, a twelve-year-old New World "nymphet" is despoiled by an opportunistic immigrant who calls himself "allergic to Europe," an "old and rotting World."[7] The novel's backdrop is an inventory of Americana, deliciously observed by an itinerant alien.

In Thomas Mann, the meanings of Pnin's exile or Lolita's rape would be pondered. But Nabokov famously disdained the novel of ideas. Nor did he feel impelled to debate the fate of civilization. Rather, he elaborately manifests a Russian type we have observed throughout this chronicle of immigrant artists: the deracinated aesthete, schooled in the cosmopolitan mores of prerevolutionary St. Petersburg. Nabokov learned to read English before he read Russian. In *Speak, Memory* (1967), a singular autobiography more sensory than intellectual, he writes:

> The kind of Russian family to which I belonged—a kind now extinct—had, among other virtues, a traditional leaning toward the comfortable products of Anglo-Saxon civilization. Pears' Soap, tar-black when dry, topaz-like when held to the light between wet fingers, took care of one's morning bath. . . . At breakfast, Golden Syrup imported from London would entwist with its glowing coils of the revolving spoon from which enough of it had slithered onto a piece of Russian bread and butter.

Nabokov was educated by tutors, each "a representative of another class or race." One of his uncles, a diplomat, frequented France, Italy, and Egypt. Another favored a "fastidious combination of French, English, and Italian, all of which he spoke with vastly more ease than he did his native tongue." The paradoxical outcome of these and other cultural dissonances was an "essential stability and completeness": Nabokov's signature equipoise.[8]

Certainly Nabokov was not without sentiment toward his homeland. In *Speak, Memory*, he writes of his loneliness in Paris and Berlin, of his "meager stock" of non-Russian and non-Jewish acquaintances during the interwar years, of "an animal aching yearn for the still fresh reek of Russia," of "an exciting sense of *rodina*, 'motherland.'" The book is a veritable paean to lost childhood and lost Russia, to "remote, almost legendary, almost Sumerian images of St. Petersburg and Moscow." "Give me anything on any continent resembling the St. Petersburg countryside," he confides, "and my heart melts." But these are asides; even in autobiography, Nabokov is no more confessional than is Stravinsky in his music, or Balanchine in his dances. Rather, like Stravinsky and Balanchine, he delights in the linguistic pleasures of his medium of choice. His precision of memory and apprehension is a facet of precise and subtle language, an achievement fundamentally aesthetic. As a student at Cambridge, he records,

My fear of losing or corrupting, through alien influence, the only thing I had salvaged from Russia—her language—became positively morbid and considerably more harassing than the fear I was to experience two decades later of my never being able to bring my English prose anywhere close to the level of my Russian. I used to sit up far into the night, surrounded by an almost Quixotic accumulation of unwieldy volumes, and make polished and rather sterile Russian poems not so much out of the live cells of some compelling emotion as around a vivid term or a verbal image that I wanted to use for its own sake. It would have horrified me at the time to discover what I see so clearly now, the direct influence upon my Russian structures of various contemporaneous ("Georgian") English verse patterns that were running about my room and all over me like tame mice.

An afterword to *Lolita* offers that this novel of misplaced affection might fairly be regarded as the record of a "love affair" with the English language. Cultural exchange, in Nabokov, is a Russian/British/American mediation of syntax and style.[9]

For Stravinsky, eloping with his mistress become bride, California was a halcyon refuge from world conflicts to which he preferred to remain oblivious. Balanchine was a serial husband and companion of nubile dancers less than half his age. Rouben Mamoulian's *Love Me Tonight* is a sybaritic divertissement. So was the Garden of Alla in which Nazimova actually lived. The pastimes of *Lolita* have something in common with these expatriate Russian pleasure tableaux. Solomon Volkov, in his cultural history *St. Petersburg* (1995), singles out Stravinsky, Balanchine, and Nabokov as American purveyors of a distinctive Petersburg modernism disdaining a traditional Russian propensity for social commitment in art. The Petersburg "mythos" Volkov extracts is refined, playful, airy, poised. (Nabokov called the city itself "light and airy.") To be sure, the mythos is barbed as well as blithe: transplanted, it conveys an arrogance denying the pain of exile without end (unlike Hitler, the Soviet Union long survived World War II). Stravinsky's insistence that music means nothing beyond itself, Balanchine's denial of pictorial "feeling" in balletic faces and gestures, Nabokov's aristocratic aversion to "heart-to-heart talks, confessions in the Dostoevskian manner," subdue St. Petersburg memories never wholly buried. This undertow of sentiment denied is tangible and humanizing. At the same time, the act of denial is aesthetically salient—as the merest glance at our Germanic immigrants will confirm.[10]

In *Doctor Faustus*, Mann's morbidity, his fascination with evil and derangement, embellish moral entanglements unknown to the St. Petersburg aesthetes. Zeitblom's ambivalence toward Leverkühn, whom he "loves, reveres, and fears," mimics Mann's

ambivalence toward his least dispensable *Kultur* god: Richard Wagner, the composer Mann wished to have been, whose musical structure and syntax condition the style of Mann's fictions, and whose dangerous psychological profundities Mann aspires equally to explore. In Wagner's *Ring*, Alberich is Wotan's shadow; so, too, does Wagner the moralist shadow Mann's sermons and world judgments. The audacious moral dimension of *Tannhaüser*, with its blasphemies against church and state, the tenuous morality of *Faustus*, with its conflicted aura of atonement, resonate in tone and intensity with the dire *Werktreue* dictates of a Serkin or Szell, with Otto Klemperer's austere imperative that "a trill is a trill!," with Schoenberg's espousal of twelve-tone religion as a duty to music, with the heretical leer, struggling free of guilt, of Brecht's "Erst kommt des Fressen, dann die Moral." Leverkühn's disease is the cloak of Murnau's Mephistopheles; it is the poison in Fritz Lang's bitter endings. Nabokov's Humbert Humbert destroys cheerfully, undemonstratively; Dietrich's Lola must flaunt her tools of destruction. In America, as agents of cultural exchange, the Germans proved as driven as Nabokov, Stravinsky, and Balanchine were supple. "Where I am is Germany," Mann said.[11] No Russian émigré claimed to be Russia.

Friedrich Nietzsche, in his compendium *Nietzsche Contra Wagner*, characterizes Wagner as a "danger":

> One walks into the sea, gradually loses one's secure footing, and finally surrenders oneself to the elements without reservation: one must *swim*. In older music, what one had to do . . . was something quite different, namely, to *dance*. The measure required for this, the maintenance of certain equally balanced units of time and force, demanded continual *wariness* for the listener's soul—and on the counterplay of this cooler breeze rests the magic of all *good* music. Richard Wagner wanted a different kind of

movement; he overthrew the physiological presupposition of previous music. Swimming, floating—no longer walking and dancing.

Wagner himself embraced Schopenhauer's perspective that music embodied "feeling" and "passion," not "reason." Remote from "all reflection and conscious intention," music, in Schopenhauer's view, spoke "a language that [the composer's] reasoning faculty does not understand, just as a magnetic somnambulist gives information about things of which she has no conception when she is awake."[12]

Sleepwalking or intoxicated, surrendering to danger, Leverkühn activates forbidden instincts. Lang's *Woman in the Window* and *Scarlet Street* swim in a thick and fathomless existential mire. *Sunrise*, its happy ending notwithstanding, struggles helplessly against demonic ontological currents. Garbo—whose German was fluent; whose mentors included G. W. Pabst—is the very magnet of evil, twisting the communion cup in *A Woman of Affairs*; her trancelike powers of destruction make her as different from less somnambulistic Hollywood femmes fatales as Lang is from the film noirs of Hawks and Welles.

Nietzsche thought of Bizet's *Carmen* as an embodiment of "dancing," combating Wagnerian narcosis. The Stravinsky/Balanchine ballets—even *Orpheus*, with its demons—are dances of this kind. Nabokov and Mamoulian, too, are light-footed; they exercise exquisite choreographic control. What remains subtly Russian in the Symphony in Three Movements—whether Stravinsky's or Balanchine's—is mainly detectable to fellow Russians. It is safe to assume that no Russian in America was ever tempted to compose an English-language tribute to FDR in the style of Tchaikovsky or Prokofiev. But the Germanness of Hindemith's *When Lilacs Last in the Dooryard Bloom'd* or Schoenberg's *Ode to Napoleon* is not residual or subliminal; it is blatantly and self-evidently actual.

Even for Nietzsche, the choice of dancing over swimming is not a final judgment. No less than Mann, he could not erase his weakness for Wagner, however hard he tried; the "German" in him was ineradicable. Dancers may delight in Bizet or Nabokov, Stravinsky or Balanchine—and yet hopelessly desert the dance floor for the ocean.

DVOŘÁK RECOGNIZED THE PROTEAN potential of "Negro melodies" for American music. Interwar immigrants in the performing arts—Russians and Germans, dancers and swimmers—were likewise inspired by deep black chords subordinating the polyglot babble of voices less oppressed. The ballet master George Balanchine, amazingly, undertook *Cabin in the Sky;* his collaborators were the ex-Constructivist Boris Aronson, who brought fresh eyes to the furnishings of poor black homes, and Vernon Duke, the Diaghilev alumnus who found the black cast members "immeasurably superior to their white counterparts." Rouben Mamoulian's first great New York success was *Porgy*—which gripped Salka and Berthold Viertel, and about which Klaus Mann reported that the black American "possessed a spontaneous and yet consciously developed artistic style . . . a new rhythmic experience, a new histrionic style, a new melody." Mamoulian's other notable Broadway productions included *Porgy and Bess* and Kurt Weill's *Lost in the Stars*. Fritz Lang had intended to cast a black actor as the lynching victim in *Fury*; Hollywood was not ready. Twenty-three years later, Douglas Sirk's *Imitation of Life* thrust black victims of America into a Hollywood family melodrama. Concurrently, Otto Preminger directed Hollywood's first mainstream black musicals.[13]

An affinity for jazz was about the only thing such diverse immigrant composers as Weill, Duke, Stravinsky, Ernst Krenek, Paul Hindemith, and Béla Bartók had in common. Darius Milhaud, who split his time between Paris and the United States, wrote, "In

jazz the North Americans have really found expression in an art form that suits them thoroughly, and their great jazz bands achieve a perfection that places them next to our most famous symphony orchestras." Maurice Ravel, visiting New York in 1926, told the *Times,* "I think you have too little realization of yourselves and that you will look too far away over the water. . . . I think you know that I greatly admire and value—more, I think, than many American composers—American jazz." Gershwin, who bonded with blacks, was befriended and espoused by the immigrants Duke, Schoenberg, Fritz Reiner, and Jascha Heifetz; Otto Klemperer held him in high regard; Balanchine choreographed his songs.[14]

An overview of native-born performing arts talent would disclose no comparable propensity to celebrate the African-American. European classical musicians—in Berlin and Paris, in New York and Los Angeles—embraced jazz as America's distinctive music; American classical music composers and audiences winced at Ellington and Armstrong. Aaron Copland claimed that two moods— "blues" and "the wild, abandoned, almost hysterical and grotesque mood so dear to the youth of all ages"—encompassed "the whole gamut of jazz emotion"; he dismissed Gershwin as a naif. Roy Harris, touted by *Time* as the "white hope" of American music, conspicuously ignored the African-American in his quest for an American sound. Mainstream opinion linked jazz to blacks and Jews: outsiders. Henry Ford's *Dearborn Independent* took note of "the organized eagerness of the Jew to make alliance with the Negro"; "picturesque, romantic, clean" popular songs had been supplanted by "monkey talk, jungle squeals, grunts and squeaks and gasps suggestive of cave love." A Musical Memory Contest in Cleveland, aiming to "cultivate a distaste for jazz and other lower forms," typified a music-appreciation caste system; the most indigenous American music was dismissed as exogenous. Paul Rosenfeld, the prestigious intellectual champion of Copland and Harris,

celebrated an American modernism cleansed of Europe and jazz both. Citing a couple of ephemeral American talents, he called Leo Ornstein "not as naive as Franck or Weber" and termed Dane Rudhyar's sonorities "harder and more intricate than Scriabin's." Of Roger Sessions, Rosenfeld wrote, "even where he is closest to Stravinsky, [he] has more robustness than ever comes the way of the somewhat chlorotic Russian." In Gershwin Rosenfeld detected a "weakness of spirit, possibly as a consequence of the circumstance that the new world attracted the less stable types"—a judgment reducing Gershwin to mere immigrant stature. Dvořák, a butcher's son born into a suppressed Hapsburg minority, told an American reporter that he looked "to the poor for greatness." So, too, were the interwar immigrants empathetic outsiders. Like Dvořák before them, they bonded with blacks from a shared experience of marginality. Like Dvořák, they applied a clarity of understanding immune to the growing pains of a young high culture separating from parents and former slaves alike.* Those who were Jewish found themselves grouped with blacks by American bigots.[15]†

To newcomers practiced in dance, theater, cinema, and music, there were many other things obviously amiss with American culture and society. To Balanchine, it was ballet that was missing: an opportunity. More typically, the missing elements signified constraint. The American culture of performance, hostile to modernism, ambushed Schoenberg, Bartók, Stravinsky, and Hindemith.

*Anthropologists write about a pertinent tendency to appreciate, romanticize, or lionize ethnic or cultural "others" and their artistic expression when they are safely distant—when they do not fully share the social space of those doing the appreciating. (I am indebted to Kenneth Bilby of the Center for Black Music Research for this insight.)

†Outside the performing arts, Hertha Pauli wrote a biography of Sojourner Truth. Albert Einstein wrote an essay, "The Negro Question" (1946), claiming that "one who comes to this country as a mature person" can see what natives miss. Hannah Arendt likened the street ballads from which Brecht drew to spirituals—songs of "people condemned to obscurity and oblivion." Herbert Marcuse sympathetically considered the language of the Black Panthers.

In Europe, their names were great; in America, Toscanini was the great name. Similarly, Max Reinhardt, Bertolt Brecht, Leopold Jessner, and Erwin Piscator from Germany, Nazimova, Mamoulian, and Aronson from Russia all had occasion to discover what the American theater was not. Their central finding was that the all-encompassing directorial vision of a Reinhardt or Mamoulian, Murnau or Lang, was an autocratic prerogative not readily compatible with the Hollywood studio system, or with collaborative musical theater as traditionally practiced on Broadway. In cinema, that some immigrant directors—notably Lang and Mamoulian— were autocratic created obstructive animosities. The dictatorship of a Toscanini or Balanchine, Rudolf Serkin or George Szell, was mainly uncontroversial: in classical music and classical dance, Americans deferred to their high authority. The high authority of a Wilhelm Furtwängler, contradicting the instructions of Beethoven or Brahms, was another matter: autocracy grown suspect. As Tocqueville put it, "men living in democratic times" cultivate the arts "after their own fashion." In the interwar United States, Americans were prone to submit excessively to, or to excessively challenge, Old World presumptions to superior knowledge.

Taken as a whole, twentieth-century American immigrants in the performing arts were not able to sustain a full growth curve upon relocating. Some lost their way entirely. Of those who did not—the case studies of the five preceding chapters—almost all enjoyed a more consummated European calling. The exceptions— the major Old World careers that accelerated in the New World—can be counted on the fingers of one hand: Balanchine in dance, Americanizing classical ballet; Ernst Lubitsch in film, parlaying operetta wit into a prize Hollywood confection; Rudolf Serkin, transcending his duo partnership with Adolf Busch as a heroic American solo artist and relentless American pedagogue; Serge Koussevitzky, inventing a New England laboratory for new American music. More typically, unreplantable Old World roots

signified stunted cumulative growth. Murnau and Lang, whose great talents dipped, fit this picture. So do Weill, Hindemith, Schoenberg, Bartók, and Stravinsky, all of whose highest achievements preceded immigration to the United States. Shallower artists often transplanted best: a Lubitsch, an Erich Korngold, a Billy Wilder. And there is a sizable group whose Broadway or Hollywood careers peaked early and lost momentum for lack of cultural nutrients: Mamoulian at Eastman, Aronson on the Lower East Side; Nazimova, Garbo, and Dietrich before they succumbed to self-parody.

As noted in my Introduction these generalizations do not apply to all facets of the intellectual migration: the American melting pot more readily absorbed immigrants in the sciences and social sciences. Immigrants in the performing arts were not sequestered in academic groves. Their professional language was English, not nuclear physics or differential geometry. In the public arena of entertainment, they were quickly subject to ideological scrutiny when the Cold War hit. Lang was blacklisted, Brecht was subpoenaed, Klemperer was denied his passport. During World War II, many of them idealized FDR; afterward, many were disillusioned. Their ambivalence toward their foreign homeland was returned. They were deferred to as authorities; they were mistrusted as "intellectuals." The red carpet rolled out for Lubitsch and Korngold led to influence and renown; for Murnau and Reinhardt, the carpet became a rug pulled out from under. "Bring me your huddled masses," the Statue of Liberty says; but the immigration restrictions that the intellectual migrants navigated were harsh and discriminatory. To this day, no area of American public policy is more confused.

And yet, in every field, the intellectual migration raised the bar, posing higher standards and new possibilities. In the performing arts, the standards and possibilities were sometimes problematic. The Europeanization of American classical music was perpetuated;

the day of the American conductor, and of the American soloist, was delayed; many an American composer took a wrong turn under the influence of imported styles and techniques. In dance, film, and theater, the new possibilities were preponderantly right and necessary. The arena was enlarged.

IN OUR TIME, CULTURAL exchange in the performing arts continues between Europeans and Americans. But the tensions of forced migration—of exile and nostalgia—have abated. So, too, have other tensions. No longer is the United States a colonial cultural outpost or new cultural frontier: the New World/Old World cleavage is largely ended. Murnau, Schoenberg, Garbo, in America were ineluctably foreign. Today, a Pierre Boulez or Gidon Kremer passes through New York or Los Angeles, London or Berlin, with perfect fluidity. Wim Wenders's *Paris, Texas* (1984) lingers to relish a foreign landscape of lonely motels blinking neon invitations, of truck stops in the desert, of straight roads leading nowhere. Wenders's fascination with spaces vast, vacant, and flat echoes Dvořák's astonishment at the American prairie vistas he called "sad to despair." Unlike Dvořák, Wenders is not empowered by an avid transatlantic educational mission. Rather, aspects of the American landscape beguile his mood or strike his fancy. His Texas sojourn is hardly novel; as one of Germany's leading postwar filmmakers, he makes his home in Berlin, Los Angeles, New York—wherever he pleases. He remains at heart a German lyric poet—and *Paris, Texas* is an affecting film. But in Wenders's New German Cinema classic, *Kings of the Road* (1976), moody estrangement illuminates an exigent general condition: Germany adrift. The earlier film makes the solitude of *Paris, Texas* seem voyeuristic and slack.

If cultural exchange in America at the turn of the twenty-first century lacks an instructional infusion or the urgencies of exile, its geographical scope of operation is something new. Far more read-

ily than in any time past, the European/American tradition in film, music, dance, and theater seeks synergies in other parts of the globe. These interactions have nourished such essential American innovators as Steve Reich and Mark Morris. They have also produced a plague of slapdash hybrids that debase cultural exchange as a kind of aesthetic opportunism.

Today's most productive American immigrants in the performing arts may be the Chinese. In such Zhou Long chamber works as *The Ineffable* (1994), for pipa, zheng, flute, violin, cello, and percussion, an Asian sensibility assiduously schooled in traditional and folk musics mates with modernist Western techniques powerfully assembled. Though there is some pairing of pipa and zheng, violin and cello, the net effect is not one of dialogue or juxtaposition. Rather, with recourse to quarter-tones, to varied glissandos and vibratos, Western instruments are stretched eastward, and Chinese instruments westward, to achieve a dynamic common ground. Western musical mechanics of tension and release link paradoxically with an aesthetics of charged stasis. As with a Balanchine or Murnau, intermingling Russian ballet and German Expressionism with American dance and film, cultural exchange is here not merely fluent but eventful, dialectical.

The Ineffable is a product of an exceptional personal odyssey shared by many Chinese of Zhou's generation. He was born in 1953 to westernized parents. The Cultural Revolution wrecked his urban home and propelled him to faraway places. He drove a tractor and hauled wheat. He also conducted and composed for a song and dance troupe. He learned folk music from farmers and clandestinely listened to broadcasts of Chinese traditional music over Soviet radio. Once Mao was dead, he studied at the reopened Central Conservatory in Beijing, then at Columbia University in New York. Now an American citizen, he revisits China as a distinguished native son. His years of cross-cultural immersion in peasant life transformed his expressive vocabulary. The political

crucible through which he passed fired an urgency of artistic vocation unknown in societies less turbulent. For Zhou Long, as for countless Chinese composers, filmmakers, and performing artists, the Cultural Revolution ultimately proved a seismic, if unintentional, catalyst for cultural exchange.

Meanwhile, the final stirrings of cultural exchange in American exile—the subject matter of this book—are to be found among post-Stalin defectors from the Soviet Union and its satellites. The most significant American-based careers include those of Miloš Forman, Mikhail Baryshnikov, and Mstislav Rostropovich. In Forman's supreme Hollywood production, *One Flew Over the Cuckoo's Nest* (1975), the droll, affectionate, and painstaking observation of human behavior, typical of his Czech films, is applied to the inmates of an American insane asylum, and so powers a reading of psychological subjugation informed by the director's own experience of confinement and debasement in Communist Czechoslovakia. Baryshnikov escaped the Kirov's Soviet traditionalism to work with a gamut of American choreographers—Alvin Ailey, Balanchine, Eliot Feld, Mark Morris, Jerome Robbins, Twyla Tharp—in addition to joining Natalia Makarova and Rudolf Nureyev in impressing the full-length Russian ballet classics upon American audiences. Rostropovich discovered a shrunken vocation as music director of Washington's National Symphony from 1977 to 1994: as a Soviet cellist, he had served Prokofiev, Shostakovich, even Benjamin Britten; as an American conductor, he became a celebrity trophy for the nation's capital. As ever, American classical music proved insular: an end; dance in America remained a work in progress.

MY CLOSE FRIENDS HAPPEN to include another Soviet defector: the pianist Alexander Toradze. Lexo is Georgian, born in Tbilisi in 1952. His father was a leading Georgian composer. His mother

was an actress. Groomed by the Soviet system, he entered Tbilisi's central music school at six and first played with an orchestra at nine. He proceeded to the Moscow Conservatory at nineteen to study with Yakov Zak—then one of the great names of Russian pianism, after Richter and Gilels. When Zak proved unsupportive, Toradze left him—for a young Soviet artist, a bold and controversial move—for Boris Zemliansky, then Lev Naumov: intimate and intense relationships. In 1976 he was sent to compete in the Van Cliburn competition in Fort Worth and finished second. A flurry of Western dates ensued, but the Russian invasion of Afghanistan soured cultural exchange with the United States. He festered. His fees were low. He felt suppressed as a Georgian. He was galled by the company of KGB "interpreters." In 1977, he ran into Rostropovich, a family friend, at a Paris airport. "When you go back, kiss the ground of our country," Rostropovich told him. "But when are you going to do something?" On tour in Madrid with a Moscow orchestra in 1983, he entered the American embassy and requested refugee status. Within three months, he began a nine-city American tour with the Los Angeles Philharmonic.

When I first knew him in the late 1980s, Lexo lived in an apartment near Lincoln Center barely larger than his grand piano. The photographs on the lid were of his family; of himself with Van Cliburn, with Zubin Mehta, and with Esa-Pekka Salonen posed alongside a smiling, life-sized cutout of Ronald Reagan. A miniature basketball hoop was affixed to the bedroom door. A three-panel panorama of Tbilisi sat privately in a closet. Toradze was a study in excess: he drank, he smoked, his weight fluctuated wildly. As a pianist, he was loved or loathed. His personal life lacked stability. But his warmth and intellect, his gift for friendship and for original conversation, forged exceptional loyalties.

In 1990, he married an American girl, a fledgling pianist from Florida. In 1991 he accepted a piano professorship at Indiana University at South Bend—a place best known for Notre Dame's

football team. Transplanted to northern Indiana, he proceeded to re-create the intense mentoring environment he had known in Moscow, as well as the communal social life he had known in Tbilisi. To date, he has recruited over seventy gifted young pianists, mainly from Russia and Georgia. They bond as a family, with Lexo the stern or soft surrogate father. They make music and party with indistinguishable relish. Lexo's big house, on a suburban street without sidewalks, is their headquarters. Since separating from his wife in 1999, he has densely decorated the downstairs rooms with an assortment of American, Russian, and Georgian books and embellishments; the upstairs walls remain blank. The basement comprises a Ping-Pong room, a table-hockey room, and a Finnish sauna. The swimming pool outside is used in winter for furious ice baths in alternation with languorous sauna sittings.

South Bend is welcoming, comforting, and incongruous. As new Americans, the members of the Toradze community eat pizza, play basketball, and barbecue salmon in the backyard. They are addicted to such gadgets and amenities as giant TVs and state-of-the-art audio systems. They shop for steak and vodka in the early hours of the morning in vast twenty-four-hour food marts. Their social rituals are Russian or Georgian. So is their informed enthusiasm for jazz, which preceded their arrival. Though they do not attend the football games, Lexo's excitement was boundless when he discovered that the forward pass was a South Bend invention.

To date, a dozen of them have become American citizens. They have found collegiate or university piano positions in Iowa, Ohio, Michigan, Massachusetts. A Toradze alumna accompanies the Notre Dame chorus. Another plays the organ in a South Bend church. Yet the group remains indissoluble. As the Toradze Piano Studio, Lexo and his students, past and present, comprise a unique touring ensemble, giving marathon programs of Shostakovich in Paris, Prokofiev in Edinburgh and St. Petersburg, Stravinsky in

Rotterdam, Rachmaninoff in Salzburg. At Germany's Ruhr Piano Festival, they offered an eight-hour Scriabin program. Instigated by Lexo, they have also launched ambitious forays into American repertoire: Gottschalk, Griffes, Farwell, Ives, Gershwin, Barber, Copland, Bernstein. At Italy's Stresa festival, they explored "Dvořák and America." Their United States bookings are less extensive: the culture of performance prefers brand names.

Toradze himself plays no American music. In his fifties, he alternates between Herculean gusts of energy and bouts of depressive calm. In the piano world, he remains a singular and confrontational artist. He insists on treating personal drama as a necessary aspect of interpretation. Teaching Beethoven's Op. 109 Sonata on Japanese television a couple of years ago, he fearlessly applied to its three-movement design the story of Beethoven's "immortal beloved." He did not insist that others agree—only that personal meanings be discovered and enforced. His style is widely considered self-indulgent or revelatory.

He is a painstaking if sporadic worker who struggles to discipline his time. He acquires new repertoire slowly. Most of what he plays is Russian: Tchaikovsky, Rachmaninoff, Stravinsky, Shostakovich. His most indelible statement comes in Prokofiev's Second Piano Concerto; interpolating darting swells and stabbing staccatos, writhing rubatos and colossal chordal onslaughts, he reinvents this music as a traumatic narrative of loss extrapolated from the dedication to Maksimilian Shmitgoff, a deceased friend of the composer. "The concerto is his friend's life and funeral, the devastation Prokofiev experienced and his desire to turn the clock back," Lexo explains. "At the start of the piano part Prokofiev writes 'narrante'—he starts his story telling you about his beloved friend who died. He asks you to share his pain. The second theme shows the youngster's playfulness; he remembers funny stories associated with him and elaborates on that. The cadenza is unique

in all Prokofiev's music; you will never find in the other concertos, or in any of the sonatas, such *intense* devastation. The climax of the cadenza is the entrance of the orchestra, which is itself an unusual thing. It says that you cannot grieve all by yourself—without sharing your sorrow, your pain, with other people. In Russia, and also in Georgia, death is a huge public event. *Everyone* comes to the funeral. It sounds so trivial to say these words, but this is such an *honest* description. I'm sure if you were to talk to Prokofiev, he never would be able to talk to you as sensitively as he speaks in his music here."

Toradze believes that the loneliness of exile is useful to him. "I can't just look at a score and think: Gosh, what a beautiful concerto; I'm going to make it just delicious. That doesn't interest me. Composers, if they are expressing something, they do it because they cannot express it in other ways, because there is something they need to get out of their system. You don't need to get out of your system pure happiness and joy. No, because it's comfortable. So you need an element of discomfort, of irritation, certain spiritual urges that make you create this or that. That's where our real differences are—in pain. Tolstoy, at the beginning of *Anna Karenina*, says: 'All happy families resemble one another; each unhappy family is unhappy in its own way.' So I have to find this element. I have to find two or three pages of pain. Then I use that, because I can associate with that, and elaborate. I can use my own experience. And fortunately, my own experience with pain is quite considerable."[16]

Toradze's most frequent concerto partner is Valery Gergiev, whom he has known since their Moscow student days; he is a de facto member of Gergiev's nonpareil Kirov ensemble, regularly touring Europe and America with the Kirov Orchestra. In 1991, he returned to Russia for the first time, to perform the second Prokofiev concerto with Gergiev. In 2005, he took the Toradze Studio on tour throughout Georgia, still the home of his mother

and the site of his father's grave, presiding over eighteen concerts of five and six hours each over the course of three weeks. His career remains European-based. With few exceptions, his friends are European, Russian, and Georgian.

Returning from abroad, Lexo will report copiously on the extraordinary musical public in Berlin, Budapest, Prague, or Tel Aviv. He permits himself rare outbursts of frustration with American cultural conditions. And South Bend can seem suffocating. Feelings of gratitude and friendship war with impatience and fatigue. There are other feelings less apparent to an American like myself. Lexo tells me:

"Very obviously, from the standpoint of nourishing cultural needs, South Bend may not be the ideal place for young artists to grow up. And it may not be true that we actually enjoy in this country all the 'open society' benefits that we've been told about. But for my generation—especially in Soviet Russia, at the Moscow Conservatory and also in Tbilisi—this notion of American freedom is still powerful, and I'm sure it's still powerful for the world at large. For my generation, even the musical aspect of freedom was symbolized by American jazz. We would stay up at night, years in a row, listening to the Voice of America at 12:15 a.m.: Willis Canover's jazz hour. That was the talk of my generation and also of my parents' generation. Of course you were in danger if you listened to these broadcasts. We often listened in a basement, where an older friend of ours had a very powerful shortwave receiver. That gave us a sense of freedom. Then life goes by and you actually get to this country and you *carry* this notion with you, even if you grow disappointed. Even if everyday life can be pretty harsh and difficult, still that cannot spoil the dream. It's a dream so strongly associated with your youth that you're just saturated with it. You can smell it, taste it, touch it. You can't kill it and you don't want to kill it. This dream is one of the things that bonds our group, even though we are now here

in America. It's a condition of hope associated with a faraway place. It's actually a dream stronger than any reality."

On New Year's Day 2006, a wedding was held at Lexo's house—the fifth to take place within the Studio. The partying lasted for three days. Lexo was best man. A Studio pianist played Mendelssohn's wedding march for the newlyweds—after which Lexo's older son, David, played "The Star-Spangled Banner" on his trumpet. The elaborate rituals of male fellowship—kissing and toasting and drinking and toasting some more—honored centuries of Georgian tradition passed from father to son. The American guests, a minority, seemed to me a welcome but marginal presence. Lexo felt otherwise. He lifted his glass and said:

"Fourteen years ago, we came here to South Bend, where I had an opportunity to gather together this group of young friends and artists. The Martins, Rex and Alice, who endow my professorship, have been involved in practically every facet of the Studio. There is also Ernestine Racklin and her family, who constantly involve my students in their social life. And there are many others. But the most important support is the gradual support of the South Bend community over time. Indiana is a slow-to-react place. But the support is true support, sincere support, and when it gets moving it becomes something difficult to stop. It has nothing to do with loud showing off, with 'Look what I've done.' It's down-to-earth support. From 1994 we started to travel a lot and we absorb very powerful experiences abroad. But then we return to the quiet and humble atmosphere of South Bend and it feels like home. This is where my boys were born. This is where some of us grew older and others of us grew up.

"When I asked David the other day what he would like to play at the wedding, he said, 'The Star-Spangled Banner.' I said, 'OK. Fantastic.' Why not? I think that even *Balanchine* would not have succeeded if he had remained in Russia. Not because he was Georgian, rather than Russian. Not because of politics either, but be-

cause the whole structure of Russian culture and tradition would not have permitted his innovations and free spirit. Something like that is also true of us. I mean, I can't envision a group of performers in which 80 percent are not native-born succeeding anywhere else. Can you imagine something like this in Russia? In Germany? In *France*? You need an open, accepting environment, you need the attitude 'Let it be.' I feel this in South Bend. People trust and respect the way we do things. In fact, there are people here, including the chancellor, who have not been in South Bend as long as we have. This is something that could only happen in America."[17]

NOTES

PREFACE *(pages xv–xix)*

1. Andrea Olmstead, *Conversations with Roger Sessions* (1987), pp. 216–17.

INTRODUCTION: CULTURAL EXCHANGE *(pages 1–21)*

1. *New York Herald*, May 21, 1893.
2. Antonin Dvořák, "Music in America," *Harper's New Monthly Magazine*, Feb. 1895. On Dvořák in America: Joseph Horowitz, *Classical Music in America: A History of Its Rise and Fall* (2005), pp. 5–10, 66–69, 222–32; and Michael Beckerman, *New Worlds of Dvořák* (2003).
3. Anthony Heilbut, *Exiled in Paradise: German Refugee Artists and Intellectuals in America from the 1930s to the Present* (1983), p. 72.
4. For a useful list of "300 Notable Emigres," see Donald Fleming and Bernard Bailyn, *The Intellectual Migration: Europe and America, 1930–1960*, pp. 675–718.
5. Louis Moreau Gottschalk, *Notes of a Pianist* (1964), p. 63.
6. See Horowitz, *Classical Music in America*, for a detailed narrative of American classical music before World War I.

CHAPTER ONE: HOW TO BECOME AN AMERICAN *(pages 23–75)*

The best Balanchine biography is still Bernard Taper's *Balanchine: A Biography*. Notes below refer to the 1996 University of California Press paperback edition.

1. Solomon Volkov, *St. Petersburg: A Cultural History* (1995), p. 312.
2. Taper, p. 91.
3. Balanchine quote in Lincoln Kirstein, *Thirty Years: The New York City Ballet* (1978 ed.), p. 66.
4. Taper, p. 106.
5. Balanchine quoted in Solomon Volkov, *Balanchine's Tchaikovsky* (1992), p. 106. Stravinsky quoted in Taper, pp. 162–63.
6. Kirstein, p. 55.
7 Balanchine quoted in Taper, p. 175. Bolger quoted in Taper, p. 181, and Terry Teachout, *All in the Dances: A Brief Life of George Balanchine* (2004), p. 71. Balanchine on Astaire in Charles M. Joseph, *Stravinsky and Balanchine* (2002), p. 158.
8. "Ashfield's Nights" in Joseph, pp. 16, 27. Taper, p. 195.
9. *Balanchine*, a documentary by Merrill Brockway (1984).
10. Nancy Reynolds and Malcolm McCormick, *No Fixed Points: Dance in the Twentieth Century* (2003), p. 147.
11. Taper, p. 157.
12. Kirstein, p. 105.
13. Taper, p. 233.
14. Taper, p. 243.
15. Reynolds and McCormick, p. 439.
16. Robert Cornfield, ed., *Edward Denby: Dance Writings and Poetry* (1998), p. 251.
17. Dvořák letters, April 12, 1893, and Sept. 15, 1893, in Otakar Sourek, ed., *Antonin Dvořák: Letters and Reminiscences*, trans. Roberta Finlayson Samsour (1954). *Balanchine by Balanchine* (San Marco Press, 1984), p. 10.
18. Balanchine quoted in Taper, p. 332. Kirstein, pp. 39, 108, 77. Cornfield, p. 222. Brenda Dixon Gottschild, *Digging the Africanist Presence in American Performance* (1996), pp. 62–78.

19. Eric Walter White, *Stravinsky: The Composer and His Works* (1979 ed.), p. 115.

20. Robert Craft and Igor Stravinsky, *Memories and Commentaries* (2002), p. 139.

21. Wayne D. Shirley, ed., "Aaron Copland and Arthur Berger in Correspondence," in Judith Tick and Carol Oja, eds., *Aaron Copland and His World* (2005), pp. 191–92.

22. Taper, p. 106.

23. "Second motherland" in Igor Stravinsky, *An Autobiography* (1962 ed.), p. 86. Berlin headline in John Willett, *Art and Politics in the Weimar Period* (1978), p. 160. Chicago in Richard Taruskin, *Stravinsky and the Russian Traditions* (1996), vol. 1, p. 3. U.S. War Department in Joseph, *Stravinsky and Balanchine,* p. 175. Nabokov in Tony Palmer, *"Once, at a border . . .": Aspects of Stravinsky* (Kultur video).

24. Letters and private papers, and ghostwriting, in Joseph, pp. 21–23; and Charles M. Joseph, *Stravinsky Inside Out* (2001), p. 24. Stravinsky, *Autobiography*, foreword and p. 176.

25. Robert Craft, *Stravinsky: Glimpses of a Life* (1992), p. 61. Taruskin, vol. 1, pp. 1–19.

26. Nabokov quote and "Mr. Truman" in Nicolas Nabokov, *Old Friends and New Music* (1951), pp. 150–51. Mann quoted in White, p. 117. Nabokov on Stravinsky's study in White, p. 126. Nabokov on "social disorder" in Nabokov, p. 150. Pearl Harbor in White, p. 122.

27. Jack Sullivan, *New World Symphonies* (1999), p. 177; White, p. 119.

28. Lillian Libman, *And Music at the Close: Stravinsky's Last Years* (1972), pp. 100, 103, 334. On resettling in England, see Joseph, *Stravinsky Inside Out*, p. 14.

29. Paul Horgan, *Encounters with Stravinsky* (1972), pp. 99, 141.

30. Libman, pp. 91, 63.

31. Craft, *Glimpses of a Life*, pp. 44, 46.

32. Libman, pp. 230, 235.

33. Craft, *Glimpses of a Life*, pp. 46, 61. "Ten years later" in Craft and Stravinsky, *Memories and Commentaries*, p. xiii. Libman, pp. 240–41. *Hi Fi/Stereo Review*, Feb. 1965.

34. Felix Galimir, in conversations with the author.

35. Claudio Spies, "Notes on His Memory," *Perspectives of New Music* 9, no. 2, and 10, no. 1 (1971): 155–56.

36. Libman, p. 111.

37. Stephen Walsh, *Stravinsky: A Creative Spring* (2000), p. 416.

38. The most comprehensive Balanchine catalogue is *Choreography by George Balanchine: A Catalogue of Works* (1984).

39. Taper, p. 221; Kirstein, p. 59.

40. Balanchine quoted in Volkov, *Balanchine's Tchaikovsky*, p. 309; and Taper, pp. 197, 316, 360. Stravinsky quoted in Kirstein, p. 310. Denby in Cornfield, pp. 218, 284, 241. Stravinsky, *Autobiography*, p. 53.

41. Taper, p. 40.

42. George Balanchine, "The Dance Element in Stravinsky," in "Stravinsky in the Theatre," a symposium prepared by Minna Lederman, in *Dance Index* 6, nos. 10–11–12 (1947). Stravinsky and Theodore quoted in Joseph, *Stravinsky and Balanchine*, pp. 12–13. Nabokov, p. 157.

43. Cornfield, p. 287.

44. Craft and Stravinsky, pp. 220–21.

45. Craft and Stravinsky, pp. 136, 190, 233.

46. Libman, p. 81. Taper, p. 258.

47. *The Flood* may be viewed at the Museum of Television and Radio, New York City.

48. Taper, p. 246.

49. Stravinsky in Joseph, *Stravinsky and Balanchine*, p. 10. Balanchine in Volkov, *Balanchine's Tchaikovsky*, p. 71.

50. On *Mir iskusstva*, see Taruskin, vol. 1 and 2. Libman, p. 306. Craft in Palmer. Stravinsky, *Autobiography*, pp. 154, 157. Soulima in Joseph, *Stravinsky and Balanchine*, p. 41.

51. Balanchine on St. Petersburg in Volkov, *Balanchine's Tchaikovsky*, ch. 3. Balanchine on religion in Volkov, *Balanchine's Tchaikovsky*, p. 39. Milstein in Volkov, *St. Petersburg*, p. 329. On Stravinsky's politics, see Craft, *Glimpses of a Life*, p. 47, and Joan Evans, "Stravinsky's Music in Hitler's Germany," *Journal of the American Musicological Society* 56, no. 3 (2003).

52. Craft and Stravinsky, p. 125. Libman, pp. 227, 84. Taruskin, vol. 1, p. 18.

53. Taper, pp. 287, 105, 288. Robert Gottlieb, *George Balanchine: The Ballet Maker* (2004), p. 166.

54. Taper, in conversation with the author, August 2006. Nabokov, p. 143. Craft, *Stravinsky: Chronicle of a Friendship, 1948–1971* (1994), p. 195.

55. "In translation" in Craft and Stravinsky, p. 16. Libman, pp. 32, 156.

56. Libman, p. 32.

CHAPTER TWO: THE GERMAN COLONIZATION OF AMERICAN CLASSICAL MUSIC *(pages 77–159)*

1. Otto Friedrich, *Before the Deluge: A Portrait of Berlin in the 1920s* (paperback, 1972), p. 155.

2. Zuckmayer in Peter Gay, *Weimar Culture* (paperback, 1970), p. 132. Bruno Walter, *Theme and Variations* (1946), p. 269. Joseph Horowitz, *Conversations with Arrau* (1982), p. 94.

3. Stephen Lehmann and Marion Faber, *Rudolf Serkin: A Life* (2003), p. 25

4. Lehmann and Faber, p. 42.

5. Lehmann and Faber, pp. 71, 73.

6. Horowitz, p. 85. Lehmann and Faber, p. 33.

7. Horowitz, p. 39.

8. Busch's wife and Busch quoted in Lehmann and Faber, pp. 92, 91.

9. Quoted by Charles Berigan in album note for Philips 456964–2.

10. Lehmann and Faber, pp. 149, 168.

11. Lehmann and Faber, p. 88.

12. Abram Chasins, *Speaking of Pianists* (1957), p. 134.

13. Lehmann and Faber, p. 42.

14. Joseph Horowitz, *The Ivory Trade* (1990), pp. 70–78.

15. Lehmann and Faber, p. 219.

16. Lehmann and Faber, pp. 103–4.

17. Lehmann and Faber, pp. 221, 223.

18. Lehmann and Faber, p. 260.

19. Reinhold Brinkmann and Christoph Wolff, eds., *Driven into Paradise: The Musical Migration from Nazi Germany to the United States* (1999), p. 21.

20. On Szell: Joseph Horowitz, *Understanding Toscanini: How He Became an American Culture-God and Helped Create a New Audience for Old Music* (1987), p. 336; and Horowitz, *Classical Music in America*, pp. 311–13.

21. Lehmann and Faber, pp. 25, 94.

22. On Price, Judson, and the New York Philharmonic conductors, see Horowitz, *Classical Music in America*, pp. 423–24.

23. For letter to Judson, see Peter Heyworth, *Otto Klemperer: His Life and Times*, vol. 2 (1996), p. 60. On Klemperer and Mitropoulos in the United States, see Horowitz, *Classical Music in America*, especially pp. 313–25.

24. Vernon Duke, *Passport to Paris* (1955), p. 250.

25. David Josephson, "The Exile of European Music: Documentation of Upheaval and Immigration in the *New York Times*," in Brinkmann and Wolff, pp. 112–20.

26. Krenek in Jost Hermand and James Steakley, eds., *Writings of German Composers* (1984), pp. 276–83.

27. Krenek quoted in Brinkmann and Wolff, p. 8. Krenek interviewed by the author in Palm Springs, 1980.

28. Schoenberg letters quoted from Erwin Stein, ed., *Arnold Schoenberg Letters* (1987), pp. 211, 204, 270, 242, 197. "From one country to another" quoted from Leonard Stein, ed., *Writings of Arnold Schoenberg* (1984), p. 148. "Driven into paradise" quoted from Brinkmann and Wolff, p. 79. On Schoenberg and film, see Sabine Feisst, "Arnold Schoenberg and the Cinematic Art," *Musical Quarterly* 83, no. 1 (1999). On Schoenberg and America: Michael Kater, *Composers of the Nazi Era* (200), pp. 183–210, and Feisst, "Arnold Schoenberg—American," a paper delivered at the 2007 conference of the Society for American Music.

29. Hindemith on Disney and Los Angeles in Hermand and Steakley, pp. 240–41. Fourteen commissions and "everybody seems to know" from Brinkmann and Wolff, pp. 201, 206. See also Kater, pp. 31–56.

30. For Bartók quotes, see Tibor Tallian, "Bartók's Reception in America, 1940–1945" and "Writings by Bartók," both to be found in Peter Laki, ed., *Bartók and His World* (1995), especially

pp. 258, 221, 103, 105, 107. Menuhin quoted in Brinkmann and Wolff, p. 72.

31. Luther Noss, *Paul Hindemith in the United States* (1989), p. 123.

32. For 1948 essay, see Stein, *Style and Idea*, p. 108. For letters, see Stein, *Letters*, pp. 236, 248. "If immigration has changed me" in Jarrell Jackman and Carla Borden, eds., *The Muses Flee Hitler*, p. 98.

33. Letters to Mahler in Stein, *Letters*, pp. 293–98. "Destiny" and "profound gratitude" in *Letters*, pp. 109, 239. "Futile success" in Stein, *Style and Idea*, p. 52. "All American orchestras" cited by Kater, p. 194.

34. Nathan Platte, "Dream Analysis: Erich von Korngold's Weaving of Music, Dialogue, and Visuals in Warner Brothers' *A Midsummer Night's Dream*," unpublished paper delivered at Society for American Music conference, March 2004.

35. Erich Korngold, "Some Experiences in Film Music," in José Rodriguez, ed., *Music and Dance in California* (1940), pp. 137–39.

36. Copland quotes from Aaron Copland, *Our New Music* (1941), pp. 260–72.

37. Felix Galimir in conversation with the author.

38. Weill quotes in Kim Kowalke, *Kurt Weill in Europe* (1979), pp. 462, 484.

39. Weill quoted in Hermond and Steakley, p. 216. Canetti quoted in Stephen Hinton, *The Threepenny Opera* (1990), pp. 190–92.

40. Weill quoted in Brinkmann and Wolff, pp. 202, 204; and in Anthony Heilbut, *Exiled in Paradise: German Refugee Artists and Intellectuals in America from the 1930s to the Present* (1983), p. 151. Lenya in conversation with the author.

41. Weill on jazz cited in Hermond and Steakley, p. 265. All other Weill quotes from Kim Kowalke, "Kurt Weill, Modernism, and Popular Culture: Offentlichkeit als Stil," *Modernism/Modernity* 2, no. 1 (1995): 33, 58, 32.

42. Klemperer quote in Brinkmann and Wolff, p. 209. Weill letter in Kim Kowalke and Lys Symonette, eds., *The Letters of Kurt Weill and Lotte Lenya* (1996), p. 209. Adorno quoted by David Drew in Kim Kowalke, ed., *A New Orpheus: Essays on Kurt Weill*, p. 218.

43. For cited reviews of Weill on Broadway, see Jürgen Schebera, *Kurt Weill: An Illustrated Life* (1995), pp. 270, 280; Ronald Sanders, *The Days Grow Short: The Life and Works of Kurt Weill* (1980), pp. 360, 311; Kim Kowalke, "Kurt Weill and the Quest for American Opera," in Hermann Danuser and Hermann Gottschewski, eds., *Amerikanismus, Americanism, Weill: Die Suche nach Kultureller Identität in der Moderne* (2003), p. 286. "Jealous composers" cited in Kowalke, "Kurt Weill, Modernism, and Popular Culture," p. 60. Moore quote in Brinkmann and Wolff, p. 210.

44. Kowalke, "Kurt Weill, Modernism, and Popular Culture," p. 37.

45. Kowalke and Symonette, p. 192.

46. Schebera, p. 315.

47. Lenya in conversation with the author, Oct. 1979.

48. For an excellent analysis, see Larry Stempel, "*Street Scene* and the Enigma of Broadway Opera," in Kowalke, *A New Orpheus*.

49. Kowalke, "Kurt Weill and the Quest for American Opera," p. 293.

50. Lenya in Kowalke and Symonette, pp. 382. Weill on Rodgers cited in Stempel, p. 324. Weill on Gershwin in Kowalke and Symonette, p. 207; and Kater, p. 69.

51. David Drew, "Kurt Weill," *The New Grove Dictionary of Music and Musicians* (1980), vol. 20, p. 308.

52. Kim Kowalke, "*The Threepenny Opera* in America," in Hinton, p. 114.

53. Kurt Weill, "Ferruccio Busoni: For His Fiftieth Birthday," in Kowalke, *Kurt Weill in Europe*, p. 477.

54. Ferruccio Busoni, "The Future of Music," in Busoni, *"The Essence of Music" and Other Papers* (paperback, 1957), pp. 39–40.

55. Busoni, pp. 40–41.

56. Kurt Weill, album note for *Street Scene* (Columbia Records). Drew, pp. 308–9.

57. Weill quoted in Stempel, p. 334. Lenya in conversation with the author, Oct. 1979.

58. Kazan quoted in Lisa Aronson and Frank Rich, *The Theatre Art of Boris Aronson* (1987), p. 85. Marjorie Loggia and Glenn Young, eds., *Clurman: The Collected Works* (2000), p. 227. Ethan Mord-

den, *Beautiful Mornin': The Broadway Musical in the 1940s* (1999), p. 163. Mark Grant, *The Rise and Fall of the Broadway Musical* (2004), p. 73.

CHAPTER THREE: THE MUSICAL "MARGIN OF THE UNGERMAN" *(pages 161–215)*

1. Oliver Daniel, *Stokowski: A Counterpoint of View* (1982), p. 226. Louise Varèse, *Varèse: A Looking-Glass Diary*, vol. 1 (1972), pp. 150, 235.

2. On Dvořák, see Michael Beckerman, *New Worlds of Dvořák* (2003), On Mahler, see Norman Lebrecht, ed., *Mahler Remembered* (1987), p. 295. On Seidl, see Joseph Horowitz, *Wagner Nights: An American History* (1994), p. 88.

3. Thomas Stoner, ed., *"Wanderjahre of a Revolutionist" and Other Essays on American Music by Arthur Farwell* (1995), p. 96.

4. Varèse, pp. 23, 102.

5. Varèse, p. 154.

6. Varèse, p. 155.

7. Carol Oja, *Making Music Modern* (2003), p. 183.

8. Varèse quote from Horowitz, *Classical Music in America*, pp. 452, 453; and Varèse, p. 49. Louise Varèse quoted in Varèse, p. 249.

9. On Varèse's disaffection for American music, Chou Wen-Chung in conversation with the author. Stokowski quoted in Oja, pp. 186–87.

10. Daniel, p. 226.

11. Philadelphia Orchestra archives.

12. Reviews in Varèse, p. 224; and Daniel, p. 226.

13. Varèse, p. 225.

14. Reviews in Daniel, p. 227; and Varèse, p. 247.

15. Varèse, p. 236. Chou Wen-Chung in conversation with the author.

16. Rosenfeld in Oja, pp. 40–41. Varèse in Jack Sullivan, *New World Symphonies* (1999), pp. 143, 144. Henderson in *New York Times*, Dec. 17, 1893.

17. Chou Wen-Chung in conversation with the author.

18. Varèse, p. 233.

19. William A. Smith, *The Mystery of Leopold Stokowski* (1990), p. 43. On Stokowski, also see Daniel; Horowitz, *Classical Music in America;* and Abram Chasins, *Leopold Stokowski* (1979).

20 Nancy Shear, in conversation with the author.

21. Horowitz, *Understanding Toscanini*, p. 176.

22. Boston Symphony Orchestra archives.

23. Nancy Shear, in conversation with the author.

24. Smith, p. 49. Tim Page, ed., *The Glenn Gould Reader* (1984), p. 261. Steven Bach, *Marlene Dietrich: Life and Legend* (1992), p. 169.

25. Nancy Shear, in conversation with the author.

26. Daniel, pp. 7, 13.

27. Nancy Shear, in conversation with the author.

28. Harry Ellis Dickson, *"Gentlemen, More Dolce Please"* (1969), p. 46. Nicolas Slonimsky, *Perfect Pitch: A Life Story* (1988), pp. 77–78, 95. Charles O'Connell, *The Other Side of the Record* (1947), p. 254. On Koussevitzky generally: M. A. D. Howe, *The Boston Symphony Orchetra 1881–1931* (1931); Hugo Leichtentritt, *Serge Koussevitzky, the Boston Symphony Orchestra and the New American Music* (1946); Moses Smith, *Koussevitzky* (1947); Horowitz, *Classical Music in America.*

29. Aaron Copland, "Serge Koussevitzky and the American Composer," *Musical Quarterly* 30 (1944): 255. Koussevitzky quoted in Olga Koussevitzky, *The Koussevitzky Story* (published memoir, New York Public Library at Lincoln Center), p. 175. Copland statistics from Boston Symphony Orchestra archives. Copland quoted in John Gruen, WNCN radio interview, Dec. 8, 1975, side B (New York Public Library at Lincoln Center).

30. Copland, pp. 255–61.

31. On Koussevitzky and Stravinsky: Stephen Walsh, *Stravinsky: A Creative Spring* (1999), pp. 332–33. "Member of the family" in Robert Craft and Igor Stravinsky, *Memories and Conversations* (2002), p. 209. Victor Yuzefovich, ed., "Chronicle of a Non-Friendship: Letters of Stravinsky and Koussevitzky," *Musical Quarterly* 86, no. 4 (Winter 2002).

32. Slonimsky, p. 149.

33. Howard Pollack, *Aaron Copland: The Life and Work of an Uncommon Man* (1999), p. 124.

34. Herbert Kupferberg, *Tanglewood* (1976), pp. 38–40, 69.
35. Leichtentritt, pp. 183–91.
36. "Proud to be an American" in unidentified Springfield newspaper, May 19, 1941, Boston Symphony Orchestra Archives. Koussevitzky quoted in Kupferberg, p. 93.
37. O'Connell, p. 271.
38. *Time* magazine, July 22, 1946, p. 56. Popular magazine article: Serge Koussevitzky, "American Composer," unidentified "Koussevitzky" clipping, New York Public Library at Lincoln Center. Olga Koussevitzky, p. 194. "Shalom" in Slonimsky, p. 107. Bernstein in Kupferberg, p. 129.
39. Nicolas Nabokov, *Old Friends and New Music* (1951), p. 184. Lukas Foss, in conversation with the author.
40. Lukas Foss, "Koussevitzky: Reminiscences," album note for RCA Victor VCM 6174 (a 3-LP Koussevitzky tribute), 1966.
41. *New York Sun*, Feb. 17, 1930. A. and K. Swan, "Rachmaninoff—Personal Reminiscences," *Musical Quarterly* 30 (1944):185.
42. A central topic in Horowitz, *Understanding Toscanini*.
43. On Heifetz and Horowitz, see Joseph Horowitz, *Classical Music in America*, pp. 336–43. Horowitz quotes in Glenn Plaskin, *Horowitz: A Biography* (1983), pp. 229, 230, 246.
44. Horowitz, *Understanding Toscanini*, p. 90.
45. On Toscanini in America, see Horowitz, *Understanding Toscanini*. NBC press dept., Marek, Ewen, Sacchi, all quoted in *Understanding Toscanini*, pp. 279, 285, 289. Toscanini quoted in Harvey Sachs, *Toscanini* (1978), p. 301.
46. Howard Taubman, "The Transformation of Vladimir Horowitz," *New York Times Magazine*, Oct. 17, 1948.
47. Bruno Nettl, "Displaced Musics and Immigrant Musicologists: Ethnomusicological and Biographical Perspectives," in Reinhold Brinkmann and Christoph Wolff, eds., *Driven into Paradise: The Musical Migration from Nazi Germany to the United States* (1999), pp. 62–63.
48. Quoted in *New York Times*, Dec. 12, 1937. Cited in Laura Manion, "Musical Immigrants: A Case Study in Nativism and Musical Identity, 1920–1945" (unpublished).
49. Erwin Stein, ed., *Arnold Schoenberg Letters* (paperback, 1987), p. 210.

CHAPTER FOUR: "IN HOLLYWOOD WE SPEAK GERMAN" *(pages 217–309)*

1. Sternberg quotes from Josef von Sternberg, *Fun in a Chinese Laundry* (1965), pp. 146–47; and *The World of Josef von Sternberg*, a BBC documentary (1966) included as part of the Criterion Collection DVD of Sternberg's *The Scarlet Empress* (2001).

2. Steven Bach, *Marlene Dietrich: Life and Legend* (1992), p. 136. Paramount executive in J. David Riva, director, *Marlene Dietrich: Her Own Song* (2001).

3. Maria Riva, *Marlene Dietrich* (1994), p. 345.

4. Riva, p. 290.

5. Riva, p. 93.

6. Riva, p. 155.

7. David Thompson, *The New Biographical Dictionary of Film* (2004), p. 236. Riva, p. 73. Bach, pp. 199, 197, 392, 163.

8. Dietrich quotes in Riva, pp. 540, 576; and Bach, pp. 309, 304.

9. Bach, p. 403.

10. Bach, p. 407.

11. Bach, pp. 400, 476. Riva, p. 589.

12. Bach, pp. 452, 761.

13. John Baxter, *The Hollywood Exiles* (1976), p. 84.

14. Baxter, pp. 48, 39.

15. Bach, p. 241.

16. Baxter, p. 202.

17. Baxter, p. 106.

18. Marc Eliot, *Cary Grant: A Biography* (2004), p. 72.

19. Zukor and Powell quoted in Baxter, pp. 197, 121.

20. Baxter, p. 70. *Motion Pictures* magazine quoted in Lotte Eisner, *Murnau* (1973), p. 169.

21. Murnau quoted in Eisner, pp. 211, 208.

22. Viertel, p. 146.

23. Murnau quoted in Eisner, p. 213. Eisner quoted in Viertel, p. 145. Thomson, p. 620. Baxter, pp. 68, 71. Viertel, p. 136. Lang and Jannings quoted in Eisner, pp. 225–26.

24. Herman G. Weinberg, *The Lubitsch Touch: A Critical Study* (1968), p. 102.

25. Lubitsch quoted in Scott Eyman, *Ernst Lubitsch: Laughter in Paradise* (1993), p. 95, 132. Bettelheim-Bentley quoted in Eyman, p. 139.

26. Eyman, p. 125.

27. Eyman, p. 81.

28. Paramount quoted in Eyman, p. 183. Weinberg, pp. 61–62.

29. Weinberg, p. 144. Raphaelson quoted in Eyman, p. 200.

30. Eyman, p. 200.

31. Lubitsch, quoted in Weinberg, p. 247. Thomson, p. 536.

32. Thomson, p. 536. Sternberg, p. 38. Raphaelson quoted in Eyman, p. 251.

33. Reinhardt quoted in Eyman, pp. 249, 251. Raphaelson quoted in Eyman, p. 281.

34. Kevin Brownlow, *The Parade's Gone By . . .* (1976), p. 130.

35. Barry Paris, *Garbo* (1994), p. 58.

36. Williams quoted in Paris, p. 410. Viertel cited in Paris, p. 423. Garbo cited in Viertel, pp. 152, 183. Paris, p. 334.

37. Tynan and Cooke quoted in Paris, pp. 235, 317.

38. Porter quoted in Baxter, p. 131. Wilder, Garbo, and Dressler quoted in Paris, pp. 550, 355, 245.

39. Viertel, p. 40.

40. Paris, pp. 255, 360.

41. Paris, p. 363.

42. Eyman, p. 269.

43. Weinberg, p. 306.

44. Richard Schickel, *Matinee Idylls* (1999), p. 44.

45. Lang and Kracauer quoted in Patrick McGilligan, *Fritz Lang: The Nature of the Beast* (1997), pp. 98, 103.

46. McGilligan, p. 20.

47. Lotte Eisner, *Fritz Lang* (1977), p. 129. Siegfried Kracauer, *From Caligari to Hitler: A Psychological History of German Film* (1947), pp. 249–250.

48. McGilligan, pp. 173, 14, 20, 179.

49. Barry Keith Grant, ed., *Fritz Lang Interviews* (2003), p. xiii.

50. McGilligan, p. 209.

51. Lang quoted in Heilbut, *Exiled in Paradise*, p. 247; and McGilligan, p. 219.

52. Nick Smedley, "Fritz Lang's Trilogy: The Rise and Fall of a European Social Commentator," *Film History* 5 (1993): 2.

53. On Lang and the anti-fascist left, see Saverio Giovacchini, *Hollywood Modernism: Film and Politics in the Age of the New Deal* (2001). (It was Giovacchini who apprised the author that Lang knew Adorno in California.) Fonda quoted in McGilligan, p. 265.

54. Giovacchini, pp. 38–39. Thomson, p. 747.

55. Robinson quoted in McGilligan, p. 311. McGilligan, p. 326.

56. Lang quoted in Grant, p. 113; and McGilligan, p. 315.

57. Lang quoted in Heilbut, p. 337; and McGilligan, p. 466.

58. Heilbut, p. 237.

59. Otto Preminger, *An Autobiography* (1977), p. 3.

60. Ed Sikov, *On Sunset Boulevard: The Life and Times of Billy Wilder* (1998), p. 252.

61. Sikov, p. 249.

62. Sikov, pp. 272, 278.

63. Sikov, p. 303.

64. Viertel, p. 162.

65. Viertel, p. 250.

66. Viertel, pp. 282, 289.

67. Otto Friedrich, *City of Nets: A Portrait of Hollywood in the 1940s* (1986), pp. 316, 314, 334.

68. Viertel, p. 302. Mann quoted in Friedrich, pp. 320, 413.

69. Viertel, p. 304.

70. McGilligan, pp. 376, 378, 397.

71. Sikov, p. 132.

72. Sikov, p. 461.

CHAPTER FIVE: DELAYED REACTION
(pages 311–393)

1. Bruno Walter, *Theme and Variations* (1946), p. 268.

2. Gottfried Reinhardt, *The Genius: A Memoir of Max Reinhardt* (1979), pp. 280, 388.

3. Nathan quoted in Oliver Sayler, *Max Reinhardt and His Theatre* (1924), p. viii. Reinhardt, p. 357.

4. Reinhardt, p. 36.

5. Reinhardt, p. 306. William Dieterle, "Max Reinhardt in Holly-

wood," in George Wellworth and Alfred Brooks, eds., *Max Reinhardt, 1873–1973: A Centennial Festschrift* (1973), p. 44.

6. Maria Riva, *Marlene Dietrich* (1992), pp. 501. Josef von Sternberg, *Fun in a Chinese Laundry* (paperback, 1987), p. 47. Ryan in Wellworth and Brooks, p. 129.

7. Harry Horner, "Notes on Max Reinhardt's Last Years'" (in Theatre Research, New York Public Library of the Performing Arts). Frederick Tollini, *The Shakespeare Productions of Max Reinhardt* (2004), p. 214.

8. Ryan, Peck, Preminger, and Adler in Wellworth and Brooks, pp. 129, 103, 111, 23.

9. Glenn Young and Marjorie Loggia, eds., *The Collected Works of Harold Clurman* (1992), p. 1052.

10. On Brecht in America, see Heilbut, *Exiled in Paradise*, ch. 9. Brecht's testimony quoted in Friedrich, p. 331.

11. Heilbut, p. 191.

12. Brecht quoted in Heilbut, p. 225. Ben Gazzara, *In the Moment: My Life as an Actor* (2004), p. 47. Clurman in Young and Loggia, p. 323.

13. Reinhardt, p. 215.

14. Christine Edwards, *The Stanislavsky Heritage* (1965), p. 215.

15. Gavin Lambert, *Nazimova: A Biography* (1997), pp. 138, 348, 173, 99.

16. Lambert, pp. 137, 146, 147.

17. Lambert, p. 198.

18. Lambert, p. 382.

19. Lambert, pp. 388–89.

20. On opera and the New Woman, see Joseph Horowitz, *Wagner Nights: An American History* (1994), ch. 12 and pp. 338–42.

21. Lambert, p. 356.

22. Lambert, p. 263.

23. Edwards, pp. 230–31.

24. Harold Clurman, *The Fervent Years: The Group Theatre and the Thirties* (paperback, 1987), p. 6. Adler quoted in J. W. Roberts, *Richard Boleslawski: His Life and Work in the Theatre* (1977), p. 234.

25. Young and Loggia, p. 652.

26. Clurman, p. 4. Young and Loggia (eds.), p. 15.
27. Heston and "other writers" in Mark Spergel, *Reinventing Reality: The Art and Life of Rouben Mamoulian* (1993), pp. 41, 33. Clurman in Young and Loggia, p. 897.
28. Spergel, p. 42.
29. Spergel, p. 53.
30. Spergel, p. 62.
31. Dale quoted in Hollis Alpert, *The Life and Times of "Porgy and Bess"* (1990), pp. 66–67. Barnes in Spergel, p. 64.
32. Ravel and Reinhardt in Spergel, p. 67. Woollcott in Mamoulian keepsake scrapbook; Mamoulian in annotated script. Scrapbook and script in the Mamoulian archives, Library of Congress (Theatre Division), carton 2 from first Mamoulian accession from Los Angeles vault.
33. The *Love Me Tonight* Kino Video DVD (K322) includes expunged material as an ancillary feature.
34. Salka Viertel, *The Kindness of Strangers* (1969), pp. 152, 183.
35. Theatre Guild materials and annotated *Porgy and Bess* score, Rouben Mamoulian Papers, Manuscript Division, Library of Congress, Washington, D.C. (carton 2 from first Mamoulian accession from Los Angeles vault).
36. All quotes from Mamoulian keepsake scrapbook, Rouben Mamoulian Papers, Library of Congress, with the exception of "Thank you," quoted in Alpert, p. 113.
37. Richard Rodgers, *Musical Stages: An Autobiography* (1975), p. 223.
38. Clayton and Molnár in Mark N. Grant, *The Rise and Fall of the Broadway Musical* (2204), pp. 240–42. On "*Carousel* Waltz," see also Ethan Mordden, *Rodgers and Hammerstein* (1992), pp. 74–75.
39. Spergel, p. 39.
40. Spergel, pp. 199, 214, 243, 291.
41. Spergel, p. 239.
42. "Friends and acquaintances" in keepsake scrapbook, Mamoulian Papers. *Carmen* script in Mamoulian archives, box 23. Leonard Bernstein, "The Drama of *Carmen*," on *Ford Presents* (March 11, 1962), may be viewed at the Museum of Television and Radio, New York City.

43. Mamoulian Papers, box 26.
44. Lisa Aronson and Frank Rich, *The Theatre Art of Boris Aronson* (1987), p. 5.
45. Aronson and Rich, p. 7.
46. Lisa Aronson in conversation with the author (2005).
47. Aronson and Rich, p. 7.
48. Aronson and Rich, p. 8.
49. Aronson and Rich, p. 9.
50. Aronson and Rich, p. 38.
51. Brown and Simonson in Aronson and Rich, p. 12.
52. Aronson and Rich, p. 13.
53. Clurman in Young and Loggia, p. 643. Kazan in Aronson and Rich, p. 54.
54. Aronson and Rich, pp. 57, 60.
55. Vernon Duke, *Passport to Paris* (1955), pp. 382–94. Aronson and Rich, p. 73.
56. Duke, p. 389.
57. Duke, p. 390.
58. Duke, p. 393.
59. Lee and Kazan in Aronson and Rich, p. 22. Aronson in video interview with Garson Kanin, March 20, 1975 (Performing Arts Library at Lincoln Center).
60. Aronson video, March 20, 1975.
61. Smith and Lee in Aronson and Rich, pp. 21, 22.
62. Young and Loggia, pp. 643–44.
63. Aronson and Rich, pp. 141–144.
64. Aronson and Rich, pp. 220–27. Aronson video, March 20, 1975. Lisa Aronson in conversation with the author (2005).
65. Harold Prince interviewed by Edwin Wilson, "CUNY Spotlight" (1989), Performing Arts Library at Lincoln Center.
66. Aronson video, March 20, 1975.
67. Kazan in Aronson and Rich, p. 85. Aronson in video, March 20, 1975.
68. Grant, p. 256. "Broadway historian" is Ethan Mordden, *Beautiful Mornin': The Broadway Musical in the 1940s* (1999), p. 47.
69. Julie Andrews in *Hanya,* TV documentary, Performing Arts Library at Lincoln Center.

CONCLUSION *(pages 395–422)*

1. Joseph Horowitz, *Wagner Nights: An American History* (1994), p. 88.
2. Horowitz, p. 253.
3. Mann quotes from Thomas Mann, *Joseph and His Brothers*, English trans. (1943), p. xiii; and Heilbut, *Exiled in Paradise*, p. 299. *Joseph* quotes pp. 1046, 1167. Golo quoted in Anthony Heilbut, *Thomas Mann: Eros and Literature* (1995), p. 568. I borrow the phrase "exile's heightened critical animus against the homeland" from Hans Vaget, "Thomas Mann: Pro and Contra Adorno," Jost Hermand and Gerhard Richter (eds.), *Sound Figures of Modernity* (2006), p. 211.
4. Mann, pp. xiii, 1004, 1141.
5. Thomas Mann, *Doctor Faustus*, English trans. (1997), pp. 529, 428.
6. Heilbut, *Thomas Mann*, p. 500. Heilbut, *Exiled in Paradise*, pp. 309–11.
7. Vladimir Nabokov, *Lolita* (1969 paperback), p. 85 (ch. 21).
8. Vladimir Nabokov, *Speak, Memory* (1989 paperback), pp. 79, 153, 71, 170.
9. Nabokov, *Speak, Memory*, pp. 278–82, 265.
10. Nabokov quoted in Solomon Volkov, *St. Petersburg: A Cultural History* (1995), p. 323. Nabokov, *Speak, Memory*, p. 286.
11. Heilbut, *Thomas Mann*, p. 541.
12. *Nietzsche Contra Wagner* in Walter Kaufmann, ed., *The Portable Nietzsche* (1954), p. 666. Schopenhauer on music in Richard Wagner, *Beethoven*, vol. 5 of Wagner, *Prose Works*, translated by William Ashton Ellis (1896), pp. 65–69.
13. Heilbut, *Exiled in Paradise*, p. 52.
14. Milhaud and Ravel quoted in Horowitz, *Classical Music in America*, p. 461.
15. Copland, Harris, and Gershwin discussed in Horowitz, *Classical Music in America*, pp. 442, 462–68. Rosenfeld quoted in Vernon Duke, *Passport to Paris* (1955), p. 252.
16. Joseph Horowitz, *The Ivory Trade: Music and the Business of Music at the Van Cliburn International Piano Competition* (1990), pp. 90–100.
17. The author witnessed (and took part in) the wedding party.

INDEX

American Musicological Society, 214
American Opera Company, 343–44
American String Quartet and *American* String Quintet (Dvořák), 5, 7, 35, 41
Amériques (Varèse), 168, 171, 173–74
Anderson, Maxwell, 142, 159, 363, 365
Anti-Nazi League, 286
Apollo (ballet), 27–28, 59
Armitage, Merle, 173
Aronson, Boris, xvi, 16, 366–88, 391–92
Arrau, Claudio, xvi–xvii, 78–79, 83–84, 203
Artists and art historians, 10
Atkinson, Brooks, 144, 377
Auer, Leopold, 200
Ausdruckstanz, 33–34

Bach, Steven, 231
Balanchine, George. *See also* Ballet
 ballets of, 20, 29–45
 collaboration of, with Igor Stravinsky, 12, 14, 22, 27–28, 36–37, 40, 59–67 (*see also* Stravinsky, Igor)
 collaboration of, with Sergey Diaghilev, 26–29
 cultural exchange and, xvi, 420–21
 St. Petersburg and, 23–25, 67–75
 theater productions of, 374–77, 390–91, 396–97
ballet. *See also* modern dance
 Mikhail Baryshnikov, 386, 414
 collaboration of George Balanchine and Igor Stravinsky, 59–67 (*see also* Balanchine, George; Stravinsky, Igor)
 before intellectual migration, 13–14, 25–29, 33
 Lincoln Kerstein and, 29–30
 Russian, 24–26
Barber, Samuel, 90, 191, 201

Barbirolli, John, 102–3, 212
Barnes, Howard, 346
Bartók, Béla, 19, 112, 116–19, 191–92
Baryshnikov, Mikhail, 386, 414
Bauhaus style, 10
Baxter, John, 236, 239–40, 246, 255
Bel Geddes, Norman, 317, 370
Bennett, Joan, 288–90
Berg, Alban, 80, 82, 128
Berger, Ludwig, 286
Bergstrom, Janet, 252
Berlin. *See also* German immigrants
 Boris Aronson in, 367–70
 as film capital, 14, 236–37
 Fritz Lang in, 278, 311–13
 Threepenny Opera in, 154
 Kurt Weill in, 138–41
 Billy Wilder in, 300–302
Berlinerisch, 140, 227, 299
Berlin Philharmonic, 79
Bernstein, Leonard, xv–xvi, 97–98, 187, 197–99, 212, 215, 364, 392
Bing, Rudolf, 101, 212, 365, 396
Black Americans. *See* African-American culture
Bloch, Ernest, 203–4
Blond Venus (film), 222–23, 233
Blue Angel, The (film), 216, 221
Bodanzky, Artur, 212
Bolcom, William, 203
Boleslawski, Richard, 338–39
Bolet, Jorge, 91
Bolm, Adolph, 13
Boston Symphony, 51, 119, 165, 183–84, 188–95, 211–12
Boulanger, Nadia, 165, 167, 190, 192
Boulez, Pierre, 212, 412
Brackett, Charles, 299, 303
Brecht, Bertolt, 11, 15, 111, 139–41, 154–55, 159, 278, 286, 291, 307, 324–27
Breen, Joseph, 290
British immigrants, 12–13, 239–40
Broadway theater. *See* Theater
Brown, Clarence, 266

Brown, John Mason, 357, 361, 371
Burleigh, Harry, 6, 7
Busch, Adolf, 82–83, 85–86, 93, 103, 114
Busoni, Ferruccio, 79, 138–39, 155–56, 162, 166, 170
Butler, Nicholas Murray, 314

Cabaret (theater production), 382–83
Cabinet of Dr. Caligari, The (film), 77–78, 236, 241
Cabin in the Sky (theater production), 32, 43, 374–77, 390–91, 407
Canetti, Elias, 140
Cantelli, Guido, 208
Carmen (film), 363–65
Carousel (theater production), 91, 152, 360, 389
Carroll, Brendan G., 131
Caucasian Chalk Circle, The (play), 325–26
censorship, film. *See* Hays Office censorship; Motion Picture Production Code
Chadwick, George Whitefield, 18
chamber music, 89–91, 94, 98–100. *See also* classical music; Serkin, Rudolf
Chasins, Abram, 89, 176
Chekhov, Michael, 338
Chicago Orchestra, 17
Chicago Symphony, 101, 211
Chinese immigrants, 413–14
choreography. *See* Balanchine, George; Holm, Hanya
Chotzinoff, Samuel, 210
Chou Wen-Chung, 172–73, 174
Cincinnati Symphony, 17, 117, 177
cinema. *See* film
City Center theater, 36–38
City Girl (film), 251–52
Clair, René, 229, 293
classical dance. *See* Ballet

classical music. *See also* composers, American; composers, immigrant; conductors; opera; soundtrack composers
American cultural identity and, xv, 1–2
American culture of performance and, 18–19, 109, 125, 409–10
American prejudice against, 214–15
author's passion for, and books about, xvi–xviii
Chinese immigrants and, 413–14
German musicians vs. non-German musicians and, 210–15 (*see also* classical musicians, German immigrant; classical musicians, non-German immigrants)
instrumentalists, 199–204 (*see also* pianists; violinists)
before intellectual migration, 16–19
theater and, 328–29 (*see also* theater)
this book and, 19
classical musicians, German immigrant, 76–159. *See also* classical music
Berlin and *Berlinerisch* spirit and, 77–81
composers, 108–25 (*see also* Bartók, Béla; Hindemith, Paul; Schoenberg, Arnold; Weill, Kurt)
conductors, 79–81, 101–8 (*see also* conductors)
instrumentalists, 90–91 (*see also* Serkin, Rudolf)
Erich Korngold and soundtrack composers, 126–37
non-German classical musicians vs., 210–15 (*see also* classical musicians, non-German immigrant)
classical musicians, non-German immigrant, 160–215. *See also* classical music

French language
 Serge Koussevitzky and, 188–89
 EdgardVarèse and, 172–73
Freund, Karl, 240
Friedman, Charles, 149–50
Friml, Rudolf, 329–30
Frohman, Charles, 334
From the New World Symphony. *See*
 New World Symphony (Dvořák)
Furtwängler, Wilhelm, 79–80, 85,
 87–88, 98–99, 101–2, 114, 136,
 410
Fury (film), 284–85

Gabin, Jean, 230
Galileo (play), 325–26
Galimir, Felix, 57, 94, 96, 136
Garbo, Greta, 14–15, 177, 181, 224,
 238, 303, 353
 early films of, 267–73
 films of, with Ernst Lubitsch, 257,
 273–77 (*see also* Lubitsch, Ernst)
Garden, Mary, 337
Gardner, Isabella Stewart, 18
Garis, Robert, 61
Gavazzeni, Gianandrea, 205–6
Gebrauchsmusik, 119
Gergiev, Valery, 418–19
Gericke, Wilhelm, 211
Germania Orchestra, 16, 88
German immigrants. *See also* Berlin
 American hostility toward, 101–8
 classical musicians (*see* classical
 musicians, German immigrant)
 Wilhelm Furtwängler's decision to
 remain in Germany, 101–2
 intellectual migration of, 11, 14–18
 relations of, with Germany, 227–28,
 230–31, 290–91
 Russian immigrants vs., 20, 395–407
German language
 Serge Koussevitzky and, 188–89
 Fritz Lang and, 284
 Max Reinhardt and, 321

Rudolf Serkin and, 95
 theater in America and, 328–29
Gershwin, George, xv, 90–91, 97, 114,
 153, 173, 190, 197, 215, 347,
 356–58, 408–9
Gershwin, Ira, 142, 146
Geva, Tamara, 32
Gilman, Lawrence, 169
Giovacchini, Saverio, 286, 308
Goldwyn Follies, The (film), 32, 44
Golschmann, Vladimir, 203
Goode, Richard, 96
Gottschalk, Louis Moreau, 16, 18, 97
Gottschild, Brenda Dixon, 42–43
Graham, Martha, 33–34, 343
Grant, Mark, 159, 360
Griffes, Charles Tomlinson, 165
Group Theatre, 339–40, 373
Gruenberg, Louis, 201
Grünfeld, Alfred, 83–84
Grünwald, Matthias, 119

Hale, Philip, 2–3
Hall, Bernard, 230–31, 233
Hamm, Charles, 358
Hammerstein, Oscar, 359–61, 389
Hanson, Howard, 109, 191, 214
Harris, Roy, 90, 167, 191
Hart, Lorenz, 348, 351
Hart, Moss, 142
Hartlaub, Gustav, 84
Hays Office censorship, 221, 228, 243,
 290, 294, 296, 351, 362–63. *See
 also* eroticism
Heifetz, Jascha, 90, 136, 200–202,
 210–11
Heilbut, Anthony, 10
Heinrich, Anthony Philip, 17–18
Henderson, William J., 1–4, 171, 174,
 199
Henreid, Paul, 322
Henschel, Georg, 211
Herbert, Victor, 17, 18, 329–30
Heymann, Werner, 275

United States (*continued*)
 intellectual migration to, 8–13 (*see also* intellectual migration)
 performing arts before intellectual migration, 13–19 (*see also* performing arts immigrants)
Urban, Joseph, 369–70
Utah Symphony, 203

Van der Stucken, Frank, 17
Varèse, Edgard, 19, 160–76
 American work of, 160–68
 collaborations of, with Leopold Stokowski, 168–76
Venable, Evelyn, 310
Vengerova, Isabella, 97
Vienna, 83–84, 277, 298
Viertel, Salka, 11, 253–54, 269, 272, 303–9, 324
violinists
 Jascha Heifetz, 200–202
 non-German, 203
 Russian vs. German, 86
visual artists, 10
Volkov, Solomon, 404

Wagnerism (Richard Wagner), xvi, 17, 250, 395–96, 405–7
Wagner Nights: An American History, xvi
Wallis, Hal, 129
Walter, Bruno, 78, 79–80, 90, 102–6, 128, 311
Wanger, Walter, 288
Warner Brothers, 129, 136, 235, 298, 305, 314
Warren, Frank H., 169–70
Waters, Ethel, 375
Waxman, Franz, 127–28, 302
Webster, David, 38
Weill, Kurt, xvi, 19, 38–39, 84, 110, 125, 137–59, 317, 347, 365, 378, 390, 397–98
Weinberg, Herman G., 261–62

Weinberger, Jaromir, 111
Wenders, Wim, 412
Werfel, Franz, 11
Werktreue, 85, 87, 98, 405
Western Symphony (ballet), 39–40
Whitney, Gertrude Vanderbilt, 164
Wigman, Mary, 33–34
Wilder, Billy, 14–15, 229, 271, 273, 292, 297–303, 298, 308
Williams, Tennessee, 269, 332
Winter, William, 333
Wolpe, Stefan, 111
Woman in the Window, The (film), 287–88
Woman of Affairs, A (film), 269
women, roles of, 336–37
Woollcott, Alexander, 346
writers. *See also* playwrights; screenwriters
 difficulties of immigrant, 10–11
 Felix Jackson, 229
 Thomas Mann, 394, 398–407
 Vladimir Nabokov, 401–7
Wyler, William, 134, 298

Yates, Peter, 112
Yiddish theater, 15, 340–41, 367–73
You and Me (film), 285–86
Yuzefovich, Victor, 198

Zak, Yakov, 415
Zambello, Francesca, 151
Zanuck, Darryl, 334
Zemlinsky, Alexander von, 13, 111
Zhou Long, 413–14
Zimbalist, Efrem, 200
Zimmermann, Heidy, 168
Zinnemann, Fred, 298
Zorina, Vera, 32, 44, 185
Zuckmayer, Carl, 78, 329
Zukor, Adolph, 235, 242
Zweig, Stefan, 77

Joseph Horowitz was born in New York City in 1948. He was a music critic for the *New York Times* from 1977 to 1980. His previous books are *Conversations with Arrau* (1982, winner of an ASCAP/Deems Taylor Award), *Understanding Toscanini: How He Became an American Culture-God and Helped Create a New Audience for Old Music* (1987), *The Ivory Trade* (1990), *Wagner Nights: An American History* (1994, winner of the Irving Lowens Award of the Society of American Music), *The Post-Classical Predicament* (1995), *Dvořák in America: In Search of the New World* (for young readers, 2003), and *Classical Music in America: A History* (2005). From 1992 to 1997 he served as artistic adviser and then executive director of the Brooklyn Philharmonic Orchestra, resident orchestra of the Brooklyn Academy of Music, and there pioneered in juxtaposing orchestral repertoire with folk and vernacular sources. He has subsequently served as an artistic adviser to various American orchestras, most regularly the Pacific Symphony. He has also co-founded Post-Classical Ensemble, a chamber orchestra in Washington, D.C. He has taught at the Eastman School, the Institute for Studies in American Music at Brooklyn College, the New England Conservatory,

the Manhattan School of Music, and Mannes College. He regularly contributes articles and reviews to the *Times Literary Supplement* (UK); other publications for which he has written include *American Music, The American Scholar, The New Grove Dictionary of Music and Musicians, The New Grove Dictionary of Opera*, the *Musical Quarterly, The New York Review of Books*, and *Nineteenth Century Music*. He is the author of "Classical Music" for both the *Oxford Encyclopedia of American History* and the *Encyclopedia of New York State*. He lives in New York City. His Web site is www.josephhorowitz.com.